...uty on my knees; and I found her bitter, and I injured her. ARTHUR RIMBAUD, 1873

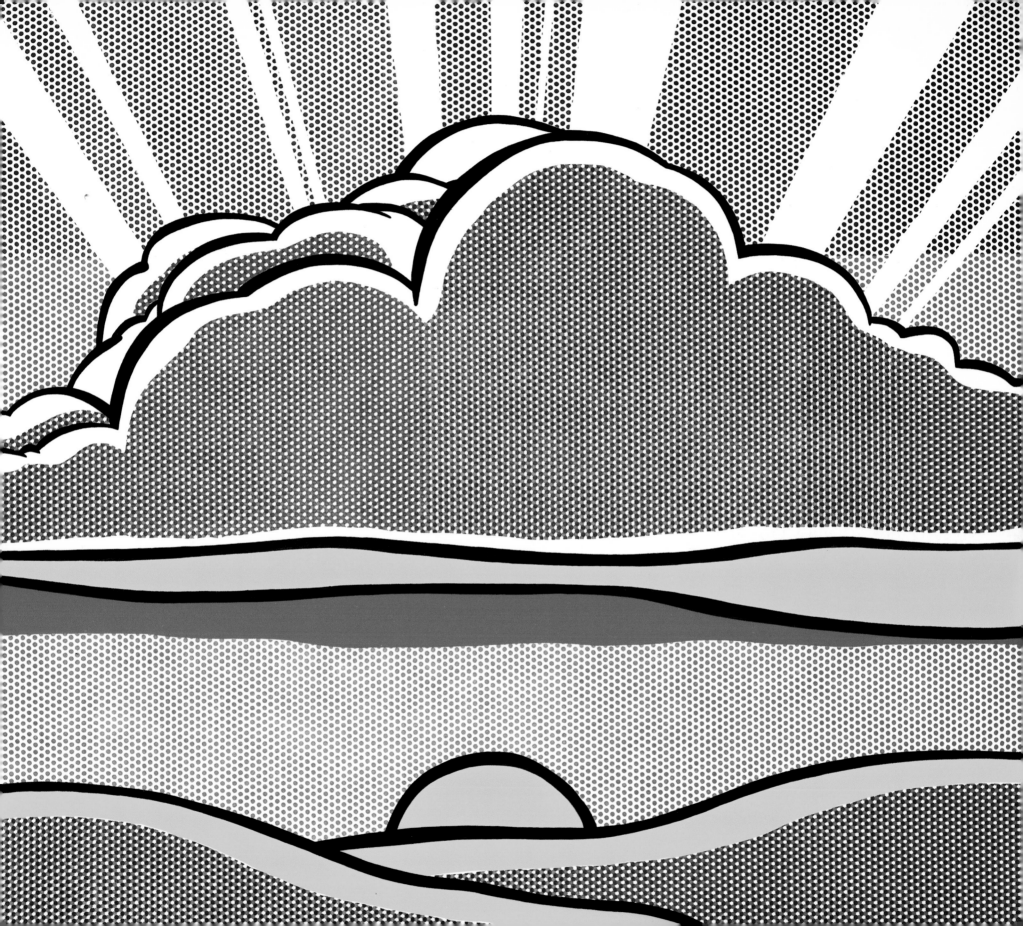

NEAL BENEZRA *OLGA M. VISO* *WITH AN ESSAY BY ARTHUR C. DANTO*

REGARDING **BEAUT**

Hirshhorn Museum and Sculpture Garden
Smithsonian Institution
Washington, D.C.

in association with
Hatje Cantz Publishers

A VIEW OF CENTURY

Published in 1999 on the occasion of an exhibition organized by the Hirshhorn Museum and Sculpture Garden.

Hirshhorn Museum and Sculpture Garden Washington, D.C. October 7, 1999– January 17, 2000

Haus der Kunst, Munich February 11–April 30, 2000

Major support for the exhibition was provided by the Holenia Exhibition Fund in memory of Joseph H. Hirshhorn; by Robert Lehrman; and by The Hill Family Foundation, Inc. Additional funding was provided by Aaron and Barbara Levine and the Phoebe W. Haas Charitable Foundation.

The catalog was made possible in part by The Andy Warhol Foundation for the Visual Arts, Inc. The media-arts gallery was funded by the Peter Norton Family Foundation, and education programs were supported in part by a grant from Carlos and Rosa de la Cruz.

Additional assistance was provided by the Canadian Embassy, Washington, D.C.; Pro Helvetia, the Arts Council of Switzerland; the Mondriaan Foundation, Amsterdam; and the Institute for Foreign Affairs of the Federal Republic of Germany.

Cover: Jim Hodges, *Our Day*, 1993, detail [not in exhibition; see cat. no. 30]

Half-title page: Roy Lichtenstein, *Sinking Sun*, 1964 [cat. no. 36], detail

Title page: Hiroshi Sugimoto, *Bay of Sagami, Atami*, 1997 [cat. no. 79], detail

Preface: Matthew Barney, *CR4: Faerie Field*, 1994 [cat. no. 3], detail

CONTENTS

The Baltimore Museum of Art

Helen and Tony Berlant

The Eli Broad Family Foundation, Santa Monica, California

Donald L. Bryant Jr. Family Trust

The Carnegie Museum of Art, Pittsburgh

Cheim and Reid, New York

Collezione Prada, Milan

Carlos and Rosa de la Cruz

Daros Collection, Switzerland

De Pont Foundation for Contemporary Art, Tilburg, The Netherlands

Jeffrey Deitch, New York

Des Moines Art Center

Mr. and Mrs. Charles Diker

Fondation Beyeler, Riehen/Basel

Fondation Cartier pour l'Art Contemporain, Paris

FUCUTEL/Centro de Cultura Casa Lamm A.C.

Barbara Gladstone Gallery, New York

Goetz Collection, Munich

Mocci Hammer

Samuel and Ronnie Heyman

Helman Collection, New York

Hirshhorn Museum and Sculpture Garden, Smithsonian Institution, Washington, D.C.

Jim Hodges and CRG, New York

Rhona Hoffman Gallery, Chicago

Camille Oliver-Hoffmann

Irish Museum of Modern Art, Dublin

Nancy Reddin Kienholz

Ulrich Knecht, Stuttgart

Imi Knoebel

Emily Fisher Landau, New York

U.S. Senator Frank R. Lautenberg

Robert Lehrman, Washington, D.C.

Lisson Gallery, London

Susan and Lewis Manilow

The Menil Collection, Houston

The Metropolitan Museum of Art, New York

Modern Art Museum of Fort Worth

Museum Ludwig, Cologne

Museum in Progress, Vienna

Guy + Marion Naggar

Eileen and Peter Norton, Santa Monica, California

PaineWebber Group, Inc.

Michelangelo Pistoletto

Howard E. Rachofsky

San Francisco Museum of Modern Art

Sonnabend Gallery, New York

Jerry + Emily Spiegel

Christian Stein Collection, Turin

Stedelijk Van Abbemuseum, Eindhoven, The Netherlands

Virginia Museum of Fine Arts, Richmond

Thea Westreich and Ethan Wagner

Private collection, courtesy Massimo Martino Fine Arts and Projects, Mendrisio, Switzerland

Private collections

LENDERS TO THE EXHIBITION

6

The barbs, epithets, scorn, ridicule, outrage, and vituperation that the general public and many of the most widely read art critics of the time heaped upon Édouard Manet and the Impressionist and Post-Impressionist painters of the last third of the last century have been followed a century later by praise, encomiums, tributes, enthusiasm, love, and adulation for the work of those self-same artists, again by the public and critics. That astonishing turnaround has been cited time and time again (to the point of becoming a cliché) by curators and collectors defending the art and artists of today. And why not? How could it be that the Parisian critic J. Claretie, after viewing in 1874 what later came to be known as the First Impressionist Exhibition, would write that "M. Monet ... Pissarro, Mlle. Morisot, etc., appear to have declared war on beauty,"[1] while today Impressionist paintings have become the very embodiment of beauty in the art of the Western world?

What has changed to bring about such a drastic reversal of opinion? We can be absolutely certain that it is not the paintings that have changed. One must logically conclude, therefore, that the public and its perception of beauty have. The eighteenth-century philosopher David Hume suggested that beauty resides in the mind of the beholder, an observation that seems more apt than the better-known adage "Beauty is in the eye of the beholder," for it is the mind that is tempered and altered by years of psychic, emotional, intellectual, and sensory experiences.

We would not be at all surprised to learn that if Claretie had great-grandchildren, they would be among those who would be astonished and amused that anyone, least of all an esteemed forebear, could have suggested that Renoir and Degas and Sisley and Cézanne, in addition to those cited above, had "declared war on beauty."

FOREWORD

JAMES T. DEMETRION

But what about the descendants of Claretie's great-grandchildren as they contemplate those same paintings in 2099 or beyond? How will they react? Will Monet's *Field of Poppies* (Musée d'Orsay, Paris) or Renoir's *The Loge* (Courtauld Institute, London) still be beautiful to them, or will their perceptions be closer to that of their nineteenth-century ancestor? Or will Impressionism have dropped out of the scope of the public arena altogether and merely be an indifferent or arcane area of study for scholars and specialists?

The goal of the present exhibition is clear: to continue a passionate dialog about the changing nature and perception of beauty over the last four decades of the twentieth century. Those years have been marked by an apparent shift from formalism — characterized by Frank Stella's "what-you-see-is-what-you-see"[2] approach — toward an art with a near total reliance on content. If, as some might contend, formalism and content are at opposite extremes, it can be said that the pendulum has begun to swing once again. Yet, when one is engaged with Renoir's *Luncheon of the Boating Party* (The Phillips Collection, Washington, D.C.), Pablo Picasso's *Guernica* (Museo Nacional Centro de Arte Reina Sofía, Madrid), Lucian Freud's *Benefits Supervisor Sleeping* [cat. no. 24, p. 56], or a silk flower installation by Jim Hodges [see cat. no. 30 and pp. 176, 177], it is evident that the pendulum does not rest fully on content or formalism. Perhaps the most beautiful art is that in which formalism and content complement each other, each enhancing the other's most positive qualities.

Neal Benezra, the Hirshhorn's Assistant Director for Art and Public Programs, and Olga M. Viso, Associate Curator, have audaciously taken on the daunting and ambitious subject of this exhibition, and they

M. Monet ... Pissarro, Mlle. Morisot, etc., appear to have declared war

are to be commended for meeting the challenge head on. Their ongoing conversation, which we hope is reflected in the themes, installation, and catalog of the exhibition, is intended to present beauty's many sides. As co-curators they have conceived and organized the exhibition, and their essays here are stimulating contributions to the litera-

ture on this important theme. In the end, the exhibition is two individuals' perspectives on a rich and complex topic that is worthy of continued investigation. Recognition is due as well to doctoral student Chris Gilbert and Research Associate Anne-Louise Marquis, who researched the biographies, verified facts, and aided in innumerable other ways relating to the contents of the book. Publications Manager Jane McAllister brought coherence to a multifaceted publication. Thanks are also owed to guest essayist Arthur C. Danto, whose examination of the philosophical underpinnings of the relationship between art and beauty has greatly enhanced this publication.

We welcome the Haus der Kunst as our partner for the exhibition. Our acknowledgments are extended to its Director, Christoph Vitali, for his enthusiastic participation, and to Hubertus Gassner, Chief Curator of that institution.

In addition, the lenders to this exhibition — the individuals and the institutions — have our profound gratitude for their support. Many individuals involved in one form or another with this project and deserving of thanks are cited elsewhere in this publication.

We are extremely grateful to all of the sponsors for their generosity. Special thanks go to the Holenia Trust in memory of Joseph H. Hirshhorn; to Robert Lehrman; and to J. Tomilson Hill and the Hill Family Foundation, Inc. Additional funding was provided by Aaron and Barbara Levine and the Phoebe W. Haas Charitable Foundation. The Andy Warhol Foundation for the Visual Arts, Inc., the Peter Norton Family Foundation, and Carlos and Rosa de la Cruz provided support for, respectively, the exhibition catalog, the media-arts gallery, and education programs. Additional support came from the Canadian Embassy, Washington,

auty. J. CLARETIE, 1874

D.C.; Pro Helvetia, the Arts Council of Switzerland; the Mondriaan Foundation, Amsterdam; and the Institute for Foreign Affairs of the Federal Republic of Germany. We are indebted to all of the sponsors for helping us realize this important exhibition and its related programs.

1
Cited in John Rewald, *The History of Impressionism* (New York: Museum of Modern Art, 1946), 263. From J. Claretie, "Le Salon de 1874," reprinted in *L'art et les artistes français contemporains*, Paris, 1876.

2
Stella, quoted in Bruce Glaser, "Questions to Stella and Judd," *Art News* 65, no. 5 (September 1966): 55–61.

ACKNOWLEDGMENT

In the late twentieth century few words challenge us more than "beauty." Uttered trivially in everyday life, the term connotes personal taste and preference. In matters of art and culture, however, its implications are exceedingly more complex. As writer Marjorie Welish has observed, "beauty" in our time "has come to mean nothing – or everything."[1]

While ascribing beauty to art may seem natural and appropriate, in recent decades beauty and contemporary art have been considered virtually incongruous. In an art world increasingly focused on global issues and social concerns, artists and critics alike have questioned beauty's efficacy and relevance for contemporary culture. Suggesting frivolity, the machinations of the art market, and a lack of seriousness and social purpose, beauty has indeed come under severe attack. The assault on beauty by the contemporary art world has left a confused and baffled art-viewing public uncertain about one of the very cornerstones of Western art and culture, namely, the pursuit of beauty.

The contemporary disregard for beauty flies in the face of centuries of philosophical debate and artistic practice. The first analyses of beauty date to our Classical forebears – Socrates, Plato, and Aristotle – who formulated the basis of our understanding of this elusive concept. It is from these Classical Greek philosophers that some of our most lasting assumptions about beauty in Western culture derive, particularly in regard to art. The ancients' attempts to define beauty, to give it lasting and tangible form and value, have so shaped the Western conception that at times it has become impossible to appreciate ideals of beauty that may be more appropriate to the present age. Despite changing styles and tastes reflected in popular culture and fashion, the Classical

ᴺᴰ *PREFACE*

NEAL BENEZRA AND OLGA M. VISO

belief in the universality of beauty still holds considerable weight in Western society. Yet, at the end of the twentieth century, the legitimacy of a universal credo seems extremely suspect. In an era of global economies, multicultural sensitivity, ecological decline, and rapidly advancing communications and genetic technologies, how can timeless ideals, eternal values and truths, and a universal culture of taste mean anything? What significance can the tradition of beauty possibly have for the late twentieth century? Or the twenty-first?

Approaching beauty, then, at this point in human history may seem a frivolous, even futile, endeavor. And as the subject of an exhibition, the pitfalls it presents may seem even more numerous. Yet, rather than mince arguments in age-old debates about beauty's existence or cultural necessity, we have chosen (as we believe many artists have) to accept beauty's equivocal status in contemporary culture and acknowledge the depth and richness of its current complexities. Exploring the potential of beauty for what it reveals about humanity on the verge of a new millennium is an infinitely more productive enterprise.

Although the concept of beauty has been a topic of exceptional interest in the contemporary art world since the publication in 1993 of Dave Hickey's seminal collection of essays *The Invisible Dragon: Four Essays on Beauty*, few exhibitions have tackled the issue in a concrete or historical fashion. In 1994 curator Ann Goldstein organized "Pure Beauty: Some Recent Work from Los Angeles" for the American Center in Paris in cooperation with the Museum of Contemporary Art, Los Angeles. That exhibition, however, focused only on a small group of regional artists working in one city in the 1990s. The next year, Lynn Gumpert organized "La Belle et La Bête" (Beauty and the Beast) for the Musée d'Art Moderne de la Ville de Paris, which built on Hickey's ideas about "transgressive beauty" and the relationship between beauty and ugliness. Her insightful examination into the work of sixteen young American artists looked, however, at only one aspect of a rich topic over a limited historical period. Likewise Dan Cameron's "On Beauty" for the Regina Gallery in Moscow in 1996 concentrated on artists of a particular generation, while in 1997, Rosa Martinez's "On Life, Beauty, Translations and Other Difficulties," the fifth Istanbul Biennial, considered beauty among many other salient contemporary issues.

Our investigation selectively examines art of the last forty years to address why the timeless notion of beauty has been so hotly contested in our time. Rather than present a chronological survey, we have pursued a thematic approach for its intriguing comparisons between artists across generations, styles, media, and traditional interpretive contexts. The earliest works date to the beginning of the 1960s, when the advent of Pop and Conceptual Art introduced a philosophical and artistic crisis of major proportions, and conventional standards of aesthetic evaluation suddenly no longer seemed applicable or valid. Analytical philosopher Arthur C. Danto has written extensively on the impact of that aesthetic crisis in his anthology of essays *Embodied Meanings: Critical Essays and Aesthetic Meditations* (1994) and in *After the End of Art: Contemporary Art and the Pale of History* (1997), and we felt that his philosophical perspective was essential to grounding our ideas. In this volume, he examines the complex relationship between art and beauty, while in our essays we trace the travails of beauty in the twentieth century, respectively considering the decades leading up to 1960 and the years since.

"Regarding Beauty" follows logically on two previous Hirshhorn exhibitions. In 1984, for the Hirshhorn's tenth anniversary, the museum organized "Content: A Contemporary Focus, 1974–1984," an exhibition that looked at the now well-known shift from formalism to content in the art of those years. In 1996 we organized "Distemper: Dissonant Themes in the Art of the 1990s," an international group show that explored a variety of themes, principal among them contemporary artists' reengagement with beauty and all its inherent contradictions in contemporary culture. As a result, "Regarding Beauty," organized to celebrate the Hirshhorn's twenty-fifth anniversary, serves as a thematic counterpoint to "Content" and a continuation and expansion of work begun in "Distemper."

The creation and production of a large thematic exhibition requires the great goodwill and sustained cooperation of a great many friends and colleagues. We are especially grateful to our gifted and veteran Hirshhorn staff who, although surely puzzled at times by our efforts, have always responded with kind good humor, sound advice, and practical assistance. From the outset, "Regarding Beauty" has been supported by the

museum's Director, James T. Demetrion, who has offered both time and wise counsel toward its realization as well as a much-appreciated grant of independence to pursue our ideas. The museum's Assistant Director for Administration, Beverly Lang Pierce, has also been unfailingly helpful in helping us realize our aims.

Staff members in every department of the museum have contributed on our behalf, and we wish to thank, in particular, Brian Kavanagh and Barbara Freund of our Registrar's office; Edward Schiesser, Robert Allen, and Albert Masino in the Exhibits and Design department; Anna Brooke and the Library staff; Laurence Hoffman and the Conservation staff; Lee Stalsworth, Chief Photographer; Fletcher Johnston and the Building Management Office staff; Laurie James and Maureen Turman in the Director's Office; and April Martin, Budget Analyst, all of whom have helped in innumerable ways. We are also grateful to Janice Deputy for her determined fund-raising efforts.

In our own Department of Public Programs, we are deeply indebted to Jane McAllister, Publications Manager, for guiding this catalog through many months of the editorial, design, and production process; Linda Powell and the Education staff; Sidney Lawrence, Head of Public Affairs; and Suzanne Pender, Public Programs Coordinator. We are also grateful to Associate Curator Phyllis Rosenzweig for her thoughts, and to Francis Woltz, for her administrative assistance and good spirit throughout the project. The research team that supported our work on this catalog included Research Associate Anne-Louise Marquis and Chris Gilbert, a doctoral student at Virginia Commonwealth University, Richmond, who have also contributed the biographies of the artists. They were assisted in turn by curatorial interns Sima Familant, Sarah Finlay, Laura Roulet, Heather Ruth, and Melanie Weeks and by Editorial Assistant Barbara Feininger.

Beyond Washington and the Smithsonian, we wish to thank Kathy Fredrickson, Cheryl Towler Weese, and the staff of studio blue, Chicago, for their imaginative book design and expert production guidance. We are grateful to Hatje Cantz Publishers and Markus Hartmann, Director of International Projects, for publishing the catalog, and D.A.P./Distributed Art Publishers and Sharon Helgason Gallagher, Director, for distributing it in the United States. We appreciate the enthusiastic endorsement of the book by the Andy Warhol Foundation for

the Visual Arts, Inc., and Pamela Clapp, Program Director. We acknowledge the Peter Norton Family Foundation, including Eileen and Peter Norton and Susan Cahan, Curator and Director of Art Programs, for its early interest in sponsoring the media-arts program, which is the subject of an independent brochure.

We are deeply grateful to all sponsors of the exhibition and its programs, who are acknowledged in the Director's Foreword. Our personal debt of gratitude to our respective spouses, Maria Makela and John Gallagher, is already vast and growing by the day. Finally, a tremendous number of individuals offered their support in a wide variety of ways and we are pleased to name them below, with our warm and affectionate appreciation:

Matthew Armstrong, Roland Augustine, Douglas Baxter, Gianfranco Benedetti, Michael Bond, John Brough, Chris Bruce, Karla Chammas, John Cheim, Margot Crutchfield, Renato Danese, Kimberly Davis, Mary Dean, Susan Dunne, Kathleen Forde, Marc Foxx, Barbara Gladstone, Marian Goodman, Paul Gray, Richard Gray, Madeleine Gryznstejn, Joanne Heyler, Antonio Homem, Walter Hopps, Xavier Hufkens, Tim Hunt, Susan Inglett, Sean Kelly, Rotraut Klein-Moquay, Nicholas Logsdail, Lawrence Luhring, Darlene Lutz, Duncan MacQuigan, David McKee, Renee McKee, Anthony Meier, Daniel Moquay, Kay Pallister, John Ravenal, Shaun Caley Regen, Janelle Reiring, James Rondeau, Robert Rosenblum, Andrea Rosen, Robert Shapazian, Lynn Sharpless, Matt Simpson, Joanna Southwell, Monika Sprüth, Vicente Todoli, Lydia Vivante, Stephen Vitiello, Diane Waldman, Jeffrey Weiss, Stuart Wheeler, Helene Weiner, Wendy Williams

1
Marjorie Welish, "Contratem-plates," Bill Beckley and David Shapiro, eds., *Uncontrollable Beauty: Toward a New Aesthetics* (New York: Allworth Press, 1998), 61.

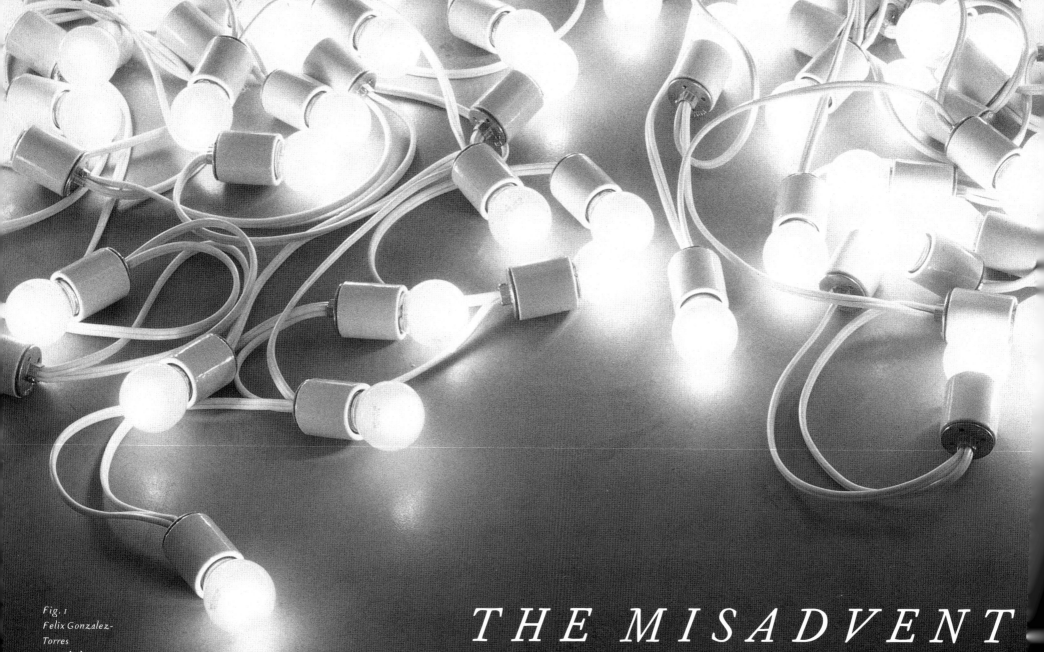

THE MISADVENT

Beauty, perhaps the loftiest aspiration of Western artists throughout history, has had a rough time of it in the twentieth century. While numerous artists have sustained and expanded the tradition of aesthetic expression in our century, for a great many of the most important modern artists in the West, beauty and aesthetics have been of secondary concern. As Barnett Newman succinctly stated in 1948, "The impulse of modern art is the desire to destroy beauty."[1] Working at midcentury, Newman and his fellow Abstract Expressionists sought to free themselves from the shackles of centuries of aesthetic tradition and expectation. For Newman as for many others, the pursuit of beauty had become an indication of conservatism and failed nerve, an ignoble ambition to be shunned at all costs.

If the overthrow of beauty occupied modern artists, beauty has been freighted with additional weight and complication during the last decade of the century. To sample the recent misadventures of beauty, consider two cases. The first dates to 1997 and Documenta X. Since its establishment in the 1950s, the large international survey exhibition Documenta has been a barometer of current thinking about art, particularly in Europe and North America. Documenta X became unusually controversial when the organizer, the respected French curator Catherine David, explicitly and self-consciously limited her selection to artists whose work featured a critical political sensibility at the expense of aesthetics. Painting, which for David and many others had become a medium of conservative aesthetics and political attitudes, was virtually absent from the exhibition. Indeed, Documenta X included no work that could in any way be described as formal. Characterizing the anti-aesthetic bias of the exhibition was a memorable commentary published in *Artforum* just prior to the opening of the

ES OF BEAUTY

NEAL BENEZRA

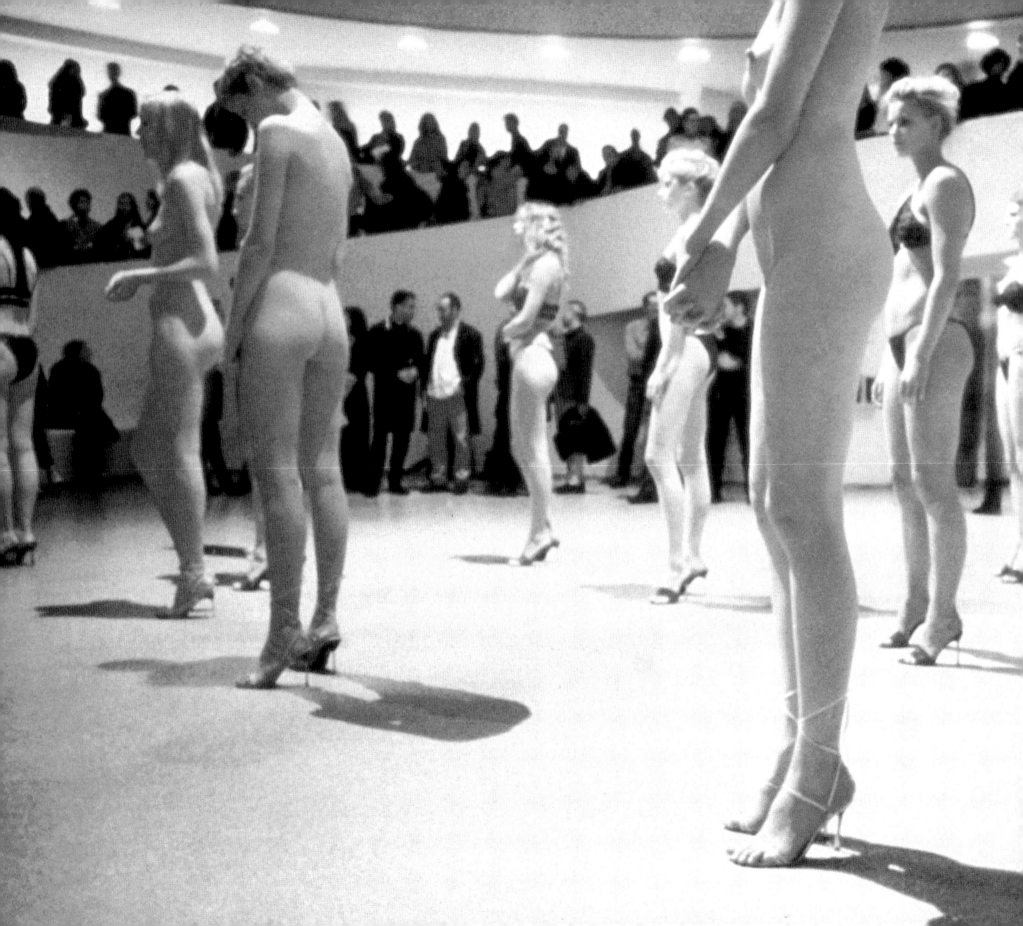

exhibition, concerning the work of Felix Gonzalez-Torres, an artist not only of extraordinary social and personal implication but also of consummate formal eloquence [*fig. 1*]. David bemoaned the "dramatic aestheticization of political debate in recent art," and justified her exclusion of the artist on that basis.[2] In short, for many critics and curators, aesthetic value in contemporary art is today necessarily divorced from meaning: form and content may not coexist; beauty is beneath contempt.

The second case involves an installation by the young Italian-born, New York–based artist Vanessa Beecroft. On April 23, 1998, Beecroft organized *Show* for the rotunda of the Solomon R. Guggenheim Museum in New York. Presented in the evening before an audience of invited guests – the museum was closed to the public – *Show* [*fig. 2*] was typical of the type of performances Beecroft has recently conceived and orchestrated. It featured twenty models, fifteen of whom were dressed in red bikinis and high-heeled rhinestone shoes by a well-known designer; five others wore only the shoes. Their movements choreographed by Beecroft, the models moved with desultory ease in the manner of a fashion-show walk. As noted in the press release that accompanied the event, "By changing the context in which the viewer sees the models – from magazine, billboard, television or runway to art institution – Beecroft transforms the models into 'ready-mades' of beauty."[3]

In these two cases the extraordinarily strained relationship between art and beauty at century's end is told. At one end of the

beauty but pose new challenges for it. Here, beauty is not considered a traditional aesthetic ideal to be sought after for its own sake, but rather, a complex cultural construct inseparable from contemporary attitudes toward the human body, sex, and mass media. The vast gap separating these diametrically opposing viewpoints reveals the difficult position that beauty has come to occupy in contemporary art. The pages that follow survey the reaction against beauty in the art of the past half-century to suggest how we have arrived at the present situation.

Any discussion of the misadventures of beauty in the twentieth century must necessarily begin in the years before World War I, in particular with Pablo Picasso. In his work during the first decade of the century, Picasso called upon non-Western artistic traditions to revitalize long-standing genres such as portraiture, landscape, and still-life. Particularly with his landmark painting *Les Demoiselles d'Avignon*, 1907 [*fig. 3*], Picasso profoundly influenced modern aesthetics by introducing Iberian, African, and Oceanic figurative models. While he was seeking new ethnographic examples of beauty in the years before 1910, other artists were looking to the machine and the new mechanical age.

Fernand Léger considered common manufactured objects the basis for a new aesthetic. Léger railed against tradition and the history of art as a repository of beauty. He would later write in "The Machine Aesthetic":

Fig. 2
Vanessa Beecroft
Show
April 23, 1998

Beauty creates shame. VANESSA BEECROFT, 1998

spectrum are artists, critics, and curators who disparage beauty and aesthetics. From their standpoint, aesthetics are inevitably politicized and thereby an inappropriate avenue for artistic investigation. The opposing, equally large and committed group embrace

Why is it necessary for these people to go into ecstasies on Sunday over the dubious pictures in the Louvre or elsewhere? Among a thousand pictures are there two beautiful ones? Among a hundred machine-made objects, thirty are beautiful, and they resolve the problem of art, being beautiful and useful at the same time.[4]

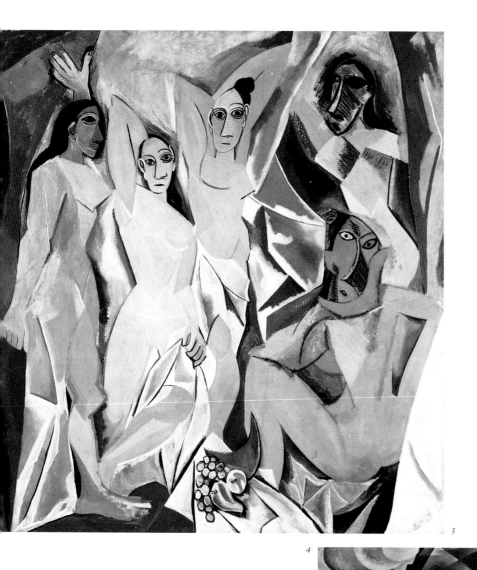

3

In the same essay, Léger was equally emphatic that "in the mechanical order the dominant aim is utility, strictly utility. The thrust toward utility does not prevent the advent of a state of beauty."[5] Léger viewed the machine as the emblematic form and perfect expression of a new type of beauty. With the increasingly mechanized, fast-paced tempo of urban life, Léger found a beauty that superseded the static images of the past. His "contrast of forms" paintings of 1913–14, with their dynamically composed, whirling tubular shapes, offer a glimpse of a novel aesthetic in step with the mechanization of urban life.

Léger's aesthetic position was established in the years just before World War I. For many, the period leading up to the war was one of enormous optimism, with the promise of change seen as a cleansing agent that could sweep away depleted traditions in society, politics, and art. A drumbeat of anticipation had begun in Germany and other European nations as well, both in military and progressive artistic circles. A dissonant celebratory note is heard in the proclamations of the Futurists, such as in F. T. Marinetti's "Foundation and Manifesto of Futurism" of 1908, first published in

The impulse of modern art

4

Le Figaro the following year. For the Futurists, the violence of war would introduce an aesthetic and a cultural epoch based on the dynamic of speed.

We declare that the splendor of the world has been enriched with a new form of beauty, the beauty of speed…. A race-automobile … is more beautiful than the Victory of Samothrace…. There is no more beauty except in struggle. No masterpiece without the stamp of aggressiveness…. We will glorify war…. We will destroy museums.[6]

Marinetti's wild-eyed, irrational embrace of the vital potential of war and with it a new form of beauty found short-lived expression in Futurist art. The titles of works by Umberto Boccioni, Luigi

Rusolo, and Gino Severini are filled with references to velocity, dynamism, and violence. Combining images of gunfire with a swiftly moving train, Severini's painting *Armored Train in Action*, 1915 [*fig. 4*], is a tight synthesis of Futurist interests and aesthetics. In this and many other works, the Futurists aestheticized violence, creating a most shocking and dissonant celebration of modernism.

World War I proved an unimaginable corrective for the naive illusions of the Futurists. Beyond the imponderable loss of life, however, was the agonizingly slow pace of the battle, which was played out in the trenches. If reports from the front quickly laid bare the Futurists' perverse anticipation of warfare, avant-garde European artists nevertheless viewed the changes brought on by war through a variety of lenses. As astonishing and diverse as were the inventions of Picasso, Léger, Severini, and others, in essence all had substituted new visions of beauty for an existing, exhausted canon. Owing to the enormous shared trauma induced by the war, art and aesthetics were now reinvented or manipulated for explicitly social or political reasons. Manifestos proliferated, and through the words and works of theorists and artists alike, aesthetics and beauty were called to serve a wide range of masters, from utopian idealism on the left to fascist populism on the right. Perhaps the most radical and ultimately influential position, however, was established by Marcel Duchamp, who leveled a direct assault on the aesthetic basis of art.

desire to destroy beauty. BARNETT NEWMAN, 1948

Duchamp began his career as a painter and in the first decade of the century moved through several progressive styles ranging from Post-Impressionism to Cubism and Futurism. It was his view that painters historically had been engaged with ideas but that the nineteenth century had produced an art that was increasingly devoid of intellectual interest and devoted instead to matters of paint application that would merely gratify the eye. By 1912, Duchamp believed that his endeavor "to put painting once again at the service of the mind"[7] had failed, and he abandoned painting altogether in favor of a variety of experiments involving language, chance, and perhaps his most lasting contribution, "readymades."

Of all the arts, Duchamp disdained painting in particular as a grand cultural institution governed by the notion of artistic genius and the reverence for masterpieces. His most conspicuous work in that regard was the notorious *L.H.O.O.Q.*, 1919 [*fig. 5*], in which he drew – graffiti style – a moustache and goatee on a small reproduction of Leonard da Vinci's *Mona Lisa* and the letters L.H.O.O.Q. underneath.[8] Owing to the fame of the original and to Duchamp's insouciance, the work became a centerpiece of Dada and later Surrealism, and it spawned a number of iconoclastic thrusts against the grand tradition by artists such as Salvador Dalí, Francis Picabia, and Man Ray. Particularly devastating was Picabia's *Portrait of Cézanne*, 1920 (no longer extant), in which a monkey serves as a surrogate portrait of the painters Paul Cézanne, Pierre-Auguste Renoir, and Rembrandt. For Duchamp and his colleagues, beauty provided an apt target for the sweeping renunciation of artistic tradition that was the essence of Dada.

Duchamp's critique of aesthetics assumed a variety of related forms. The artist recognized and sought to combat the notion that art had always been governed by matters of taste and craft. That he willingly adopted chance as a creative method manifested itself in a small group of objects that he designated as readymade art objects – a urinal [*fig. 6*], a bicycle wheel [*see fig. 57*], and a bottle rack, among others. In one of modern art's most often-repeated tales, the French artist, living in New York in 1917, purchased a

Fig. 3
Pablo Picasso
Les Demoiselles d'Avignon
1907
oil on canvas

Fig. 4
Gino Severini
Armored Train in Action
1915
oil on canvas

nondescript porcelain urinal from the J. L. Mott Iron Works, signed "R. MUTT" on the rim in large black letters, and entered it anonymously under the title *Fountain* in the Society of Independent Artists exhibition, an annual nonjuried exhibition to which any artist who paid the nominal entrance fee was entitled to participate. Duchamp's submission in the 1917 exhibitions, only one of 2,125 works entered by twelve-hundred artists, caused a great stir. Moments before the exhibition was to open, *Fountain* was rejected by the Society's board of directors. Significantly, leading the campaign against the sculpture were two well-known American painters, George Bellows and William Glackens. It was the latter who announced the work's rejection to the press, stating that "By no definition [was *Fountain*] a work of art."[9]

Fountain had its defenders, and the terms of its defense go to the heart of the prevailing debate. At the time a friend and patron of Duchamp's, the well-known collector Walter Arensberg, his tongue perhaps embedded in his cheek, explained the sculpture to Bellows, stating, "A lovely form has been revealed, freed from its functional purpose, therefore a man has clearly made an aesthetic contribution."[10] If Arensberg were attempting to explain Duchamp's irony on the basis of aesthetics – Bellows might well dispute the aesthetic contribution of *Fountain*, but it was an argument in which he could doubtless engage – he unknowingly touched on the ability of modern culture to aestheticize even the most unorthodox ideas and objects. And indeed, Duchamp recognized that predilection. Reflecting on *Fountain* many years later, Duchamp disavowed Arensberg's advocacy, stating, "When I discovered readymades, I thought to discourage aesthetics.... I threw the bottle rack and the urinal in their faces as a challenge, and now they admire them for their aesthetic beauty."[11]

Duchamp's anti-aesthetic position was established in New York in 1917, at the height of World War I. Although the United States had joined the allied effort that year, the war was conducted

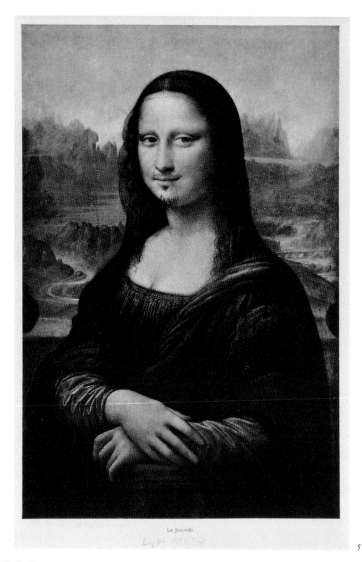

La Joconde

L.H.O.O.Q.

5

Fig. 5
Marcel Duchamp
L.H.O.O.Q.
1919
rectified
readymade: pencil
on a reproduction

Fig. 6
Marcel Duchamp
Fountain
1917
porcelain urinal
Photograph by
Alfred Stieglitz

Fig. 7
Jean Arp
**Squares Arranged
According to the
Laws of Chance**
1917
cut-and-pasted
papers, ink,
and bronze paint

6

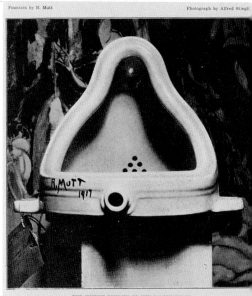

Fountain by R. Mutt Photograph by Alfred Stiegli

THE EXHIBIT REFUSED BY THE INDEPENDENTS

exclusively on European soil, where the unparalleled devastation that was unleashed was to have profound and lasting social and cultural implications. Progressive artists in many European capitals shared Duchamp's irony and renunciation of painting. Painting connoted craft, but it also signified a Europe locked in the grip of static cultural values. In many circles, Duchamp's ideas were considered exemplary, and his espousal of readymades, chance, and accident had an enormous effect in fostering the widespread reaction against beauty. That attitude found special expression in Dada, a loose confederation of artists established in 1916 in Zurich whose ideas spread to Paris, Berlin, and numerous other cities almost immediately and provided a significant avenue for anti-aesthetic exploration well into the 1920s. Dada was a movement driven by intellectuals who were activists as well as artists. Their disgust with the grandeur of art and their indifference to all forms of tradition were equaled only by their high-spirited spontaneity and engagement with the contradictions of life. The term "dada" was itself a chance designation, having apparently been selected at random from a dictionary by Richard Huelsenbeck and Hugo Ball. Anarchic subversion of all established institutions lay at the heart of Dada. Dadaists devised a wide range of alternative methods for constructing images that might defy traditional painterly methods, the artist's hand, or any form of aesthetic judgment.

Rationality was anathema to Dadaists, and they adopted various means to combat it. Working in Zurich during World War I, Jean Arp dropped cut pieces of paper on the ground and used the resulting arrangements as points of departure for works such as the collage *Squares Arranged According to the Laws of Chance*, 1917 [*fig. 7*]. Whereas Arp's interest in chance ironically yielded works of great lyrical beauty, other artists developed methods that generated more disconcerting results. For example, to overcome conscious control of the hand, André Masson

7

evolved a system of automatic drawing in which the pen was allowed to wander rapidly over the page. The resulting skeins of line admitted neither comprehensible images nor pleasing abstractions. Another form of automatism was unleashed a few years later in the "Exquisite Corpse" drawings [*fig. 8*] done by groups of Surrealists. The title derived from the random pairings of several words and phrases (the original instance was "The exquisite/corpse/shall drink/the bubbling/wine"), and images were generated by passing a folded sheet of paper between artists, with each contributing a segment. The results were stunning in their odd psychological associations and decidedly unaesthetic conjunctions.

The artistic response to World War I was far different elsewhere. German art during the war and immediately thereafter was most often highly political, whether in the form of expressionism or in the Berlin variant of Dada. While the war could be perceived as absurd to Dada artists living in a neutral capital like Zurich or distant New York, in Germany the attack on beauty had more to do with imaging the war-ravaged body. Nearly two million German soldiers were lost in the war, and scores of disabled survivors of the devastating trench warfare filled the streets. The psychological damage done to the survivors was profound. Huelsenbeck was overwhelmed by what he found on his return to Berlin in January 1917, writing, "We had found in the war that Goethe and Schiller and Beauty added up to killing and bloodshed and murder. It was a terrific shock to us."[12]

Art historians have generally drawn fine and subtle distinctions in articulating the development of German art in the years between the wars. Important formal differences distinguish the anguished expressionism of artists such as Ernst Ludwig Kirchner [*fig. 9*] and Wilhelm Lehmbruck, the contemptuous social satire of Otto Dix and George Grosz, the politicized collages and photomontages of Raoul Hausmann, John Heartfield, and Hannah

Höch, or the social realism of Christian Schad [*fig. 10*]. Variations in means and materials, however, are far outweighed by the shared impact of the ravaged human body and spirit that characterized these artists' work. The annihilation was so compelling, so utterly shattering, that there could no longer be any hope that the body would provide beautiful images in art.

If beauty seemed an inconceivable response for many postwar artists, a contrasting idealist impulse simultaneously called on aesthetics to perform a constructive function in the reinvention of modern society. In that view, the war had swept away a corrupt social and cultural system, and artists of idealist bent felt an imperative to shun ironic anti-art impulses or expressionist subjectivity. For idealists involved in the early years of the Russian Revolution as well as those active in the formation of De Stijl, the Bauhaus, and other movements, aesthetics played a seminal role in the invention of the new consciousness. The constructive idealism was international and wide ranging. The revolution in Russia produced the sweeping pronouncements of Alexander Rodchenko and Vladimir Tatlin, placing aesthetics in the service of the mind and the state rather than the aristocratic elite. At the Bauhaus in Germany, Walter Gropius discounted art's historic celebration of individual artistic genius and decried the "lack of vital connection with the life of the community which led inevitably to barren aesthetic speculation." [13] In Amsterdam, Theo van Doesburg proclaimed, "[The] aim of the artist is to create formative harmony, to

Standard histories of modernism after World War I have generally concentrated on progressive formal developments, new expressive approaches to the figure, the pursuit of Surrealist automatism, or the idealism of pure abstraction. Underrepresented are the many who self-consciously returned to Classical standards of beauty in the years between the wars. [15] Their enthusiastic interest in Classical subjects (pastoral landscape, languorously posed bathers, Greek architecture) and styles (volumetric and restrained linear figuration) has been viewed as a conservative response to the terror of the war and a rejection of modernism more generally. The Classical canon of beauty seemed to provide a respite from the catastrophic changes brought on by the war. The revival of Classicism and traditional conceptions of beauty was heralded by older artists such as Aristide Maillol and Renoir but included younger artists as well. Giorgio de Chirico was perhaps the first artist of a younger generation to engage with antiquity, famously describing himself in 1919 as a "Classical painter." [16] Beginning with "metaphysical" works such as *The Uncertainty of the Poet*, 1913 [*fig. 11*], he made regular reference to ancient statuary and Italian piazzas in an evident attempt to summon up unconscious memories of a Mediterranean past.

A number of artists whose work had come to characterize the avant-garde in the years before World War I now sought out Classical norms as a way to reestablish art on a familiar aesthetic footing. Some of the principal champions of avant-garde mod-

In the war...Goethe and Schiller and Beauty added up to killing and bloods

give truth in the way of beauty." [14] Despite their differences, these artists shared a utopian idealism and constructivist interest, which resulted in ambitious collaborations among artists, designers, and architects seeking to give a new and most often purely abstract form for the built environment.

ernism – Georges Braque, André Masson, Fernand Léger, Pablo Picasso, and Gino Severini – would spend several years occupied with Classical figuration and the Mediterranean landscape, employing solid volumetric forms and measured line and brushwork. The compositional dynamism and urban industrial subjects

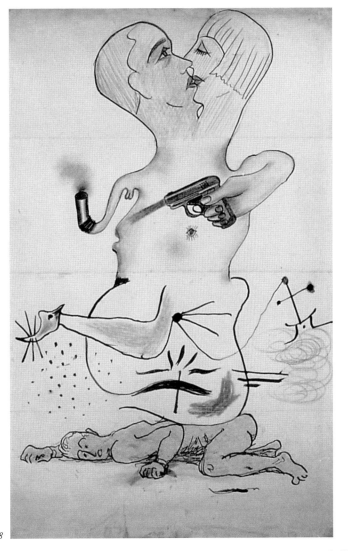

8

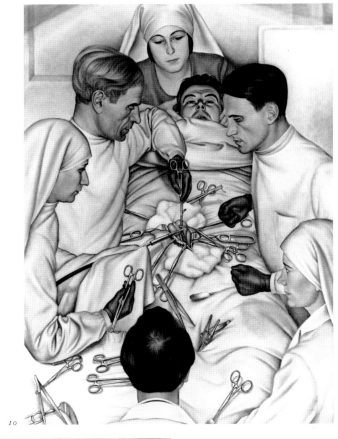

10

Fig. 8
Man Ray, Yves
Tanguy, Joan Miró,
and Max Morise
Exquisite Corpse
1928
ink, colored pencil,
and crayon on paper

Fig. 9
Ernst Ludwig
Kirchner
**Self-Portrait
as Soldier**
1915
oil on canvas

Fig. 10
Christian Schad
Operation
1929
oil on canvas

9

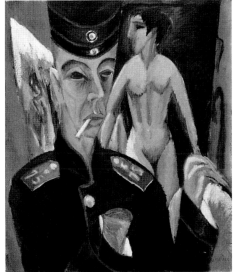

of Léger's work of the 1910s now gave way to the languid, Classicizing calm of his great and stately *Three Women (Le Grand déjeuner)*, 1921 [*fig. 12*], for which he openly acknowledged Jacques-Louis David and Jean-Auguste-Dominique Ingres.[17]

For his part, Picasso, who challenged traditional canons of beauty in the first decade of the century before embarking on a long period of rigorous Cubist work, reengaged with the Classical tradition through much of the 1920s. In paintings such as *The Source*, 1921 [*fig. 13*], Picasso explored the timeless theme of Classical female beauty. In other works he focused on bathers in a landscape, sitters in Classical dress, and figures studying and admiring Classical sculpture.

Classicism provided an extended reprieve from the scourge of the war and the psychological trauma of its aftermath. Yet for Picasso, Léger, and a few others, Classicism offered just one aesthetic option among many; the former was simultaneously immersed in Surrealism, seemingly the antithesis of Classicism. In the hands of many other artists of the 1920s, Classicism yielded only academic pastiche. Much more troubling was the appropriation of the Classical tradition in the service of fascism.[18] In Germany the National Socialists developed an exceedingly well-orchestrated cultural policy to support their political mission, the implications of which are well known. Adolf Hitler's obsessive politicization of cultural values resulted in the forcible eviction of scores of leading artists from their teaching positions and the confiscation of approximately twenty thousand works by contemporary German and international artists from national museum collections. He also staged the notorious and extraordinarily well-attended "Entartete Kunst" (Degenerate Art) exhibition mounted in Munich in 1937, which toured to several German and Austrian cities. "Entartete Kunst" demonstrated in graphic terms the National Socialists' profound fear of modernism and the lengths they were willing to travel to eradicate it. The exhibition included

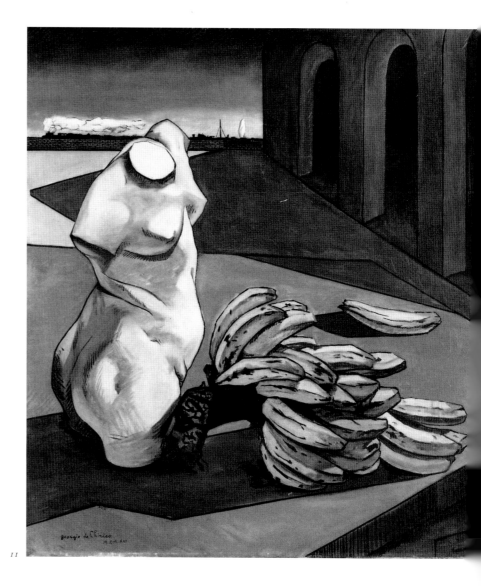

11

650 modern works taken from German museums; they were accompanied by defamatory wall texts, comparative works allegedly made by the "insane," and photographs of individuals with facial deformities.

A corresponding exhibition of sanctioned contemporary work by German artists, the "Grosse Deutsche Kunstausstellung 1937" (Great German Art Exhibition 1937) was mounted in the Haus der Deutschen Kunst (now Haus der Kunst). Held annually through 1944, the "Grosse Deutsche Kunstausstellung" is of equal interest for it demonstrates that the National Socialists were no less committed to establishing their own aesthetic standards, in terms

of form and content, that would elucidate public values for the German citizenry. There can be little doubt that Hitler attached the highest importance to that effort; he and Adolf Ziegler, a painter and the president of the Reichschamber for the Visual Arts, actually oversaw the selection process, and on July 18, 1937, Hitler inaugurated the exhibition. In his opening address, he inveighed against modern art as a passing fashion and a corrupting influence and proclaimed the moral imperative of the eternal values of beauty.

Until the moment when National-Socialism took power, there existed in Germany a so-called "modern art," that is, to be sure, almost every year another one, as the very meaning of this word indicates. National-Socialist Germany, however, wants again a "German Art," and this art shall and will be of eternal value, as are all truly creative values of a people.[19]

The aesthetic and cultural ideal that the National Socialists promoted in this and subsequent exhibitions and countless public art commissions, not to mention the staging of the Berlin Olympics of 1936, was based in large measure on the achievement of Greek sculpture [*fig. 14*]. The work of the eighteenth-century German classicist J. J. Winckelmann offered support for the claim by the National Socialists that antique sculpture provided the paradigm of timeless beauty, one that was beyond contemporary aesthetic fashion. The work of sculptors such as Arno Breker [*fig. 15*] and Josef Thorak dominated the "Grosse Deutsche Kunstausstellung 1937" and subsequent approved shows and public commissions. Lithe, athletic figures presented exemplary images of determination,

13

12

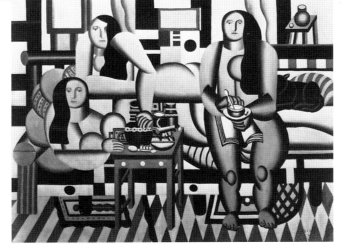

Fig. 11
Giorgio de Chirico
The Uncertainty
of the Poet
1913
oil on canvas

Fig. 12
Fernand Léger
Three Women
(Le Grand déjeuner)
1921
oil on canvas

Fig. 13
Pablo Picasso
The Source
1921
oil on canvas

energy, and mental focus to produce a model for German youth of public virtue and unwavering decency. The nudity of the figures was contradicted by their utter lack of sensuality; indeed, they are among the most frigid representations of the human form ever made. In effect, National Socialism annexed Classical beauty to defy modernism and the perceived decadence of the Weimar period, and also to mandate a moral standard using Classical form as a guide.

Beauty took a terrible beating following World War I. Some artists disdained beauty for the purposes of irony; others manipulated it for political reasons; and still others embraced traditional aesthetics as an escape from the challenges of modernity and the war. Much the same occurred after 1945. In part this can be explained by the appropriation of beauty by the National Socialists, but there was also a renewed condemnation of beauty among leading modern artists. Artists as different as Jean Dubuffet [*fig. 16*] and Barnett Newman viewed aesthetics as a bankrupt product of Western European civilization. Dubuffet, in his 1951 lecture "Anticultural Positions," stated:

This idea of beauty is however one of the things our culture prizes most, and it is customary to consider this belief in beauty and the respect for this beauty, as the ultimate justification of Western civilization, and the principle of civilization itself is involved with this notion of beauty. I find this idea of beauty a meager and not very ingenious invention.[20]

If Dubuffet would strip away the very notion of Western aesthetics, Newman contrasted beauty with the sublime. In his landmark essay "The Sublime Is Now," published in *Tiger's Eye* in 1948, Newman described the liberation underway from the tradition of beauty, with its "impediments of memory, association, nostalgia, legend, myth ... that have been the devices of Western European painting." Newman proclaimed, "Here in America, some of us, free from the weight of European culture, are finding the answer by completely denying that art has any concern with the problem of beauty and where to find it."[21] For Newman, to be a modern artist meant that one's search for beauty must be superseded by pursuit of the sublime. Similarly, Robert Motherwell, perhaps the postwar American painter with the firmest grounding in the European aesthetic tradition, noted in 1946 that the "strictly aesthetic – which is the sensuous aspect of the world – ceases to be the chief end in view."[22]

If Dubuffet, Newman, Motherwell, and others issued assaults against beauty and the formal basis of art, radical acts of aesthetic negation proliferated right through the 1950s and into the 1960s. Robert Rauschenberg produced possibly the most concise and rhetorical anti-aesthetic statement of all. In a Duchampian gesture of the first order, the young Rauschenberg in 1953 obtained from Willem de Kooning a small drawing, which he then carefully erased. The resulting work, *Erased de Kooning Drawing* [*fig. 17*], set the stage for a generation of Conceptual art; by methodically

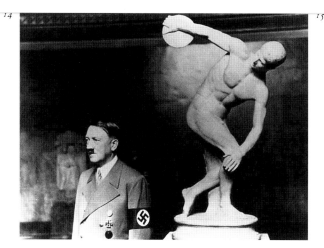

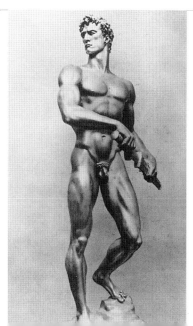

Fig. 14
Film still from
**The Architecture
of Doom**, 1991
showing Hitler in
front of a sculpture
of **Discobolus**
(Disk Thrower),
after a bronze
original of c. 450 B.C.
by Myron

Fig. 15
Arno Breker
Readiness
1937
bronze

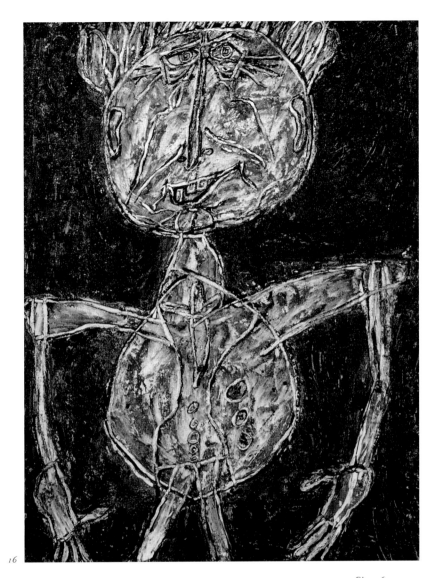

Fig. 16
Jean Dubuffet
Limbour as a
Crustacean
1946
oil and sand on
canvas

eradicating a drawing made by de Kooning – not coincidentally
the supreme draughtsman of the postwar period – Rauschenberg
directly challenged the time-honored value placed on the marks of
the artist's hand as the essence of art.

Work of a conceptual bent proliferated. These explorations
range from Robert Morris's *Statement of Aesthetic Withdrawal*,
1963 (The Museum of Modern Art, New York), a typed and nota-
rized document bearing the artist's declaration, "The undersigned...
withdraws from said construction all aesthetic quality and con-
tent," to Piero Manzoni's *Merda d'artista*, 1961 [*fig. 18*], in which
the artist's excrement was canned and priced for sale according
to weight.

In contrast to such iconoclastic gestures, the aesthetic charac-
ter of art in the post–World War II period was kept alive primarily
by the critic Clement Greenberg. Beginning with his landmark
essay "Avant Garde and Kitsch" published in 1939, Greenberg
constructed a theory of form that had enormous importance in New
York art circles. He consistently rejected the conceptual direction
championed by Duchamp in his readymades as a "fascination that
is more historical, cultural, theoretical than it is aesthetic."[23]
According to Greenberg, Duchamp had had a pervasively negative
effect on subsequent generations of artists, for he legitimized the
"shocking, scandalizing, startling, the mystifying and confounding
as ends in themselves ... and the impact, more often than not, was
to be on cultural habits and expectation, social ones too, rather
than taste."[24]

For Greenberg, the evolution of aesthetic taste was a matter
of historical necessity, and he expressed his position with complete
self-assurance. Contemporary aesthetics, in Greenberg's view,
must necessarily develop in a manner paralleling that of modern
industrial culture generally, that is, toward the division and
specialization of labor. Applying the same logic to the visual arts,
Greenberg called for an elevation of the formal values that he

argued are inherent in a given medium (in painting, color, shape, and the two-dimensional surface of the canvas), and the rejection of those that he considered extraneous (pictorial illusion and narrative). Writing in 1949, Greenberg was characteristically unequivocal.

The various modernist arts try to confine themselves to that which is most positive and immediate in themselves, which consists in the unique attributes of their mediums. It follows that a modernist work of art must try, in principle, to avoid communication with any order of experience not inherent in the most literally and essentially construed nature of its medium. Among other things, this means renouncing illusion and explicit subject matter. The arts are to achieve concreteness, "purity," by dealing solely with their respective selves – that is, by becoming "abstract" or nonfigurative.[25]

Greenberg was an enthusiastic advocate of several abstract artists, from Jackson Pollock and David Smith in the early postwar years, to Helen Frankenthaler, Kenneth Noland, and the Color Field painters in the 1950s and 1960s. His influence in certain New York art circles was at times overwhelming, for Greenberg alone offered a coherent aesthetic direction. And yet, while Greenberg's formalist aesthetics attracted many disciples, there were equally passionate dissidents as well.

It was the critic Harold Rosenberg, Greenberg's great rival in New York, who most actively countered Greenberg's aesthetic. In his early landmark essay "The American Action Painters," first

reproduce, re-design, analyze, or "express" an object, actual or imagined. *What was to go on the canvas was not a picture but an event.*[26]

Rosenberg's point of reference was doubtless Pollock and his shocking method of deliberately pouring and dripping paint on a canvas on the floor. Although Pollock was in no way working against aesthetics, the publication of photographs made by Hans Namuth – which depict the artist dramatically applying paint as if an actor on stage – had a profound and liberating effect on a subsequent generation of artists when they appeared in 1951 [*fig. 19*]. Within a few years these images had an analog in Europe, in the form of photographs of the French artist Yves Klein directing the movements of nude women slathered in blue paint and performing as "living brushes" in the creation of his "Anthropometries" [*fig. 20*].

By the 1960s the international proliferation of performance-based art was astonishing. Happenings in New York, Gutai in Japan, and Nouveau Realisme, Fluxus, Actionism, and Arte Povera in various European capitals all bespoke a fundamental shift in the premises of art.[27] The age-old tradition of individual artists' creating perfectible and static works of art was now under attack in the hands of those who, in the flush of prevailing optimism, disconnected art from aesthetics and attached it to life instead. Ironically, that international movement would produce some of the great object makers of recent decades – Joseph Beuys

It is necessary to separate aesthetics from art. JOSEPH KOSUTH, 1969

published in 1952, Rosenberg described the radical new approach to the making of art implied in the work of Jackson Pollock, Franz Kline, and others.

At a certain moment the canvas began to appear to one American painter after another as an arena in which to act – rather than as a space in which to

Fig. 17
Robert
Rauschenberg
Erased de Kooning
Drawing
1953
traces of ink and
crayon on paper
with mat and
label hand-lettered
in ink, in gold-leaf
frame

[*fig. 21*], Jannis Kounellis [*cat. no. 35, p. 42*], Mario Merz, Bruce Nauman, Claes Oldenburg, among them — yet each matured in a free-wheeling artistic climate in which the activity of an artist was valued over the formally refined product. The pursuit of aesthetic refinement was considered anathema.

Oldenburg's early work is of particular interest here. The Swedish-born sculptor participated in Happenings in New York in the late 1950s and created his first body of sculpture using scrap wood, cardboard, newspaper, and assorted detritus collected in the streets of New York. Although today thought to be among the artist's most important works, at the time his gritty, unpretentious junk sculptures were virtually inseparable from the Happenings. Although Oldenburg organized his unsightly constructions into installations such as "The Street" in 1960 [*fig. 22*], he was, in fact, seeking to free himself from any allusion to art: "Why should I even want to create 'art' — that's the notion I've got to get rid of. Assuming that I wanted to create some thing, what would that thing be? Just a thing, an object. Art would not enter into it."[28]

If Oldenburg and other artists were conjoining notions of beauty and art and attempting to banish both, a parallel movement, which for a time pressed the art object to the verge of extinction, also developed in the 1960s. Artists Joseph Kosuth and Lawrence Weiner exhibited together and issued perhaps the strongest and most articulate case yet against aesthetics. In a series of essays published in 1969 under the title "Art after Philosophy," Kosuth

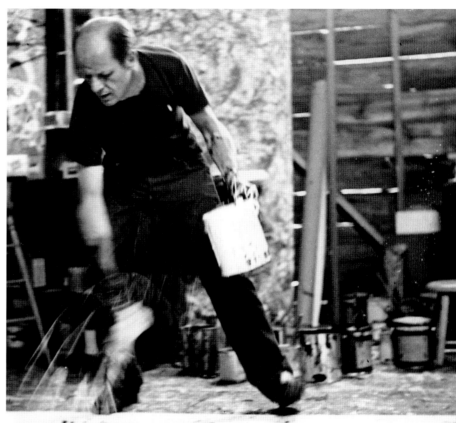

19

17

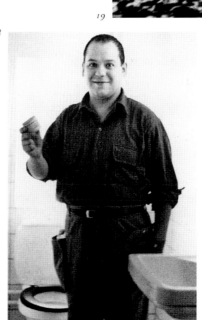

18

Fig. 18
Piero Manzoni
holding
Merda d'artista
1961
metal can

Fig. 19
Jackson Pollock
painting
**Autumn Rhythm:
November 30, 1950**
1950
Photograph by
Hans Namuth

offered a well-reasoned, philosophically grounded argument against the relationship of art and aesthetics and, more radically, against the need for the art object. Kosuth challenged the history of aesthetics as derived from decoration.

It is necessary to separate aesthetics from art because aesthetics deals with opinions on perception of the world in general. In the past one of the two prongs of art's function was its value as decoration. So any branch of philosophy which dealt with "beauty" and thus, taste, was inevitably duty bound to discuss art as well.[29]

In Kosuth's view, Duchamp's readymades had made it possible to question an art based in aesthetics and to change art's focus "from the form of the language to what was being said." By that logic, Kosuth could describe works of art as "analytic propositions," which derive their meaning by "influencing other art, not by existing as the physical residue of an artist's ideas."[30] Kosuth's own work was predicated on language as the expression of analytic propositions. His seminal work *One and Three Chairs*, 1965 [*fig. 23*], is an installation in which object, image, and dictionary definition come together to offer the clearest expression of Conceptualism's determined eradication of aesthetics in favor of linguistic formulation. Still more radical was Weiner, whose work consisted only of phrases published in book form or mounted on walls. Weiner has long taken special pleasure in eliminating objects from his art, thereby denying the commercial viability of his work. As he noted in

demand that artists must renounce "illusion and explicit subject matter" reeked of authoritarianism, Kosuth's own dictate that "being an artist now means to question the nature of art"[32] is equally oppressive in its implications. By 1970, Conceptualism and formalism represented polar opposites and warring camps in the battle for the soul of contemporary art.

The "form versus content" argument has dominated contemporary art ever since. While successors to Greenberg have been ardent in their defense of modernist aesthetic standards, originality, and quality, postmodernists have critiqued aesthetics as an expression of elitist culture. The most passionate and eloquent exponent of the former position has been Hilton Kramer. In the pages of the journal *The New Criterion*, which he edits, or in his collected essays, *The Revenge of the Philistines* (1985), Kramer has been a staunch defender of the autonomy of works of art within the modernist aesthetic and a critic of any form of art historical revisionism.

Kramer set out his critical viewpoint as early as 1970 in reviewing the late work of Canadian-born painter Philip Guston. Guston's long career had included an early social realist period, lyrical "abstract impressionist" (Kramer's characterization) canvases in the 1950s, and a late cycle of highly charged figurative images. The late paintings were rendered with an emotional power and directness—founded equally on his early memories of the Ku Klux Klan and the graphic style of the comics—that startled long-

I detest artists who empty themselves in their paintings ... in place of think.

1990, "They don't have to buy it to have it – they can have it just by knowing it."[31]

The problem with Conceptualism was that, like Greenberg's formalism, it narrowed the possibilities of art in such an extreme manner that it left artists few avenues to pursue. Just as Greenberg's

time observers of his work [*fig. 24*]. Although widely recognized today as some of the most important painting of the contemporary period, Guston's late pictures represented, for Kramer, the antithesis of modernism. In a devastating review, "A Mandarin Pretending to Be a Stumblebum," published in the *New York Times*

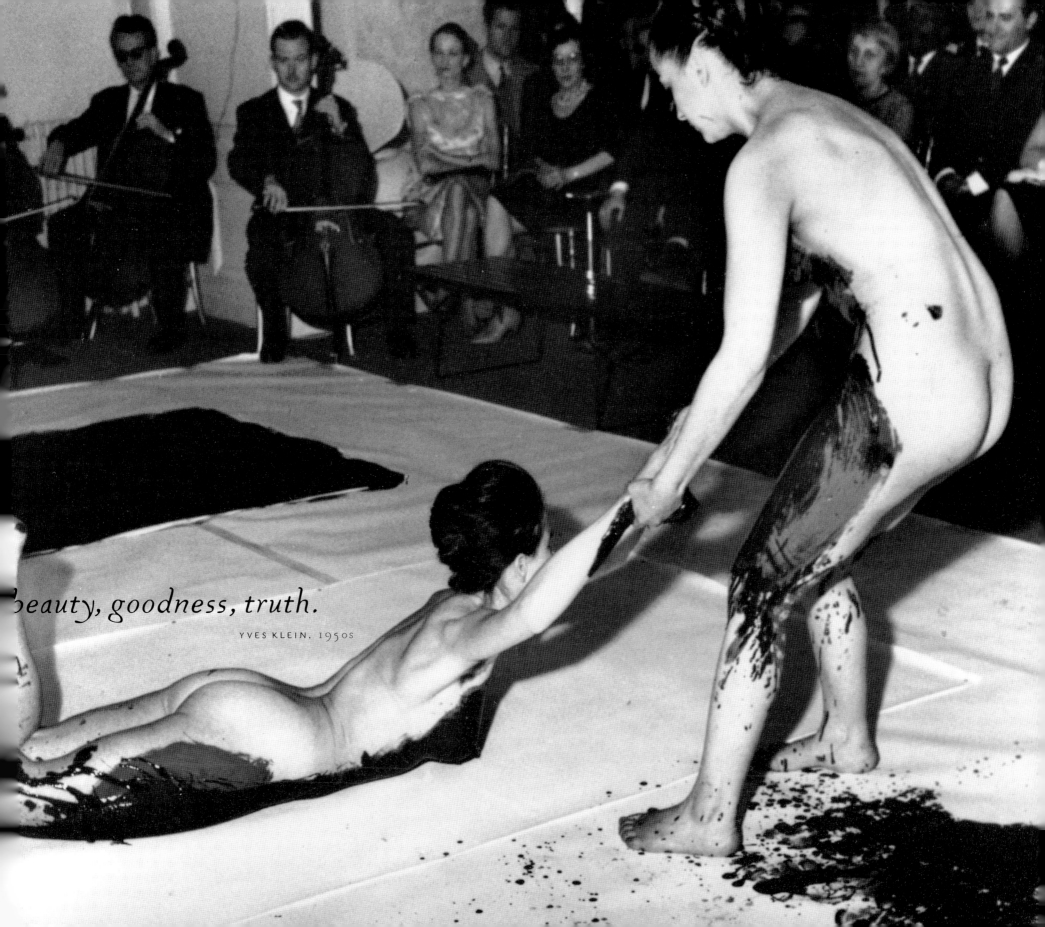

beauty, goodness, truth.

YVES KLEIN, 1950s

when they were exhibited for the first time in 1970,[33] Kramer came after Guston with a vengeance. He derided Guston's often-quoted statement "I got sick of all that purity! I wanted to tell stories!," and described the work as "cartoon anecdotage" representing a "taste for something funky, clumsy and demotic." Kramer trivialized what he considered the urban primitivism of Guston's content and method of painting, contrasting them with those of modernism, which he favored: "Throughout the history of modern painting, the primitive has repeatedly been called upon to rescue and rejuvenate the vitality of 'high' art, and Mr. Guston is clearly seeking such a rejuvenation in turning to the popular visual slang of the cartoonists as the basis of a new pictorial style."[34] For Kramer, as for Greenberg before him, the invention of a supposed high painterly style derived from cartoons could be nothing more than kitsch.

In recent years Kramer has energetically deplored the positive reassessment of previously disparaged movements in the history of art (for example, German Romanticism and the Pre-Raphaelites) as symptomatic of an attitude in which "critical judgments are finally unimportant, for even bad art, even non-art, can be found to have meaning."[35] Kramer has especially disdained much recent content-based art, saying,

The primary question for me about works of art is what they are, rather than what they mean. And I think one of the things that is wrong with a lot of art that is highly praised today is that it can only be experienced in its

"meaning"; because what it is is so negligible that you're being invited to respond to its posted agenda, not what the artist has actually made for you to look at.[36]

Kramer's hard and fast advocacy of the autonomy of art and the necessity of aesthetic standards stands in stark contrast to those who in the 1980s came to consider aesthetic interest to be a badge of conservatism. While the latter group continues to value Duchamp's logic and Conceptual art in general, that position has assumed an unyielding tone in the writings of Benjamin Buchloh, Douglas Crimp, Hal Foster, Rosalind Krauss, and other "anti-aesthetes." Whether in the pages of *October* or the aptly named anthology *The Anti-Aesthetic: Essays on Post-Modern Culture* (1983), they discuss postmodernism as a "break with the aesthetic field of modernism."[37] For these critics, aesthetic issues are inextricably tied to the larger workings of society. As Foster noted in his preface to the anthology,

"Anti-aesthetic" also signals that the very notion of the aesthetic, its network of ideas, is in question here: the idea that aesthetic experience exists apart, without "purpose," all but beyond history.... "Anti-aesthetic" also signals a practice, cross-disciplinary in nature, that is sensitive to cultural forms engaged in politics or rooted in a vernacular — that is, to forms that deny the idea of a privileged aesthetic realm.[38]

The polar positions concerning aesthetics voiced by recent critics such as Kramer, Foster, and the others are not new.

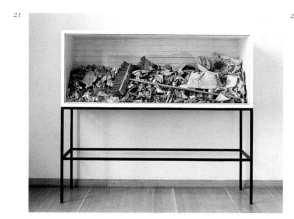

21

22

Fig. 21
Joseph Beuys
Ausfegen
1992
vitrine with
mixed media

Fig. 22
Claes Oldenburg
installing
"The Street" at
Judson Gallery,
New York
1960

Fig. 23
Joseph Kosuth
**One and Three
Chairs**
*1965
wood folding chair,
photographic copy
of a chair, and
photographic
enlargement of
a dictionary
definition of a chair*

Fig. 24
Philip Guston
City Limits
*1969
oil on canvas*

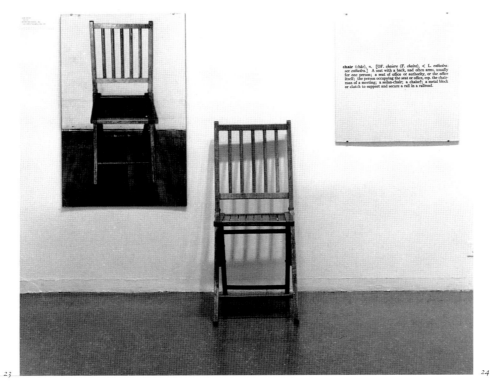

23

24

Kramer's views are modeled closely on Greenberg's, and those of Foster and his colleagues derive in no uncertain terms from Duchamp. What changed in the 1980s, however, was the dogmatic hardening of ideologies and the manner in which aesthetics became charged in the process. The assault against beauty in the 1980s paralleled another, undertaken by artists Mike Kelley [*fig. 25*], Barbara Kruger [*see fig. 38*], Richard Prince, and many others. Their challenge to aesthetics is reminiscent of the Dadaists' early in the century, for it constituted but one part of a much larger and more sweeping critique of the social and political culture of the

moment. Kelley has been particularly emphatic and effective in this regard, thoroughly assailing the art world for prizing any work driven by formalist aesthetics.

Signaling the predominance of these attitudes among critics and artists, many exhibitions at the turn of this decade in American museums featured work of a powerfully anti-aesthetic character.[39] Moreover, the degree to which the issue of beauty has become a lightning rod is indicated by the simple fact that by the early 1990s the term had largely disappeared from the radar screen of the art world. As Peter Schjeldahl noted in 1996, "Beauty ... has been

quarantined from educated talk."[40] Indeed, beauty as a measure of the quality of a work of art has most often been replaced by the terms "difficult," "challenging," and "tough." While artists such as Barnett Newman had once taken the time and trouble to argue against beauty, in recent years artists have simply ignored the topic altogether. As Catherine David's words, cited in introducing this essay, suggest, "beauty" could reasonably be used to dismiss or disparage a work of art or an artist. And, as Dave Hickey noted in his crucial text *The Invisible Dragon: Four Essays on Beauty* (1993), if you employed the word "beauty," "you ignited a conversation about the [art] market."[41]

 The Invisible Dragon reintroduced the issues of beauty into conversations about art, and since its publication other critics have taken up the matter as an idea worthy of our attention. Whether one subscribes to Hickey's intriguing view that in the coming years beauty will not be "an attribute of objects but a pattern of response,"[42] one can certainly hope that Schjeldahl's prediction that a century from now "beauty will be neither commodified nor politicized, neither safe nor sorry,"[43] proves true. Beauty has indeed led an endangered existence throughout our now rapidly declining century. Held hostage to political movements and war, as well as the vagaries of art-world ideology, beauty has often been vilified as bearing responsibility for perceived shortcomings with modern and contemporary art. And yet an alternative reading is also possible. Whereas aesthetics and beauty were once unyielding

Fig. 25
Mike Kelley
Eviscerated
Corpse
1989
stuffed animals,
sewn together

Beauty is now underfoot wherever

doctrines, admitting neither flexibility nor change, today beauty might be praised as a concept that acknowledges regular shifts in cultural perception. While some may decry such a fluid state of affairs, to be effective and meaningful, standards of all sorts must be responsive to their times. And surely beauty must as well.

e the trouble to look. JOHN CAGE, 1912–1992

1
Newman, "The Sublime Is Now," *Tiger's Eye* (December 1948). Reprinted in John O'Neill, ed., *Barnett Newman: Selected Writings and Interviews* (New York: Knopf, 1990), 172. Throughout this essay I am indebted to Anne-Louise Marquis for her research assistance and to Maria Makela for her suggestions.

2
David quoted in "Kassel Rock: Robert Storr Talks with Documenta's Catherine David," *Artforum* 36, no. 9 (May 1997): 142. I am indebted here to a conversation with Nancy Spector.

3
Press release prepared by Fitz and Co., New York, for Beecroft's *Show*, presented by Yvonne Force, Inc., New York.

4
Léger, "The Machine Aesthetic: The Manufactured Object, the Artisan, and the Artist," in Edward F. Fry, ed., *Functions of Painting*. Trans. Alexandra Anderson (New York: Viking, 1973), 59.

5
Ibid., 53.

6
Marinetti, "The Foundation and Manifesto of Futurism," in Herschel B. Chipp, *Theories of Modern Art: A Source Book by Artists and Critics* (Berkeley: University of California Press, 1968), 286.

7
Duchamp, "Painting … at the Service of the Mind," from an interview with James Johnson Sweeney in "Eleven Europeans in America," *Bulletin of the Museum of Modern Art* 13, no. 4–5 (1946): 19–21. Reprinted in Chipp, *Theories of Modern Art*, 394.

8
When spoken rapidly in French, the letters pronounce the words "Elle a chaud au cul," meaning "She has a hot ass."

9
Glackens quoted in Calvin Tomkins, *Duchamp: A Biography* (New York: Henry Holt, 1996), 182.

10
Arensberg quoted in ibid. I am indebted to Judith Zilczer and Naomi Sawelson-Gorse here.

11
Duchamp, 1962, quoted in Hans Richter, *Dada: Art and Anti-Art* (New York: McGraw-Hill, 1965), 208.

12
Huelsenbeck quoted in Tomkins, *Duchamp*, 191–92.

13
Gropius, "The Theory and Organization of the Bauhaus," in Charles Harrison and Paul Wood, eds., *Art in Theory, 1900–1990: An Anthology of Changing Ideas* (Oxford: Blackwell, 1992), 339.

14
Van Doesburg, "Manifesto 1," in ibid., 281.

15
See Elizabeth Cowling and Jennifer Mundy, *On Classic Ground: Picasso, Léger, de Chirico and the New Classicism, 1910–1930* (London: Tate Gallery, 1990).

16
De Chirico quoted in ibid., 71.

17
See ibid., 141.

18
See Stephanie Barron, *"Degenerate Art": The Fate of the Avant-Garde in Nazi Germany* (Los Angeles: Los Angeles County Museum of Art, 1991), in particular, Barron, "1937: Modern Art and Politics in Prewar Germany," 923, and George L. Mosse, "Beauty without Sensuality," 25–31.

19
Hitler quoted in Chipp, *Theories of Modern Art*, 476.

20
Dubuffet delivered "Anticultural Positions" in English at the Arts Club of Chicago on December 20, 1951. It was published in an exhibition catalog by World House Galleries, New York, 1960, and reprinted in Richard L. Feigen, ed., *Dubuffet and the Anticulture* (New York: Richard L. Feigen, 1969), 8ff.

21
Newman, "The Sublime Is Now," 173.

22
Motherwell, "Beyond the Aesthetic," *Design* 47, no. 8 (April 1946): 38.

23
Greenberg, "Counter-Avant-Garde," *Art International* 15, no. 5 (20 May 1971): 16. Reprinted in Joseph Masheck, comp., *Marcel Duchamp in Perspective* (Englewood Cliffs, N.J: Prentice-Hall, 1974), 122.

24
Ibid., 124.

25
Greenberg, "Sculpture in Our Time," in *Modernism with a Vengeance, 1957–1969,* vol. 4 of *Works: The Collected Essays and Criticism* (Chicago: University of Chicago Press, 1986–93), 55–56.

26
Rosenberg, *The Tradition of the New* (London: Thames and Hudson, 1959), 25. See also his later essay, "De-aestheticization," in Rosenberg, *The De-definition of Art: Action Art to Pop to Earthworks* (Chicago: University of Chicago Press, 1972), 28–38.

27
See Paul Schimmel, ed. *Out of Actions: Between Performance and the Object, 1949–1979* (Los Angeles: Museum of Contemporary Art, 1998).

28
Oldenburg quoted in Jan McDevitt, "Object: Still Life; Interview," *Craft Horizons* 25, no. 5 (September 1965): 31.

29
Kosuth, "Art after Philosophy," *Art International* 178, no. 915 (October 1969): 134.

30
Ibid., 135.

31
Weiner quoted in Colin Gardner, "The Space Between Words: Lawrence Weiner," *Artforum* 29, no. 3 (November 1990): 158.

32
Kosuth, "Art after Philosophy," 135.

33
Kramer, "A Mandarin Pretending to Be a Stumblebum," *New York Times,* October 25, 1970, D27.

34
Ibid.

35
Kramer, "The Happy Critic: Arthur Danto in *The Nation,*" *New Criterion* 6, no. 1 (September 1987): 30.

36
Kramer quoted in Suzanne Ramljak, "Summit: Arthur Danto vs. Hilton Kramer," *Sculpture* 14, no. 3 (May–June 1995): 13.

37
Hal Foster, ed., *The Anti-Aesthetic: Essays on Postmodern Culture* (Port Townsend, Wash.: Bay Press, 1983), ix.

38
Ibid., xv.

39
While many exhibitions featured an anti-aesthetic tone around 1990, perhaps the most visible was the 1993 Whitney Biennial. See the preface by David A. Ross, "Know Thy Self (Know Your Place)," in Elizabeth Sussman, *1993 Whitney Biennial* (New York: Whitney Museum of American Art in association with Abrams, 1993), 8–11.

40
Schjeldahl, "Beauty Is Back," *New York Times Magazine,* September 29, 1996, 16.

41
Hickey, "Enter the Dragon: On the Vernacular of Beauty," in Hickey, *The Invisible Dragon: Four Essays on Beauty* (Los Angeles: Art Issues, 1993), 13.

42
Hickey in conversation with the author, 1998.

43
Schjeldahl, "Beauty Is Back," 16.

PLATES PART I

BE

How and where can we discover beauty,
whether inside or outside the work? GIULIO PAOLINI, 1992

AUTY OBJECTIFIED

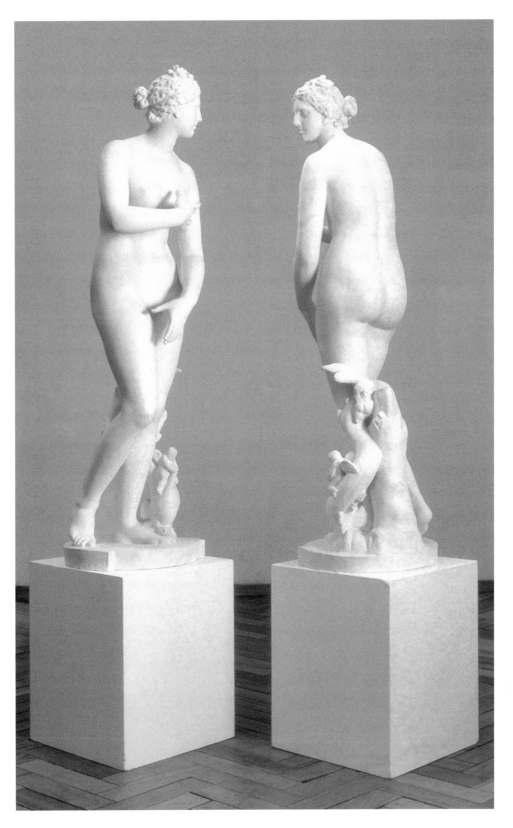

Giulio Paolini
Mimesis
1975–76
cat. no. 43

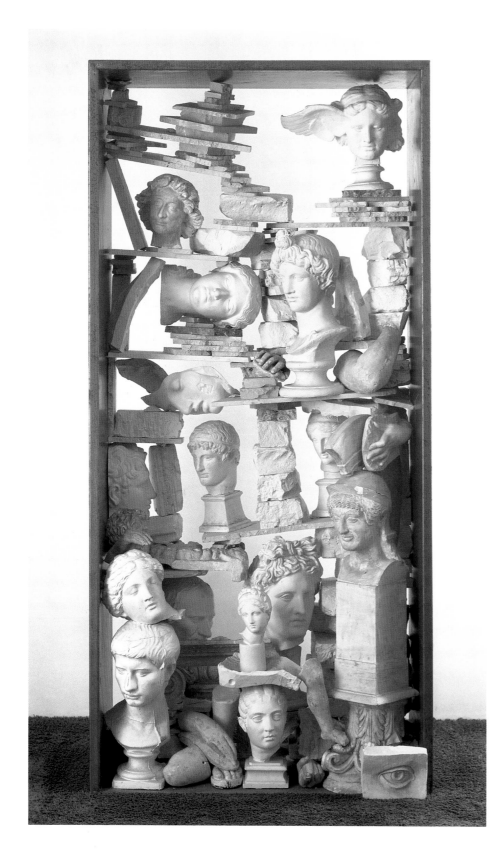

Jannis Kounellis
Untitled
1980
cat. no. 35

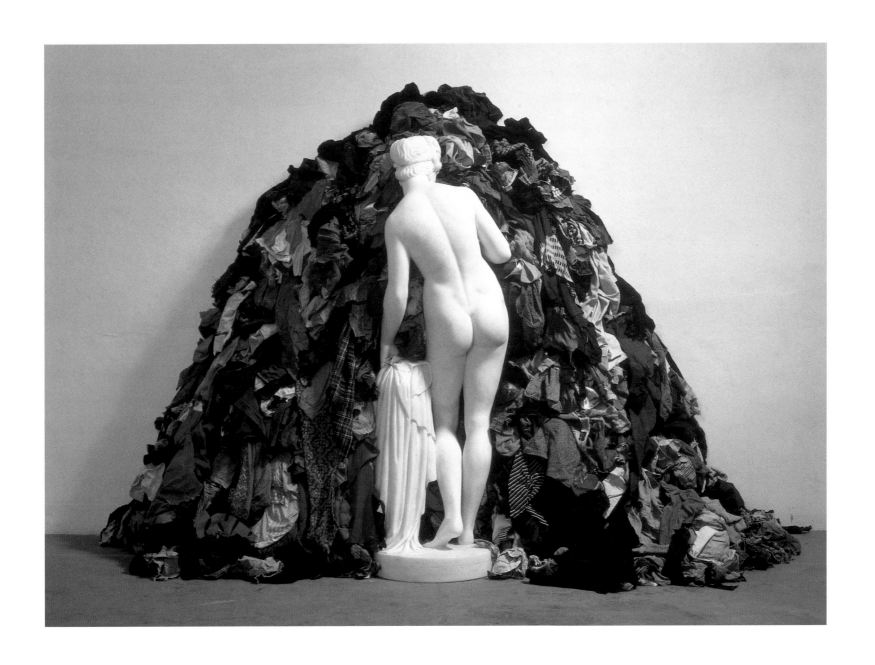

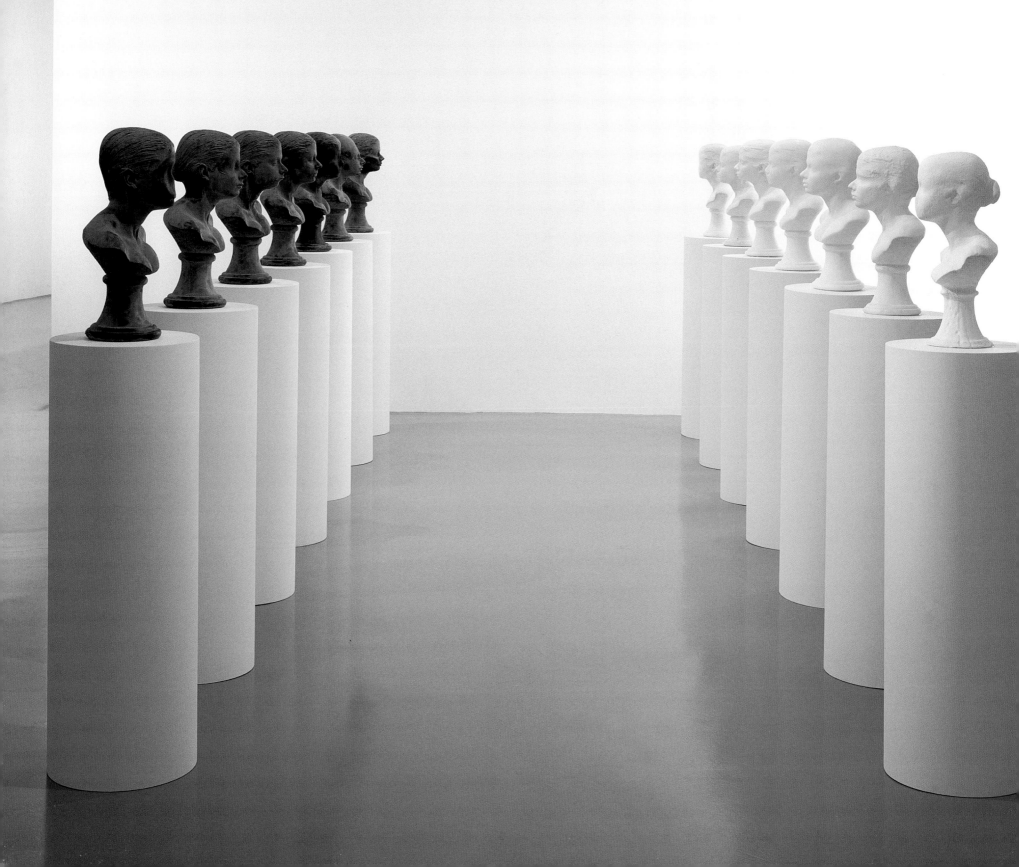

Janine Antoni
Lick and Lather
1993–94
cat. no. 1
installation view (left)
and details

45

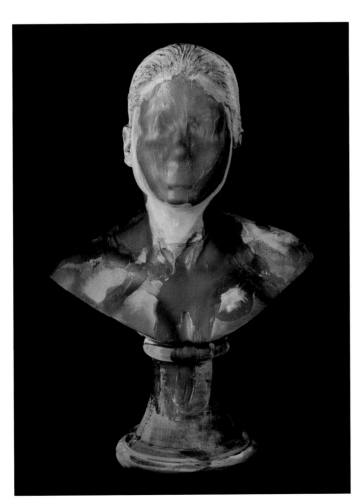

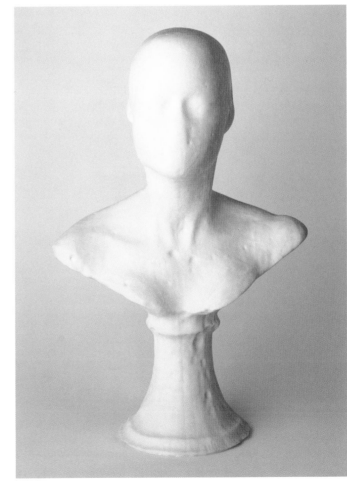

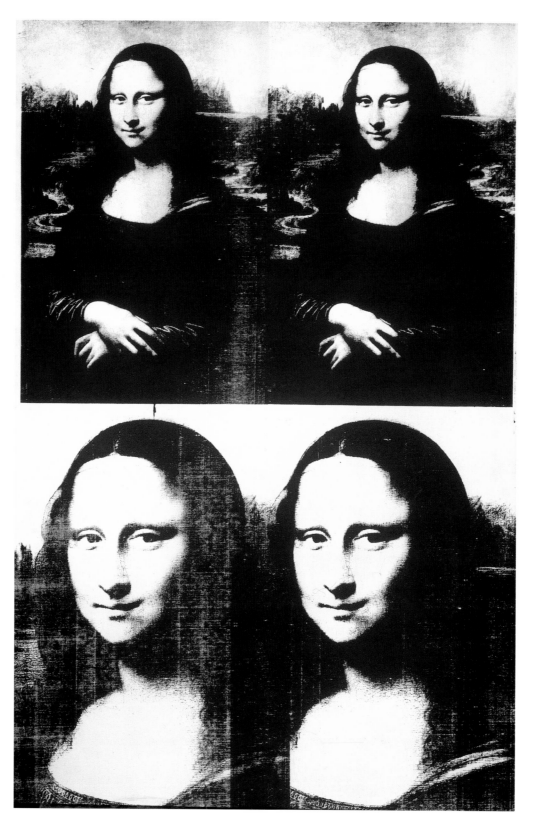

Andy Warhol
Mona Lisa
1963
cat. no. 86

46

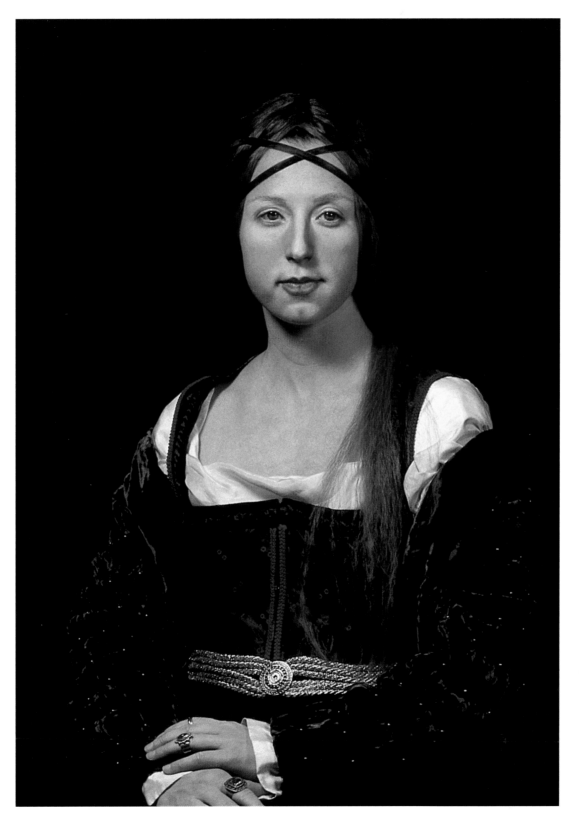

Cindy Sherman
Untitled #209
1989
cat. no. 67

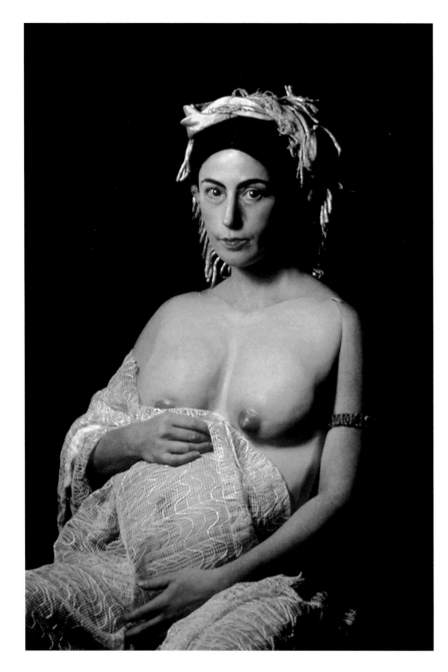

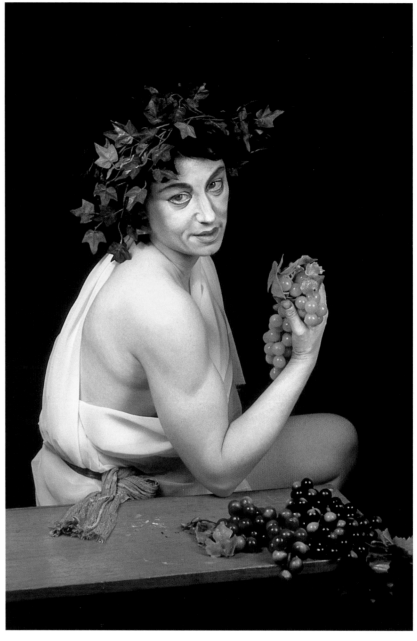

Cindy Sherman Cindy Sherman
Untitled #205 **Untitled #224**
1989 1990
cat. no. 66 cat. no. 68

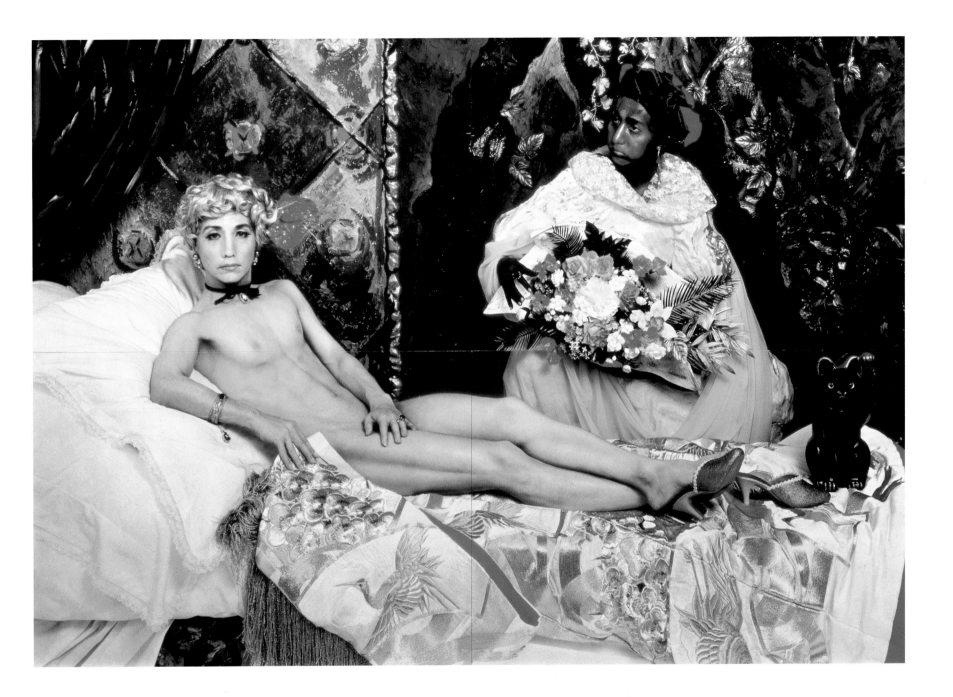

Yasumasa Morimura
Portrait (Futago)
1988
cat. no. 42

50

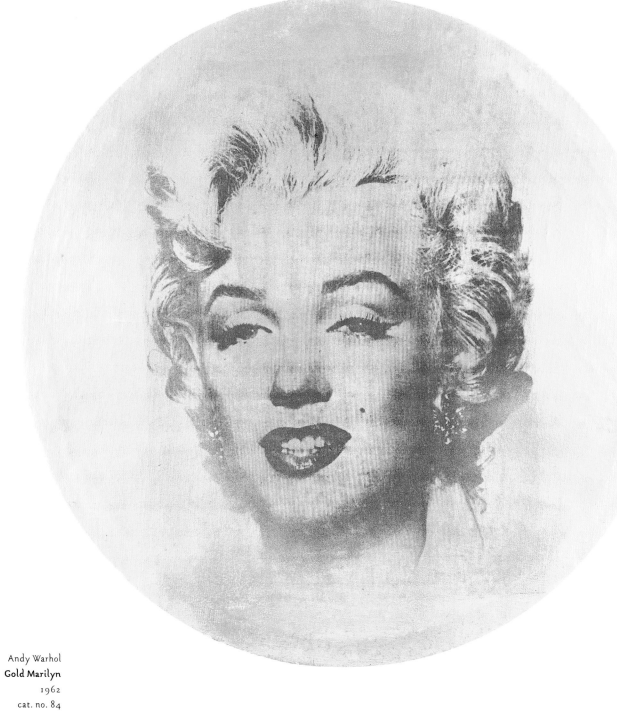

Andy Warhol
Gold Marilyn
1962
cat. no. 84

Imi Knoebel
Grace Kelly
1990/98
cat. no. 34

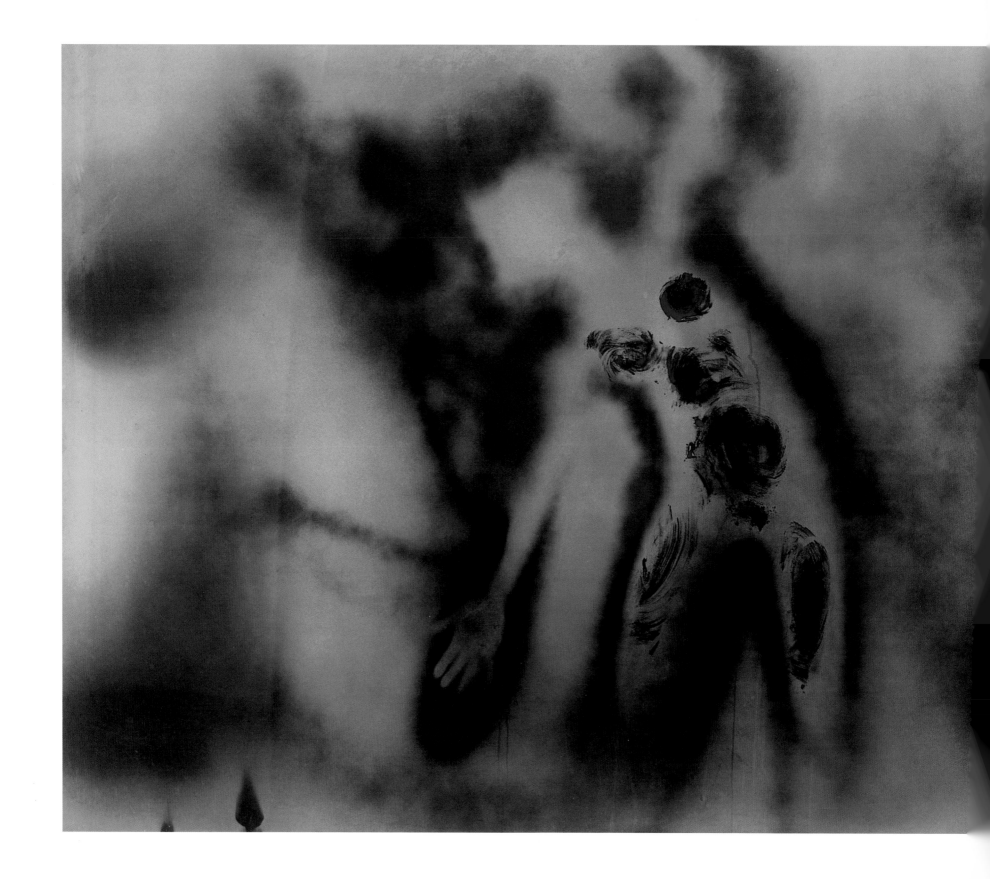

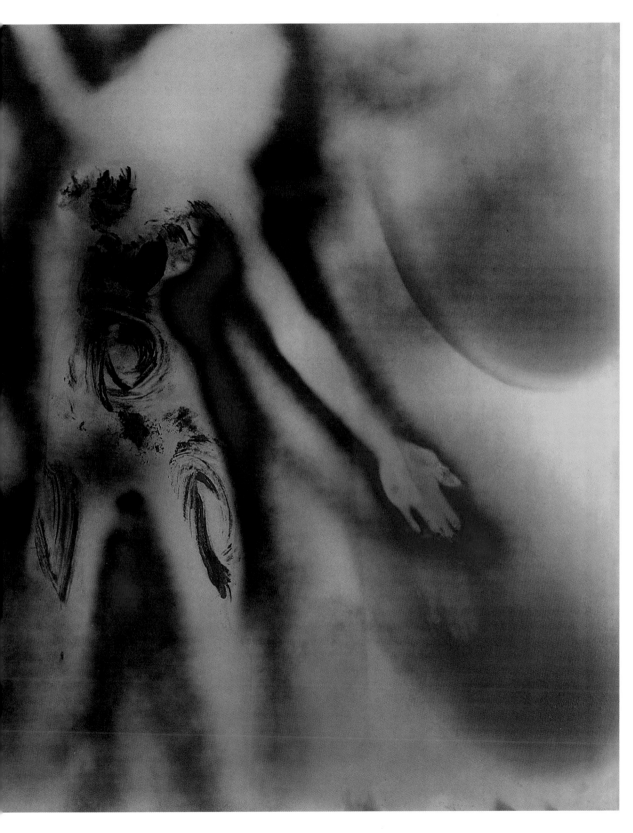

Yves Klein
FC1 (Untitled Fire Color Painting)
1961
cat. no. 33

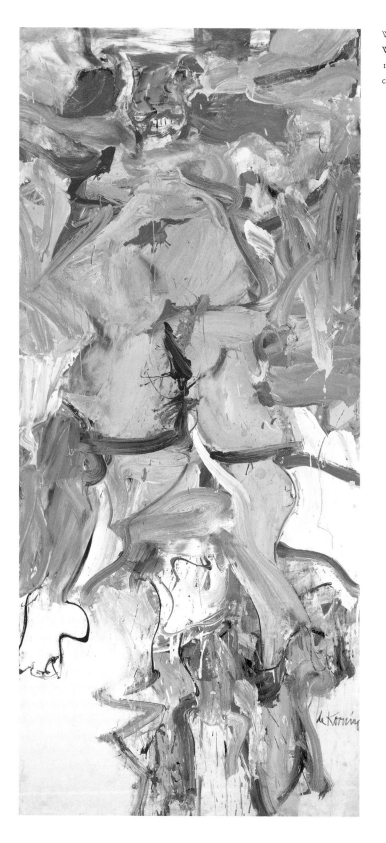

Willem de Kooning
Woman, Sag Harbor
1964
cat. no. 20

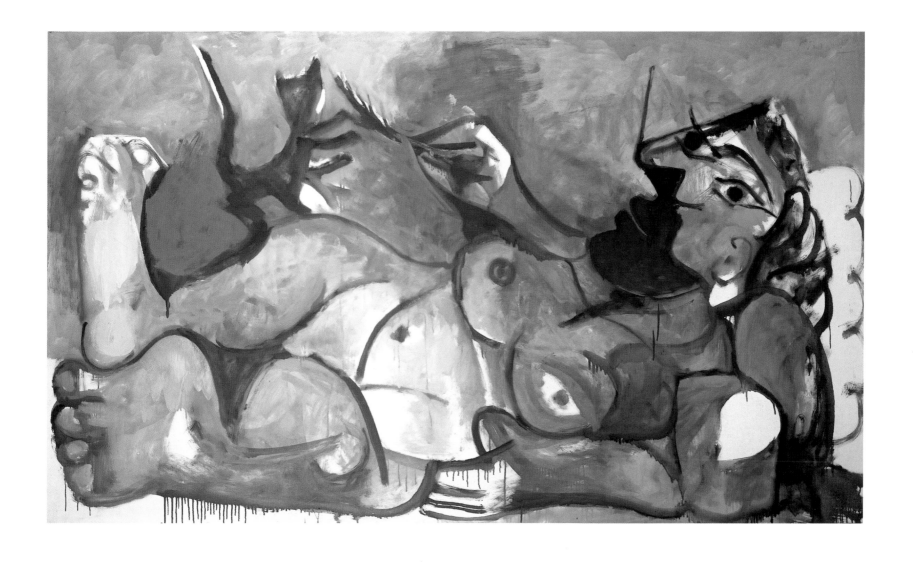

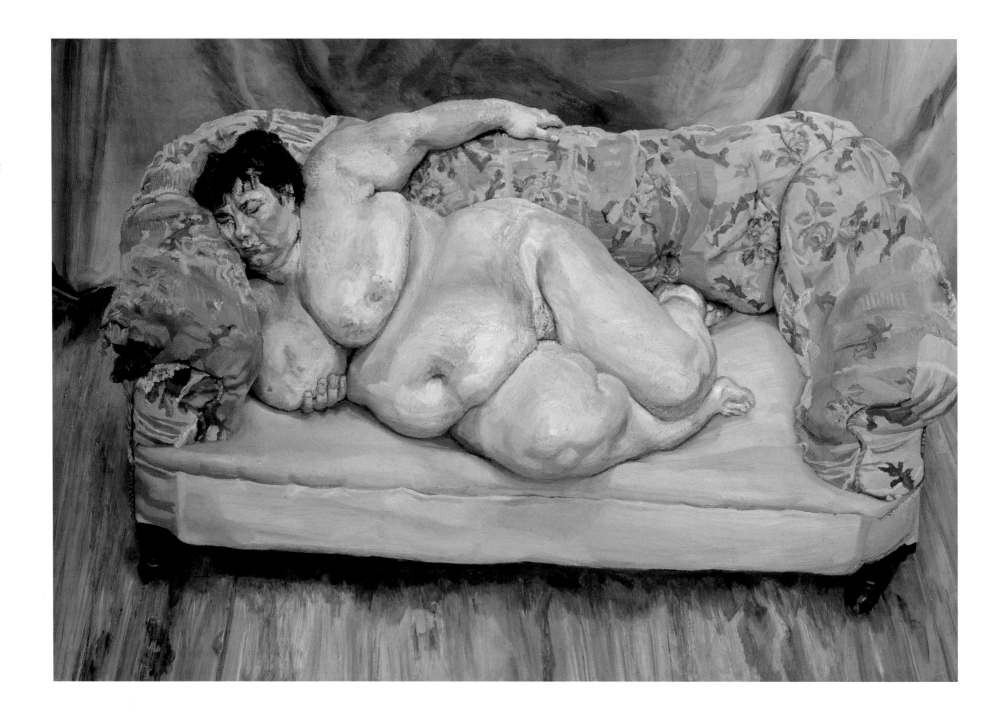

Lucian Freud
**Benefits Supervisor
Sleeping**
1995
cat. no. 24

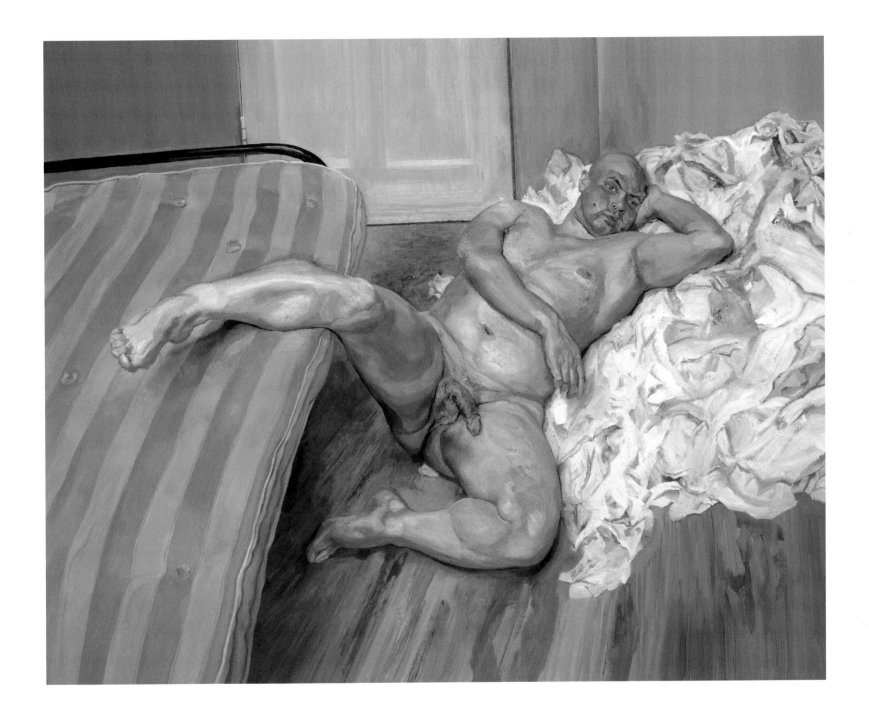

Lucian Freud
Nude with Leg Up
(Leigh Bowery)
1992
cat. no. 22

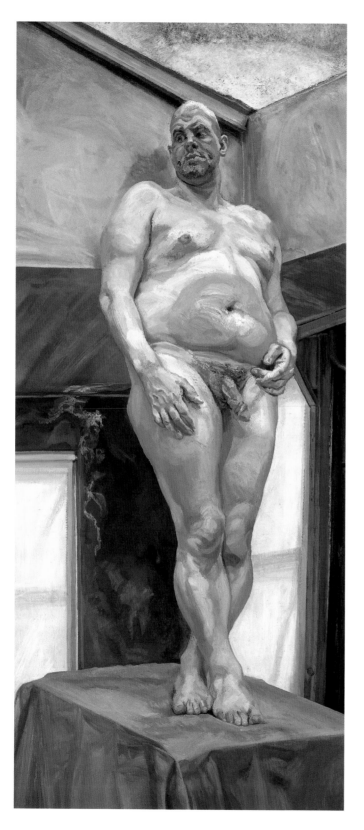

Lucian Freud
Leigh under the Skylight
1994
cat. no. 23

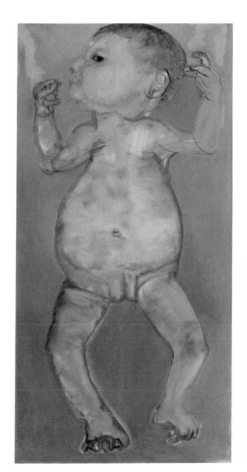
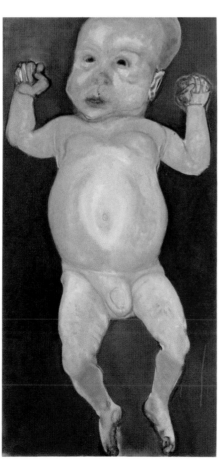
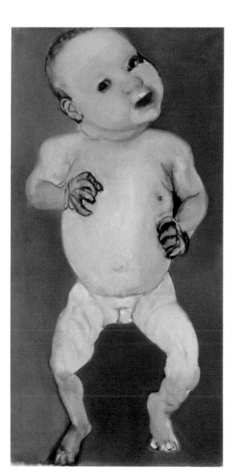
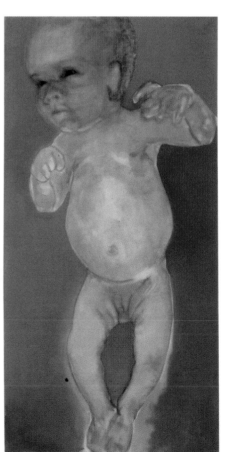

Louise Bourgeois
The She-Fox
1985
cat. no. 9

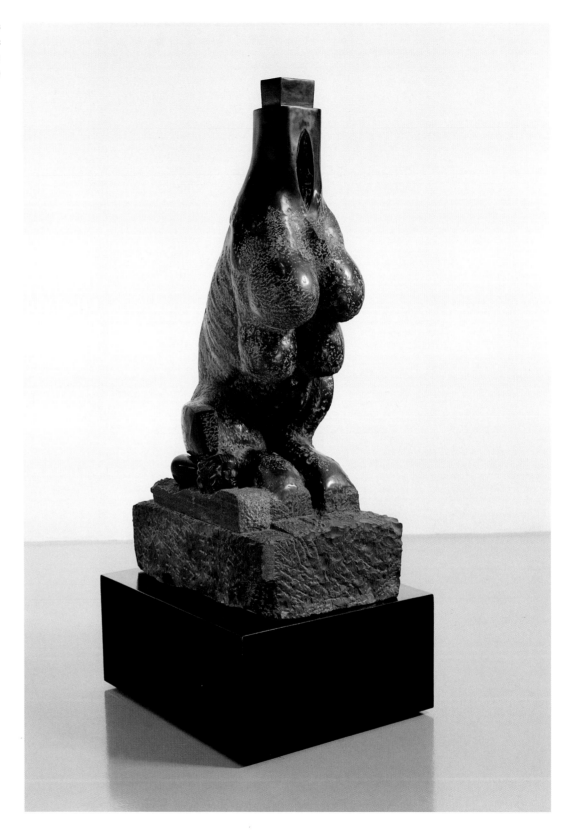

Louise Bourgeois
Single III
1996
cat. no. 11

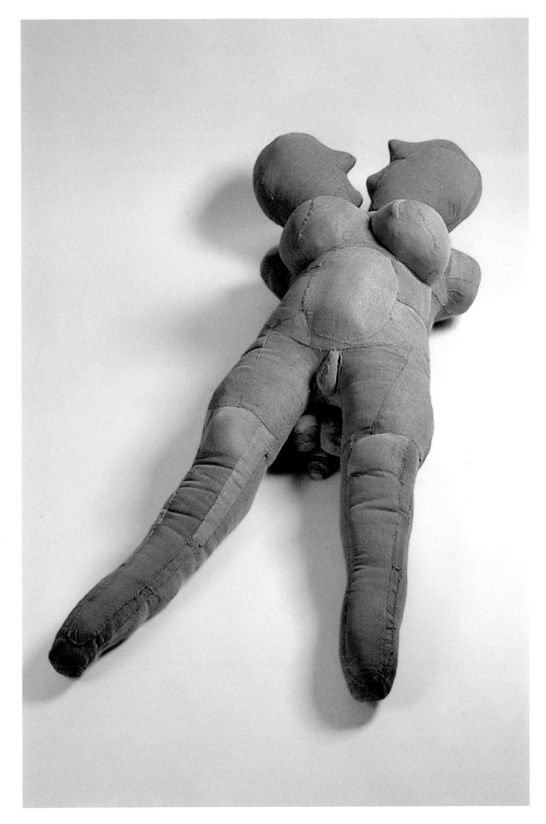

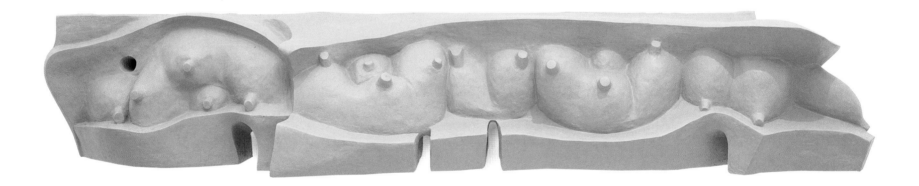

Kiki Smith
Peacock
1994
cat. no. 70

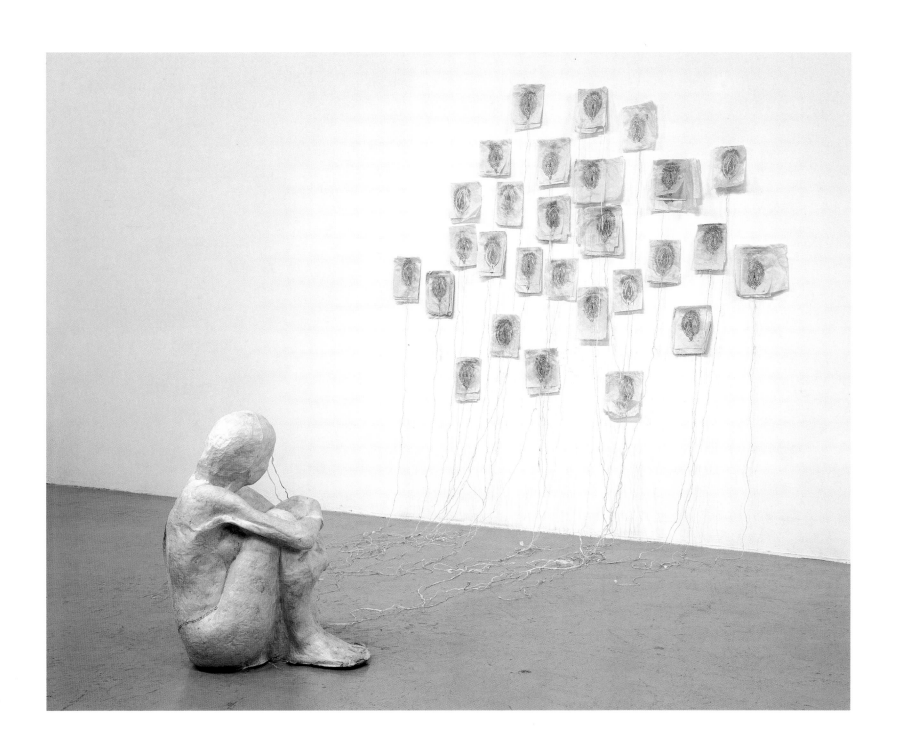

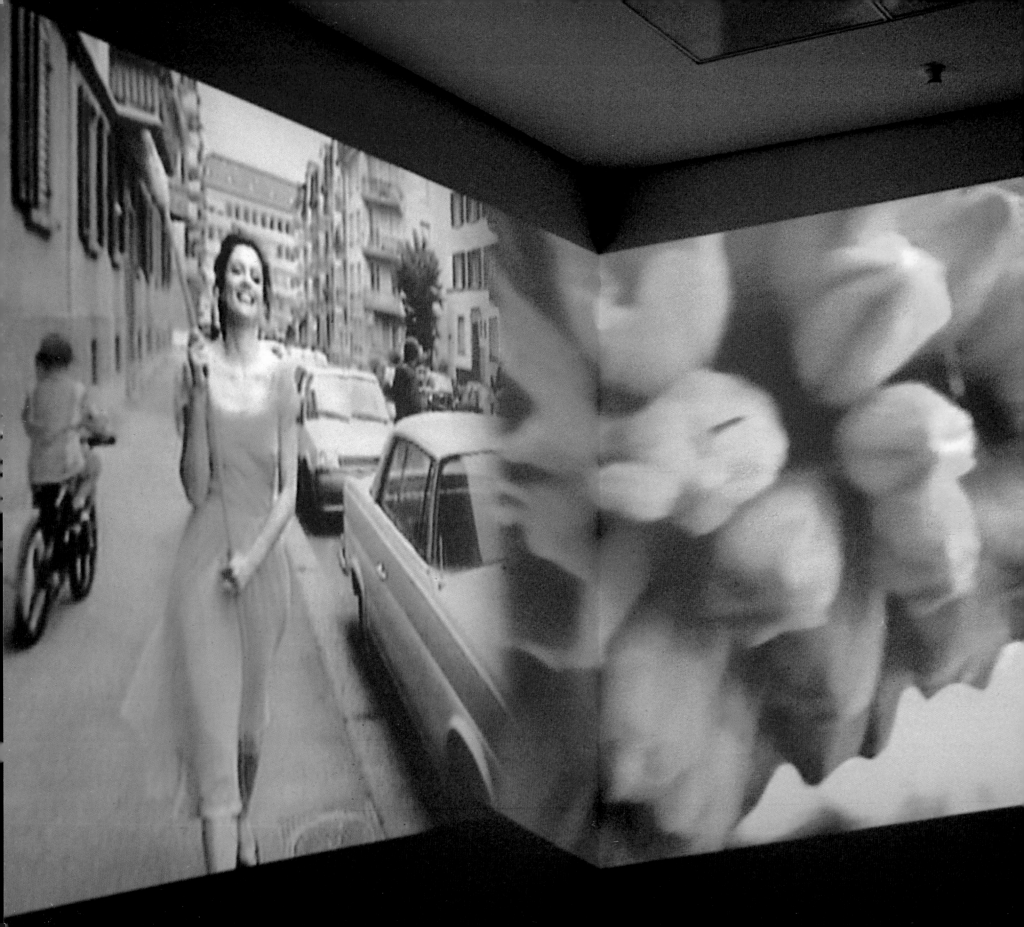

Pipilotti Rist
Ever Is Over All
1997
cat. no. 56
installation view (left)
and video stills

65

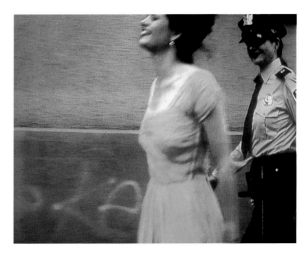

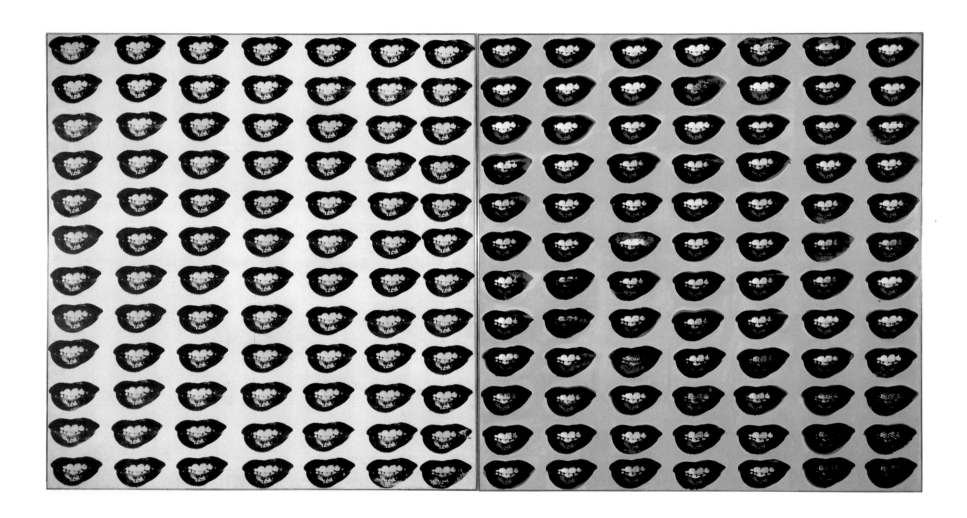

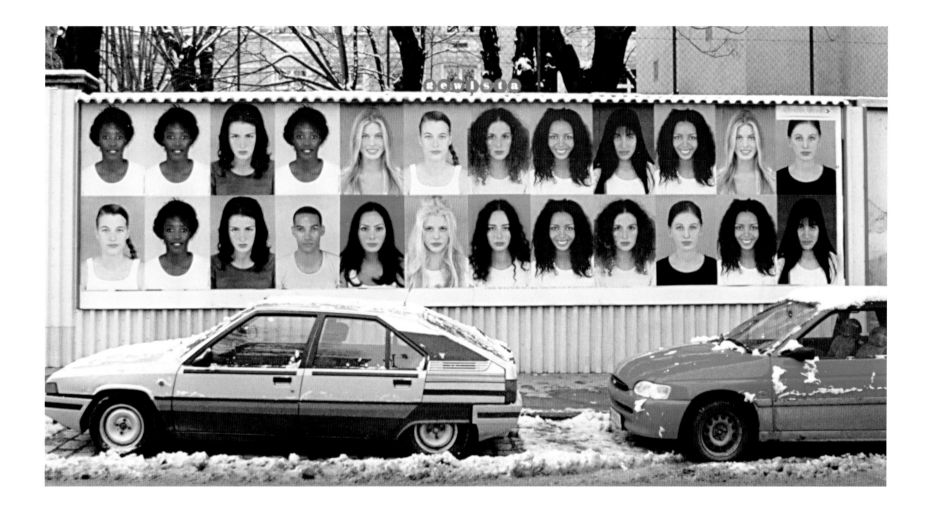

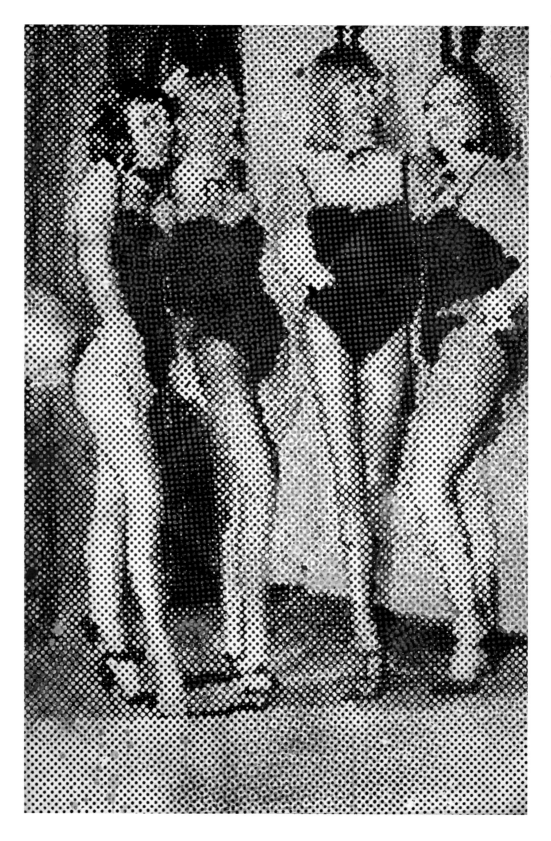

68

Sigmar Polke
Bunnies
1966
cat. no. 46

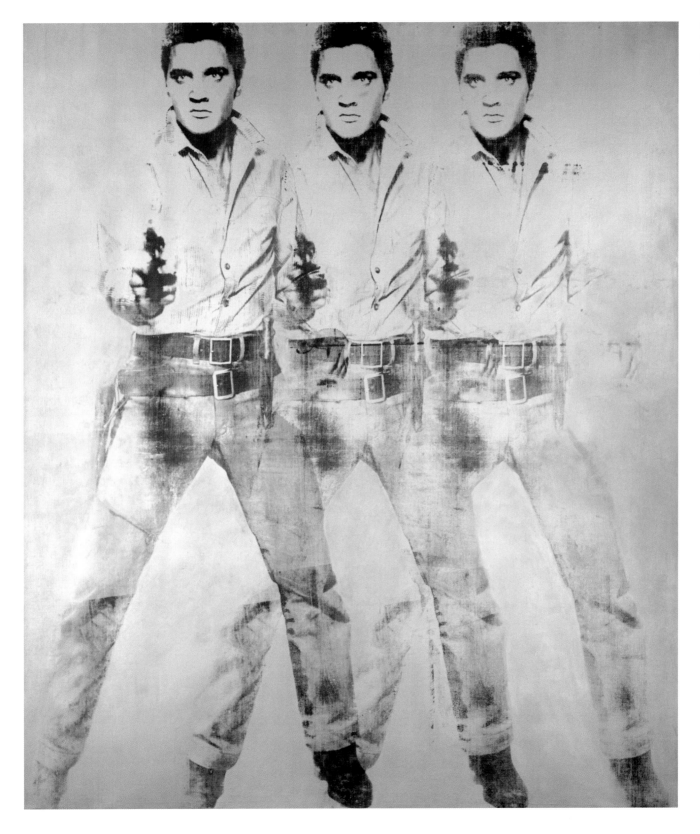

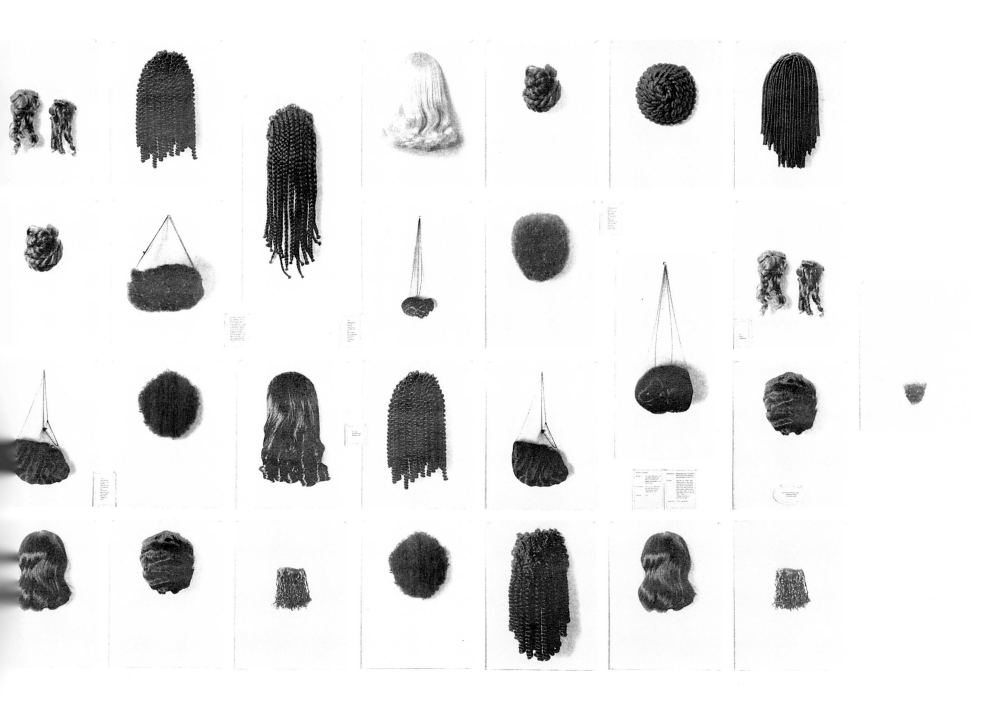

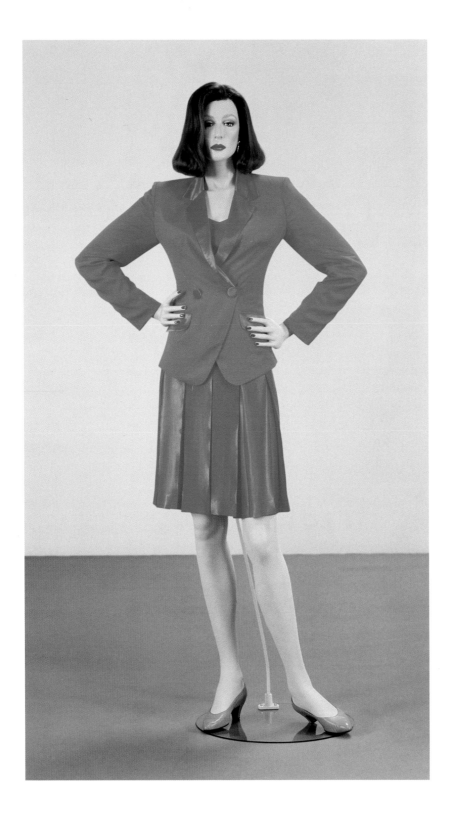

Charles Ray
Fall '91
1992
cat. no. 47

Beverly Semmes
Red Dress
1992
cat. no. 58

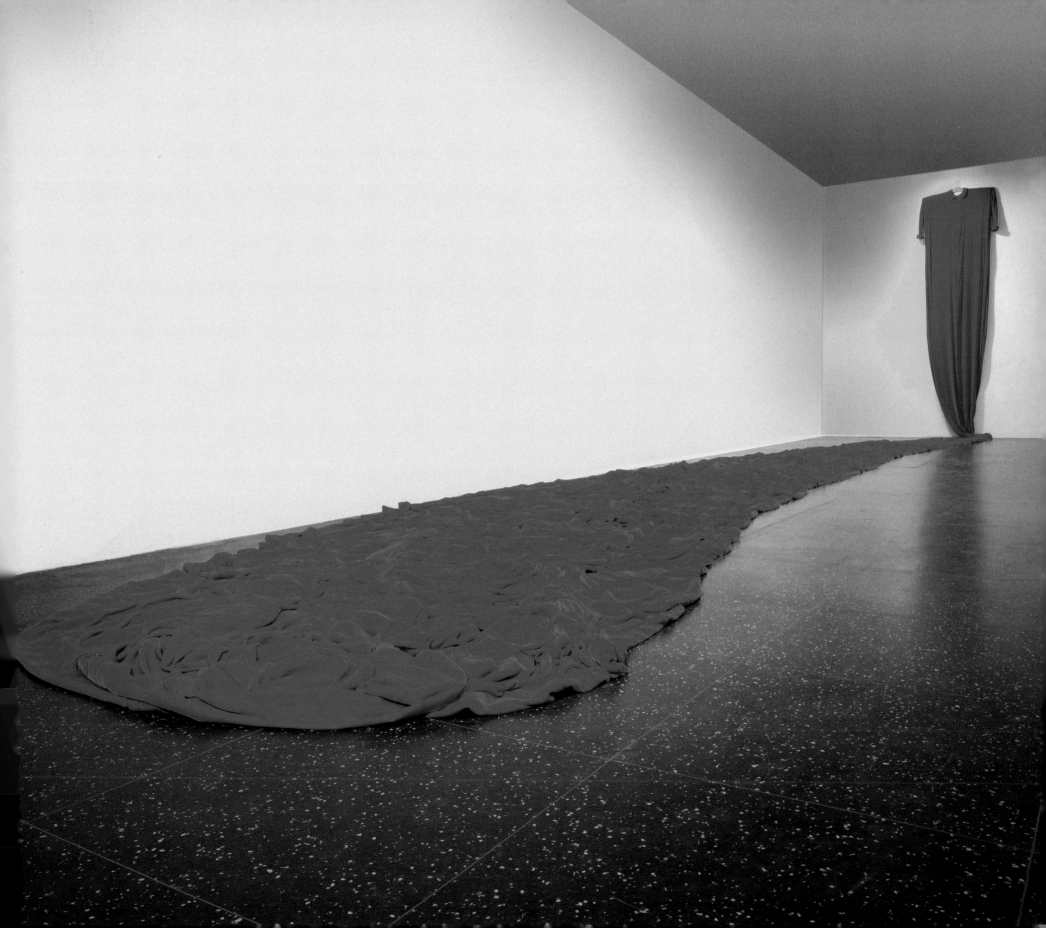

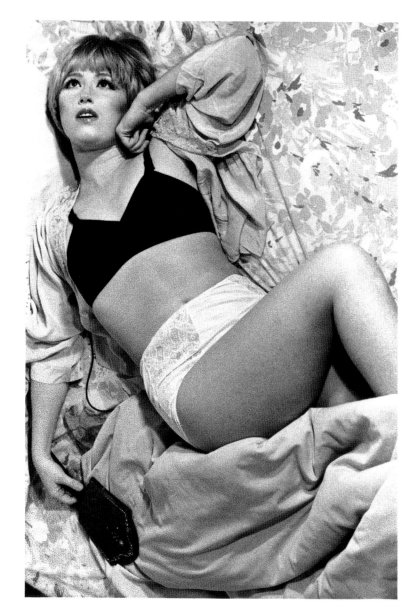

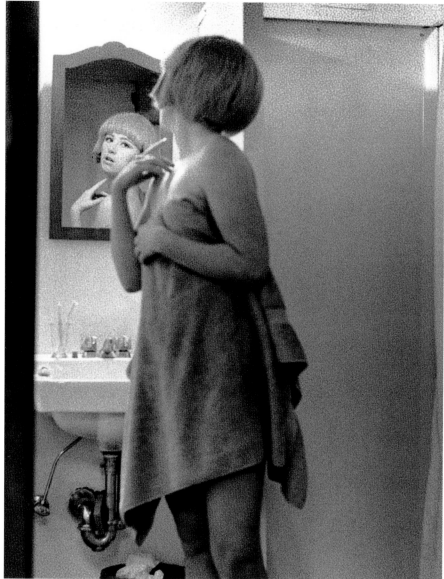

Cindy Sherman
Untitled
Film Still #6
1977
cat. no. 60

Cindy Sherman
Untitled
Film Still #2
1977
cat. no. 59

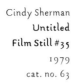

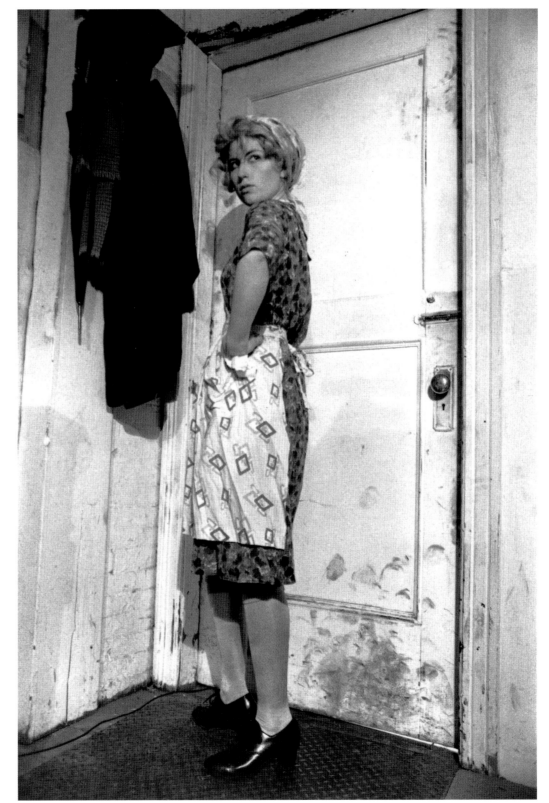

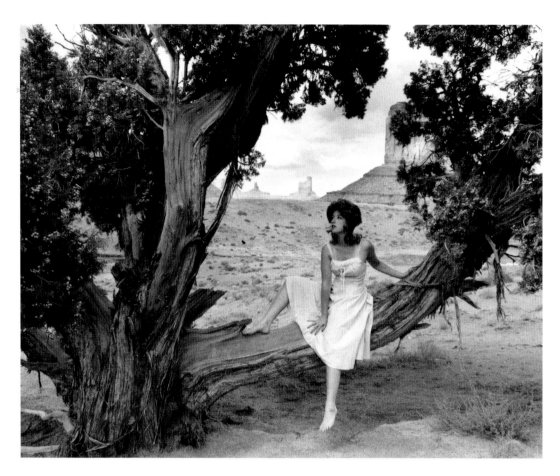

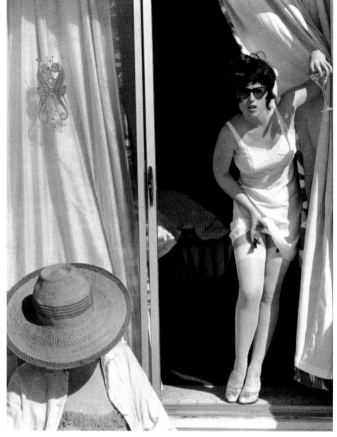

Cindy Sherman
Untitled
Film Still #43
1979
cat. no. 64

Cindy Sherman
Untitled
Film Still #7
1978
cat. no. 61

Cindy Sherman
Untitled
Film Still #16
1978
cat. no. 62

Cindy Sherman
Untitled
Film Still #54
1980
cat. no. 65

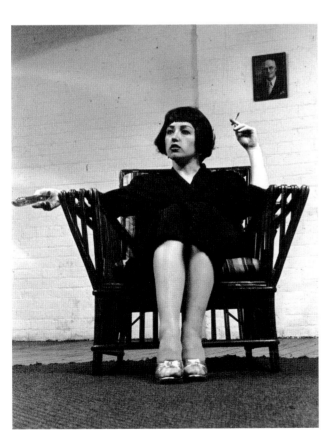

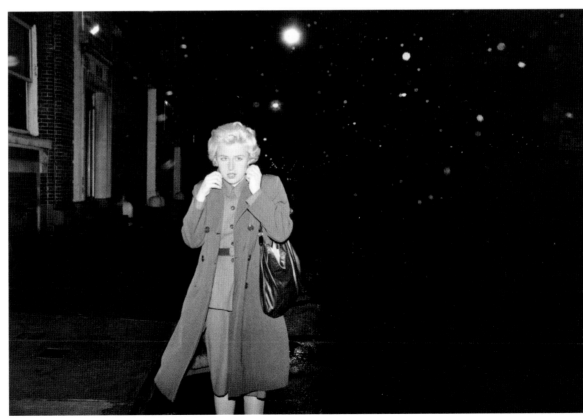

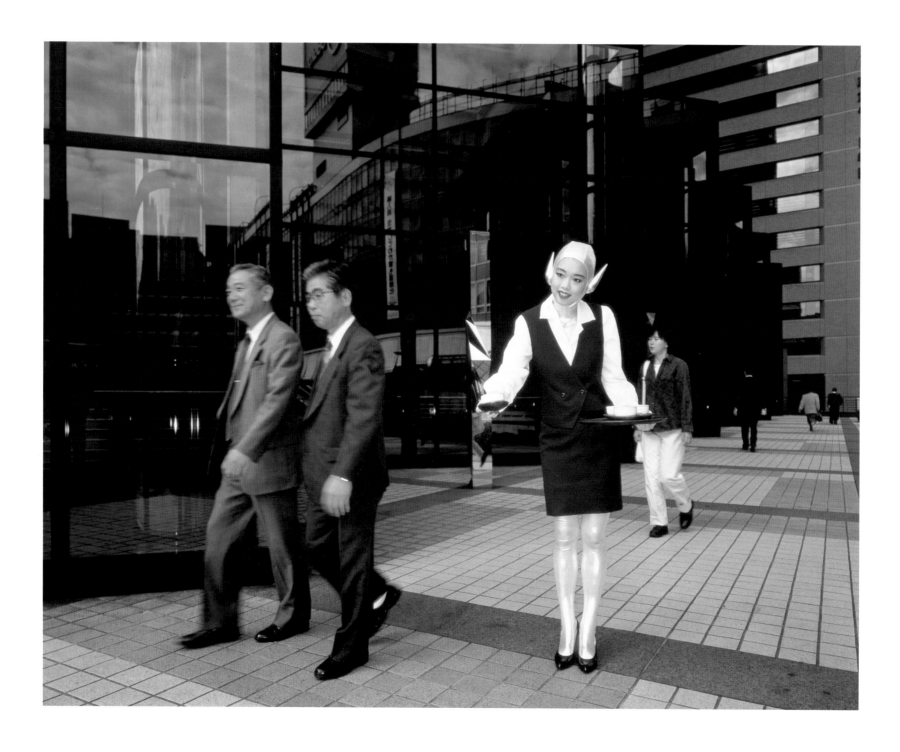

Matthew Barney
CR1:
Goodyear Chorus
1995
cat. no. 6
detail

79

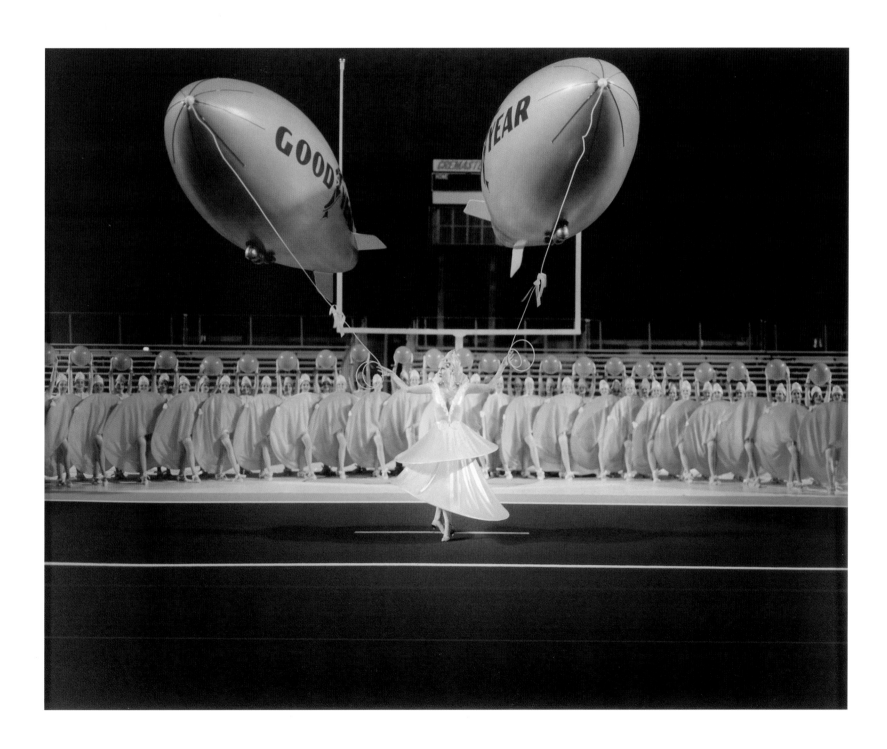

Matthew Barney
CR4:
Loughton Manual
1994
cat. no. 4

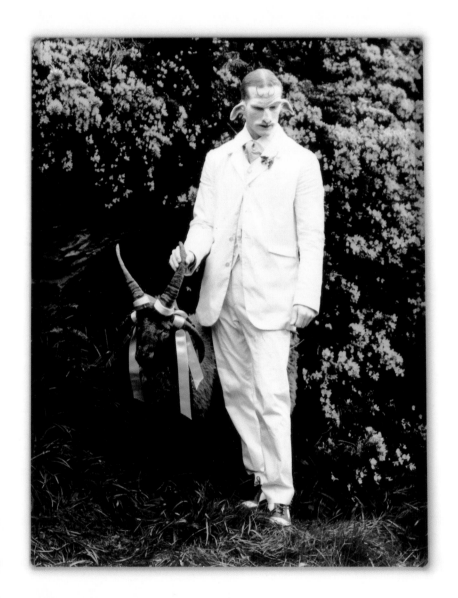

Matthew Barney
**CR1: Choreography
of Goodyear**
1995
cat. no. 5

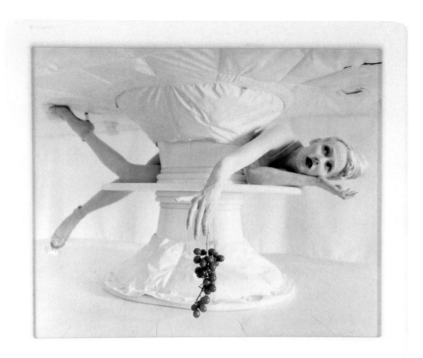

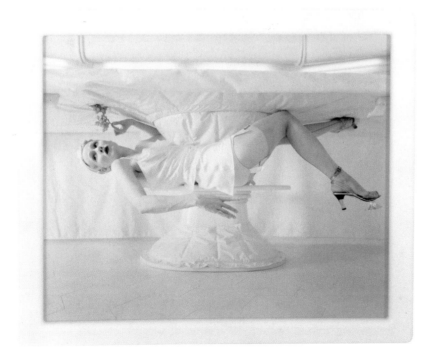

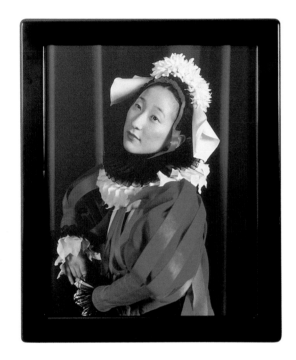

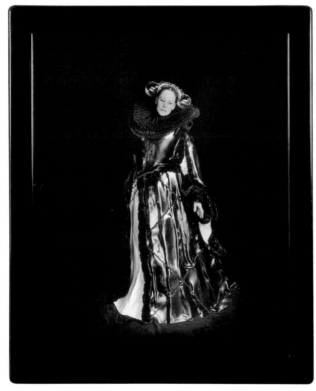

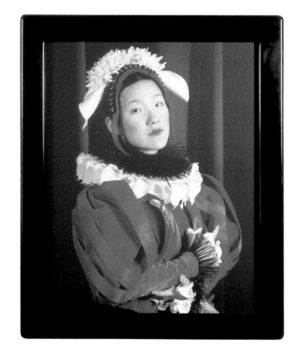

Matthew Barney
Cremaster 5:
Court of Chain
1997
cat. no. 7

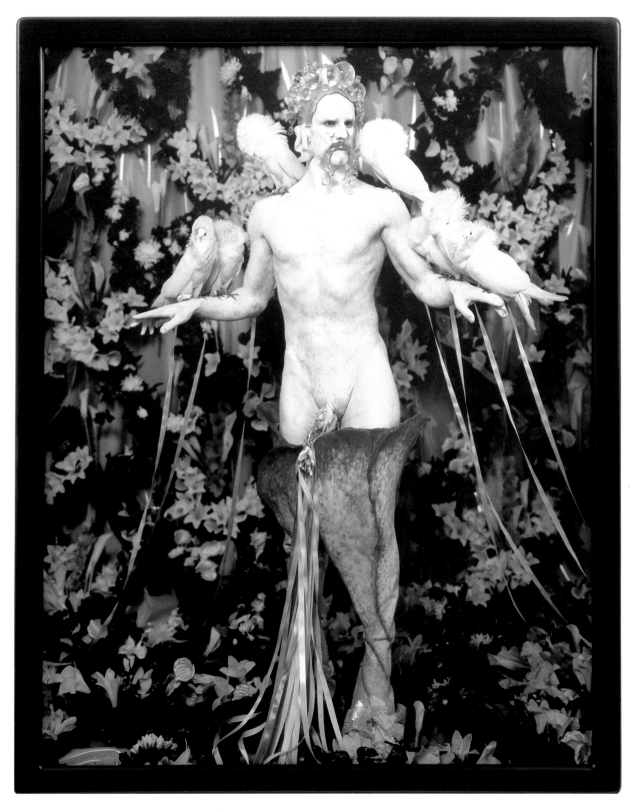

Matthew Barney
Cremaster 5:
her Giant
1997
cat. no. 8

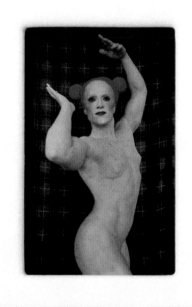

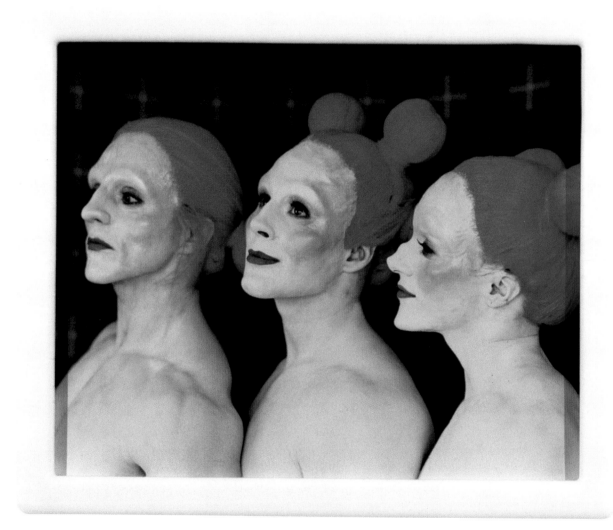

Matthew Barney
CR4: Faerie Field
1994
cat. no. 3

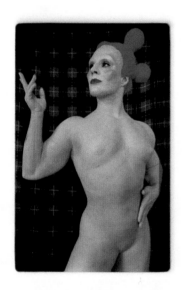 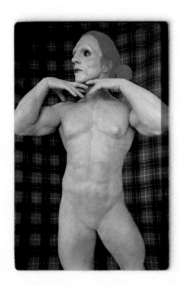

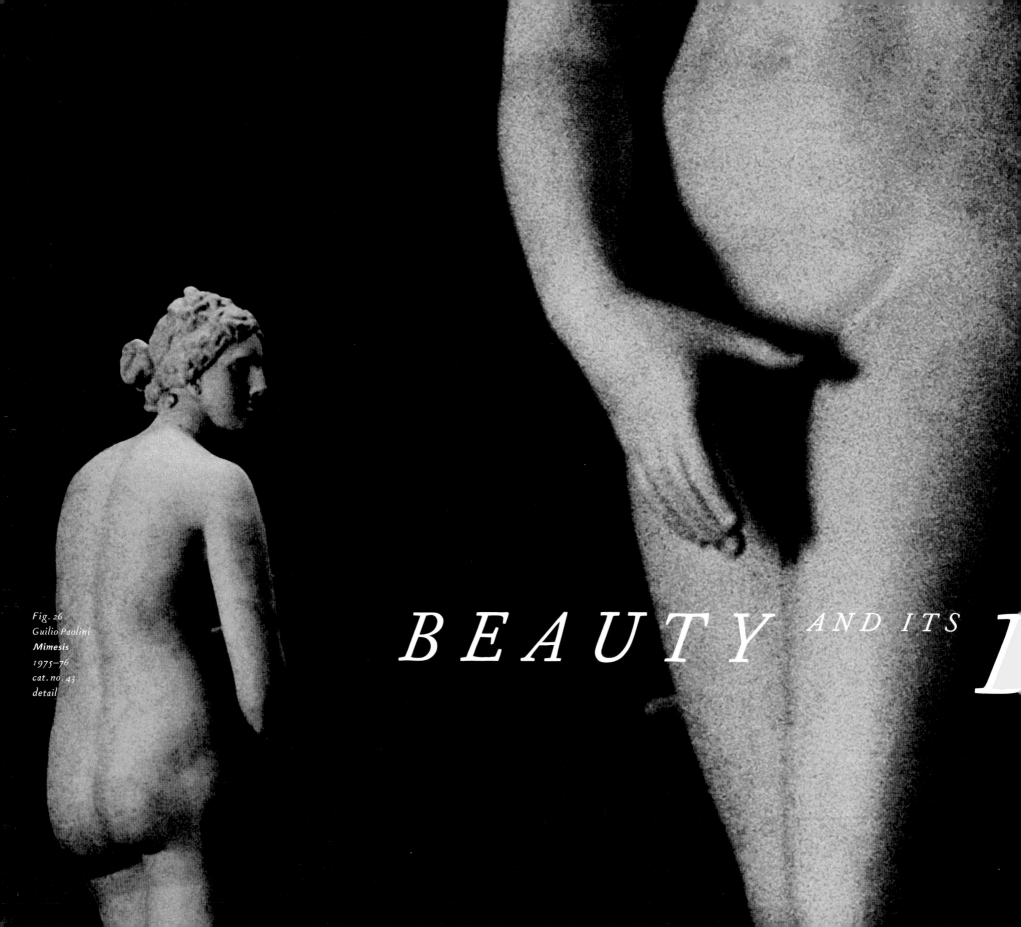

BEAUTY AND ITS

Is beauty in the eye of the beholder, or does it reside instead within the limits of the object beheld? This debate has riddled humanity for centuries. Philosophers in ancient Greece argued that beauty was a quality present in objects, possessing identifiable characteristics and forms, and they quantified beauty in terms of conceptual formalisms such as order, symmetry, and proportion. They applied these attributes to nature and humanity as well as to art, which was considered a reflection of nature. As a foundation of Western art and culture, the ancient belief in beauty's objective standards persisted throughout the Renaissance and beyond.

It was not until the seventeenth century that beauty came to be seen increasingly as a matter of subjective experience, of sensations occurring outside the object, in the viewer's heart, mind, and soul. Considered an intangible essence located beyond the limits of art and language, the subjective view of beauty led to the birth of aesthetics in the eighteenth century. This discipline within philosophy initially investigated the nature of things "felt" as beautiful. Allowing the vicissitudes of taste to enter into the determination of beauty, the new aesthetics also placed a high value on the spiritual and transcendental possibilities of art, which found its most extreme manifestation in a condition popularly described as the "Stendhal syndrome." First observed by the French novelist and critic Marie Henri Beyle (pseudonym Stendhal) in 1817, the "syndrome" described the "symptoms" associated with looking at beautiful art, such as swoons, tears, and rapturous fatigue [*fig. 27*].[1]

Although such extreme physical responses to art are viewed with some suspicion today, the subjective nature of beauty is still highly valued, as is the insistence on beauty's objective standards. Indeed, most people now advocate a measure of both, alternating between objective or subjective interpretations depending on

ILEMMAS

OLGA M. VISO

whether the context is art or any number of settings including fashion, nature, or philosophy. The field of aesthetics, too, has significantly broadened to encompass more than the subjective experience of, or feeling for, beauty, to embrace everything considered in the philosophy of art, including the object of art, the artist, and the spectator. These semantic and philosophical ambiguities have led to the deep and manifold contradictions that govern our perception of beauty in Western art and culture today.

In approaching beauty as the subject of this exhibition, we have chosen to contrast the objective and subjective views by organizing the show in two parts, "Beauty Objectified" and "Intangible Beauty." The first considers the objectification of beauty in art and the human body, where most arguments about beauty have been launched, particularly in recent decades. The artists here have dealt with the weight of the Classical past to propose new and surprising ways to at once honor and subvert time-honored ideals. Expanding traditional conceptions of the human body to include the grotesque, this part of the exhibition also examines alternative forms of beauty that look to the internal processes of the body and mind, incorporate media-derived constructions of beauty, and mediate gender and cultural diversity in subversive and even transgressive ways. The second grouping, under the heading "Intangible Beauty," moves away from the object to explore beauty's elusiveness. Here, artistic investigations into subjective realities evinced by abstraction, the sublime potential of the natural landscape, and the desire to affect the viewer viscerally through sensory stimulation are considered. The exhibition's structure is pointedly paradoxical in that a certain amount of subjectivity was required to designate objects as "beautiful" for "Beauty Objectified," while objects are, ironically, used to give form to subjectivity in "Intangible Beauty." It is our hope that this framework — itself based on and evocative of a rudimentary paradox of beauty — will provide a rich environment for the continued dialog on one of the most enigmatic and provocative concepts in human history.

27

Fig. 27
In Jean-Léon Gérôme's interpretation of the ancient myth, **Pygmalion and Galatea** (c. 1890, oil on canvas), the artist's extreme passion for the beauty of his sculpture miraculously transforms art into life

Fig. 28
The marble **Doryphoros (Spear Bearer)**, a Roman copy after the original of c. 440–450 B.C. by Polykleitos, may be an illustration of the artist's "canon" of ideal human proportion

Fig. 29
Leonardo da Vinci **Study of Human Proportion in the Manner of Vitruvius** c. 1490 pen, ink, wash, and chalk on paper

BEAUTY OBJECTIFIED

BEAUTY AND THE CLASSICAL IDEAL

The Classical belief in beauty's objective qualities has led to an endless search for ideal standards. The ancient Greeks, who defined many of those standards in Western culture, sought to rationalize beauty. Looking to nature as a model, ancient theorists followed a doctrine of "selective beauty," which advocated abstracting from several natural examples to achieve an ideal, or composite, of "perfected" nature. The Greek sculptor Polykleitos developed a canon (now lost) that established the principles for a "perfect" representation of the human body through a series of ratios and proportions [*fig. 28*]. The mathematical basis of beauty developed in ancient Greece had such a lasting effect on Western culture that it was studied with great earnestness by Renaissance masters for whom Classical models were often interpreted as the best guides to "improving nature" [*fig. 29*].

Even in our century the belief in the existence of absolute standards of beauty has persisted. In the early 1930s the cosmetic company Max Factor developed a "Beauty Calibrator" [*fig. 30*], a ridiculous mechanical contraption used to calculate the structure of the "perfect" human face. In the late twentieth century, plastic surgery has enabled humanity to enhance and alter natural features in

the pursuit of "perfection" [*fig. 31*]. We have not reserved the quest for ideal beauty solely for the human body. The history of garden design also reveals our desire to improve and perfect nature – to have it conform to ideal standards that are often ironically misconstrued as "natural." The rose is a perfect case in point. Hybridized to such an extent that its original five-petal form now exists in a profusion of petals, the rose has, in reality, been turned into a freak of nature for the sake of beauty.

Contemporary Russian artists Vitaly Komar and Alexander Melamid have explored the Western insistence on the universality of beauty in art. In their ongoing project of the "Most Wanted" and "Least Wanted" paintings, the artist team has sought to quantify ideal qualities in painting, in which beauty is a critical ingredient. Based on extensive international polling, the artists have, with tongue in cheek, created painting "composites" for individual countries that reflect a consensus of popular opinion [*figs. 32 and 33*]. Attempting to discern the existence of a universal sense of what is pleasing across cultures, Komar and Melamid strike at the deepest roots of Western cultural tradition. Their project reveals beauty as a social construction motivated by subjective factors (taste, geography, economics, and cultural tradition) rather than an overarching set of absolutes. In her iconoclastic book *Sexual Personae* (1990), Camille Paglia also considers beauty a societal invention. Developed to mask the true formlessness of nature and the ugliness of humanity that lie below the surface, beauty, accord-

30

31

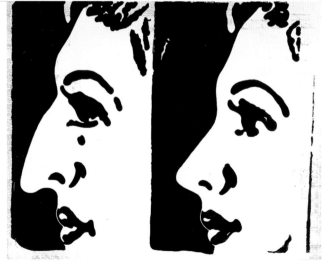

Fig. 30
Max Factor with the
"Beauty Calibrator,"
1932, a measuring
device to reveal the
"perfect" face

Fig. 31
Andy Warhol
Before and After
1960
synthetic polymer
and silkscreen ink
on canvas

Figs. 32 and 33
Vitaly Komar and
Alexander Melamid
The People's Choice:
Most Wanted
Paintings
in the United States,
1994 (left),
and in Germany,
1997 (right)
acrylic and oil on
canvas

ing to Paglia, is "our weapon against nature; by it we make objects, giving them limit, symmetry, proportion. Beauty halts and freezes the melting flux of nature."[2]

Considering the weight of Classical aesthetics in the Western conception of beauty, it is appropriate to begin the exhibition by examining works by contemporary artists who interrogate the efficacy of the ancient standards and their relevance for our time. It is also fitting that it would be artists closest to the Classical tradition – Greek and Italian sculptors such as Jannis Kounellis, Giulio Paolini, and Michelangelo Pistoletto – who would question those ideals most directly. Associated with a loose federation of diverse Italian-based artists known as Arte Povera, these sculptors were driven by a social agenda shared by many artists in the 1960s that sought to merge art and life. Working with unconventional materials, ephemeral substances, and often incorporating performance into their sculpture-based installations, Arte Povera artists coupled an idealism about history and art with a solid grounding in the material world. Their opposition of humble, everyday materials (rags, cement, twigs, and vegetables) with traditional forms of sculpture (stone and metal) underscored this concern. Pistoletto's *Venus of the Rags*, 1967 [*cat. no. 45, p. 43*], for example, contrasts the solidity of Classical statuary with a mound of soiled painter's rags, creating a dialog about the artistic "exhaustion" with tried-and-true academic standards. Originally siting the plaster cast outside the traditional art context in the geographic and sociological

terrain of an Italian neighborhood, Pistoletto also pointedly commented on issues of class stratification in his country in the mid-1960s.

The tempering of historical consciousness with the realities of the present also distinguishes the work of Jannis Kounellis, whose pervasive use of sculptural fragments since the 1960s originated from a desire to seek wholeness out of the extreme fragmentation of Europe in the decades following World War II. For Kounellis, it was imperative to understand the core values and ideals of Western culture if one were to participate responsibly in the evolution of history and arrive at new ideals more appropriate to one's own time. The Classical fragment represents the full embodiment of ancient ideals, providing insight into a "reality which conditions us deep down."[3] In Kounellis's *Untitled*, 1980 [*cat. no. 35, p. 42*], cast shards of Classical sculpture and slabs of marble are stacked inside a doorway, presented as archaeological strata revealing layers of cultural history. Blocking immediate passage, the door serves as an apt metaphor for the burden of Classical ideals in our time. Present yet highly precarious, the past is not a crumbling obstacle but a potential source of strength. Constantly recombining and reconstituting his installations as his work moves from site to site or into a different cultural context, Kounellis underlines the fluid nature of history as well as the notion of a unique or absolute work of art. His critical view of the "authentic" brings his art close to the concerns of his con-

32

33

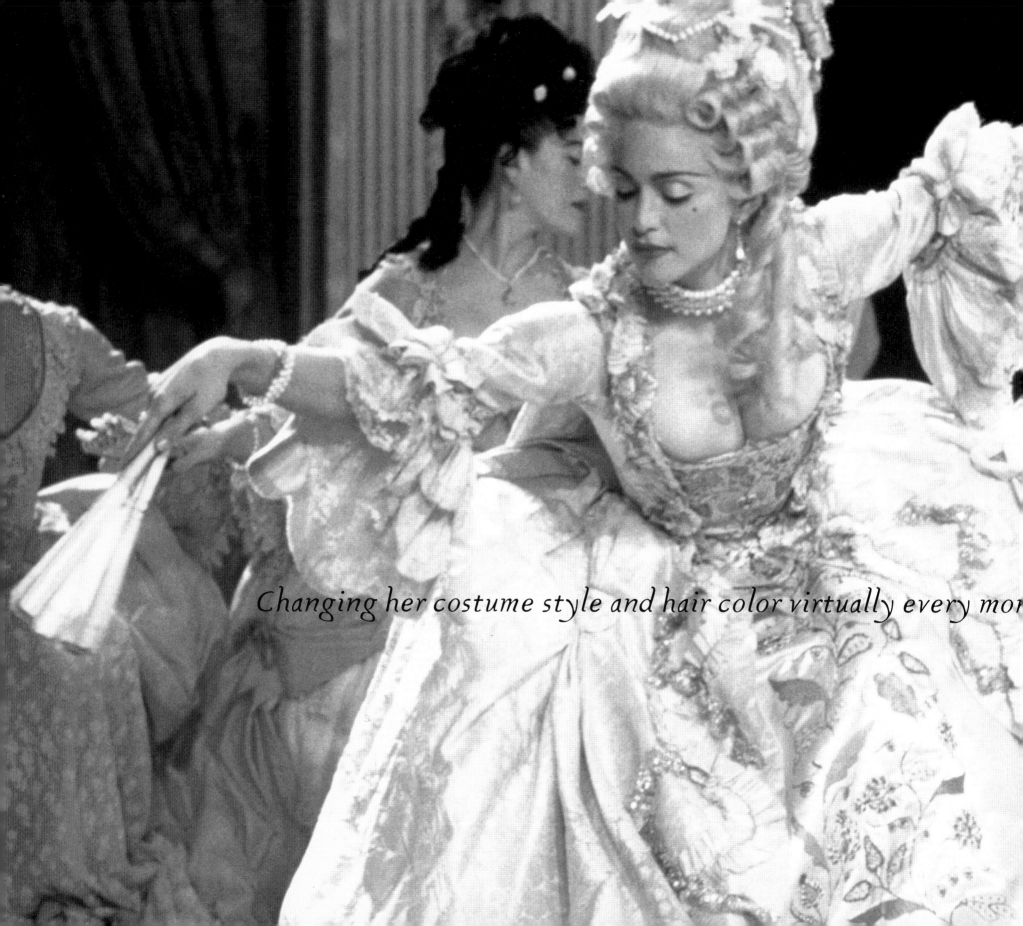

Changing her costume style and hair color virtually every mor

temporary Giulio Paolini, who throughout his career has investigated the nature of representation and the myth of Classical aesthetics.

In *Mimesis*, 1975–76 [*cat. no. 43, p. 41*], Paolini borrows an iconic embodiment of beauty from Classical antiquity – the Medici Venus of the first century B.C. – and constructs a curious relationship between two plaster casts of the figure. Set atop pedestals and posed facing each other, these identical copies stand in absurd opposition, each profoundly absorbed in reflection of the other. Paolini's pointed attack on the mimetic theories of Platonist aesthetics pokes holes in the view of art as a faithful transcription of nature. It also brings to light one of the inherent paradoxes of Platonic theory – the irreconcilability of the mystical experience of beauty with rational, mind-ordered ideals. Commenting on the nature of beauty in art, Paolini states:

I am still searching for, or waiting for, beauty.... We claim as beautiful certain lineaments of the real that our eyes are trained to see but that really have nothing to do with beauty, and are inadequate to depict it, to give it face. For beauty may grow out of the real, but does not recognize the real as its model. How and where can we discover beauty, whether inside or outside the work?[4]

Paolini's philosophic dispute with the work of art has led him in subsequent installations to dismantle other existing orders and systems – Renaissance perspective, Baroque architecture, and the representational function of painting. As in *Mimesis*, he often employs

"Warhol's celebrity portraits, including *Gold Marilyn*, 1962 [*cat. no. 84, p. 50*], and his renditions of Western icons such as the Mona Lisa (*Mona Lisa*, 1963 [*cat. no. 86, p. 46*]) evolved out of his interest in the anesthetizing effects of television and the print media on contemporary culture. Using silkscreen, a mechanical means of reproduction, to create his images, Warhol commented on the distortion and trivialization of meaning that occur through endless repetition. To that end, Warhol frequently multiplied an image several times across a single canvas, as in *Mona Lisa*, *Marilyn Monroe's Lips*, 1962 [*cat. no. 85, p. 66*], and *Triple Elvis*, 1963 [*cat. no. 87, p. 69*]. Although Warhol's commercial approach to artmaking suggests his boredom with traditional aesthetic standards, the resonance of history and artistic convention were still crucial to him. In *Gold Marilyn* the face of the film star appears inscribed in a Renaissance tondo, a traditional format usually reserved for a saintly Madonna. The gold background of the painting, a feature common in Byzantine religious icons and Trecento Italian art, underscores the spiritual and devotional status of the legendary actress. Warhol's fascinating fusion of sexuality and religion, of art history and popular culture, in this and other pictures presents a compelling illustration of Paglia's theories on the persistence of "sexual personae" in contemporary society.

In *Sexual Personae*, Paglia contends that many Western conceptions about the body are based on sexual personae originated by the Greeks. From the ancient Egyptian princess Nefertiti to the

...donna embodies the eternal values of beauty and pleasure. CAMILLE PAGLIA, 1990

doppelgangers," or mirrors of originals, to explore the enigma of representation. Paolini's interest in the replication of the image has interesting parallels with Andy Warhol, who, more than any artist in this century, has addressed how ubiquitous duplication has had an impact on the original.

nineteenth-century American author Emily Dickinson, Paglia examines what lies behind the lasting power of mythic individuals such as Venus, Cleopatra, Mona Lisa, Don Juan, Lord Byron, Rudolf Valentino, and Elvis. According to Paglia, these iconic personalities harnessed the "pagan" sense of beauty – which fuses sex,

cruelty, divinity, and at times androgyny – to maximum effect. Paglia argues that despite the Judeo-Christian destruction of paganism nearly two thousand years ago, the "pagan continuity of sexual personae" and the "pagan theatricality of Western identity" have continued uninterrupted.[5] In Paglia's estimation, the contemporary master of pagan beauty is Madonna, who has made a career of donning a variety of sexual personae in her music videos [*fig. 34*].[6]

Warhol and Imi Knoebel (*Grace Kelly*, 1990/98 [*cat. no. 34, p. 51*]) touch on society's fascination with these personae, as do several of the younger artists in the exhibition, including Cindy Sherman and Yasumasa Morimura, who cast themselves in the guise of art historical personae to explore contemporary issues related to gender, beauty, and identity. In Sherman's "History Portraits," a photographic series created in Rome in 1989–90, the artist stages reconstructions of familiar paintings dating from the fourteenth through nineteenth centuries, including Giulio Romano's depiction of Raphael's mistress La Fornarina (*Untitled #205* [*cat. no. 66, p. 48*]), Leonardo da Vinci's Mona Lisa (*Untitled #209* [*cat. no. 67, p. 47*]), and Caravaggio's Bacchus (*Untitled #224* [*cat. no. 68, p. 48*]). Wearing period costumes, applying makeup and prostheses, Sherman casts herself as the subject, often rendering herself, as well as the original painting, unrecognizable. The photograph presumably inspired by Mona Lisa is a perfect case in point. While the ambiguous smile of the Renaissance woman resembles Leonardo's original, the outfit and head ornament do not correspond; they were probably drawn from another portrait. Making composites from various painting "types" is a working method that curiously mirrors the ancient practice of creating an ideal from numerous models. For Sherman, who often forgets (or chooses not to reveal) the art historical references for her photos, faithfulness to the original is not crucial – the original is, after all, a reproduction from a book,

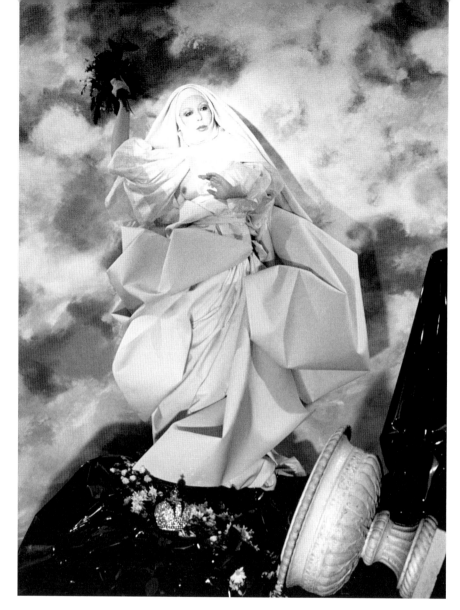

Fig. 35
Orlan
Madone blanche
en assomption
(The Assumption of
the White Madonna)
1984
Cibachrome

Over the last two decades, French performance artist Orlan has undergone an endless series of surgical procedures to alter her physical features, conforming to a variety of feminine ideals drawn from the history of art

which has already been distilled of its authenticity. This philosophy allows Sherman to alter details to draw attention to the fallacy of certain stylistic conventions in painting, as in *Untitled #205*. In Sherman's interpretation, La Fornarina is not the erotic mistress who fondles her breasts for Romano; she is, rather, an androgynous creature with pursed lips, fake breasts, and cheap clothes.

Interested in how memory softens, distorts, and even combines disparate images, Sherman exaggerates details in her photographs and, in the words of Arthur C. Danto, effectively "drains the old masters and their subjects at once of a certain power, by showing the artifice, the convention, the transparent fakeness of the worlds they believed were solid and unshakable and real."[7] The curious distance that she forces between memory and truth in the "History Portraits" as well as in her earlier "Film Stills" has intriguing parallels with Vanessa Beecroft's odd, improvisational performances in which she asks a select group of models to stand in place and pose according to each individual's recollection of feminine posture in a famous painting [*see fig. 2*]. The results, which vary from the shy *Venus Pudica* to more languorous poses, are also echoed in the works of French performance artist Orlan [*fig. 35*], which call into question our ideas about painterly beauty as well as the efficacy of what Danto has so aptly described as "historical modes of allurement."[8]

While Sherman and Beecroft address the generalized conventions of beauty deeply embedded in our cultural consciousness, Yasumasa Morimura maintains a fascination with the original that is specifically relevant to his intent. Confounding "paradigmatic personae" with his own non-Western (Japanese) ethnicity, Morimura's photographic series in which he remakes Western icons opens the door to a whole set of complex issues related to the projection of beauty from a variety of cultural, racial, and sexual contexts. In *Portrait (Futago)*, 1988 [*cat. no. 42, p. 49*], Morimura assumes the role of the subject of Édouard Manet's infamous

Olympia, 1863 (Musée d'Orsay, Paris). Wearing a blonde wig, junk jewelry, pink nail polish, and metallic slippers, the artist reclines on a bed covered with a shimmery bridal kimono – all pointed variations of detail from Manet's original. The black maidservant, also played by Morimura, carries a basket of plastic rather than fresh flowers, and the cat (also a fake) is a cheap commercial figurine like those typically seen in Japanese shop windows announcing business and a place where money is exchanged. The backdrop of the mural-size photograph is sketchily painted, underscoring the fiction of painting. Morimura goes further than Sherman in his critique of the fallacy of painting by adding "Old Master" texture to the surface so that it resembles canvas in the large version of the photograph (Collection of Eileen and Peter Norton, Santa Monica, California). Presenting his subject in a garish, gold-gilt frame, Morimura seems to have complete irreverence for *Olympia*. Yet the brilliance of Morimura's seeming pastiche is the manner in which he draws on Manet's own iconoclasm for his purposes.

It is telling that in 1988, the year Morimura made *Portrait (Futago)*, art historian Griselda Pollock published a revisionist interpretation of Manet and Impressionism in *Vision and Difference: Feminism, Femininity, and Histories of Art*. Her "unmasking" of *Olympia* was supported by other art historians, including T. J. Clark and Eunice Lipton, whose respective essays from 1984 and 1975 revealed Manet's subject to be a working-class woman, maybe even a prostitute, whose depiction demonstrated sexual and class privilege rather than the ennobling standards promulgated by the French academy.[9] The artist's unidealized presentation of a common woman, a courtesan, tore at the fabric of French social mores in the 1860s. By inserting himself, an Asian male, in the place of Olympia – not to mention the complications he introduces with his *futago*, or twin, in the guise of a black female – Morimura creates a cross-cultural dialog that comments on the Japanese cannibalization of Western culture as much as it

critiques the Western stereotyping of Asian society. Responding to critics, Morimura stated:

I am Japanese, so why am I dealing with Western work? Because it feels as close to me as traditional Japanese art. If I had used a canvas to explore my themes, it would have shown partiality to a Western language, but photographs, I think, are neither Japanese nor Western. They represent my feeling that I exist in between the two worlds. [10]

Morimura's reminiscences on art history, if viewed from this perspective, achieve a level of self-portraiture in a way quite unlike Sherman, whose own subdued personality remains buried in the makeup and costumes.

Although all the artists discussed thus far seek to find a measure of the individual within the strictures of historical convention, Yves Klein and Janine Antoni push further beyond the canons and the objective view of beauty in their desire to record the body's physical energy in their art. In his "Anthropometries" of the 1960s, Yves Klein used the human body as a "living brush" [*see fig. 20*]. Bathing his models in his signature International Klein Blue paint (an ultramarine color he patented as IKB), Klein would direct the women in performances frequently accompanied by an orchestral symphony (the artist's "Monotone Symphony"). Under his supervision, the models would press and drag their bodies across surfaces of paper and canvas, leaving elegant, rhapsodic impressions. Localizing the paint to the torso, the resulting forms of the body (mostly female) were reduced to the essentials, becoming anthropometric symbols related to the canon of human proportion. Although seemingly random in their composition, it is possible to discern a number of art historical references in the nearly two hundred such carefully choreographed studies Klein made during his short life. Suggesting an inventory of different periods and styles ranging from the figural to the abstract, his works include images of a Nike and caryatids from Classical antiquity, nudes reminiscent

of Degas's and Matisse's, as well as painterly *art informel* abstractions. While some scholars suggest Klein's quotations are deliberate – sometimes playful, at other times critical of fellow abstractionists Georges Mathieu or Jackson Pollock – their presence underscores the lasting power of historical modes of presentation as well as Klein's desire to release the body from conventions that sublimate its inherent sensuality. Klein thus moved his art into a considerably more subjective realm.

Janine Antoni mediates the territory further between body art, performance, and traditional sculpture. Sharing Klein's interest in the transfer of bodily energy into sensuous matter, Antoni, in dialog with Klein, used chocolate and soap rather than paint to register the impressions of the body in the sculptural installation *Lick and Lather*, 1993–94 [*cat. no. 1, pp. 44, 45*]. Choosing to work with her own body rather than models, Antoni closed the distance between the artist, the viewer, and the work of art. Her approach is quite a departure from that of Klein, who often wore white gloves during his Anthropometry performances to underscore his artistic distance and authority. Making a mold from her own body, Antoni cast seven self-portrait busts in chocolate and seven in soap to create *Lick and Lather*. Set atop pillars, the sculptures are displayed facing one another in Classical progression. Indeed, the artist's decision to make seven in each substance conforms to the ancient predilection for seven as an ideal number. Antoni's faithfulness to Classical models, however, ends here. Rather than adhere to a homogenous presentation of idealized likenesses, Antoni individualizes each head by respectively "licking" and "lathering" the busts over a period of time. While the features are preserved in several examples, noses, chins, eyes, and ears in others are altered and in some instances erased.

These actions as well as the artist's choice of materials suggest a variety of concerns related to the presentation of the body in contemporary culture, alluding to the effects of aging, the vanity

of cosmetics and plastic surgery, the drives that lead to eating disorders, and cultural values associated with shades of skin color. Antoni's ambitious project reinforces the lengths to which society will go for the pursuit of beauty, as well as the extreme pleasures one must forfeit to achieve perfection. Chocolate, which is itself a direct source of pleasure (as well as an aphrodisiac), epitomizes one's inner cravings, while soap embodies consciousness about one's outward appearance in society. Although drawn by the sensuous aroma of both materials in the gallery, the viewer is curiously repelled by the conflicting smells, not to mention the cakey-white surface of the once-edible, blooming chocolate. Antoni's interest in seduction and replusion introduces one of the most compelling paradoxes of beauty, that is, its relationship to ugliness.

DIFFICULT BEAUTY

The correlation between beauty and ugliness is indeed a complex issue, one that has captured the artistic imagination throughout the history of art. In the late twentieth century, as beauty has come under more severe attack, the connection between beauty and ugliness, between the seductive and the repellent, has been a topic of growing concern for young artists proposing alternative forms of beauty when beauty has been devalued. In 1995 curator Lynn Gumpert organized the exhibition "La Belle et La Bête" (Beauty and the Beast) for ARC Musée d'Art Moderne de la Ville de Paris that

us something of which we may not approve in such a way that we cannot resist it."[11] The evocation of pleasure through discomfort is, in his view, a deliberate form of transgression. A slightly earlier exhibition that lent credence to this idea was the Whitney Museum of American Art's "Abject Art: Repulsion and Desire in American Art" in 1992. Bringing together works by artists ranging from Marcel Duchamp to Mike Kelley, the exhibition's curatorial team used as its theoretical basis Julia Kristeva's much-quoted "Powers of Horror – An Essay on Abjection" (1982), which explored a type of artistic degradation with transformative potential that could move darkness and pain into aesthetic form.

Despite the contemporary interest in the topic, the resistance to creating beauty, even in a transformed state, has persisted into the late 1990s. The reasons for such disregard lie once again at the feet of our ancient predecessors the Greeks, who associated beauty with good and named it an essential component in human excellence. Considered a virtue of the Gods, beauty during the Classical age was a divine and eternal gift. Beauty's corollary then, ugliness, signaled the absence of beauty and ergo the presence of evil. In this scheme beauty and ugliness were viewed as polar opposites. Since then, many have argued that beauty and ugliness are not diametrically opposed, but rather, that each possesses one ingredient of the other.

Perhaps one of the greatest figures still active during the latter half of this century to articulate the complex relationship

Beauty in art is often nothing but ugliness subdued. JEAN ROSTARD, 1939

explored the work of sixteen emerging artists engaged with aspects of difficult beauty. Central to her thesis was Dave Hickey's notions of a "transgressive" form of beauty that encompasses the dual qualities of attraction and repulsion. For Hickey, beauty is "the agency that causes visual pleasure in the beholder – by showing

between beauty and ugliness was Pablo Picasso. Throughout his seventy-year career, the painter's unconventional and often violent treatment of the human body was often interpreted as an "insult" to beauty. That characterization tended to accompany his many female nudes, whose distortions and disfigurement, coupled with

an unnaturalistic use of color, belied a vehemently "unaesthetic" view of the human form. Yet, for Picasso, neither beauty nor humanity were that simple. For him the absolute beauty of Western art was sterile, and early in his production he abandoned the Classical conception of female beauty in favor of a new reality that was closer to life and considerably more disturbing. Although he would return to Classicism in the 1920s only to abandon it again shortly after, his rationale for his venture into the "ugly" was that humanity fundamentally loves a woman rather than Venus.[12] He stated:

The Academy devised the formula; not long ago they submitted the senses to the "official" judgment of what is beautiful and what is ugly. The Renaissance invented the size of noses. Since then reality has gone to the devil.[13]

Picasso's dismemberment of the human form, and thus his dismantling of the Greek vision of beauty, was born of a sense that beauty and ugliness, as well as objective and subjective beauty, were inextricably enmeshed. As Picasso scholar Roland Penrose wrote, Picasso did not "hesitate to mingle the monstrous images which for many reasons perturb us deeply among those which our aesthetic judgement feels to be of profound beauty."[14] Indeed, he was interested in the transformative power of both. His extraction of horror and ugliness from love and beauty, and his transmutation of ugliness into beauty, have been the subject of much speculation leading

works, aging. In the portraits of Dora Maar from the thirties and forties (a period when he bore no specific animosity toward his lover), the tortured visage of Maar is presented as the antithesis of beauty. Her mangled, severely outlined features and her perpetually tearing eyes embody his suffering during World War II. It was not until later that Picasso would trace in the portraits the demise of his relationship with Maar. So, too, he could proffer the destructive forces of his style to the numerous renditions of his beloved second wife, Jacqueline Roque, in the late 1950s and throughout the 1960s (*Reclining Woman Playing with a Cat* [*cat. no. 44, p. 55*]).[15] That Picasso could render the women he loved with such exquisite brutality on the one hand and such reverential grace on the other confirms that his interest in beauty was not located in the perfections of the physical body but in the psychological and emotional force that makes us all vulnerable, human, and, in the end, beautiful creatures.

With the same ease that Picasso could transform feminine beauty into whimsical reverie or fatalistic brutality, so too could his younger rival, Willem de Kooning, who also painted women throughout his career. De Kooning's depiction of women was "born of all those idols," the world's total inventory of "sacralized female imagery."[16] Mixing the time-honored nude of Western art, legendary film stars, and the goddesses of antiquity, de Kooning created a fluid vision of femininity that presented her as conversely passive or aggressive, mysterious or frank, modest or carnal,

Art is not the application of a canon of beauty but what the instinct

to a variety of psychoanalytic interpretations of his tumultuous relationships with women throughout his career. Yet many Picasso scholars have argued that his paintings are about art, not women, and that in his depiction of women Picasso was expressing ideas about violence, war, societal values, love, loss, and in his mature

seductive or self-assertive, physical or spiritual. The figure in *Woman, Sag Harbor*, 1964 [*cat. no. 20, p. 54*], is a virtual femme fatale with her aggressive teeth and legs splayed before the viewer. This figure, presumably a bather on the shore near East Hampton, is disconcerting not only in its posture but also in its flaming hair,

bright green eyes, and menacing grimace. De Kooning's women, like Picasso's, do not reflect a preoccupation with physical perfection or beauty in the Classical sense, and the artist's range of presentation suggests that he had no interest at all in idealizing females. Although his works have often been interpreted as expressions of his aggression toward women, in recent years scholars have come to a more forgiving view, acknowledging that de Kooning's presentation of women is in the end multifaceted, encompassing the many sides of femininity. Indeed, the weight of Venus appealed to de Kooning, and the fact that the female body had been rendered over and over again fascinated him; de Kooning was not only working through Picasso's handling of the female form but also facing a tradition going back five-hundred years to the Renaissance: "He fought through Picasso to grapple with Ingres/Delacroix, Rubens, and Titian."[17]

Rather than transform beauty into ugliness in the manner of Picasso, Lucian Freud seduces the viewer with the lure of the grotesque, converting ugliness into refined beauty through his virtuoso handling of the flesh in his lush, monumental nudes.

his intent, the artist has often titled his pictures "naked portraits." Claiming not to pose his models, he takes advantage of the long time it takes to render his pictures, which allows him to register change in people – alterations in mood, weight, skin color, and texture – as well as the growing fatigue of the sitter, who poses anywhere between fifty and one hundred hours for each portrait.

In his paintings of the late London-based Australian fashion designer and performance artist Leigh Bowery [*cat. nos. 22 and 23, pp. 57, 58*], Freud honored his sitter's strangeness. Yet, it is curious to note Bowery's initial reluctance to model for Freud:

I was very nervous about my naked body when the idea of sitting for a picture for Lucian first came up, not only because I'm an unusually big heifer… but because of some of my body piercings in both my cheeks…. So, when I thought of this catalogue of ghoulish features, I began to feel self-conscious and a little embarrassed – distant from the regular nudes.[19]

Bowery's characterization of himself as "distant from the regular nudes" may imply certain expectations on his part of what was

brain can conceive beyond any canon. PABLO PICASSO, 1935

Although the figure in *Benefits Supervisor Sleeping*, 1995 [*cat. no. 24, p. 56*], appears in the conventional setting of the model in the studio, the languorous pose of the obese woman reclining on the couch is worthy of a painting by Rubens. Yet the model's pocked flesh and rolls of pliable fat and cellulite are not edited or idealized. It is not just the female body that is the subject of Freud's scrutiny; the male body suffers the same unrelenting eye. Freud's figure studies are what many would call "naked" rather than "nude," in that the body is not used as a repository of cultural values and ideals. Freud refuses, as Marina Warner explains, to "subsume a particular body into a prior canon of desirability."[18] To underscore

considered an acceptable subject of beauty in art. His reservations are even more surprising when one considers Bowery's iconoclastic personality and the scandalous nature of his public performances, in which he registered no inhibitions about his admittedly grotesque body [*fig. 36*]. Indeed, it was Bowery's inherent ability to seduce and disturb that Freud was appropriating for his own work.

The attraction and repulsion of the flesh, which is Freud's subject, is also a concern of Marlene Dumas's. Yet, rather than work from live models to make her paintings, Dumas culls her images of humanity from the media and popular culture, working

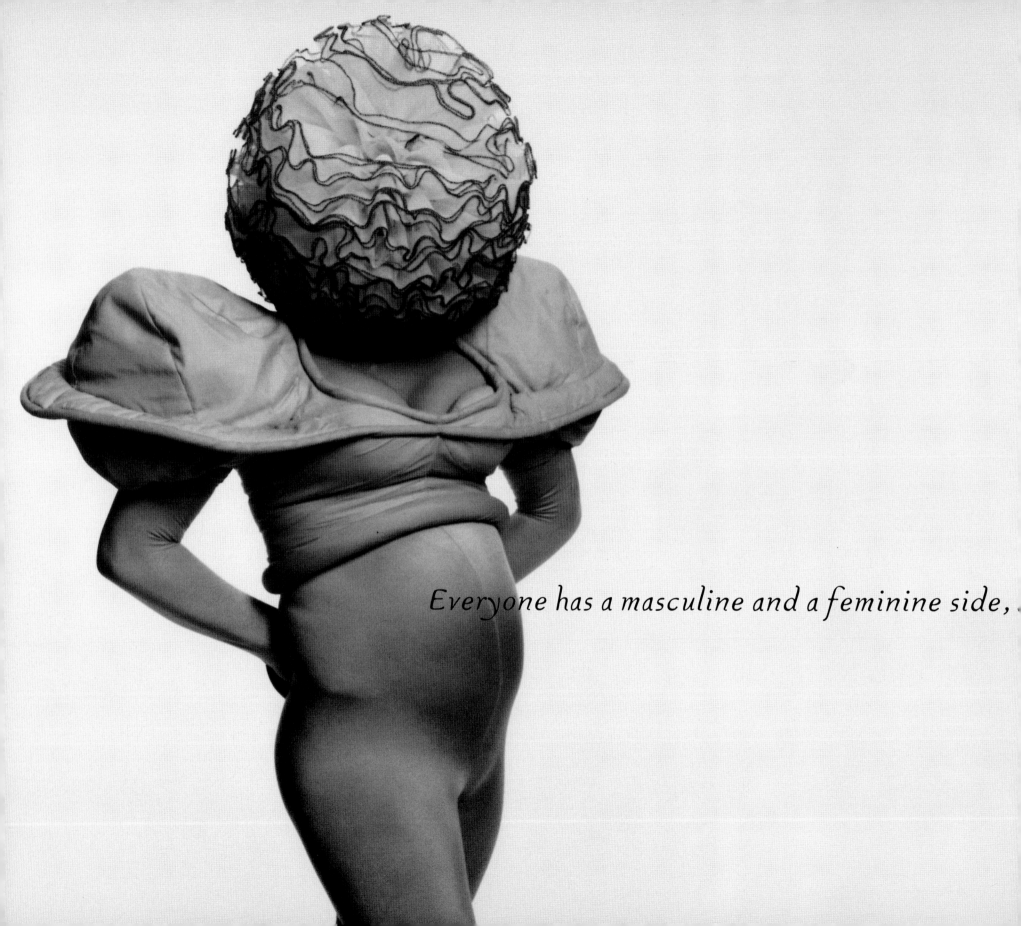

Everyone has a masculine and a feminine side,

with photographs, taken by herself in her early works or found in magazines, newspaper clippings, and television. Like Freud, she is intrigued with the relationship between the painter and the model, and the model's function as the repository of meaning throughout the history of art. And like Bowery, she is curious about the assumptions that still govern the presentation of the human figure on canvas and the topics which, by definition, are considered "unpaintable" within the tradition of art. Interested in the illusionism that photography as well as painting creates, Dumas does not use photographs for aid in transcribing reality. Posing the body unconventionally and often titling her works so that the narrative implied is at odds with the image, Dumas underscores that the model is not always receptive to the meaning inscribed on his or her body. Dumas has, for example, brought issues of racism (referring to Apartheid in her native South Africa) to bear on ambiguous images of children playing. Titles for these pictures refer to childhood fairy tales, such as Snow White, gone bad (*Snow White in the Wrong Story*, 1988, Collection J. & M. Eyck, Wijlre, The Netherlands).

Dumas's interest in the misunderstanding that occurs between "subjective expression" and "objective representation" is especially clear in the four canvases that comprise *The First People (I–IV)*, 1990 [*cat. no. 21, p. 59*], in which the artist renders four images of a newborn with a frank and honest intensity. Painted soon after the birth of her daughter, Helena, Dumas's presentation of infancy is

*Fig. 36
Leigh Bowery in
Future Juliette
1991*

I was accused by women of misusing babies. It has been said that I mistreat grownups, but at least they could defend themselves and babies couldn't. And even if a baby looked like that, they did not want to see them in that way.[20]

Dumas's series "Models," 1994, likewise examines the dominance of certain modes of presentation in regard to the human figure. Inspired by the visage of the black supermodel Naomi Campbell [*fig. 37*], Dumas calls into question the dominance of the white female body as the icon of Western culture. Commenting on the representation of women in general, Dumas adds: "One cannot paint a picture / or make an image of a woman / and not deal with the concept of beauty."[21] Dumas's assertion focuses our attention on another major dilemma surrounding beauty, which is addressed not only in her paintings but also in the works of Picasso and de Kooning. This is the question of beauty's gender.

THE GENDER OF BEAUTY

Although beauty presumably has no gender, in Western culture beauty has generally been understood as a feminine ideal. Unlike the other dilemmas discussed so far, the gendering of beauty does not have its foundations in ancient traditions. On the contrary, in Classical antiquity, cults of beauty existed for both sexes, and androgyny was often admired, particularly in Hellenistic Greece.

·n both sides are expressed, I find it beautiful and fascinating. JEAN-PAUL GAULTIER, 1985

not the purified vision of childhood presented on a baby-food label; it is the gangly, discolored, misshapen figure of a creature who has just made a traumatic journey through the birth canal. Commenting on the public reaction to her pictures, Dumas recounts:

Yet through the ages in Western art and culture, the female anatomy has often taken center stage in the articulation of the beautiful. Since the late 1960s, feminist ideology has asserted the feminine notion of beauty as expressly political. Seeking to reverse the "male gaze" and lift the constraints brought on by the male objec-

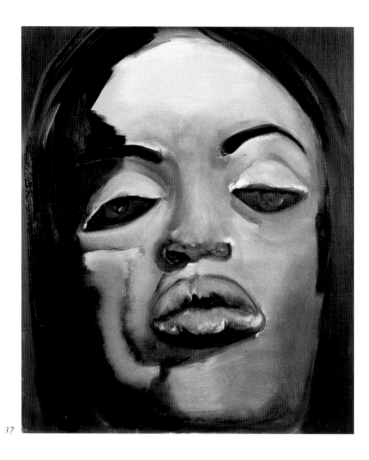

Fig. 37
Marlene Dumas
Naomi
1995
oil on canvas

tification of women as sexual objects, the feminist movement declared the female body a "battleground" [*fig. 38*]. Motivated by this plea, an entire generation of women artists, including Judy Chicago, Carolee Schneemann [*fig. 39*], and Hannah Wilke, made work throughout the 1970s and 1980s that addressed the aestheticization and commodification of women's bodies. The form that their work often took was expressly "unaesthetic," not only in terms of the use of unconventional media and materials but also in the unidealized and unexpurgated presentation of the female body in all its physical and biologic glory. Often focusing on the more vulgar, taboo aspects of femininity – in essence, difficult beauty –

the intent was to expose cultural prejudices, repressions, and biases as well as to celebrate the complexity and mysteries of female power. In demystifying women's bodies, the feminist movement hoped to draw attention to the gender's intellectual abilities and women's potential to effect change in all aspects of society [*fig. 40*].

Although feminism has wrought tremendous changes over the last thirty years, in its extreme the movement's efforts to equalize power and effectively degender beauty created an atmosphere in which women were encouraged to subvert or even deny their sexuality. In more recent years, feminism has taken on a surprising twist as a younger generation proposes an alternative, and much contested, view of femininity that puts sensuality back at the center. Described by some as intensely self-absorbed, gratuitous, and slavishly wed to fashion and popular culture, the "feminism" of the 1990s embraces female beauty and sexuality without apologizing.[22] Lampooning male myths of domination, examining the quixotic female quest for beauty, and playing with a variety of historical depictions of women throughout time, the new break with conventional feminism uses humor and satire "to examine and invoke the manifold contradictions women face in trying to be both strong and feminine."[23] Madonna [*see fig. 34*] is often credited as a major catalyst for this shift in focus. As a role model, she has taught young women how to be fully female and sexual while still exercising total control over their lives and bodies.[24]

The perceptual shifts in the locus of feminine beauty in the 1990s would not have been possible without the pioneering efforts of many women artists, including Louise Bourgeois. Although Bourgeois has been reluctant to wear the badge of feminism throughout her career, her sculptural investigations into the human condition since the 1940s have earned her a venerable place within the feminist tradition. Privileging the marginal and the ephemeral, the power of memory and raw emotions, Bourgeois's art draws on

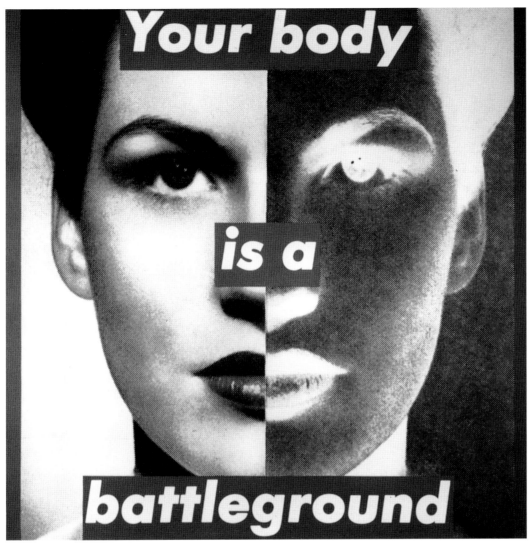

38

39

40

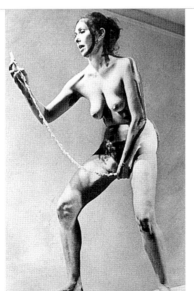

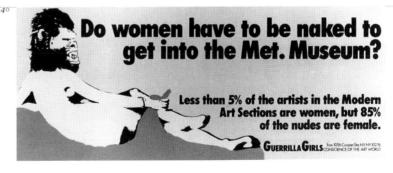

the intimate and unmentionable yearnings of the human animal. Reshaping the body's internal realities and rhythms into a form of idealized landscape, Bourgeois looks to the subjective realities that lie below the surface. As Bourgeois explains: "It is not the appearance of the body that interests me – clothed or unclothed. I want to know how things work – and why."[25] Viewing her art as a form of exorcism, she uses the sculptural process as a way to relieve pain and anxiety derived from her childhood and her experience as an artist, a wife and widow, and a mother of three sons. Themes of motherhood, isolation, betrayal, guilt, intimacy, fear of failure, eroticism, and healing are potent subjects in her oeuvre.

Resisting stylistic categorization in her sixty-year career, Bourgeois has worked with a variety of materials, including rubber, wax, plaster, glass, and fabric (see *Single III*, 1996 [**cat. no. 11, p. 61**]) – whatever medium is essential to expressing her fundamental ideas. She has, however, also used conventional sculptural media such as bronze and marble, endowing these rigid and stable substances with qualities of softness, weightlessness, fragility, and movement. The marble *She-Fox*, 1985 [**cat. no. 9, p. 60**], which pos-

structibility may also allude to the animal's cunning and insurmountable tolerance, a comment on her mother's blatant acceptance of the decade-long philanderings of her husband with Louise's live-in tutor. Despite the She-Fox's mutilation, the figure's dignity and presence remain intact, as do her roles as nurturer and protectoress. Bourgeois explains: "People do things to her but she can endure it, she can stand it, it doesn't affect her, mutilated as she is."[26] *Mamelles*, 1991 [**cat. no. 10, p. 62**], which is made of a pliable pink rubber, is a continuation of the same theme but this time is directed at her father. Revealing a succession of nurturing breasts, *Mamelles*, according to the artist, "portrays a man who lives off the women he courts, making his way from one to the next. Feeding from them but returning nothing, he loves only in a consumptive and selfish manner."[27]

The territory that Bourgeois opened early on in the century is the path taken by Kiki Smith, who finds beauty not only in the body's psychic mysteries but also in its unseen, abject processes. Her interest in the function and logic of the human body is anticipated in the work of Bourgeois as well as in the history of perform-

One cannot paint a picture / or make an image of a woman / and not a

sesses the monumentality of a Classical figure in its scale and disposition, resembles the ancient *Ephesian Artemis,* popular in Hellenistic Greece, whose mummiform torso is covered with a profusion of either bull testicles or breasts. In Bourgeois's presentation the figure is mutilated and headless despite its plentiful breasts, which appear ripe for succor. The harsh chiseling marks across the surface of the marble reveal the violence done to the creature. In interviews, Bourgeois acknowledges a reference to her mother as well as to herself; the face carved into the stone at the base of the sculpture is presumably a self-portrait nestled amidst the graceful hind legs of the tortured goddess. The She-Fox's inde-

ance and in the seminal works of Marina Abramović, Vito Acconci, Ana Mendieta, Bruce Nauman, and Carolee Schneemann from the late 1960s and 1970s. In search of an "authentic experience" with the body, Smith, fascinated with the mechanics of the human form, has sought to expose "all the life that happens between the tongue and the anus."[28] Beginning with individual organs in the 1980s, Smith progressed in the 1990s to anatomical studies of the digestive, urogenital, and nervous systems, and biological processes such as tearing, bleeding, lactating, menstruating, and childbearing. Her efforts to de-eroticize the physical self have resulted in a moving body of work distinguished for

both its subtle delicacy and scatological emphasis. Like Bourgeois, Smith has expressed herself in a variety of media, including paper, cloth, glass, and beeswax, materials that are not typically associated with power or convention. She began to use paper in her sculptures out of an interest in creating a veneerlike surface similar to human skin.

In *Peacock*, 1994 [*cat. no. 70, p. 63*], a woman seated at floor level is fashioned from papier-mâché. A cluster of delicate drawings are pinned to the wall beyond the figure. They are linked to her by a series of paper strings that flow from each rendering, converge on the floor, and connect to the figure's eyes. In Christian iconography, the peacock is a symbol of immortality, a reading that originates in the legendary belief that the bird's flesh does not decay. The pattern on the peacock's distinctive tail feathers connoting a "hundred eyes" is also a symbol of the "all seeing" church, and in Buddhist religion is a representation of compassionate watchfulness. The peacock's habit of strutting and displaying its plumage has also made it an emblem of worldly pride and vanity.[29] In Smith's installation the "eye" of the peacock, which appears painted in a "peacock blue" color on the back of the figure as well as in each of the accompanying drawings, doubles as female sexual anatomy. The symbol suggests the generational life force that ensures human immortality through reproduction. The articulated chain around the woman's waist, however, weighs down the figure, alluding to the female peacock's inability to show her "true

Pipilotti Rist's *Ever Is Over All*, 1997 [*cat. no. 56, pp. 64, 65*], a video installation with multiple projections, epitomizes the more relaxed view of feminine beauty that has been increasingly prevalent in the latter half of the 1990s. In the main projection, a "mythic woman" dressed in a flowing, blue chiffon dress strolls haphazardly down an urban street wearing red shoes that match her bright red lipstick. Her melodious sachet is accentuated by the slow speed of the projection and the hypnotic humming voice and electronic background music. Carrying a large red flower known as a "red-hot poker,"[30] the woman with the beatific smile randomly smashes the windows of parked cars in a fantasy of liberation and abandon. Perceiving her danger of being busted by the police patrolperson off in the distance, we are relieved to discover that the woman's escapade will continue unabated; much to our dismay, the female officer wears the same shade of lipstick! If we view the poker as analogous to a painter's brush, *Ever Is Over All* is a fittingly humorous send-up to Picasso and de Kooning and the male-dominated tradition of painting the feminine form. Wielding her destructive painterly brush, Rist's woman wreaks havoc on masculine identity, which is objectified by the car and echoed in the very tool of her aggression. That Rist's videos have a relationship to painting is clear, and she has often described her media installations as "behind-glass paintings that move."[31] Her interest in the painterly qualities of the medium has led her to reject the slick, polished look of video in favor of a rough, more immediate

h the concept of beauty. MARLENE DUMAS, 1995

colors." As in most bird species, it is the male that possesses exotic plumage while the female is typically drab and colorless. Reduced to her mere biologic function, her sexuality is revealed layers at a time, just as the renderings of the figure's genitalia on the wall are presented in layers of delicate paper.

approach in which she can manipulate color, and in other projects splice imagery from music videos, computer graphics, fashion, and advertising to simulate the brain's unconscious processing of sounds and visual imagery in contemporary life. Acknowledging the great "need for sensual perception"[32] in our time, Rist's unique

vision effectively mediates the arena where art and contemporary society intersect.

BEAUTY AND CONTEMPORARY SOCIETY

While the notion of absolute beauty rides high in the venerable traditions of painting and sculpture, in the realm of popular culture another sense of beauty rules. This is the sense of beauty as relative and changeable over time, as well as varied from one cultural context to another. Indeed, if one examines popular culture through the ages, changing fads and fashions have dictated wildly opposing ideals. While the emaciated waif of Calvin Klein's "Obsession" ads has suggested a measure of youthful beauty in the 1990s, in previous eras fleshier perceptions of both female and male anatomy have been valued [*figs. 41 and 42*]. Across cultures, too, beauty is measured in an infinite variety of ways. Women of the Padaung in Burma, for example, preserve an ancient ritual by wearing conically stacked metal rings to elongate their necks. In their culture, such bodily refiguration is considered a sign of beauty and elegance; the women with the longest necks are perceived to be the fairest of them all. What one can surmise from these and other examples is that beauty, in terms of fashion and geography, is varied, always evolving, and determined by subjective factors such as taste as well as social custom.

While popular Western culture would seem to be more accepting of alternative forms of beauty as demonstrated by the

reveals variety, the basic body shapes favored by the media have remained relatively consistent. For women, the image of the slim, light-skinned female has been a constant despite slight shifts in weight and bust size. In recent years, however, the fashion industry has monitored major shifts in perception. In the book *What Is Beauty? New Definitions from the Fashion Vanguard* (1998), leading figures in the field agree that notions of absolute beauty are in a current state of collapse as beauty has come to reflect and personify the social and cultural issues of the day.[33] The desire to be multiculturally diverse, to reflect the attractiveness of sexual power while also revealing intellect and experience, and to accommodate the body-morphing potential of cosmetic surgery, biotechnology, and prostheses have given way to the alternative forms of beauty that have taken center stage in the 1990s. Street-inspired styles like "heroin chic," the growing emphasis on androgyny epitomized by pop star Marilyn Manson [*fig. 43*], and the high-keyed color resolution of a kind of "virtual fantasy" style inspired by computer simulation [*see fig. 47*] are examples of recent breaks with conformity.

In the exhibition "Post Human" in 1992 curator Jeffrey Deitch traced a similar dissolution of standards but from a wider sociological perspective.[34] For him, the deflation of absolutes in the cultural, socioeconomic, and political environment since the late 1960s has set the stage for a new kind of belief structure based on multiple realities and perceptions. In his catalog essay he posed

Since every age and every people have had their own form of beauty, we inevita

passing of trends and changing clothing styles, it is clear that the entertainment and fashion industries also perpetuate their own set of absolutes. Body types, hairstyles, and apparel choices are dictated by these powerful contemporary makers of taste. Although a survey of fashion over the last several decades undoubtedly

the question whether society is creating a new kind of model of a human being based on the implications of genetic engineering, developments in cyberspace, plastic surgery, brain-chip implantation, and other forms of body alteration and improvement. He used the term "post-human" to describe a world that is quickly

becoming more artificial than real. According to Deitch, those developments will no doubt contribute to revised constructions of the self as well as to new structures of thinking and perceiving the world. These radical changes will not only necessitate uncharted forms of social behavior and morality but also potentially create shifting standards of beauty. On what exactly these standards will be based is yet to be seen.

As noted earlier, Yasumasa Morimura and Marlene Dumas asked us to consider what happens to beauty outside the traditional Western context. Their dialog on cultural difference was not based on an examination of non-Western aesthetics but on a study of signs and symbols present within Western culture in which specific cultural attitudes and values were inscribed. The photo-text works of Lorna Simpson from the late 1980s and early 1990s were born of a similar desire to deconstruct the embodied meanings of images and language. Simpson's investigations have often been most pointedly directed at Western perceptions of the black female body. Renouncing the fixed, static vision of African American stereotypes, Simpson has often called attention to aspects of black female iden-

41

42

e ours. CHARLES BAUDELAIRE, 1846

tity that tend to be erased, overlooked, or devalued in Western and specifically American culture. Working with the image of the body, or surrogates for the body such as masks, shoes, and wigs, Simpson disrupts conventional ways of seeing by removing charged symbols from their expected contexts, reconfiguring them in neutral situations, and posing a variety of questions or associations through the insertion of language.

The artist considers an array of racial, social, and sexual stereotypes associated with hair in the large multipanel installation *Wigs*, 1994 [**cat. no. 69, pp. 70–71**], a configuration of felt panels delicately pinned to the wall. Here, a sampling of wigs, hair exten-

Fig. 41
During China's Tang dynasty (A.D. 618–906), the notorious Lady Yang, the full-figured concubine of Emperor Xuan Hong (A.D. 713–756), became the standard of beauty for all court women during his rule

Fig. 42
In the eighteenth century, fashionable waistcoats accentuated pelvic girth in men as a desirable quality, as shown in Joseph Blackburn's **Jonathan Warner** *1761 oil on canvas*

sions, and a mustache are printed, illustrating a range of hair types and styles from black braids to tumbling blonde tresses. By presenting the image of hair devoid of a face, the artist invites the viewer to imagine the types of individuals who might wear the hairpieces and the kinds of societal roles they might play. The additional text panels that are interspersed throughout the work reveal a host of social and cultural uses for the wig that go beyond bodily enhancement or adornment. From role playing during childhood to cross-dressing as adults, the passages identify events through which social modes of behavior are received, projected, and in some instances rejected. While several of the phrases quote popular "truisms" like "if the shoe fits" and "the clothes make the man," other passages are much more disturbing in their allusions to the use of wigs by African Americans to escape slave owners, by criminals running from the law, or by individuals seeking to conceal or reveal their sexual identities. The phrases "strong desire to blur" and "strong desire to decipher" connote the power of wigs to transform the individual in society, not only physically but also in terms of identity.

While Simpson stresses that hair color, texture, and style are often potent yet ineffective markers of personal identity, she also addresses the weight of certain connotations associated with hair type and coiffure. For African Americans, for example, hair (as skin color) has always been a racial signifier. Within black culture itself, racial hierarchies exist based on shades of skin and grades of

abolition of slavery, it was not until the black cultural revolution of the 1960s that many African Americans refused societal pressures to straighten their hair in favor of "natural" styles. The interest in African styling, which followed in the proceeding decades, also developed as a form of opposition as well as a means of cultural reclamation. Losing some of its political charge over the last decade, the popularization of Afro-centric hairdos has grown into such a major commercial industry that consumers are white as well as black [*fig. 44*].

By juxtaposing coils and strands of coarse black braids with the image of soft, flowing blonde hair, Simpson presents the two extremes of desirability as well as the multiple options in between. The prominence of the blonde wig, which is repeated several times across the wall, reminds us that black hair is not the only type of hair subject to stereotype. Blonde locks carry their own set of negative assumptions. Connoting the "dumb" or "dizzy" blonde, this particular perception of femininity epitomized by Marilyn Monroe has been a major point of contention for many women struggling to get beyond attitudes perpetuated by the mass media. Warhol's 1962 canvas filled with undifferentiated images of Marilyn Monroe's lips [*cat. no. 85, p. 66*] stands in sharp, even humorous contrast to Simpson's wall of individualized wigs. While Warhol comments on the absolute vision of beauty reinforced by the media, Simpson addresses the growing need to question the efficacy of these objective ideals in a multicultural world.

The vernacular of beauty…remains a potent instrument of change in t

hair. According to African American historians, the development of a class system based on physical attributes originated during the history of slavery, when slaves with straighter, softer hair were accorded higher social standing and assigned domestic rather than field labor.[35] Internalized by African American culture after the

Also in dialog with Simpson are Cindy Sherman's mysterious "starlets" of the series "Film Stills," 1977–80 [*cat. nos. 59–65, pp. 74–77*], and the "models" of the series "Fashion," 1980s. Donning wigs and costumes, and staging her photographs to resemble scenes from Hollywood "B" movies, Sherman presents in the

"Film Stills" an array of feminine stereotypes perpetuated in the media – from the dreamy-eyed romantic pining for a lover [*cat. no. 60, p. 74*] to the forlorn cigarette-smoking diva [*cat. no. 62, p. 77*]. Using the language of films and media advertising, Sherman's small-scale "publicity" photographs comment no less powerfully on the enormity of the myth the media sells than Charles Ray's monstrous department-store mannequin or Beverly Semmes's gigantic *Red Dress*, both 1992 [*see cat. nos. 47 and 58, pp. 72, 73*]. In Sherman's "Fashion" pictures [*fig. 45*] the artist further unravels the attitudes implicit in a pose, a garment cut, or hairstyle, and alludes to the false promises of media advertising. Ironically held up as standards to be emulated in society, Sherman's models possess troubled, dejected, even sinister faces, indicating an array of real life problems – eating disorders, loneliness, drugs, alcoholism, and depression – that lie below the mask of perfection. Andy Warhol's celebrity portraits of Elvis (*Triple Elvis*, 1963 [*cat. no. 87, p. 69*]), James Dean, Jacqueline Kennedy, and Marilyn Monroe [*cat. nos. 84 and 85, pp. 50, 66*] also possess the tinge of tragedy that characterizes Sherman's "Fashion" images and many of the "Film Stills," revealing the shattered, tumultuous lives of some of our most beloved media icons. The intentional lack of color registration in Warhol's silkscreened portraits underscores the made-up, manufactured nature of these public personae. In Sigmar Polke's *Bunnies*, 1966 [*cat. no. 46, p. 68*], Playboy centerfolds are rendered in similar fashion, this time in an enlarged Benday dot pattern as if

lization.

DAVE HICKEY, 1993

43

44

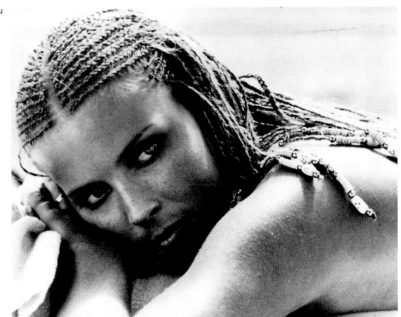

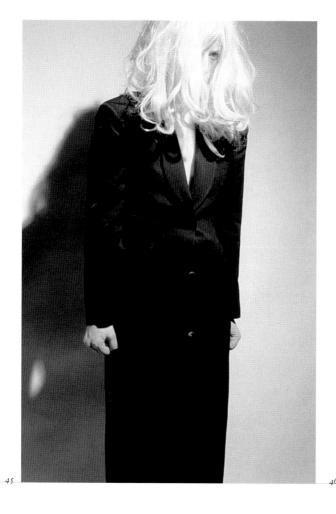

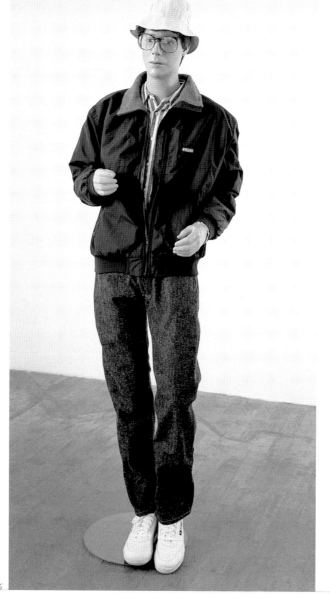

45

46

Fig. 45
Cindy Sherman
Untitled #122
1983
unique color
photograph

Fig. 46
Charles Ray
Self-Portrait
1990
mixed media

taken directly from the newspaper. Polke's wry critique of American culture and sexual politics presents an intriguing European perspective on the attitudes implicit in American media culture.

The enormous scale of Ray's mannequin and Semmes's gigantic dress confronts the impossibility of achieving the ideals of beauty professed by the media. Semmes's *Red Dress* [**cat. no. 58, p. 73**], which is suspended on a hanger nearly twelve feet off the ground, piles and pools on the floor of the gallery and has spilled out as much as fifty feet into the viewer's space when installed. The intoxicating velvet-red color of the fabric, which is reflected in the gallery, creates a supernatural glow around the piece that

assaults the senses. The viewer is overwrought with an insatiable need to touch and possess this sensuous object despite its ridiculous proportions. Rather than suggest a real person, Semmes charts a psychological landscape of desire.[36]

Although Semmes first began to use the dress form in the late 1980s as an element in performance-based films and staged photographs, it was not until 1991 that she began to make discrete "clothing" sculptures that would hang independently on the wall devoid of the body. Like Simpson's headless wigs, the empty dress form allowed Semmes to explore the social and cultural implications of clothing without the charge of the body and its defining

physical attributes. Working alternatively at a human and a monumental, architectural scale, Semmes typically distorted the dresses and suits she made in the early 1990s – sleeves and skirts are severely elongated or cropped, shoulders or cuffs are sewn together, tiny collars accompany enormous bodices. The artist has also worked with an array of fabrics, including velvet, organza, moire, mohair, flannel, and wool, often combining incongruous patterns and materials to poke fun at the excess and extravagance of haute couture. What kind of woman would wear these dresses? Is she beautiful, or grotesque? Is she extraordinarily slim, or extremely obese? Is she sexy, or conservative, or perhaps a little of both? In *Red Dress* the scale and intensity of the crimson color suggests power, sexuality, and aggression, while the truncated sleeves and modest "Peter Pan" collar connote a more reserved, contradictory personality. Semmes admits her interest in these ambiguities and has explained her works as presentations of the multifaceted, paradoxical nature of self. Harnessing the power of clothing to define identity, the dress, like the wig, is a carrier of meaning that embodies societal ideals as well as private obsessions.

Charles Ray's mannequin sculptures from the 1990s similarly address the role of fashion in the construction of identity. The fuschia-colored suit worn by the mannequin in *Fall '91* [*cat. no. 47, p. 72*] befits the powerful, independent career woman of the early 1990s. Tasteful yet seductive attire was the uniform of the corporate feminine executive who, "dressed to kill," sought success without compromising her attractiveness. Two other related mannequins also titled *Fall '91* present alternative looks that are perhaps slightly more conservative but no less fashionable. Wearing tailored suits, these models suggest the power of fashion to alter one's public image, allowing the individual to either conform or exert identity in a variety of situations and contexts.

Ray's use of the mannequin as a vehicle for sculpture grew out of his interest in this surrogate of the human body as a form of contemporary figuration. Although society ascribes mannequins little aesthetic value, considering them neutral commercial props for the display of merchandise, Ray views the mannequin as a popular art form. In researching the medium, Ray discovered that as with traditional figurative sculpture, a specific canon of proportion governed the design and manufacture of the objects. Known as the "Sears Standard," the definitive ratio of anatomical proportion was developed in the late 1950s by Sears designers when fiberglass became available for the mass production of mannequins. Before this standard, cloth and papier-mâché models were the convention. In his study of the Sears construction manual, which outlined specific design dimensions and features, including facial characteristics and expressions, Ray learned of several intriguing requirements. The most notable was the insistence that a mannequin should never look at the consumer or smile. These qualities, according to Sears, made people nervous and uncomfortable, giving the impression that the statue was haunted. The peculiarities of the standards fascinated Ray, as did the need for a consistent set of anatomical proportions. As Ray explains, "That whole idea of the Sears Standard to me seemed not too far off from the Greek idealization of ... proportion."[37]

Ray's various mannequin sculptures from the early 1990s play with the conformity implicit in mannequin design. Working with "mannequin sculptors," the artist produced a variety of mannequins with individualized features. In *Self-Portrait*, 1990 [*fig. 46*], it was his own countenance that accompanied the generalized, sexless body of the commercial figure, while *Male Mannequin*, 1990 (The Eli Broad Family Foundation, Santa Monica, California), remained anonymous with the exception of its fiberglass genitalia, which was cast directly from the artist's body. The "inappropriate" specificity of his figures exposes attitudes regarding the body's presentation that go back to centuries of convention in which male genitalia was reduced and even covered, and the

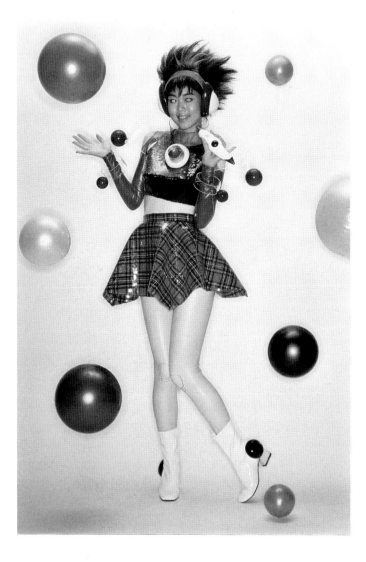

Fig. 47
Mariko Mori draws
on the hyperrealistic
qualities of a "virtual
fantasy" style to
create the "techno-
dream woman
of tomorrow" in
Birth of a Star
1995
3D Duratrans print,
acrylic, and
fluorescent lights

posters, "Beauty," 1995 [*cat. no. 80, p. 67*], addresses this concern and the power of new technologies to change our vision and standards of perfection. Placed outdoors in a public site, the posters mimic the "United Colors of Bennetton" ads that celebrate physiognomic and multicultural difference. The youthful countenances of eleven female models and a single male, however, are not quite what they seem. Rather than unique models of individuals, each portrait ironically presents a cyber-generated "clone" of itself free of natural imperfections; in each case one half of the face has been mirrored through the use of computer digitalization.

Mariko Mori's photographs of cybernetic beings interacting with society pose many similar questions. Dressing herself in futuristic outfits that fuse aspects of science fiction, Japanese animation and comics, virtual reality, and high fashion, Mori blurs the lines between fine art and popular culture to create the "techno-dream woman of tomorrow"[38] [*fig. 47*]. Her view of the "synthetic" beauty of the future is born of a curious admixture of Western perceptions about the body filtered through the ultraconsumerist attitudes of contemporary Japanese culture. In the photograph *Tea Ceremony III*, 1995 [*cat. no. 41, p. 78*], Mori appears as a servile cyborg (half human/half alien) dressed in the uniform of the typical Japanese "office lady." Offering tea to middle-aged businessmen as they pass her on an urban street, Mori is seemingly ignored by the corporate executives dressed in their predictable blue business suits. Reduced to a mere robotic gesture, Mori's character addresses the submissive, often programmed roles women in contemporary Japan are still expected to play. Her reference to the Japanese tradition comments further on the weight of societal customs in her native country, where the tea ceremony is considered to be an appropriate feminine pursuit that stresses constraint, discipline, and history.[39]

Rather than stage her photographs and work with actors, Mori in *Tea Ceremony III* and related images records a type of pub-

female pubic region was suggested but never naturalistically represented. Besides the obvious connections to figural traditions in the history of art, Ray's study of the human tendency to generalize and degender the body for public consumption has wider implications if one considers the impact of recent advances in cosmetic surgery, genetic engineering, and cybernetic technology. As humanity continues to develop the means to improve and perfect the physical body as well as simulate artificial beings, what will the body of the future look like? Will its physiognomy conform to Classical canons of proportion, the Sears standard, or a set of new absolutes yet to be determined? Rosemarie Trockel's series of

lic performance in which the fictional character is enacted by the artist on a populated street. The photographs, which document the genuine responses of passersby, record the actual event. In the case of *Tea Ceremony III*, Mori explains that ignoring someone in Japan is the "most expressive form of reaction," a "passive aggression" that connotes serious disapproval.[40] Playing on the blatant public disregard of her futuristic persona, Mori draws on the perplexing paradoxes of contemporary Japanese society, where the pressures of ancient social mores and traditions are often gravely at odds with contemporary private realities. The Japanese fascination with childhood reflected in women's attire, "image clubs," and Japanese pornography, for example, are subjects Mori has investigated in related works in which her cyborg character appears as an under-aged high-school student in an "image club" or as a prostitute in Tokyo's red-light district. In these photographs, she dons juvenile garb, poses as a "kittenish nymphet," and in *Tea Ceremony III* wears a kinky silver lamé cap with ears mimicking "doggie garments" prevalent in Japanese fashion magazines.[41] The presence of these extreme, even puerile obsessions in the face of ancient conservatism are what a contemporary critic described as a "recreational release valve from Japan's conventions of public conformity."[42]

Mori's embrace of new media in her photographs and recent film and video projects has put her at the forefront of a generation of artists responding to an increasingly virtual world in which fiction and reality are instantly conflated and the incongruous spheres of magic, art, science, nature, fashion, advertising, technology, and religion are made to coexist, fused in simultaneous streams of images. Her interest in the conflation of metaphors is shared by her contemporary Matthew Barney, who brings together many of the concerns addressed thus far in the exhibition.

Merging Classical ideals of perfection with an imaginative sense of the body's internal logic, Barney creates a world of mythological creatures that are as ravishingly beautiful as they are grotesque. Drawing on the language of sports, the metabolics of biology, the glamour and kitsch of Hollywood film, the violence of Classical mythology, and the romance and tragedy of opera, Barney creates a cinematic universe of beings that exist in states of extraordinary potential. The ambitious "Cremaster" cycle, 1994–2000, a series of feature-length films in progress, presents a moving allegory of bodily evolution. The overarching title of the five-part epic derives its name from the muscles of the male anatomy that raise and lower the testicles according to temperature and anxiety levels. Greek in origin, "cremaster" literally means "that which suspends," a term that aptly describes beings in a constant state of evolutionary suspension.[43]

The complex narratives developed in the first three "Cremaster" films (1, 4, and 5) have been variously described as "allegories of sexual differentiation"[44] in which fantastic creatures (half human/half animal and reminiscent of Classical satyrs and faeries) represent different aspects and agents of the reproductive system. As metaphors for the stages of prenatal development, these beings — which are also the subject of an independent series of photographs related to each film — journey, struggle, and traverse a variety of psychic and geographic terrain. While no creature is specifically feminine or masculine in Barney's universe, some characters possess considerably more feminine traits than others. The pale, thin "Goodyear" in "Cremaster 1" (*CR1: Choreography of Goodyear* and *CR1: Goodyear Chorus*, both 1995 [*cat. nos. 5 and 6, pp. 81, 79*]) is a youthful goddess, while the "Giant" (*Cremaster 5: her Giant*, 1997 [*cat. no. 8, p. 83*]) and the "Loughton Candidate" (*CR4: Loughton Manual*, 1994 [*cat. no. 4, p. 80*]) are decidedly more masculine in gender. Other characters in the mythology exist in hybridized states of dubious sex, such as the red-headed "Faeries" in "Cremaster 4" (*CR4: Faerie Field*, 1994 [*cat. no. 3, pp. 84–85*]). While their bodies possess the musculature more typical of men, their fleshy breasts, hair, and attire suggest feminine personalities. As critical agents throughout the films,

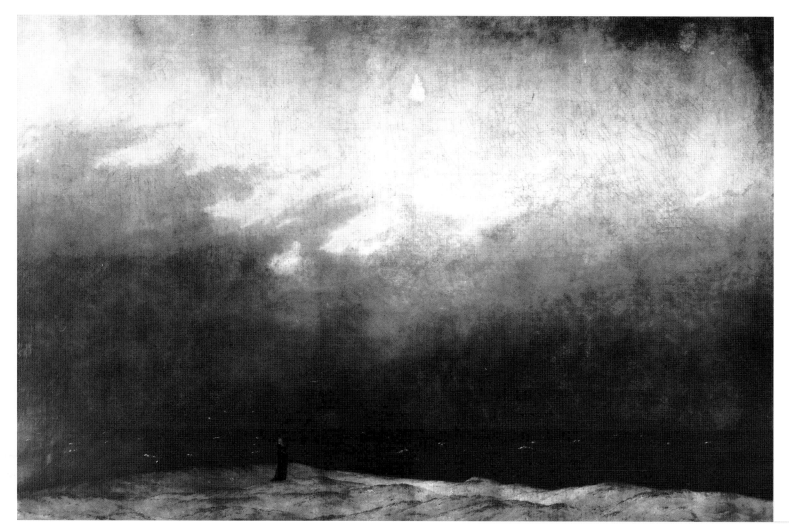

Fig. 48
Caspar David
Friedrich
Monk by the Sea
1808–10
oil on canvas

androgynous entities attend to creatures in states of transition and evolution. Throughout, signs of transformation are presented. Mucouslike substances (petroleum jelly and tapioca) ooze from walls, receptacles, the landscape, and clothing, while the skin of the creatures (formed of latex, prostheses, and cosmetics) suggest molting, amphibious surfaces in fluid transition. The more "gendered" characters also appear to be part of a larger cycle of life. While the Loughton Candidate and Goodyear are youthful beings at the peak of their development, the Giant and the Queen of Chain (*Cremaster 5: Court of Chain*, 1997 [*cat. no. 7, p. 82*]) are regal figures at the apotheosis of their reproductive roles.

For Barney, the body is a miraculous organism existing in a constant state of flux and transition. As we reflect on his poetic study of the limitless beauty and possibilities of the human body, we are reminded of the Classical casts of Venus by Paolini and Pistoletto [*cat. nos. 43 and 45, pp. 41, 43*] that open the exhibition. Barney's androgynous Faeries evoke ironic comparisons with these idealized goddesses. Harnessing the transgressive powers of beauty, Barney suggests not only the body's capacity to continue to evolve into new objective ideals of perfection — but also art's potential to go there.

purity and transcendence. Still others harness all of beauty's attendant mysteries and contradictions, attempting neither to define nor diminish beauty's elusive and generous nature.

SEEKING THE IMMATERIAL

Throughout history the natural landscape and abstract form have alternatively served as agents to gain access to the immaterial and the infinite. Caspar David Friedrich's melancholic painting *Monk by the Sea*, 1808–10 [*fig. 48*], which pictures a lone figure gazing upon a stormy windswept ocean, epitomizes a tradition, centuries old, that upholds the transcendent possibilities of nature. Affording heightened states of consciousness in which beauty as well as the sublime may be witnessed, communion with god and nature had the power to reveal the mysteries of existence. One of Friedrich's disciples, Carl Gustav Carus, well expressed the Romantic conception of landscape:

When man, sensing the immense magnificence of nature, feels his own insignificance, and, feeling himself to be God, enters into this infinity and abandons his individual existence, then his surrender is gain rather than loss. What otherwise only the mind's eye sees, here becomes almost literally visible: the oneness in the infinity of the universe.[45]

Just as landscape has served as a conduit for accessing impalpable truths, so too has abstract form. In many Eastern philosophies and mystic faiths, simple geometry and reductive symbols are used as tools of contemplation to focus the mind and spirit [*fig. 49*]. By emptying the mind and freeing the body of material distractions, practitioners achieve heightened states in which perfection, beauty, and transcendence are possible. Throughout the history of Western art, many artists have similarly turned to nonobjectivity – to sheer immateriality and formlessness – to stimulate the unconscious mind to grasp aspects of the infinite. Although abstraction has served many other ideological and secu-

INTANGIBLE *BEAUTY*

The second half of the exhibition moves away from the objectification of beauty in the body into the subjective realm of perception and considers beauty's intangibility. Acknowledging beauty's existence outside of objects – in the province of the mind and the spirit – the artists in this section assume that beauty is elusive and essentially undefinable. Attempting to capture beauty and its mysterious, even magical qualities, these artists look alternatively to the sublimity and the purity of abstraction, the poetic and lyrical qualities of the natural landscape, and the intensity of sensory experience to inspire moments of heightened awareness in which beauty may be recognized. While many embrace beauty with exquisite reverence, others question beauty's potential for

lar agendas throughout the twentieth century – conveying utopian social ideals, embodying the modern industrial age, and reflecting the horrors of a violent postwar world – abstraction has always allowed artists to express feelings and sensations that are not easily articulated in other forms, such as written language. In this regard, abstraction (like music, to which it is often compared) functions as a kind of subjective metalanguage. In the second half of this century, Agnes Martin, Yves Klein, and Anish Kapoor have examined notions of purity, perfection of form, and the sublime potential of abstraction to articulate the ineffability of life, beauty, and the human spirit. For these artists, beauty is but one of many intangibles capable of being reached through art. By compelling the viewer to a state of heightened sensibility, these artists elicit a whole range of emotions in which the experience of beauty may be found.

For Agnes Martin, art in and of itself is not beautiful; art cannot depict beauty nor deal with it as a subject since beauty and perfection are immaterial. In her view the same is true of nature. A rose or a serene ocean are not in themselves beautiful; they merely represent occasions for beauty to be recognized. Yet for Martin, the existence of beauty is stable, even absolute. It is an emotion that exists "in the mind."[46] What does vary, in her estimation, is humanity's "awareness" of beauty, which fluctuates owing to the infinite distractions of daily life that keep individuals from staying focused and in touch with beauty. The same can be said for perfec-

tion and happiness, which she sees as equally relevant. Art, then, has a tremendous power in serving to reawaken the mind's awareness of beauty, by providing memories and experiences in which to explore life's mysteries.

Martin's ongoing pursuit of beauty, happiness, and perfection in her own life has, since the late 1950s, led to the development of an art of extreme subtlety and pure vision. Using abstraction as a tool for revelation, she turned to geometry for the structural basis of her art. Drawing parallel lines in graphite, charcoal, and colored pencil over pale tonalities, and filling in continuous grids of rectangles that hover in equilibrium, Martin forged a minimal vocabulary that embodies unity and wholeness. For the artist, this is a holistic language appropriate to the communication of impersonal emotions and abstract truths. As in Tantric art, Martin uses simple forms to put the viewer in the right plane (or frame of mind). Her aim is to enable her audience to slow down, focus, and empty their minds to see perfection and truth and thus awaken to beauty.

The subtle vibrations that occur on the surfaces of Martin's canvases – where paint meets pigment, a pencil line, or the thread of the canvas – force the eye to adjust and focus. As one approaches or steps back from any of her exquisite paintings of the 1960s, including *Grey Stone II*, 1961 [*cat. no. 37, p. 136*], and *Falling Blue*, *Flower in the Wind*, and *Night Sea*, all 1963 [*cat. nos. 38–40, pp. 137–39*], lines seem to fade in and out of vision, colors advance and recede. Although the titles of Martin's paintings refer to nature,

Fig. 49
In Tantric
philosophy the
yantra *is a vehicle*
for concentrating
the mind and
creating a
fundamental map
of harmony

the artist firmly contends that her works are "anti-nature." She explains, "It was not a matter of representing nature, but of representing those sensations of exultation which nature commonly elicits – feelings of leaving the ego behind and merging into a field of vision without objects, interruptions, or daily cares."[47] Martin continues to work within the same visual and conceptual parameters, seeking moments of revelation in infinite variation and keeping perfection and beauty close at hand.

Yves Klein's herculean quest for immateriality in his life and art was also guided by a supreme sense of the quality, beauty, and fascinating strangeness the world has to offer.[48] Developing a utopian belief that humans could be transformed through their imagination, Klein in his short life created an enigmatic body of work that sought to heighten human awareness of beauty as well as the infinite. For him, the pursuit of beauty was paramount. In a private prayer discovered in a votive offering he created for St. Rita da Cascia in 1961, the artist invoked the beneficence of a favored saint on his behalf.

and violence to sublimity and peace), Klein finally determined that blue was the purest and most spiritual of all colors. Associated with the sea and sky, it evoked nature in its most abstract form. Suggesting tranquility, blue simultaneously conveys infinite distance and immediate presence. He preferred to scale his pictures to human proportions, which allowed the intensity of color to draw in the viewer so that an individual's emotional sensibilities could be triggered and thus lead to heightened states of perception. The incorporation of pigment-saturated sponges as relief elements in Klein's later monochromes enhanced the color vibrations and sense of serenity he desired in his pictures. For the artist, the sponges were also apt metaphors for the interpenetration of material presence and spiritual essence that became a growing concern of his art. Klein's interest in subjectivity and animating human consciousness led to several extreme actions in which he attempted to transcend the limits of the canvas into space, and by association, the cosmos. In 1958 at the Galerie Iris Clert in Paris he exhibited "Le Vide" (The Void), an empty gallery painted white, which he proposed was charged with the medium of energy and human con-

Beauty is the mystery of life. AGNES MARTIN, 1989

St. Rita da Cascia, please intercede with Almighty God the Father that he may always grant me ... the favour of inhabiting my works and that they may become ever more beautiful, and also the favour that I may continually and regularly discover ever new and lovelier things in art even if alas I may not always be worthy to be a tool for the construction of Great Beauty. Please let everything that comes out of me be Beautiful. Amen, Y.K.[49]

Devoting himself to the production of monochromes through the late 1950s [*cat. no. 32, p. 141*], Klein focused on pure color to encourage one to "sense the soul, without explanation, without words."[50] Working with reds and oranges, and later pinks and golds (for their ability to elicit a range of feelings from anger

sciousness. Going even further in 1960, the artist staged a precipitous jump out of a second-story window – his prophetic "Leap into the Void" [*see p. 211*] – as a symbol of his unrelenting search for the "ineffable aura possessed by every great work of art."[51]

Klein's belief in the poetic and life-affirming qualities of the void are echoed in the work of Anish Kapoor, whose sculptural investigations have also manifested an appreciation for the transcendent qualities of pure pigment, the lure of emptiness, and thresholds where materiality meets the "non-material."[52] Working since the late 1970s in a variety of sculptural media, including stone, bronze, steel, mirror, and pigment-covered fiberglass and

wood, Kapoor has been fascinated with edges and the tension between positive and negative space. The result has been a remarkable oeuvre of optical and perceptual complexity. Kapoor's minimal forms, some geometric and others relating more to architecture or nature, typically reveal penetrations or voids, as in *My Body Your Body II*, 1993 [*cat. no. 31, p. 140*], and *At the Hub of Things*, 1987 [*fig. 50*]. Gaping holes, sinking surfaces, interior vortexes, and subtle convexities and concavities either envelope or dispel the viewer depending on his or her line of vision or physical orientation to a sculpture.

Like Martin, who seeks to slow down the viewer to heighten perception, Kapoor struggles to "hold things to a certain stillness, where beauty, content – even narrative – enter the frame of looking without ever being spelt out."[53] For Kapoor, "beauty is everything" and, like Martin, he believes:

You cannot make something beautiful. It is either beautiful or it is not. You cannot look for beauty; you either have it, or you do not have it. And I think the same is true of a work. I believe very deeply that works of art, or let's say things in the world, not just works of art, can be truly made. If they are truly made, in the sense of possessing themselves, then they are beautiful.[54]

Kapoor's intriguing notion of "truly made" does not imply a factual truth to materials, content, the artist's intent, or even art's faithfulness to reality. For Kapoor, "truly made" implies the crucial and elusive "meeting of material and non-material,"[55] places of transition where, for example, the sea meets the sky. For Kapoor, as for Martin and indeed many artists in this exhibition, the intangible place between subjectivity and objectivity is where beauty resides. It is here that all the mythological, psychological, and philosophical possibilities of life, art, and existence are enjoined.

The respect that Martin, Klein, and Kapoor bestow on beauty has often been critiqued by contemporary artists who have questioned not only beauty's lofty claims to perfection, as seen in the

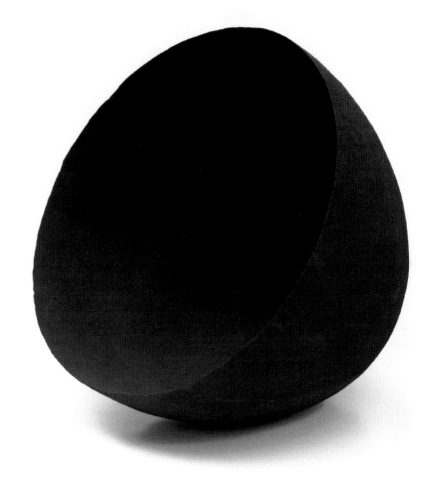

50

first half of the exhibition, but also beauty's potential for transcendence. John Baldessari and Andy Warhol present two perspectives that oppose those artistic pursuits. Baldessari's wry indictment of "pure beauty" in *Pure Beauty*, 1967–68 [*cat. no. 2, p. 142*], challenges both the ideology of aesthetic beauty and Klein's belief in the "ineffable aura" possessed by great works of art. In his early text paintings, Baldessari takes "some mystery – a lot of mystery – out of art"[56] by questioning the properties that constitute a work of art, such as originality, authorship, beauty, quality, and purity. Valuing the artist's thought process above any aesthetic considera-

tions, Baldessari hired a professional sign painter to render the lettering on his canvases from the late 1960s as straightforwardly and artlessly as possible. Baldessari's tongue-in-cheek approach to painting was also an attack on the seriousness of formalist painting and the theories of Clement Greenberg. Several of Baldessari's text paintings from that period quote Greenberg and other critics, presenting their words as worn-out clichés rather than artistic dogma. Bruce Nauman's neon sign *The True Artist Helps the World by Revealing Mystic Truths*, 1967 [*fig. 51*], was born of the same critical spirit.

Warhol's "Oxidation Paintings" of 1978–80 further undermine the notion of "purity" in art as well as the heroic gestures of Abstract Expressionism. In the tradition of Yves Klein, Warhol turned himself, as well as his assistants and frequent guests to the Factory, into "living brushes." The canvases, popularly known as "piss" paintings, were coated with metallic copper paint, spread out on the floor, and then urinated upon while the paint was still damp. Acid from the urine oxidized the copper sulfate from the pigment to create the green patina as well as the ethereal swells across the surface of *Oxidation Painting*, 1978 [*cat. no. 88, p. 143*]. While some writers have interpreted this series as Warhol's attempt to convert body fluids into something of aesthetic value, the piss paintings also assert that beauty is a fallacy, a surface quality that is only "skin deep."

THE LURE OF NATURE

While abstraction has been a powerful vehicle for the investigation of the sublime and the beautiful, numerous artists have also looked to nature as a source of wonder and enlightenment. The consideration of the vastness of landscape in Western art has already been suggested through the example of Caspar David Friedrich and the Romantic tradition of painting he represents. In our century, however, the transcendent possibilities of landscape have come under fire for numerous reasons, including the vast scientific discoveries since the Enlightenment that have created a culture that values scientific fact over a mystical appreciation of nature. According to contemporary psychologist James Hillman, the demystification of nature through science and the contemporary awareness of the earth's fragile, expiring ecology have made late twentieth-century society immune to the world's complex magnificence. Our interest in nature, he contends, is "less to its sensate presence than to its subtle interactionism: microorganisms, ozone layers, virus strains, methane, tropic heat, evaporation, chlorophyll, gene pools, interdependency of species." The results of such a view, argues Hillman, have contributed to the "repression" of beauty in our time.

Hillman also considers the disregard for beauty in urban architecture and the design of the social environment, where decisions based on profitability and shrinking budgets have led to an "economics of ugliness." According to Hillman, bad design and

51

Fig. 50
Anish Kapoor
At the Hub of Things
1987
fiberglass and blue pigment

Fig. 51
Bruce Nauman
The True Artist Helps the World by Revealing Mystic Truths (Window or Wall Sign)
1967
neon tubing with clear glass tubing suspension frame

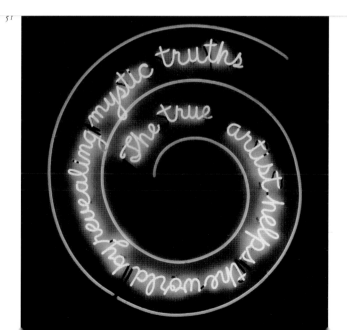

cheap construction, poor lighting conditions, and "sick" buildings have proven to have serious effects on the physical well-being and psychological balance of individuals. In his view, the lack of concern for one's physical surroundings has created a disinterested, narcissistic, self-referential culture that mistrusts beauty and the senses (among other things).[57] Also contributing to the mistrust of sensory experience suggested by Hillman are the sensorial and aesthetic possibilities presented by the media age. The hyperaccelerated speed of electronic media, and with it the potential to simulate and even create any number of virtual realities, suggests a range of future experiences that we cannot even begin to anticipate. It has been noted in the advertising industry that "we now buy our most powerful aesthetic experiences from the entertainment and culture industries, because nature cannot deliver them fast enough."[58]

For artists working in the late twentieth century, the above-mentioned factors may or may not be explicit considerations. Yet within the practice of Western art, the power of landscape to continue to inspire as well as embody contemporary values and ideals has been a topic of considerable debate. Fraught with centuries of convention, the genre of landscape has, like traditional figure painting and abstract expression, been put to the service of numerous ideologies, from the aesthetic and the metaphysical to the moralistic and the political, such that it might seem to have become virtually impossible to paint a landscape that has contemporary meaning. Gerhard Richter begs to differ.

jective expression, and transcendence – Richter resists stylistic categorization in his art. Moving fluidly between abstract and representational modes over the last four decades, the artist has created seemingly "Romantic" landscapes like *Seascape (with Clouds)*, 1969 [*cat.no.48,p. 145*], and *Garmisch*, 1981 [*cat.no.49,p. 146*], and "painterly" abstractions like *Structure (1–4)*, 1989 [*cat.nos. 51–54, pp. 149, 147, 150, 144*], that are not as straightforward as they might initially appear. While Richter's tumultuous seascape and hazy Alpine vista evoke Romantic notions of natural beauty, the artist does not evoke Friedrich to suggest the presence of the divine in nature. He seeks, rather, to emphasize that such a Romantic interpretation of nature presents a "fictive model"[59] of reality, not only conjured by the imagination of the artist but also emblematic of a tradition and the ideology that that tradition entails. By working from photographs and rendering a soft-focus finish to his canvases, Richter critiques the fundamental verity of landscape as well as the objectivity of photographs, which he describes as "ready-made" models of reality. In discussing the Romantic associations of his landscapes, the artist admits, "Of course my landscapes are not only beautiful or nostalgic, with a Romantic or classical suggestion of lost Paradises, but above all 'untruthful' (even if I did not always find a way of showing it); and by 'untruthful' I mean the glorifying way we look at Nature."[60]

While Richter has stated that his interest in landscape emerged from a desire to paint "something beautiful,"[61] it is the

There is something crazy about a culture in which the value of beauty becor

In his disdain for art's ideologic function, Richter has, throughout his career as a painter, found ways to render both landscape and abstraction in a manner that simultaneously embraces and confounds artistic and aesthetic tradition. Taking a subversive stance to the historical tasks of painting – imitation of reality, sub-

very beauty (and at times banality) of his pictures that is the source of their transgression. Richter explains, "Though these pictures are motivated by the dream of classical order and a pristine world – by nostalgia, in other words – the anachronism in them takes on a subversive and contemporary quality."[62] The picture-postcard

quality of *Waterfall*, 1997, or *Barn*, 1984 [**cat. nos. 55 and 50, pp. 148, 151**], for example, is as saccharine as it is breathtaking; these are superior examples of "pretty" pictures – Kodak moments waiting to be photographed. While the paintings draw on centuries of thought and tradition for their presentation, these exquisite landscapes are surprisingly empty and suspiciously unreal to late twentieth-century eyes. Such an assessment ironically says more about contemporary culture and the pandemic "repression" of beauty described by Hillman than it does about the tradition of painting.

Richter also challenges ideas of pure painting in his "Abstracts," which he similarly describes as "fictive models for the non-visual."[63] Although the artist would seem to be conjuring archetypal concepts such as the sublime, the void, the infinite, and the absolute in his Abstracts, the luscious canvases of dragged paint such as *Structure (1–4)* are not born of spontaneous physical gestures; they are carefully contrived and meticulously rendered. Nor does the artist profess to induce emotional or mental states in the viewer in keeping with Agnes Martin or Yves Klein. Richter's

While Richter's statements about landscape and abstraction would appear to present a negative view of painting as an empty, ritualistic practice, in which both beauty and meaning are no longer possible or valid, the artist does insist that "art is the highest form of hope."[65] His frequently contradictory remarks, when taken as a whole, reveal the paradoxes and delights of painting, of which beauty is an undeniable ingredient. For Richter, it is the "incomprehensibility" of a painting that makes it meaningful and profound: "Painting is the making of an analogy for something nonvisual and incomprehensible: giving it form and bringing it within reach. And that is why good paintings are incomprehensible."[66] Perhaps for Richter, incomprehensibility is the aura that Klein sought in his own art – a place where beauty might exist.

Richter's colleagues in the United States, Roy Lichtenstein, Edward Ruscha, and Andy Warhol, cast a slightly more cynical eye on the tradition of the sublime in landscape. Whether it is Lichtenstein's rendering of a sunset in his characteristic Benday dot method (*Sinking Sun*, 1964 [**cat. no. 36, p. 153**]), or Warhol's

ntroversial. PETER SCHJELDAHL, 1994

comments on abstract painting reveal an interpretation that is decidedly less romantic.

Abstract paintings are fictitious models because they visualize a reality which we can neither see nor describe but which we may nevertheless conclude exists. We attach negative names to this reality: the unknown, the ungraspable, the infinite, and for thousands of years we have depicted it in terms of substitute images like heaven and hell, gods and devils. With abstract painting we create a better means of approaching what can be neither seen nor understood because abstract painting illustrates with the greatest clarity, that is to say with all the means at the disposal of art, "nothing."[64]

reduction of landscape to a paint-by-numbers children's game (*Do It Yourself (Flowers)* and *Do It Yourself (Landscape)*, both 1962, [**cat. nos. 82 and 83, pp. 154, 152**], both artists leveled a great aesthetic tradition. Also drawing on the language of advertising and popular culture to comment on traditional practices, Ruscha, like Richter, tempers his irreverence with a certain amount of respect, but no less humor. In *Who Am I?*, 1979 [**cat. no. 57, p. 155**], Ruscha presents a heavenly vista – a quintessential cliché of a romantic landscape that pointedly recalls Friedrich's *Monk by the Sea* [**see fig. 48**]. While this dramatic rendition is meant to evoke awe and the emotional sublimity of nature, the offhanded, quizzical state-

ment "Who am I?," and the response, "Yes, that's right, who am I?" (that are painted across the colorful sky) "forestall" any specific metaphysical or religious conclusions.[67] Retaining "enough of art's conventional nature to register the delicate spasm of numberless violations,"[68] Ruscha, like Richter, delights in the ability of art to produce beauty while addressing subversive, even antithetical content as well.

HARNESSING THE SENSES

While many of the artists represented in the second half of the exhibition value perception and seek to stimulate the sensorial faculties of the viewer, no artist engages the audience as viscerally as James Turrell. Dispensing with conventional media, Turrell conveys the immensity of nature and the immaterial through the medium of light. Drawing together landscape and abstraction, Turrell relates the sensations inspired by both experiences to the body. Building room-size environments and harnessing light in the form of projections, Turrell demonstrates the nature of seeing, presenting both the possibilities and the limits of perception. While his work touches on the yearnings of the soul for spiritual revelation, the artist prefers to leave his work open-ended, allowing audiences to attach to the encounter any aesthetic, religious, metaphysical, or philosophical meanings they desire. In this regard Turrell's art comes close to the objectives of Martin and Kapoor, who create

wall, Turrell has, since the 1960s, created a variety of experiences for the viewer. His "apertures," "corners," "wedgeworks," "dark spaces," and "skyspaces" allow the audience to sense and observe changes in light, color, perceptual depth, and atmosphere. As in *Milk Run*, 1996 [*cat. no. 81, p. 156*], a recent "wedgework," Turrell frequently provides a viewing space where the visitor may sit and a sensing space accessible only by sight. Employing optical theories, aeronautics, and his knowledge of the mechanics of human vision, Turrell urges his audience to remain inside his spaces for extended periods. Long observation and retinal focus will reveal gradations and alterations in color as the eyes adjust and adapt to new fields of vision. In *Milk Run*, Turrell provides three different qualities of light – opaque, translucent, and transparent – by projecting at an angle across the viewing space so that the experience of "wedging" occurs. This aeronautical term describes the "differentiation of vision caused by weather and water vapor when one flies into a front."[69] In Turrell's simulated experience, suspended planes of color appear to hover in space, creating an otherworldly glow in which time appears to stand still.

Turrell's most ambitious project to date is *Roden Crater* [*fig. 52*], a celestial observatory he has been working on since the early 1970s. Constructed within an extinct volcano north of Flagstaff, Arizona, which the artist purchased, the site will include a series of tunnels and chambers where natural light, stars, and the changing sky can be observed in a variety of situations and settings. The

It is said that analyzing pleasure, or beauty, destroys it. LAURA MULVEY, 1989

situations that predispose the viewer to contemplation. The architectural scale and grandeur of Turrell's light projections and environments, however, take the viewer beyond normal experiential limits.

Creating light-filled holes in space or projecting floating masses of color that appear to advance from or recede into the

most impressive optical experience will be the sense of "celestial vaulting" created by the rim of the crater against the sky in which the mouth of the volcano will appear to be capped by a heavenly dome. Providing humanity with opportunities to witness nature's great magnificence, Turrell acknowledges that he values the sensu-

Fig. 52
James Turrell
Roden Crater
1982
aerial view

ousness that comes from sensing: "I am working for pure visual delight and sensation. And when I say delight I mean in the sense of the sublime."[70]

Vija Celmins's art is also fixed on perception. Although her paintings and drawings of vast seas and heavenly skies are considerably more modest in scale than Turrell's light environments, their effect on the viewer is no less hypnotic. Indeed, those who observe her work find themselves absorbed by the minutiae of detail provided in the oceans [*cat. nos. 12, 13, and 15, pp. 161–63*], night skies [*cat. nos. 16–19, pp. 157–60*], and moon surfaces [*cat. no. 14, p. 164*]. Meticulously rendered in either graphite or paint on rel-

atively small sheets of paper or canvas, Celmins's universes are as limitless as they are contained, and as subjective as they are objective. While appearing to focus on every pebble, every flicker of sunlight, every celestial event as it occurs, Celmins also suggests a vastness that is decidedly abstract. Awed by the verity of the virtually photographic details transcribed by her hand, we are simultaneously struck by the artificiality of her pictures and their place outside reality. Although replete with information that would seem to place these landscapes in nature, the oceans do not document specific locations, and the night skies do not chart particular constellations. Like Richter, Celmins works from photographs to distance herself from her paintings. By cropping her images, eliminating the horizon lines, and refusing to articulate vanishing points or focus on a single element over another, Celmins suspends the potential for any narrative, mystical or factual, to enter into her pictures. Also creating "fictive models" of reality, she obsessively builds imagery from "nothing" into "nothing," to borrow Richter's words, for the evocation of "nothingness."

Celmins's approach to landscape has many parallels with Richter's — these artists have indeed shared many interesting points of convergence since the 1960s, despite their initial unawareness of each other — but in the end, the artists differ widely. While Richter also works within limited subject matter and series (landscapes, abstracts, and photo paintings), Celmins's range, even within each subject heading (oceans, night skies, and moon and desert surfaces), is considerably less varied and decidedly more in keeping with the rigors and means of Agnes Martin. While Celmins refrains from the aspirations of ideology in her work, even as a form of a critique, her potentially romantic ruminations on the heavens are consistently more detached and impersonal than Richter's. The lack of inflection and drama is part of the charge of her work, as is the fluid manner in which her images fluctuate between materiality and illusion, abstraction and representation,

vast depth and utter flatness. Meditating on the nature of vision – the problems of looking as well as its pleasures – Celmins has aptly described her paintings as "records of mindfulness."[71]

In his ongoing series of black-and-white photographs of oceans, Hiroshi Sugimoto records the effects of light and weather on remote bodies of water. Ranging from crisp to soft-focus, his images hover between representation and abstraction in much the same way that Celmins's depictions of vast heavens and infinite oceans emerge from flat materiality into limitless depth. At once clear and unfathomably ambiguous, Sugimoto's seas, unlike Celmins's oceans, refer to specific locations, which he cites parenthetically in his titles. Since 1980 the artist has traveled around the world to take his photographs, which he often shoots from remote promontories overlooking the ocean. He has made photos in treacherous locations in Europe, North America, the Caribbean, and Asia, and continues to cover the globe to complete the ongoing series. Choosing to focus on serene moments rather than tumultuous storms where the drama of nature is enacted, Sugimoto has focused his interest in the natural seam where the sea meets the sky. Using an 8x10-format view camera, black-and-white film, slow shutter speeds during the day, and long exposure times at night, the artist patiently records subtle atmospheric variations that occur along the horizon. The selection of seas presented in this exhibition [*cat. nos. 71–79, pp. 165–73*] capture slight wind shifts, momentary wave crests, and sparkling sunbeams as they filter through the clouds across generally still waters. These seemingly insignificant events become increasingly apparent the longer the viewer allows his or her eyes to focus, as in a Turrell installation. This is especially true of the nightscapes, where nearly imperceptible nuances and variations exist in rich tonal variations of black, silver, and gray.

While Sugimoto's titles would suggest that place is of the utmost significance, when the seascapes are seen together the titles

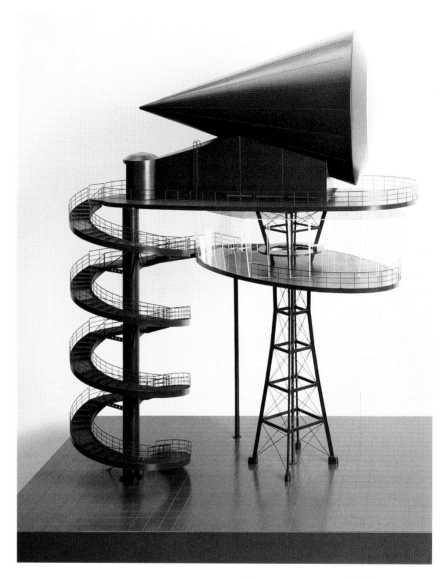

Fig. 53
Rodney Graham
Millennial Project
for an Urban
Plaza (with
Cappucino Bar)
1992
architectural model

with the
collaboration of
Robert Kleyn
plexiglass, brass, and
painted iron base

appear to be virtually interchangeable. Read as an abstract whole in which the horizon lines between individual photos seem to line up, the seascapes induce a complex dynamic of visual and perceptual stimulation. For G. Roger Denson, the viewer's line of vision follows a circular path that begins and ends with the single image. He describes the perceptual trail as follows:

First in the single image, then to a comparison between similar images, to the overall project that brings the images together, to the conditions that produced that project as they are instanced in the individual images, to the world that has produced the conditions, to the mind that has constructed the means by which to fathom that world, to the significance projected from that mind back to the single image, and around ad infinitum.[72]

Yet for Sugimoto, oceans are much more elemental, even primordial in their allusions. Embodying "ancient memory ... of what human beings used to see in nature as they gazed at the water," his photographic project reflects his endeavor to "encounter what the first humans recognized as an ocean."[73] The reality that Sugimoto hopes to evoke is one that is perhaps more internal and abstract than real. He prefers to think of the seas as "an early example of a human being naming something outside the world inside himself."[74]

Sugimoto's visual approximations of the infinite have been lauded as apt expressions of the sublime "for an age that has forgotten that such majesty exists on a shrinking polluted planet."[75] The artist, however, dismisses any preservationist leanings in his work. The state of ecology is of great interest, however, to Rodney Graham. As a resident of Vancouver, Graham since the late 1970s has addressed the devastating effects of deforestation on the British Columbian wilderness in various photographic series and several outdoor projects and public proposals. He is among a generation of contemporary Canadian artists whose critique of the impact of modern industrialization is frequently approached through the "prism" of the Romantic tradition.[76] Taking on the nature of perception, Graham's photographic series such as the "Oxfordshire

Oaks," 1990 [*cat. nos. 28 and 29, pp. 175, 174*], and outdoor projects such as *Camera Obscura*, 1979, and *Millennial Project for an Urban Plaza*, 1992 [*fig. 53*], undermine the Romantic aesthetic by attempting to realign vision. Graham has often used a method of inversion to disrupt the pantheistic view of nature and expose the often contradictory strategies at work in the construction of images.

In the "Oxfordshire Oaks" series, Graham draws on the power of a solitary tree – a romantic symbol of human mortality as well as a tragic record of societal progress frequently employed by the environmentalist movement. According to Jeff Wall, this symbol elucidates a number of ideological paradoxes. While to Wall the "spectacle of the tragic death of something nobler than ourselves is the sublime shock which can inaugurate radical transformation,"[77] the lone tree also provides a false sense of hope in survival. In Graham's view this symbol is a "totem" to devastation and not to the nobility of a humanity that takes solace in preserving isolated examples. By inverting the loaded image of the tree, Graham compounds the sense of loss yet effectively drains the image of its Romantic associations. As a meditation on the nature of seeing, Graham's photographic inversion mirrors the way humans as well as cameras process visual imagery. While Richter and Celmins use photography to underscore the fiction of painting, Graham questions the essential nature of "photographic truth" and reveals the equally powerful myth-making potential of the medium. In this regard, the "Oxfordshire Oaks" have a strong correlation with Edward Curtis's photographs of Native Americans or Walker Evans's studies of vernacular architecture earlier in the century. Although these "documentary" photographs originated from a Romantic desire to record a "passing way of life," the passage of time has revealed them to be reflections of the attitudes of a time and the biases of their makers.

The "Oxfordshire Oaks" series – which was shot in England rather than Canada, where a parallel history of devastation is

recorded in the countryside – relates to two earlier outdoor projects in which Graham first used the tree as an ideological symbol and a critical focal point for his photographs. Sited directly in the British Columbian landscape, *Camera Obscura* presented a shedlike structure situated on a hill across from a solitary tree. The camera, which was located in the shed, projected an inverted image of the foliage on the building's interior wall. In *Millennial Project for an Urban Plaza*, a proposal which has never been realized, Graham sites a similar camera-obscura theater in an urban plaza. Rather than displace a mature tree found in nature, Graham's project calls for a sapling whose image would not be in full view of the camera until it reached maturity decades later. Drawing on the irony of the "negative ecology" of urban planning, in which tree-lined malls provide a "false reconciliation of city and countryside,"[78] Graham's "time machine" awaits the tree's growth for completion. The message of his project and related photographs is a poignant comment about the fragile existence of nature and beauty within contemporary culture.

The fragility of life and the vicissitudes of perception are powerful subjects in Felix Gonzalez-Torres's oeuvre. In the paper stacks printed with elegiac images of the heavens, the glistening piles of candy mounded on the floor, or the ethereal light strands suspended from the ceiling, Gonzalez-Torres mediates poetic moments of transience and transition as well as exquisite beauty. Refusing to employ conventional aesthetic standards or media to

the audience on visceral and emotional levels while conveying a multitude of personal, social, and cultural meanings. Addressing such powerful themes as loss, sickness, death, and the struggle with AIDS, as well as politics and social responsibility, Gonzalez-Torres's art celebrates life, love, beauty, and happiness with equal fervor. Subsuming the terrors of loss and death in the seductive qualities of shimmering candy wrappers, and memorializing his dead lover in the romance of soft incandescent light, Gonzalez-Torres harnessed the transformative potential of beauty to tremendous effect.

In making work that was both "aesthetically refined" and socially provocative, Gonzalez-Torres came as a shock to an art world uncertain of the place of beauty in contemporary society. Early in his career the duality of his work was identified as the subversive nature of his art. In an exhibition review in *Tema Celeste* magazine in 1990, Pat McCoy noted Gonzalez-Torres's "extreme irony" in "confronting social responsibilities and health through esthetics – at a conceptualized remove."[79] Other critics noted how the work "slowed you down," suggesting that this kind of delay, this quiet experience of beauty, was "old fashioned." Yet for Gonzalez-Torres, it was critical to make work that was accessible. By allowing his audience to take away a part of the image, in the form of individual sheets from paper stacks in works such as *"Untitled" (Aparición)*, 1991 [*cat. no. 25, p. 179*], or to consume the candies from his candy spills, Gonzalez-Torres invited a direct,

Beautiful things can be very deceiving. They make you feel good f

create his art, Gonzalez-Torres forged a poetic language of seduction and significance by working with common, everyday materials. Through an extreme economy of means and simple gestures, he transformed seemingly base cultural artifacts (clocks, mirrors, puzzles, candy, and lightbulbs) into complex soliloquies that engage

sensorial encounter between the work of art and the viewer. His extreme gesture of generosity toward his audience, which is one of the defining characteristics of his art, was also extended to those who acquired his work. His light strands, including *"Untitled" (America #3)* and *"Untitled" (For New York)*, both 1992 [*cat. nos.*

26-A and 26-B, pp. 180, 181], for example, may be configured any number of ways – laterally, vertically, draped, or scalloped; the artist leaves the aesthetic decisions to the owner. Although ideal heights for the paper stacks and ideal weights for the candy spills are provided for each piece, the artist again leaves it to the exhibitor to determine what height the objects should finally be, and whether the paper or candy should be replenished daily or left to disappear as it is consumed by the audience.

While Gonzalez-Torres's objects can always be reconstituted, it is the ephemeral and fragile nature of each installation that endows his work with such profound and exquisite poetry. Proposing beauty as a transitory, life-affirming quality, Gonzalez-Torres harnesses beauty's essence and energy in his artwork if only for a moment. Possessing that moment, he then struggles to give it away, to share its mysteries with others. Yet in the act of imparting it, beauty quickly disappears. In an interview with Robert Nickas, Gonzalez-Torres addressed the power as well as the frustrations of beauty:

e while. FELIX GONZALEZ-TORRES, 1991

Beautiful things can be very deceiving. They make you feel good for a little while. It's a placebo because it's an artwork. It's a substitution for what? Yes, it was very beautiful ... but only for five days.[80]

While the artist made this statement in regard to his candy piece *Untitled (Placebo)*, 1991 (The Museum of Modern Art, New York), it underscores one of the great challenges and mysteries of beauty, that is, the inability to define it or possess its true essence. This and other universal paradoxes are poignantly revealed in Douglas Gordon's *Untitled (Text for some place other than this)*, 1996 [*cat. no. 27, p. 178*]. Gordon's text is composed of a seemingly

endless string of diametrical oppositions – "hot is cold ... day is night ... pain is pleasure ... repulsion is attraction" – which are cited and then ritualistically transposed in the body of the text. Gordon's poetic pairing and reversal of antonyms have tremendous resonance with the work of Gonzalez-Torres, who often coupled objects and opposing forces as subjects in his art. In dialog with Gonzalez-Torres's sculpture *Untitled*, 1989–90 (Rosa and Carlos de la Cruz Collection), a double paper stack in which one stack with the text "somewhere better than this place" faces a second stack that reads "nowhere better than this place" – Gordon's *Untitled (Text for some place other than this)* questions the very limits of perception. For Gordon, as for Gonzalez-Torres, the location of beauty is no less tangible or clear.

Another artist intrigued by the elusive qualities of beauty is Jim Hodges [*cat. no. 30; see pp. 176, 177, and cover*]. Also working with humble materials drawn from life, Hodges transforms ordinary objects – paper napkins, fabric flowers, silk scarves, mirrors, tissue paper, a stack of men's shirts – through subtle interventions that bring home the immediacy of life and the lasting power of transitory moments. In *A Diary of Flowers*, 1992–93 (Rosa and Carlos de la Cruz Collection), for example, Hodges pinned to the wall hundreds of used coffee-shop napkins, each carrying sketches of flowers rendered in pencil and ballpoint pen. When seen together, the doodled napkins reveal a disconnected journal of thoughts reflecting variations in moods, reminiscences, and daydreams in the life of an individual (in this case, his own). Although private in their origins, Hodges's "souvenirs" of memory and emotion invite the viewer to create a new, equally intimate narrative from the cues provided. The intersection between the personal and the collective is of utmost importance to the artist, who also struggles to make

To THE MOST SPECIAL
LADY DI
THE WORLD HAS EVER HAD!

WE DO BELIEVE THE LORD ABOVE
CREATED YOU FOR THE WORLD
TO LOVE,
HE PICKED YOU OUT FROM ALL
THE REST BECAUSE HE KNEW THE
BEST.

It is as though bea

his work accessible as well as poetic.

Hodges's choice of materials, like Gonzalez-Torres's, stems from a desire to demystify art and communicate with people on a basic human level. While Gonzalez-Torres often turned to the medium of advertising and methods of mass communication (billboards, posters, and lights), Hodges prefers to work with a visual language that is less direct and confrontational. He admits that he is often attracted to materials that have "heavy" meanings, like flowers and mirrors. Exploring the many nuances implicit in an object, he then attempts to activate the various layers of signification through his art. Hodges's use of flowers, for example, grew out of his interest in the devaluation of floral subjects in contemporary art. Associated with craft and sentimentality, the decorative quality of flowers made them inappropriate, empty topics for an art world focused on issues and social dilemmas. Yet Hodges became intrigued by the pervasive use of flowers in contemporary society as potent carriers of human sentiment. Making suitable gifts for virtually any occasion, flowers are commonly given as a sign of love, friendship, joy, and caring to others. As an expression of sorrow, flowers also have the power to transform loss into a poetic yet transitory symbol of life and beauty. The endless procession of flowers laid at the gate of Kensington Palace following the death of Princess Diana of Wales in 1997 [*fig. 54*] demonstrated the tremendous ability of flowers to convey the overwhelming sentiment and grief felt at that moment by the world at large.

nature. His work suggests countless possibilities, ranging from moments of pure reverie to deep consolation. Hodges, too, has mourned the loss of friends and colleagues, including the late Felix Gonzalez-Torres, in his flower installations. While treading a fine line between poetry and sentiment, Hodges, like Gonzalez-Torres, avoids the dangers of oversentimentalization in his work. Art critic Joshua Decter aptly noted that no matter how specific or loaded Hodges's subjects are, they always "stop short of allegory." Decter continues:

If there is some kind of narrative at work here, it's one that leads us back to the artist's own desires, fetishes, and pleasures – which may just be our own…. If Hodges has a crush on beauty it is as much for its mystery as for its surface appeal.[81]

In *This Way In*, 1999, his installation for this exhibition [**not illustrated**], Hodges presents a sculptural metaphor for the experience of beauty as he seduces the viewer through a doorway with a delicate small spray of muted flowers pinned to the wall. Upon entering the full gallery, a dense profusion of colorful flowers erupts across the adjacent wall in an explosive assault on the senses. The sense of building, of a swelling wave of pleasure, with a high and low ebb, of intense anticipation followed by exhaustion, is a metaphor not only of love and physical pleasure but also life and perhaps beauty itself. In a world where infinite distractions and a fast pace prevent us from recognizing beauty,

*ig. 54
Kensington Palace
awn covered with
lowers after
Princess Diana's
eath, September
997, London*

e a … catalyst, transforming raw grief into tranquil sadness.　　ARTHUR C. DANTO, 1990

Hodges draws on the transformative potential of beauty to create his breathtaking curtains of cascading silk flower petals [*fig. 55*]. Addressing ideas of excess as well as the fragile delicacies of life, his flower installations inspire an array of emotions and memories in the viewer – rapturous moments of dream, of fantasy, or more tangible sensations brought on by a direct encounter with

Hodges's works slow us down, forcing us to stop and look, and even gasp in awe. Restoring our faith not only in humanity but also in beauty's potential, Hodges's poetry comes not from the sensual delights of his chosen medium but from his true and generous nature. His work suggests that perhaps generosity is the promise of beauty in our time.

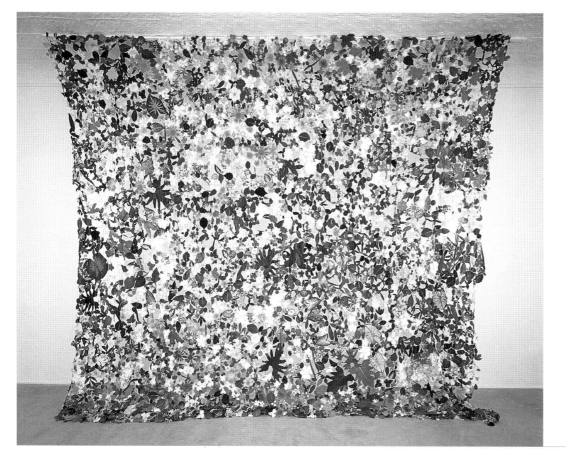

Fig. 55
Jim Hodges with
The Fabric Workshop
Every Touch
1995
silk flowers and
thread

In his introduction to *Uncontrollable Beauty: Toward a New Aesthetics* (1998), Bill Beckley alludes to the important relationship between beauty and generosity in the art of our time. His position is supported by other writers, including Peter Schjeldahl, and a growing number of curators who have monitored the desire of many contemporary artists to make their art increasingly accessible to their audiences.[82] The appreciation, or lure, of beauty is but one of the many ways artists today seek to engage humanity. The art of Jim Hodges and Felix Gonzalez-Torres, which closes the exhibition, reveal that beauty can still be a powerful and viable agent in creating art with potent contemporary meaning.

Whether revealed in the depths of the mind or spirit, or located in the contingencies of an object, beauty in the late twentieth century takes many forms. For many, beauty is fluid and forever evolving. For others, it is difficult, contradictory, and at times even temperamental. Still others find beauty a form of exquisite transgression. Accepting the mysteries of beauty and mining all its attendant dilemmas, artists no longer shun beauty as a form of intellectual or formal constraint. They choose, rather, to regard beauty a "crowning satisfaction"[83] to be embraced as well as challenged.

Olga M. Viso

1

Marie Henri Beyle (1783–1842) wrote under the pseudonym "Stendhal." The first case of a condition popularly known as the "Stendhal syndrome" was recorded in the author's diary in 1817 and described in his book *On Love*, 1822. Stendhal traced the common malady that afflicted travelers who visited Renaissance masterpieces during extended Italian sojourns. Since then the syndrome has been studied by the contemporary Italian psychologist Graziella Magherini, whose findings are recorded in *La sindrome de Stendhal* (Florence: Ponte alle Grazie, 1989). In 1990, Catherine Liu, Curtis Mitchell, and Andrea Rosen organized an exhibition at Rosen's gallery in New York, "Stendhal Syndrome: The Cure," and invited artists to respond to Stendhal's proposition on art and beauty.

2

Camille Paglia, *Sexual Personae: Art and Decadence from Nefertiti to Emily Dickinson* (New York: Vintage Books, 1990), 57.

4

Giulio Paolini, "Identikit," *Artforum* 30, no. 7 (March 1992): 74.

5

Paglia, *Sexual Personae*, 141.

6

Paglia, "Madonna II: Venus of the Radio Waves," in *Sex, Art, and American Culture: Essays* (New York: Vintage Books, 1992), 6–13.

7

Arthur C. Danto, *Cindy Sherman: History Portraits* (New York: Rizzoli, 1991), 13.

8

Ibid., jacket cover text.

9

Griselda Pollock, *Vision and Difference: Femininity, Feminism, and Histories of Art* (London and New York: Routledge, 1988), 50–90. Also see T. J. Clark, "Olympia's Choice," *The Painting of Modern Life: Paris in the Art of Manet and His Followers* (London: Thames and Hudson, 1984), 79–146, and Eunice Lipton, "Manet: A Radicalized Female Imagery," *Artforum* 13, no. 7 (March 1975): 48–53.

11

Hickey quoted in Lynn Gumpert, *La Belle et La Bête* (Beauty and the beast) (Paris: ARC Musee d'Art Moderne de la Ville de Paris, 1995), 103, which refers to Hickey's original essay "Enter the Dragon: On the Vernacular of Beauty" in *The Invisible Dragon: Four Essays on Beauty* (Los Angeles: Art Issues Press, 1993), 16–17.

12

Roland Penrose, *Picasso: His Life and Work* (New York: Icon Editions, 1973), 465.

13

Picasso quoted in Dore Ashton, comp., *The Documents of 20th-Century Art* (New York: Viking Press, 1972), 73. Reprinted from Jaime Sabartés, *Picasso: portraits et souvenirs* (Paris: Louis Carré and Maximilien Vox, 1946).

14

Roland Penrose, "Beauty and the Monster" in Roland Penrose and John Golding, eds., *Picasso in Retrospect* (New York: Praeger, 1973), 157.

15

Picasso met the significantly younger Jacqueline Roque in the

The idea that beauty is unimportant is the real beauty myth. NANCY ETCOFF, 1998

3

Kounellis quoted in Kristine Stiles and Peter Selz, *Theories and Documents of Contemporary Art: A Sourcebook of Artists' Writings* (Los Angeles: University of California Press, 1996), 670.

10

Morimura quoted in Carol Lufty, "Gaining Face: Japan's Artists Emerge," *Art News* 89, no. 3 (March 1990): 147.

early 1950s. They married in 1961. Picasso remained devoted to her until his death in 1973 at age ninety-two.

16

Peter Schjeldahl, *Picasso's Dora Maar and De Kooning's Women* (New York: C and M Arts, 1998), 1.

17

Ibid., 3.

18
Marina Warner, "Lucian Freud: The Unblinking Eye," *New York Times Magazine*, 4 December 1988.

19
Freud quoted in Hilton Als, "Life as a Look," *New Yorker*, 30 March 1998, 91.

20
Marlene Dumas: Sweet Nothings, Notes and Texts (Amsterdam: Galerie Paul Andriesse, 1998), 64.

21
Ibid.

22
Camille Paglia, "The New Sexism: Liberating Art and Beauty," *Vamps and Tramps: New Essays* (New York: Vintage Books, 1994), 115; Ginia Bellafante, "Feminism: It's All about Me," *Time*, 29 June 1998, 54–62; Roberta Smith, "Body of Evidence," *Vogue* (August 1994): 152–58.

23
George Melrod, "Lip Shtick," *Vogue* (June 1993): 88.

24
Camille Paglia, "Madonna – Finally, A Real Feminist," *New York Times*, 14 December 1990, sec. A 39.

25
Bourgeois quoted in Marie-Laure Bernadac and Hans Ulrich-Obrist, eds., *Louise Bourgeois: Destruction of the Father, Reconstruction of the Father, Writings and Interviews, 1923–1997* (London: Violette Editions, 1998), 219.

26
Ibid., 140.

27
Bourgeois quoted in Charlotta Kotik, *Louise Bourgeois* (Brooklyn: Brooklyn Museum of Art, 1993), n.p.

28
Smith quoted in *Kiki Smith: Unfolding the Body* (Waltham, Mass.: Rose Art Museum, Brandeis University, 1992), 5.

29
George Ferguson, *Signs and Symbols in Christian Art* (1954; reprint, London: Oxford University Press, 1961), 23.

30
The botanical name for the flower is *Kniphofiam* as identified in James Rondeau, *Pipilotti Rist/MATRIX 136* (Hartford: Wadsworth Atheneum, 1998), n. 1.

31
Rist quoted in Christoph Doswald, "Ich halbiere bewusst die Welt, Pipilotti Rist im Gespräch mit Christoph Doswald" (I divide conscious world: Pipilotti Rist in conversation with Christoph Doswald), *Be Magazin* (Künstlerhaus Bethanien, Berlin) 1 (1994): S. 91–96.

32
Rist quoted in interview with Hans-Ulrich Obrist, "Rist for the Mill," *Artforum* 36, no. 8 (April 1998): 45.

33
Dorothy Schefer, ed. *What Is Beauty? New Definitions from the Fashion Vanguard* (London: Thames and Hudson, 1998).

34
The exhibition "Post Human" was curated by Jeffrey Deitch in 1992 for the FAE Musée d'Art Contemporain, Pully/Lausanne; Castello di Rivoli, Museo d'Arte Contemporanea Rivoli, Turin; Deste Foundation for Contemporary Art, Athens; and Deichtorhallen Hamburg. The catalog was distributed in the United States by D.A.P./Distributed Art Publishers, New York, and in Europe by Idea Books, Amsterdam.

35
Beryl J. White summarizes Kobena Mercer's article "Black Hair/Style Politics" in *Lorna Simpson: For the Sake of the Viewer* (Chicago: Museum of Contemporary Art, 1992), 20–21.

36
See Olga M. Viso, *Directions: Beverly Semmes* (Washington, D.C.: Hirshhorn Museum and Sculpture Garden, 1996).

37
Ray quoted in interview with Robert Storr, "Anxious Spaces," *Art in America* 86, no. 11 (November 1998): 103.

38
Dominic Molon, "Countdown to Ecstasy" in *Mariko Mori* (Chicago: Museum of Contemporary Art, and London: Serpentine Gallery, 1998), 3.

39
Ibid., 5.

40
Mori quoted in "Future Perfect: An Interview with Mariko Mori," *New Art Examiner* 26, no. 4 (November 1998/January 1999): 45.

41
Sarah Bayliss, "An Appreciation of Cute Finds a Niche in High Art," *New York Times*, Sunday, 6 December 1998, sec. AR 43, 45.

42
Ibid.

43
Webster's New International Dictionary, 3d ed., s.v. "cremaster."

44
David Frankel, "Hungarian Rhapsody," *Artforum* 36, no. 2 (October 1997): 79.

45
Carus quoted in Lorenz Eitner, comp., *Restoration/Twighlight of Humanism*, vol. 2 of *Neoclassicism and Romanticism, 1750–1850: Sources and Documents* (Englewood Cliffs, N.J.: Prentice-Hall, 1970), 48.

46
Agnes Martin, "Beauty Is the Mystery of Life," in Bill Beckley and David Shapiro, eds., *Uncontrollable Beauty: Toward a New Aesthetics* (New York: Allworth Press, 1998), 399.

47
Martin quoted in Barbara Haskell, *Agnes Martin* (New York: Whitney Museum of American Art and Harry N. Abrams, 1992), 109.

48
Hannah Weitemeier, *Yves Klein, 1928–1962* (Cologne: Taschen, 1995), 48.

49
Klein quoted in Pierre Restany, *Yves Klein e la mistica di Santa Rita da Cascia* (Milan: Domus, 1981), 17.

50
Ibid., 15.

51
Ibid., 31.

52
Kapoor prefers to use the word "non-material" rather than "immaterial" (see essay p. 118, n. 55).

53
Kapoor quoted in "U.K. Artist Q and A: Anish Kapoor," *Art Newspaper* 9, no. 78 (February 1998): 50.

54
Kapoor quoted in Sherry Gaché, "Interview: Anish Kapoor," *Sculpture* 5 (February 1996): 22.

55
Ibid.

56
Baldessari quoted in *John Baldessari: National City* (San Diego: Museum of Contemporary Art, 1996), 87.

57
James Hillman, "The Practice of Beauty," in Beckley and Shapiro, eds., *Uncontrollable Beauty*, 264.

58
Steven Skov Holt, "Twisted, Shifted and Lifted Ideas of Beauty," *Graphis* 50, no. 294 (November/December 1994): 33.

59
Richter quoted in Roald Nasgaard, *Gerhard Richter Paintings* (London: Thames and Hudson, 1988), 110. In the same catalog, Michael Danoff discusses Richter's theories of "models" of reality and perception (pp. 9 and 10).

60
Richter quoted in Hans-Ulrich Obrist, ed., *The Daily Practice of Painting* (London: Thames and Hudson and Anthony D'Offay Gallery, 1995), 124.

61
Richter, 1970, quoted in Dietmar Elger, *Gerhard Richter Landscapes* (Munich: Cantz, 1998), 12.

62
Ibid., 21.

63
Ibid.

64
From the artist's Documenta VII statement, 1982, quoted in Nasgaard, *Gerhard Richter Paintings*, 107.

65
Ibid., 110.

66
Richter, 1981, quoted in Elgar, *Gerhard Richter Landscapes*, 7.

67
Peter Schjeldahl, "Ed Ruscha: Traffic and Laughter," *Ed Ruscha* (Lyon: Octobre Desarts, 1985), 53.

68
Ibid., 45.

69
Turrell quoted in *James Turrell: Spirit and Light* (Houston: Contemporary Arts Museum, 1998), 18.

70
Turrell quoted in Richard Andrews, *James Turrell: Sensing Space* (Seattle: Henry Art Gallery, University of Washington, 1992), 51.

71
Celmins quoted in Madeleine Grynsztejn, *About Place: Recent Art of the Americas* (Chicago: Art Institute of Chicago, 1995), 28.

72
G. Roger Denson, "Satori among the Still Stills: Models for the Real Circling in Hiroshi Sugimoto's Photography of Contemplations," *Parkett* 46 (1996): 145.

73
Sugimoto quoted in interview with Betsy Wright, *Hiroshi Sugimoto: Currents 42* (Saint Louis: Saint Louis Art Museum, 1990), n.p.

74
Sugimoto quoted in Atsuo Yasuda, "The World through a Camera Obscura," *Sugimoto* (Houston: Contemporary Arts Museum; Tokyo: Hara Museum of Contemporary Art, 1996), 24.

75
Maria Morris Hambourg, *Bulletin of the Metropolitan Museum* 52 (Fall 1994): 75.

76
Grynsztejn, *About Place*, 16.

77
Jeff Wall, "Into the Forest: Two Sketches for Studies of Rodney Graham's Work," in *Rodney Graham, Works from 1976 to 1994* (Toronto: Art Gallery of York University; Brussels: Yves Gevaert; Chicago: Renaissance Society at the University of Chicago, 1994), 21.

78
Ibid., 20.

79
Pat McCoy, "Felix Gonzalez-Torres," *Tema Celeste* 8, no. 25 (April-June 1990): 64.

80
Gonzalez-Torres quoted in Robert Nickas, "Felix Gonzalez-Torres: All the Time in the World," *Flash Art* 24 (November- December 1991): 89.

81
Joshua Decter, *Artforum* 35, no. 3 (November 1996): 104.

82
I am grateful to colleague James Rondeau, Associate Curator of Contemporary Art at the Art Institute of Chicago, for sharing his thoughts on generosity and contemporary art, the subject of a lecture he delivered at the University of Chicago in the fall of 1998.

83
Peter Schjeldahl, "Beauty," *Art Issues* 33 (May–June 1994): 28.

*All artwork is about beauty; all positive work
represents it and celebrates it. All negative art protests
the lack of beauty in our lives.* AGNES MARTIN, 1989

PLATES PART II INTA

NGIBLE *BEAUTY*

Agnes Martin
Grey Stone II
1961
cat. no. 37

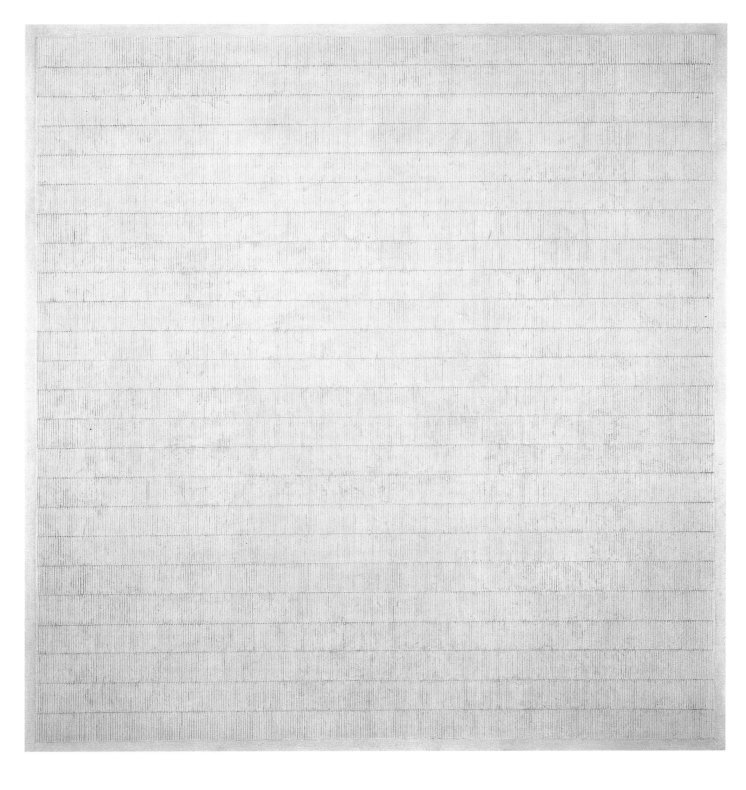

Agnes Martin
Falling Blue
1963
cat. no. 38

Agnes Martin
Night Sea
1963
cat. no. 40

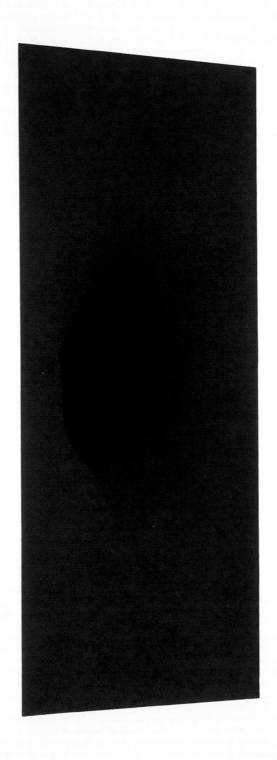

Anish Kapoor
My Body Your Body II
1993
cat. no. 31

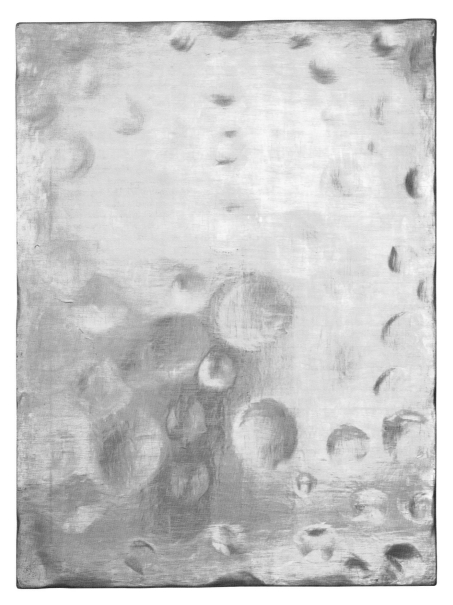

Yves Klein
Untitled
(**Monogold**)
c. 1960
cat. no. 32

John Baldessari
Pure Beauty
1967–68
cat. no. 2

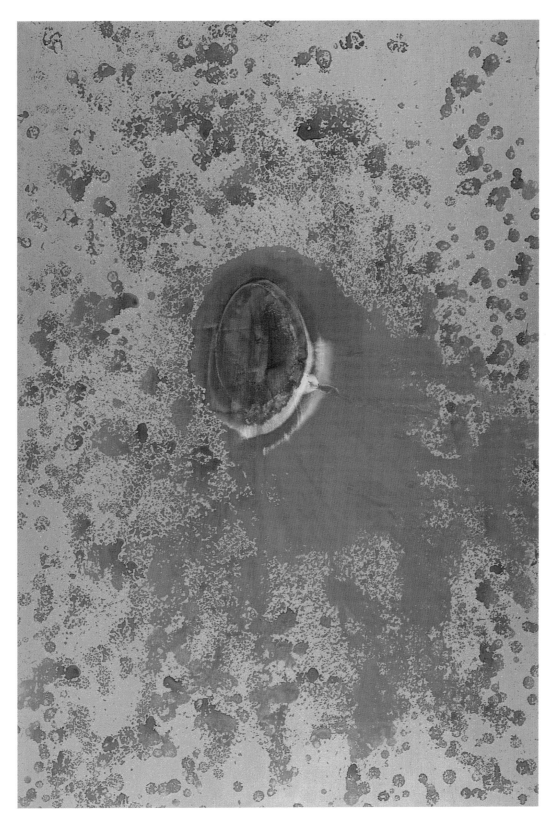

Andy Warhol
Oxidation Painting
1978
cat. no. 88

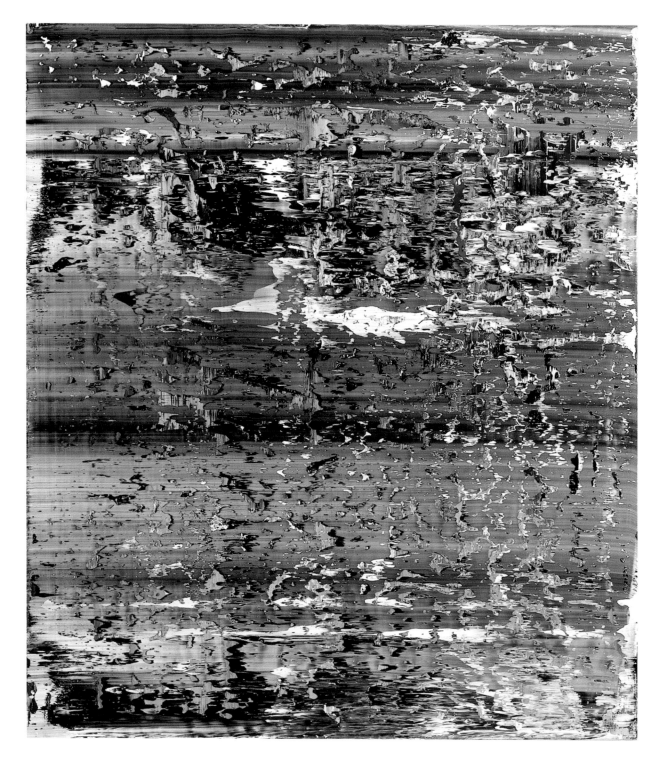

Gerhard Richter
Structure (4)
1989
cat. no. 54

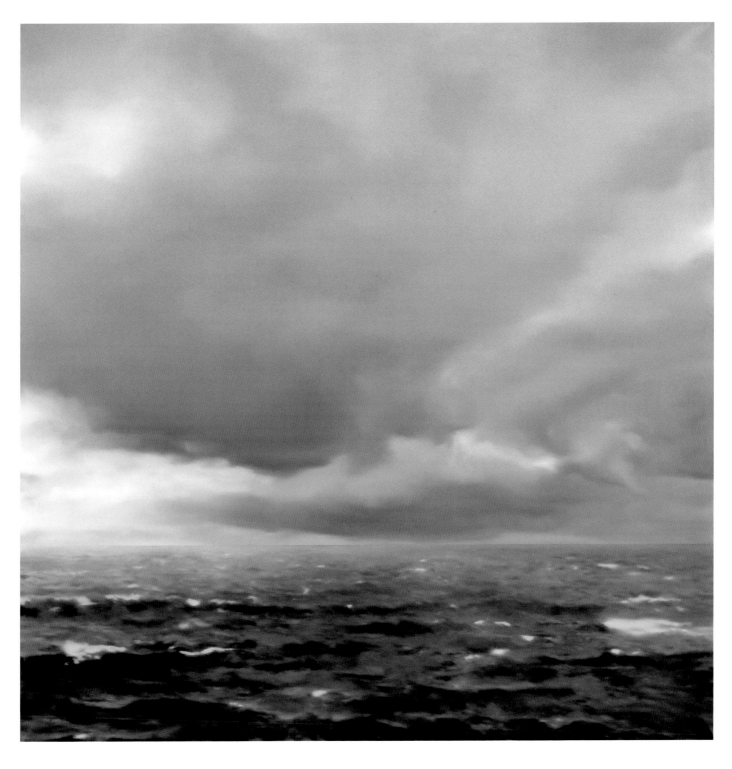

Gerhard Richter
Seascape
(with Clouds)
1969
cat. no. 48

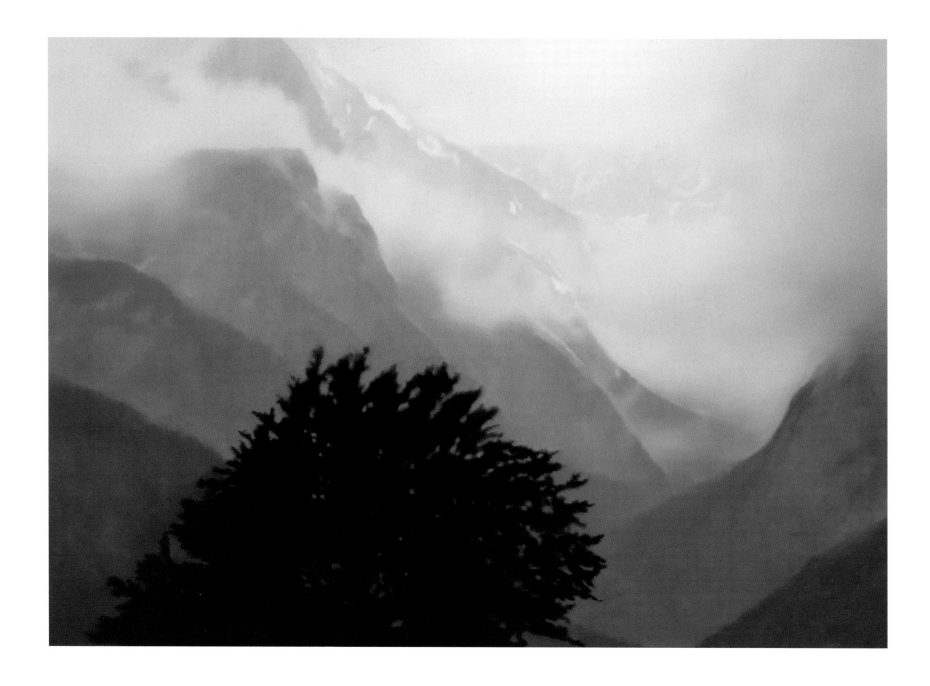

Gerhard Richter
Garmisch
1981
cat. no. 49

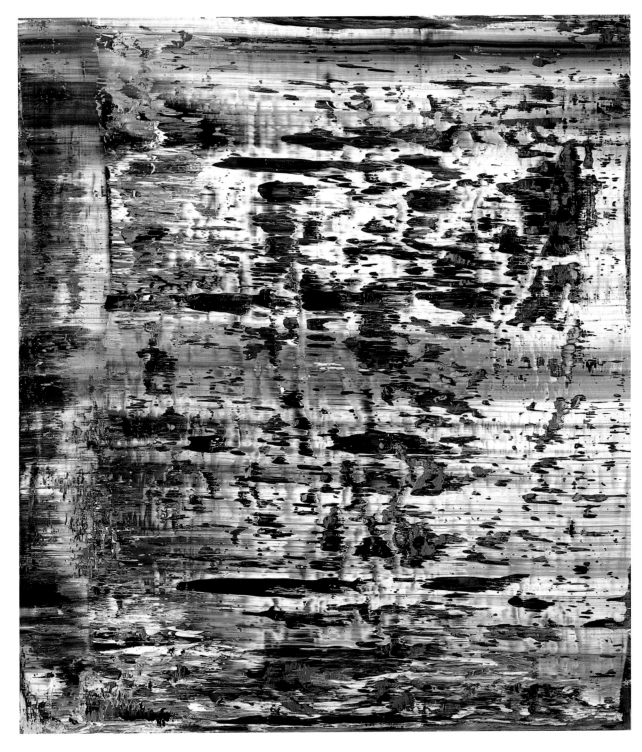

Gerhard Richter
Structure (2)
1989
cat. no. 52

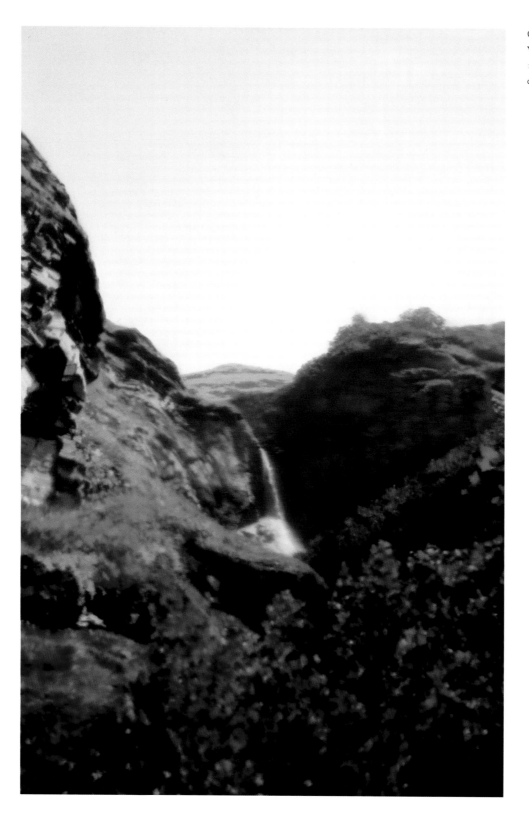

Gerhard Richter
Waterfall
1997
cat. no. 55

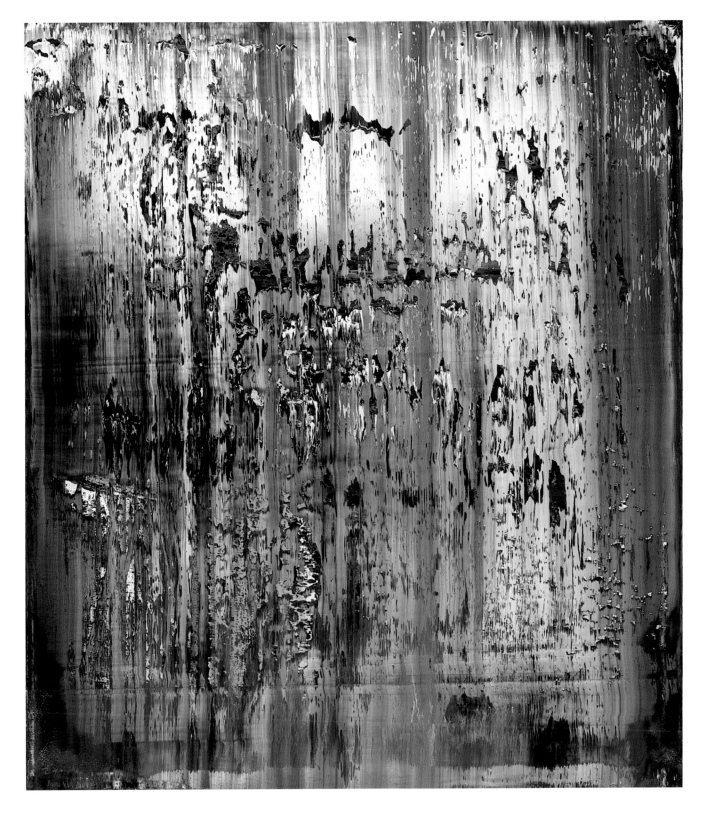

Gerhard Richter
Structure (1)
1989
cat. no. 51

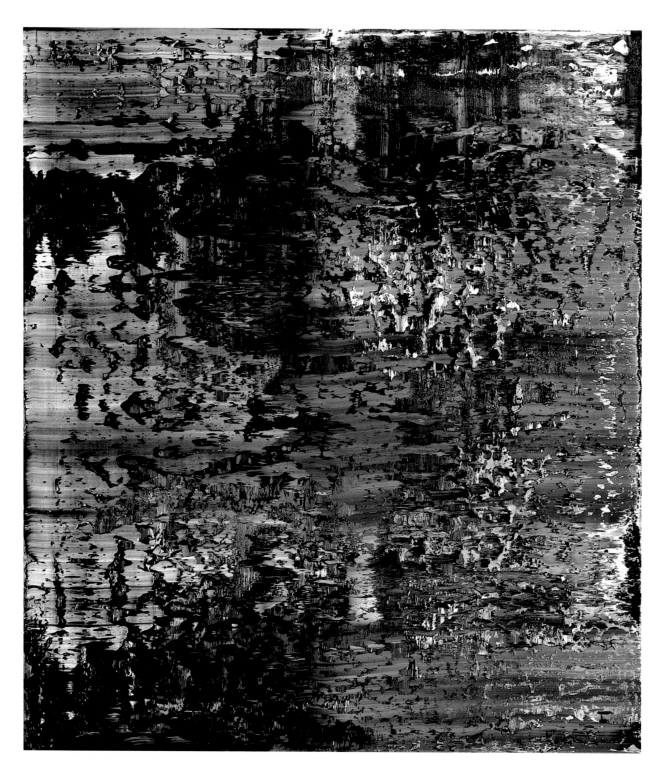

Gerhard Richter
Structure (3)
1989
cat. no. 53

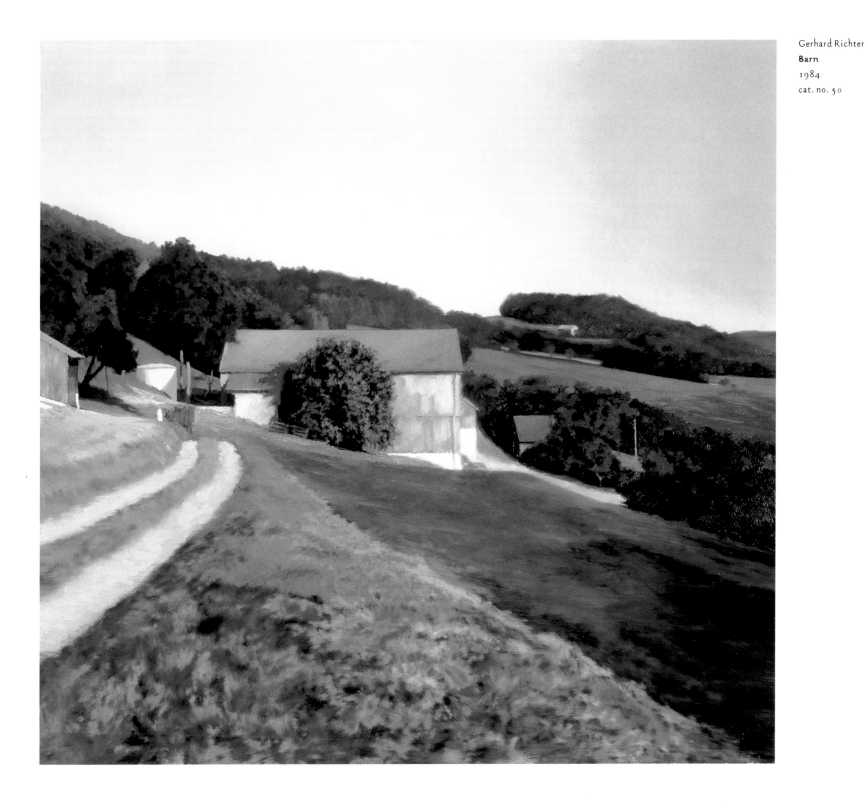

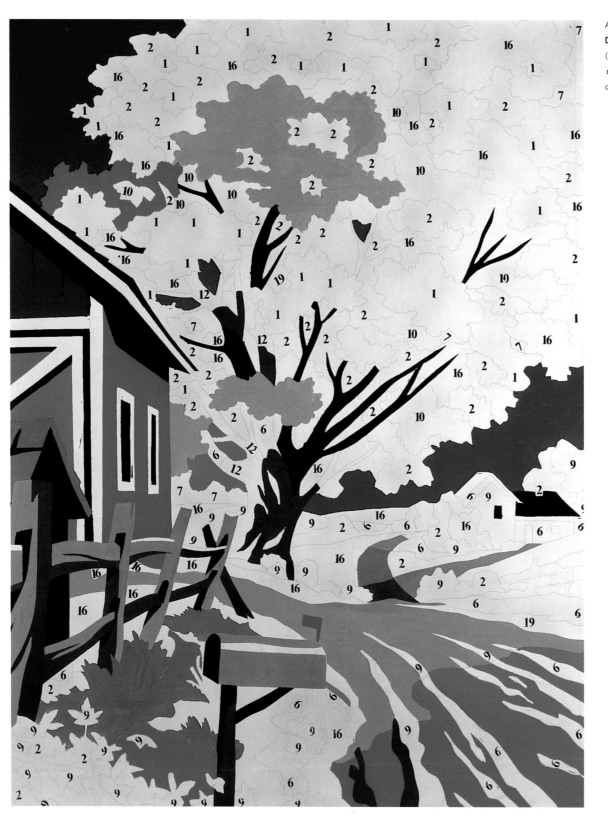

Andy Warhol
Do It Yourself
(Landscape)
1962
cat. no. 83

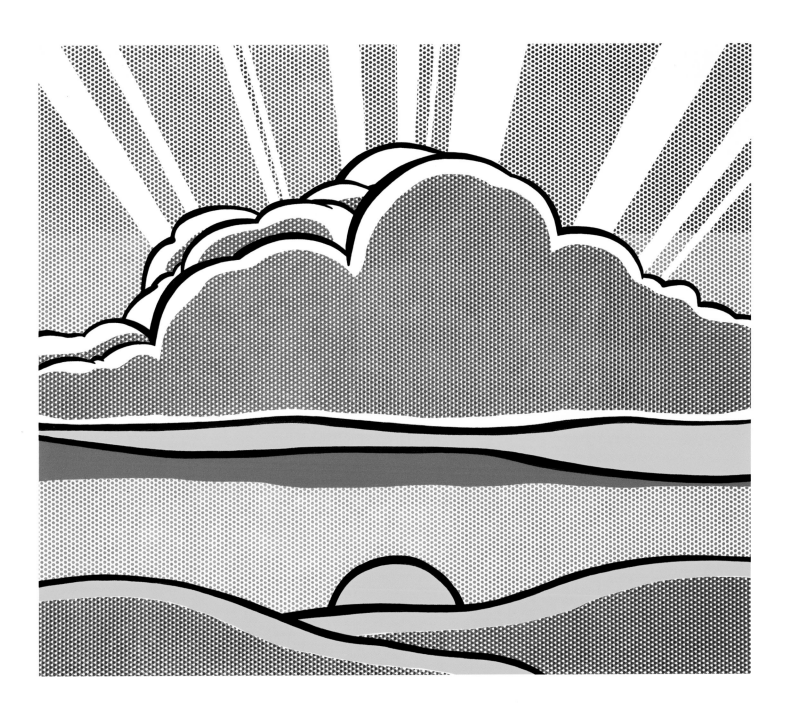

Andy Warhol
Do It Yourself
(Flowers)
1962
cat. no. 82

Vija Celmins
Night Sky #5
1992
cat. no. 17

Vija Celmins
Night Sky #12
1995–96
cat. no. 19

Vija Celmins
Untitled
(Big Sea #1)
1969
cat. no. 13

161

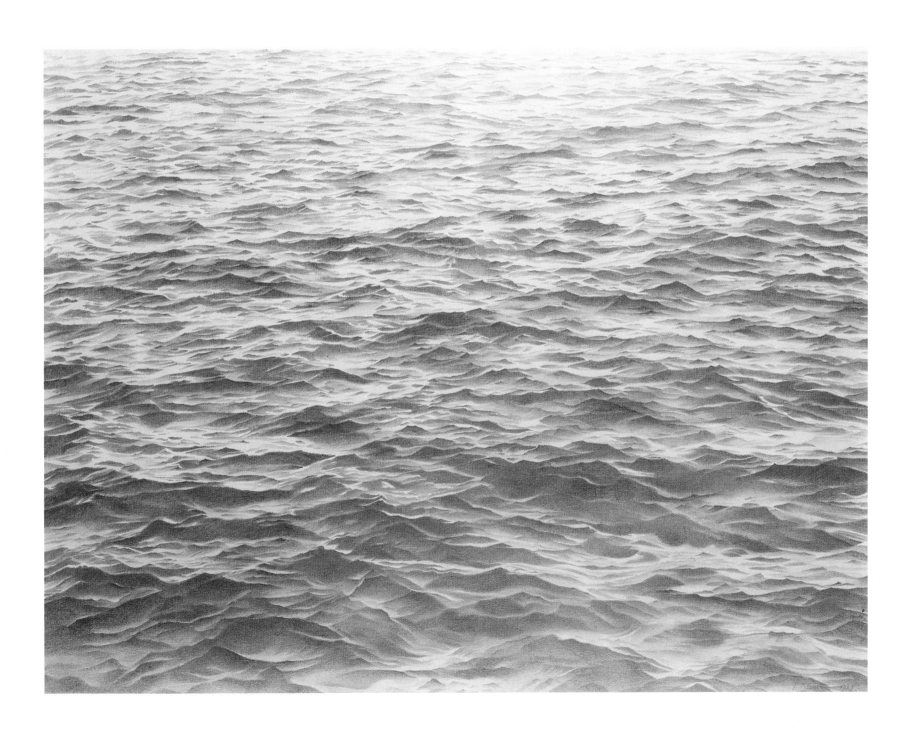

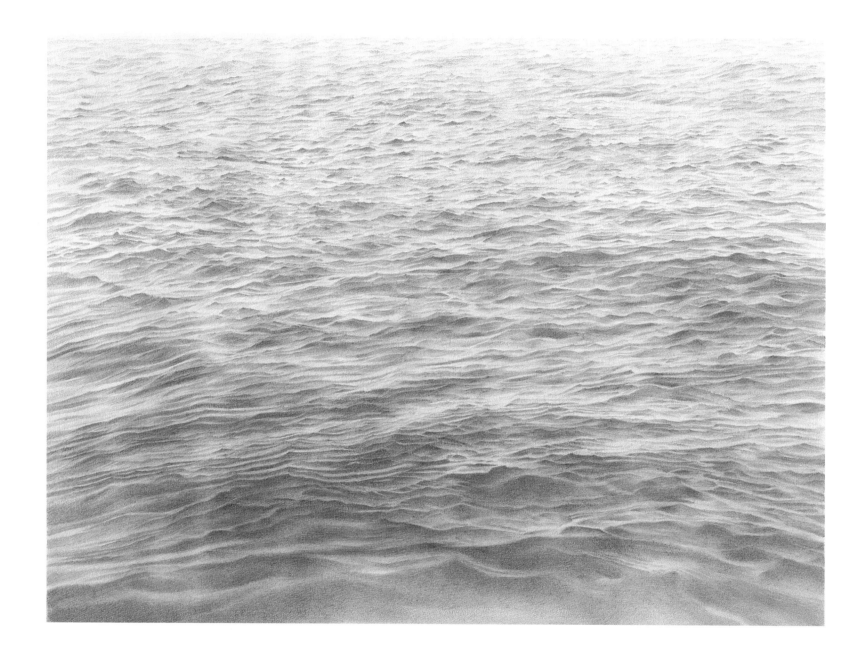

Vija Celmins
Untitled (Ocean)
1970
cat. no. 15

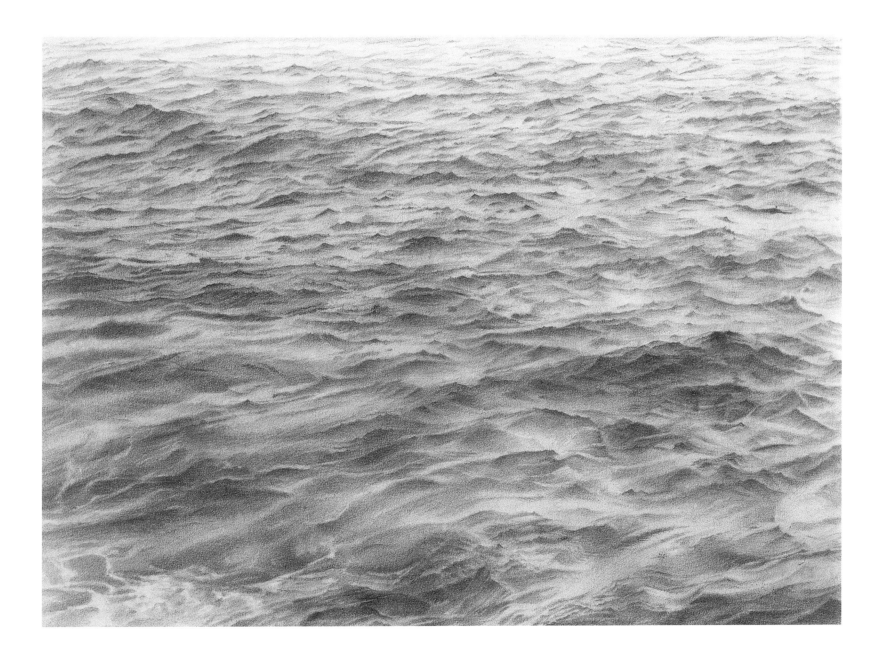

Vija Celmins
Untitled (Ocean)
1968
cat. no. 12

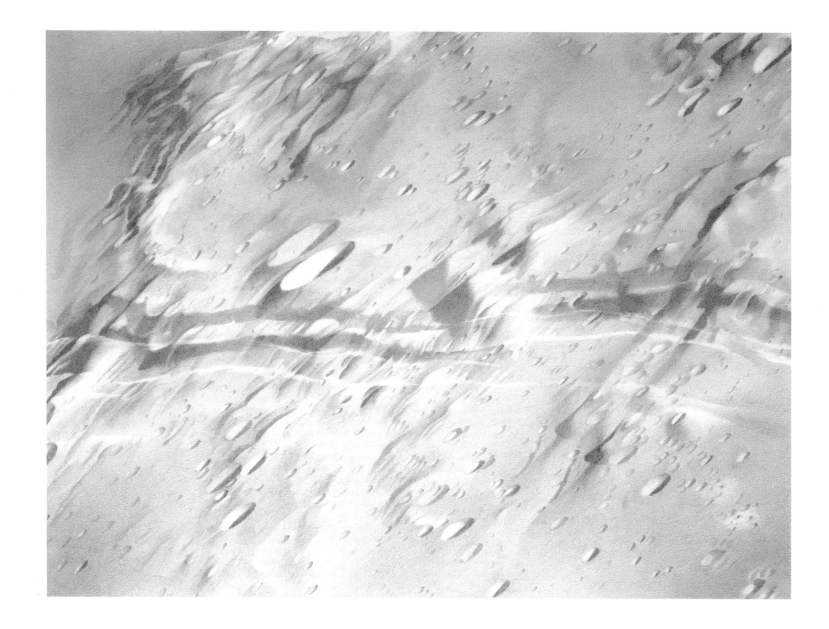

Vija Celmins
**Untitled (Double
Moon Surface)**
1969
cat. no. 14

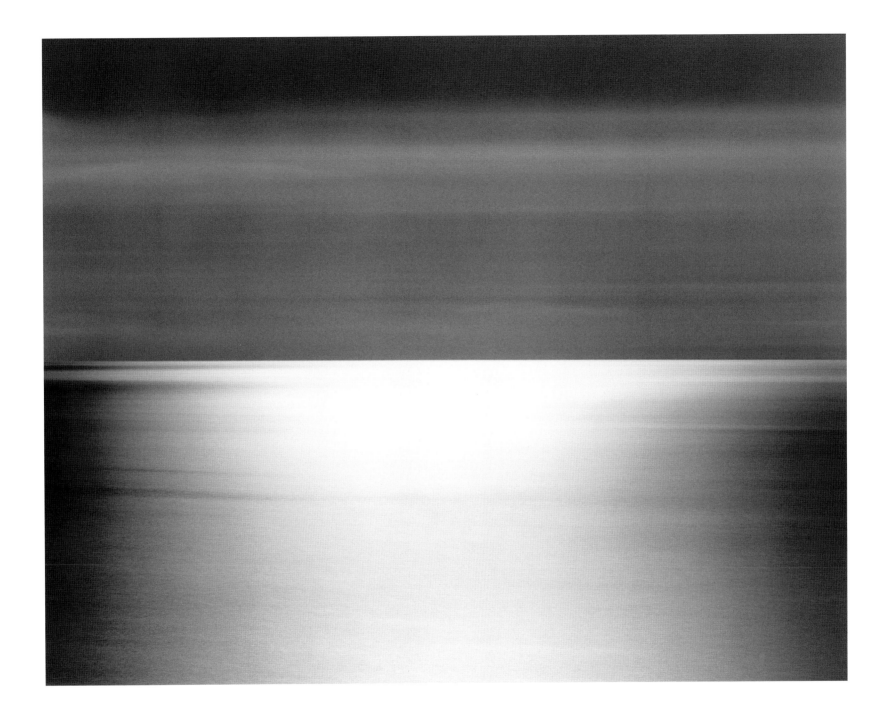

Hiroshi Sugimoto
N. Atlantic Ocean,
Cape Breton Island
1996
cat. no. 74

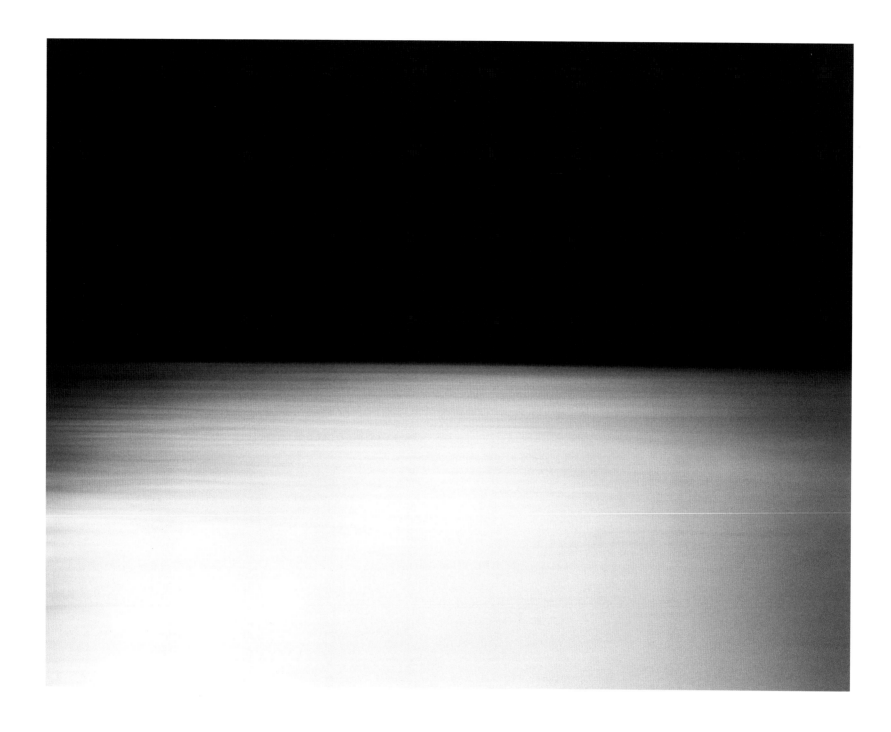

Hiroshi Sugimoto
**Bay of Sagami,
Atami**
1997
cat. no. 75

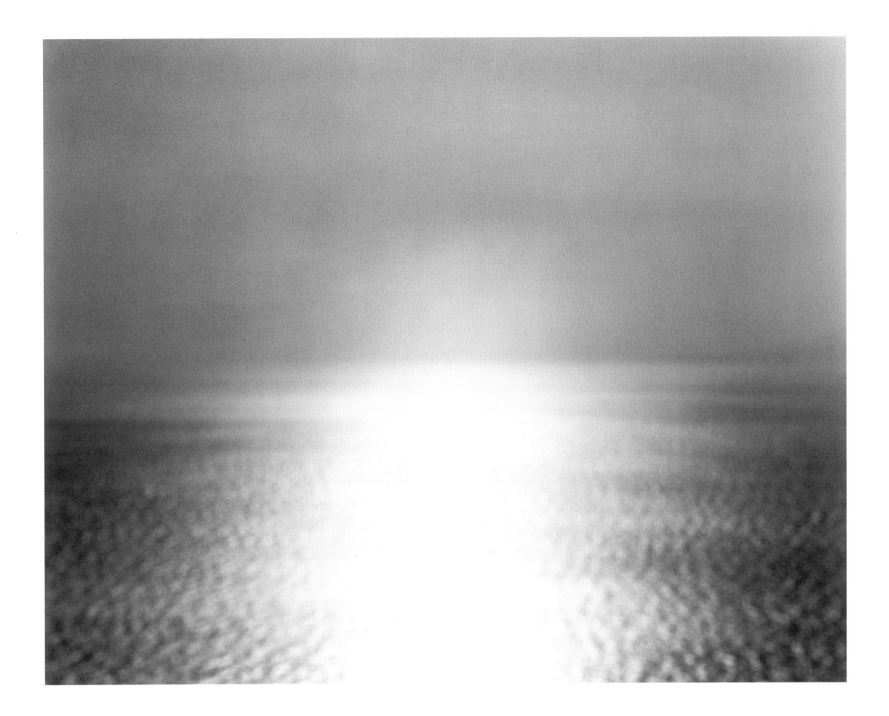

Hiroshi Sugimoto
**Bay of Sagami,
Atami**
1997
cat. no. 76

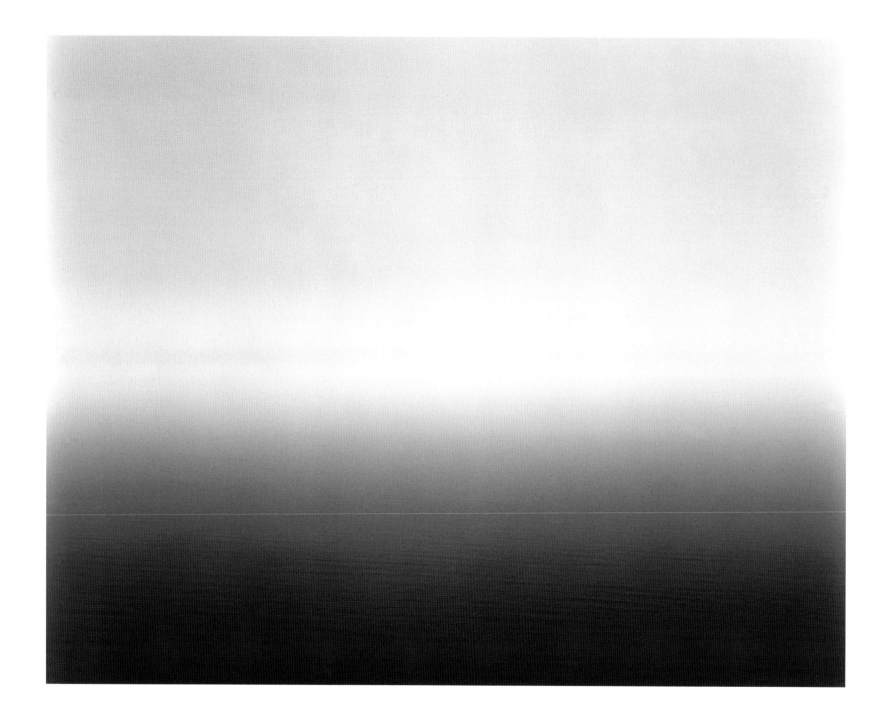

Hiroshi Sugimoto
Ligurean Sea,
Saviore
1993
cat. no. 73

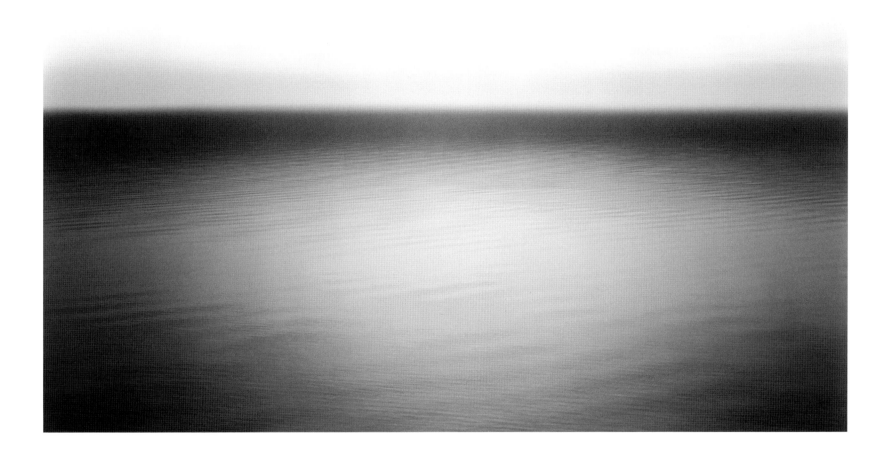

Hiroshi Sugimoto
Boden Sea, Uttwil
1993
cat. no. 72

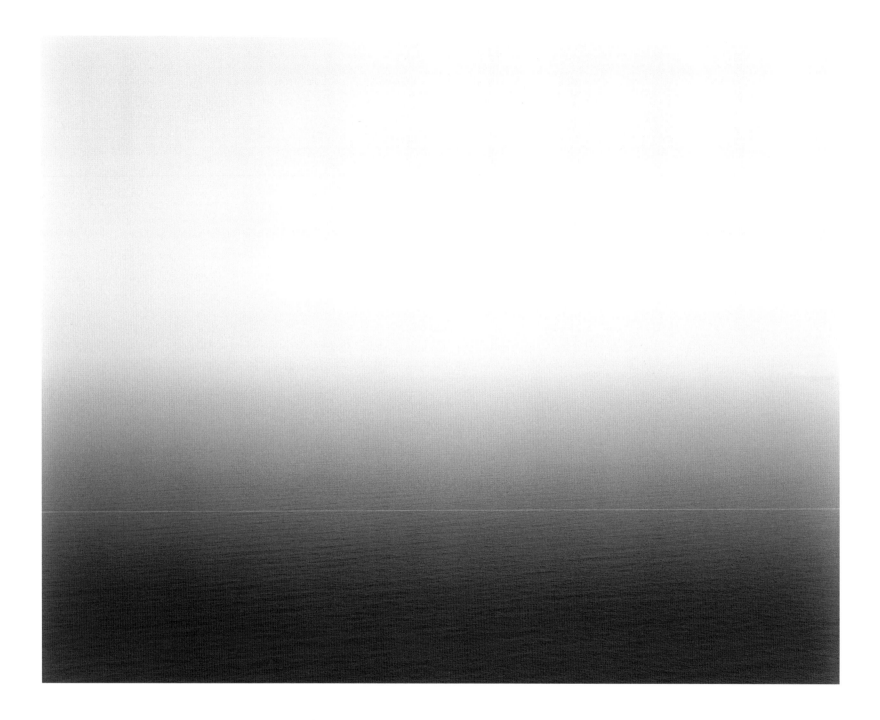

Hiroshi Sugimoto
Aegean Sea, Pilion I
1990
cat. no. 71

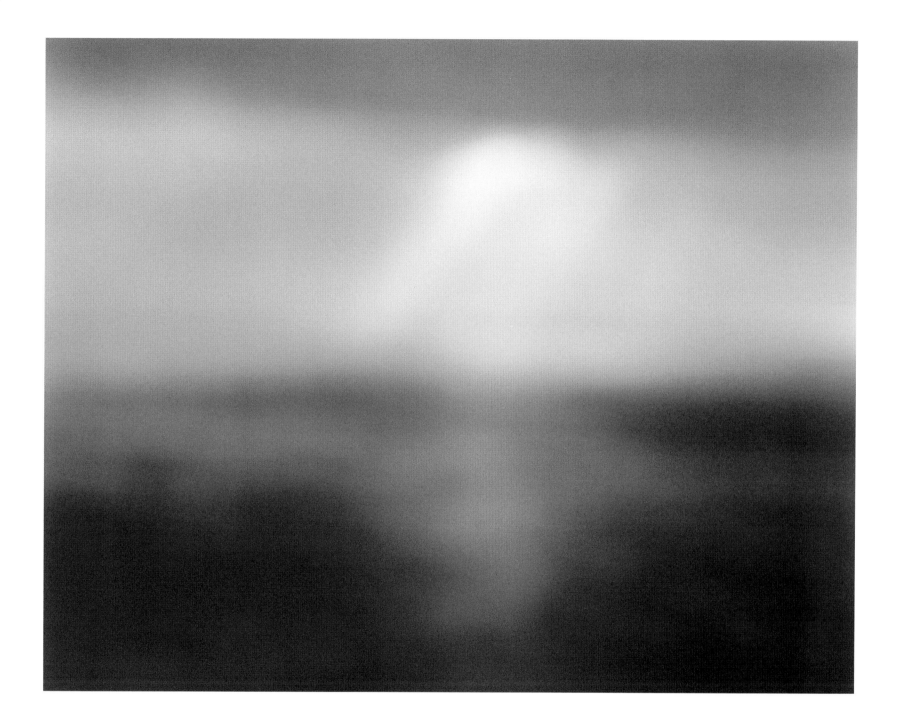

Hiroshi Sugimoto
Bay of Sagami,
Atami
1997
cat. no. 77

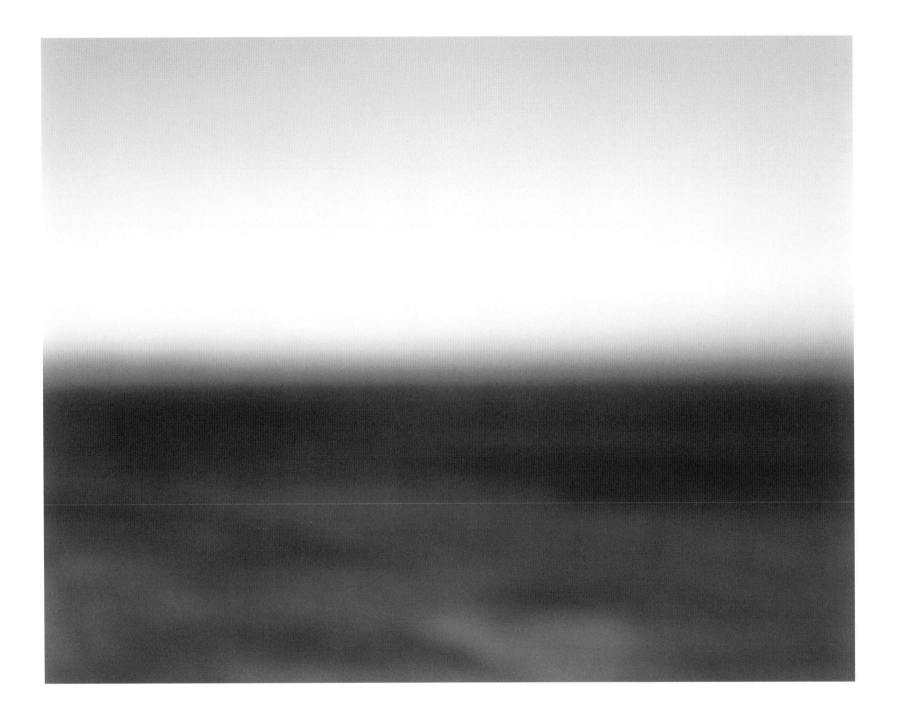

Hiroshi Sugimoto
**Bay of Sagami,
Atami**
1997
cat. no. 78

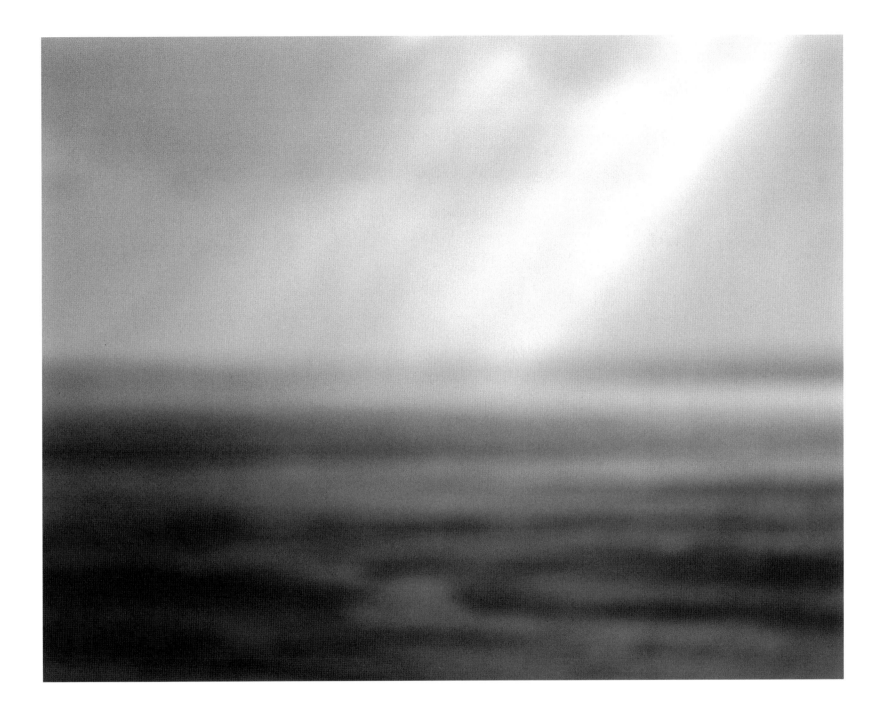

Hiroshi Sugimoto
**Bay of Sagami,
Atami**
1997
cat. no. 79

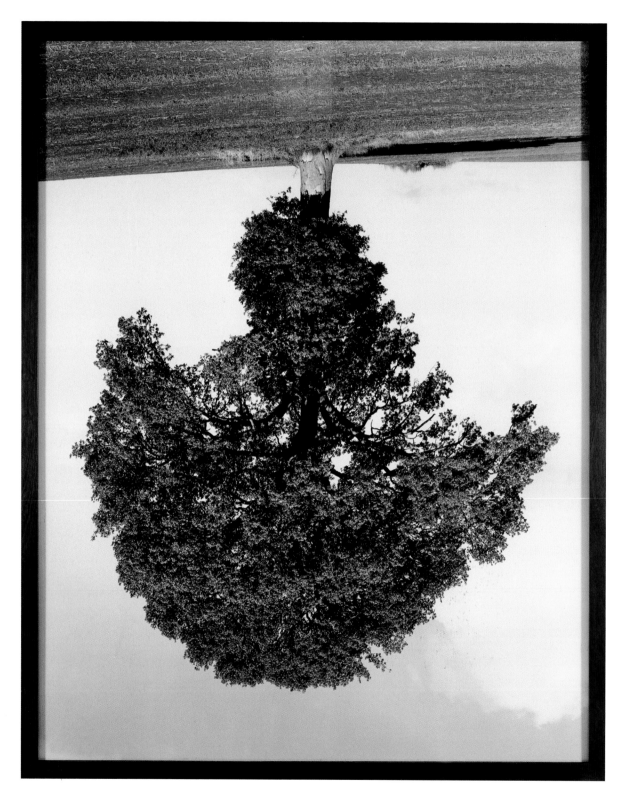

Rodney Graham
**Oak, Wroxton
Heath II,
Oxfordshire,
Fall 1990**
1990
cat. no. 29

Rodney Graham
**Oak, Banford,
Oxfordshire,
Fall 1990**
1990
cat. no. 28

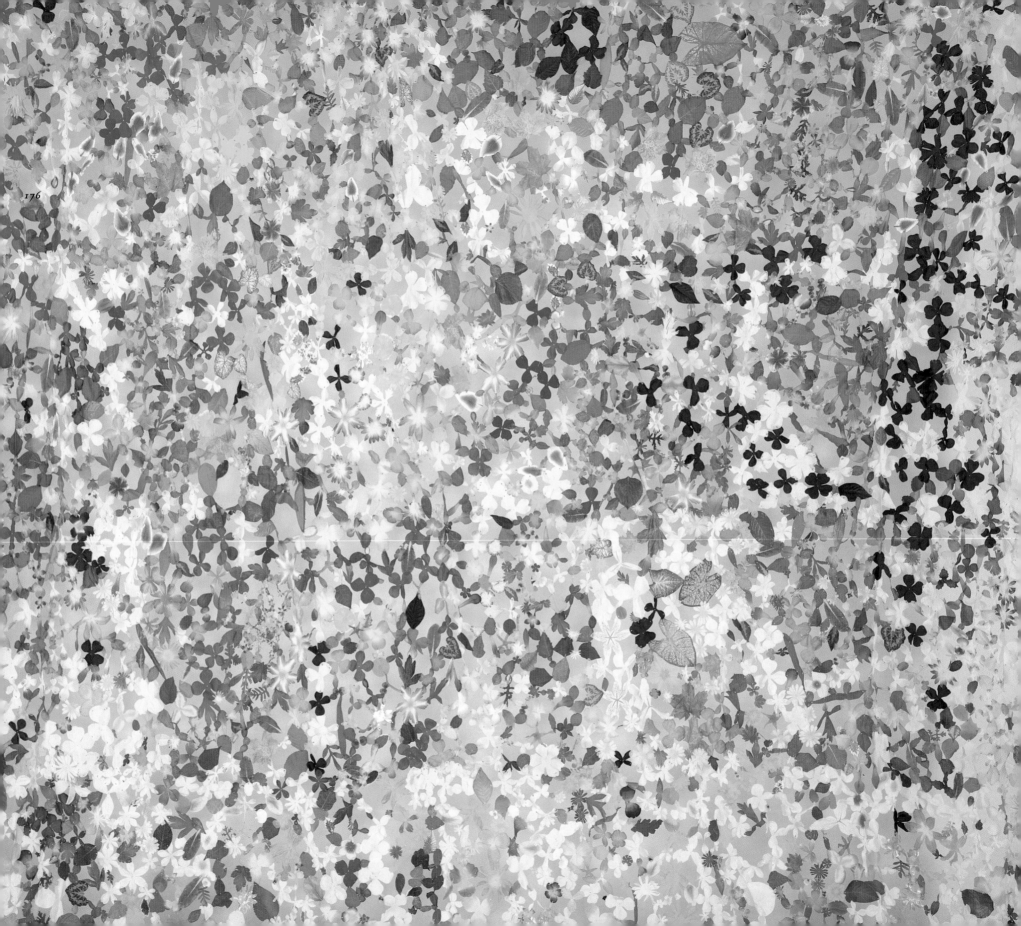

Jim Hodges
No Betweens
1996
detail
not in exhibition;
see cat. no. 30

Jim Hodges
Changing Things
1997
not in exhibition;
see cat. no. 30

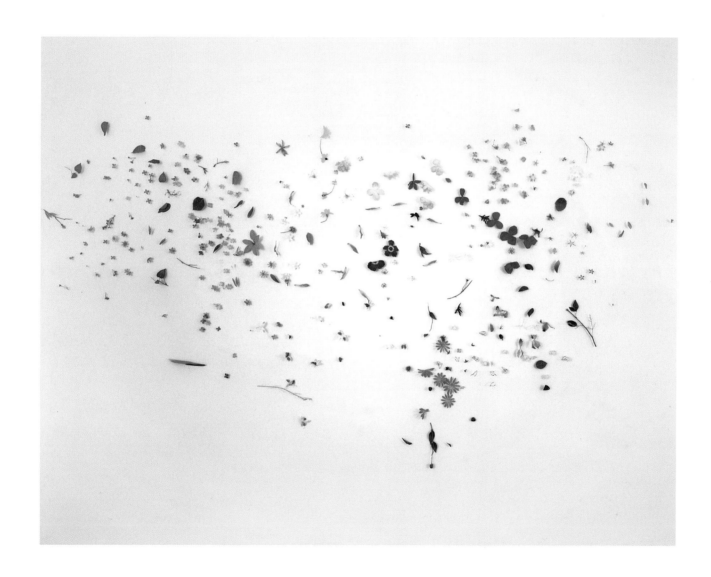

...hot is cold, day is night, lost is found, everywhere is nowhere, something is nothing, pain is pleasure, blindness is sight, hell is heaven, confinement is freedom, black is white, inside is outside, famine is surplus, bad is good, nature is synthetic, life is death, fiction is reality, equilibrium is crisis, doubt is faith, hypocrisy is honesty, feminine is masculine, open is closed, neglect is cultivation, laughing is crying, contaminated is pure, blessing is damnation, construction is demolition, blunt is sharp, sweet is bitter, satisfaction is frustration, depression is elation, nightmares are dreams, flying is falling, water is blood, truth is a lie, hate is love, trust is suspicion, shame is pride, sanity is lunacy, outside is inside, forward is backward, shit is food, dark is light, right is wrong, left is right, future is past, old is new, losing is winning, work is play, attraction is repulsion, screaming is silence, desire is fulfilment, I am you, you are me, fulfilment is desire, silence is screaming, repulsion is attraction, play is work, winning is losing, new is old, past is future, right is left, wrong is right, light is dark, food is shit, backward is forward, inside is outside, lunacy is sanity, pride is shame, suspicion is trust, love is hate, lies are truth, blood is water, falling is flying, dreams are nightmares, elation is depression, frustration is satisfaction, bitter is sweet, sharp is blunt, demolition is construction, damnation is blessing, pure is contaminated, crying is laughing, cultivation is neglect, closed is open, masculine is feminine, honesty is hypocrisy, faith is doubt, crisis is equilibrium, reality is fiction, death is life, synthetic is natural, good is bad, surplus is famine, outside is inside, white is black, freedom is confinement, heaven is hell, sight is blindness, pleasure is pain, nothing is something, nowhere is everywhere, found is lost, night is day, cold is hot...

Douglas Gordon Felix Gonzalez-Torres
Untitled "Untitled"
(Text for some place (Aparición)
other than this) 1991
1996 cat. no. 25
cat. no. 27

Felix Gonzalez-Torres
"Untitled"
(America #3)
1992
cat. no. 26-A

Felix Gonzalez-Torres
"Untitled"
(For New York)
1992
cat. no. 26-B

Fig. 56
Yves Klein
FC1 (Untitled Fire
Color Painting)
1961
cat. no. 33
detail

BEAUTY

Give unto them beauty for ashes, the oil of joy for mourning, the garment of praise for the spirit of heaviness. ISAIAH 61:3

If a significant enough number of artists today are seeking, independently of one another and each in his or her own way, to bring beauty into their art, one cannot but wonder if this is because art, since at least the time of the Dada movement, has been regarded as having for too long given ashes in place of beauty — the reverse of Isaiah's "good tidings." Dada understood itself as an attack against a society that, although dedicated to the fine arts, literature, and music, was at the same time prepared to send some 8,400,000 young men to their deaths in an unprecedentedly horrifying war. So the Dadaists determined to give society the kind of art it deserved — infantile, nonsensical, raucous, and buffoonish. Since a society is judged by its cultural achievements, Dada more or less constituted a kind of cracked mirror in which the society that made the war could perceive its moral ugliness. From the perspective of the late twentieth century, the immense disproportion between Dada's pranks on the one side and the horrendousness of the Great War on the other reveals how highly art and beauty must have been esteemed, if artists could suppose that depriving society of artistic beauty could begin to balance the scales or motivate society to change its ways. George Santayana's book *The Sense of Beauty* (1896) was published in the long twilight of the nineteenth century, which the World War brought crashing to an end. Many years later, writing to the aesthetician Thomas Monro, Santayana explained that in that period, "Beauty — which we must not speak of today — was a living presence or an aching absence night and day."[1] There is little

R ASHES

ARTHUR C. DANTO

reason to suppose Santayana ever became acquainted with Dada, but had he done so, he would have seen as mere impudence what its perpetrators regarded as acts of radical transvaluation. But we can get some sense for the meaning of beauty that prevailed in the era of Dada from Arthur Rimbaud's *Season in Hell* (1873): "One evening I sat Beauty on my knees; and I found her bitter, and I injured her." Before that violation, his life had been a feast "where every heart was open, and the wines all flowed."[2] Injuring beauty meant losing that world.

It is not as though the world has become an especially better place since Dada dressed art up in jester's motley and sought to catch the conscience of a war-making culture through aesthetic insubordination. Is a return to beauty, then, an acknowledgment of art's limitations when it comes to effecting social change? Or have artists come to sense a desolation to which they themselves have contributed – mere ashes, given the lingering hope for beauty? Is a return to beauty a gesture of reconciliation with a world desperately in need of it after what it has been through in the intervening decades – a kind of aesthetic amnesty? Or, finally, is the

the concept of art is but also that they have no internal relationship – that beauty is not a necessary condition for art. That art need not be constrained by aesthetic considerations was probably the major conceptual discovery in twentieth-century art. It effectively liberated artists from the imperative to create only what is beautiful, and at the same time freed the philosophy of art from having to concern itself with the analysis of beauty, which had been the central preoccupation of the discipline of aesthetics since its establishment in the eighteenth century, and which, in my view, accounted for the so-called dreariness of the subject. Dada's mission may not have been philosophical, but it was well in advance of the philosophy of its time in demonstrating that an object can still be art when its beauty is replaced with some of beauty's opposites – the silly, the abrasive, the infantile. From this it follows that creating beauty is but one option for artists, who also have the choice of injuring or merely disregarding beauty, to mention two others.

Whatever Dada's success in dissociating art from beauty, it did not separate art from aesthetics entirely, since many of Dada's effects constitute negative aesthetic values – values like abrasive-

One evening I sat Beauty on my knees; and I found her bitter, and

return a concession that in a futile effort to modify social awareness, art has sacrificed precisely that which gives it its deepest meaning? Perhaps withholding beauty is no less deep a moral infraction as much of what deliberately de-beautified art criticizes. Why should anyone believe an artist who inveighs against the way the environment is treated yet whose own work gives ashes instead of beauty?

These questions arise against a philosophical question of what the relationship between art and beauty really is. And it was in posing that question that Dada may have made its greatest contribution, demonstrating not only how open and accommodating

ness, for example, or willed indecorousness. Beauty is not the only positive aesthetic quality, nor ugliness the only negative one. Our aesthetic vocabulary is exceedingly subtle and rich, as philosophers sensitive to the nuances of usage came to discover: the leader of the Ordinary Language School of philosophical analysis J. L. Austin wrote, "If only we could forget for a while about the beautiful and get down instead to the dainty and the dumpy."[3] Or to the "unified, balanced, integrated, lifeless, serene, somber, dynamic, powerful, vivid, delicate, moving, trite, sentimental, tragic" – to preempt a partial list provided by Frank Sibley in his masterly essay "Aesthetic Concepts."[4] So in substituting for beauty a range of

negative aesthetic qualities, Dada did not divide art from aesthetic qualities as such. But once again the Dadaists were not philosophers, concerned to frame definitions. They were activists and moralists, out to change society and in the process have a marvelous time.

It is to Marcel Duchamp that we must turn to find, particularly in his readymades of 1915–17, the most radical dissociation of aesthetics from art. "A point which I very much want to establish is that the choice of these 'readymades' was never dictated by aesthetic delectation," Duchamp wrote in 1961. "The choice was based on a reaction of visual indifference with at the same time a total absence of good or bad taste … in fact a complete anesthesia."[5] In 1924, Duchamp made it clear that finding an object with no aesthetic qualities was far from simple, but we can get a sense for his intention if we consider his *Comb*, 1916 (no longer extant), which Calvin Tomkins describes as "the most serenely 'anesthetic' of all Duchamp's readymades."[6] No one can be said to have either good or bad taste in metal grooming combs! They exemplify the principle of the readymade inasmuch as they contain "no beauty, no ugliness, nothing particularly aesthetic about it," and from that perspective, one of them is as good as any other. We can see how little Duchamp's closest associates understood his agenda from the fact that Duchamp's patron, Walter Arensberg, imagined the artist's intent in submitting a urinal [*see fig. 6*] to the Society of Independent Artists exhibition in 1917 was to draw attention to

porcelain surface. That crude signature is a perfect Dadaist gesture, of a piece with drawing a moustache on the *Mona Lisa* [*see fig. 5*]. The same presumption that art must be beautiful is palpable in the way Alfred Stieglitz photographed the work, after it had been rejected. It looks rejected and melancholy in Stieglitz's image, with its sad entry label dangling from one of its holes. Stieglitz paid special attention to the work's internal shadows, which he believed resemble, in shape, "anything from a Madonna to a Buddha."[9] Both Arensberg and Stieglitz more or less took it for granted that if something was art, it had somehow to be beautiful. It was that assumption that Dada cracked permanently.

The readymades served to disconnect the concept of art from the whole tradition of philosophical aesthetics, which – through its greatest exemplar, Immanual Kant's *Critique of Judgment* (1790) – made taste the central factor in the analysis of beauty. In making art out of objects in neither good nor bad taste, Duchamp was no more interested in injuring aesthetic sensibility than he was in gratifying it. His view was that taste – good or bad – was the "enemy of art."[10] Since he presented his first readymade, consisting of a bicycle wheel [*fig. 57*], in 1913, it is clear that Duchamp's investigations were in response not to the moral failings of society but to a disinterested question concerning the philosophy of art. His practice was to strip away from art as many of its traditional attributes as occurred to him, much as a bachelor strips the bride of hers. From Duchamp's ironic perspective, Dada's polemical use of bad taste

d her. ARTHUR RIMBAUD, 1873

a "lovely form"[7] and to the formal parallels between this piece of industrial plumbing and the sculpture of Constantin Brancusi.[8] How deeply Arensberg was situated in the world targeted by Dada may be inferred from his having failed to perceive the ugly "R. MUTT 1917" with which Duchamp smutched *Fountain*'s white

would have been part of the same complex it intended to injure by means of it. New York Dada, to which Duchamp belonged, had run its course before America entered the war. *Fountain* was in Stieglitz's Gallery 291 when it closed in March 1917 because of the war.

It is important to recall Duchamp's own somewhat ascetic point of departure. In remark upon remark, Duchamp polemicized against aesthetic delectation and hence against art made deliberately to gratify the senses. He saw art as a much higher activity than beautification. He saw it as intellectual and analytical. When he said that painting was dead, as he did in a legendary discussion with Brancusi and Fernand Léger [*see fig. 12*] in 1913, when they were looking at a propeller in an aeronautical exhibition, he was tacitly considering painting in sensuous terms. And he sought to put art on an intellectual level in every way parallel to that of science. Aesthetics, in his view, plays no greater role in art than it does in science, however intimately art and aesthetics had been judged to be in history. His attitude was Platonist, in effect, in view especially of Plato's notorious attack on the senses as conducive to illusion and false beliefs. Socrates praised the form of Beauty and distinguished it from its various instances in the world of senses — the paintings, the poems, the tragedies art lovers cherish.[11] "Beauty bare,"[12] unmingled with the senses, is to be grasped through an act of intellectual insight, hence unaesthetically. It is the form rather than the instances of beauty we must love.

Etymologically, "aesthetics" derives from the Greek word for sense experience. Thus, were one asked to explain how one knows something to be red or sweet, it would have been appropriate to say that ones knows it aesthetically, that is, through the senses. The section of Kant's *Critique of Pure Reason* (1781) that discusses

learned German usage. That usage derived from a volume explicitly titled *Aesthetics* (1750), by A. G. Baumgarten, which Kant in a footnote described as seeking "to bring the critical treatment of the beautiful under rational principles, and so to raise its rules to the rank of a science."[13] Kant urged his readers to "give up using the name in this sense." But a cultivated taste had come to distinguish an ideal human personality in the eighteenth century. Men and women were concerned that they be perceived as having good taste in clothing, decor, works of art, books, and manners — and such works as William Hogarth's *Analysis of Beauty* (1743) or Sir Joshua Reynolds's *Discourses* (1768–69) had precisely that audience in mind. Kant came to realize that an analysis of human beings that left the critique of taste out of the picture would be radically incomplete.

In a famous passage in his *Critique of Practical Reason* (1788), a book dealing with the metaphysical foundations of moral judgment, Kant wrote that two things moved him profoundly whenever he thought of them – "the starry heavens above and the moral law within."[14] Together these imply a conception of humans as cognitive and moral beings, responsive through different features of our makeup to natural and moral laws. The fact that Kant came to write his great treatise on aesthetic judgment – using the term "aesthetic" now in the precise sense given to it by Baumgarten – is evidence that he recognized that there is more to rational beings than a capacity to understand science and make moral judgments.

I threw the bottle rack and the urinal in their face

the senses' role in human cognition is thus called *Transcendental Aesthetic*. Here, Kant is really concerned with identifying certain forms through which the world as sensed is experienced; he is anxious to distinguish his appropriation of the term from the "critique of taste," which aesthetics had only recently come to mean in

A person without taste is not fully a human being, as the Enlightenment conceived of it. It is instructive to realize that Duchamp's readymades seem to have been chosen with just such persons in view. There can be no basis in taste for distinguishing one grooming comb from another. But that would be the case

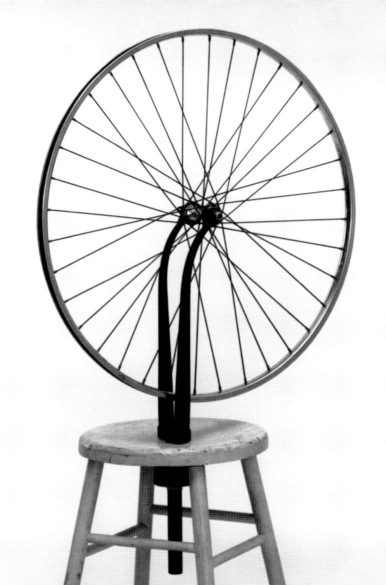

allenge, and now they admire them for their aesthetic beauty. MARCEL DUCHAMP, 1962

for everything, so far as what we might term the "aesthetically impaired" is concerned. It is the mark of such impairment that it would be impossible to explain what we respond to when we identify objects as beautiful. Strictly, we see nothing that such a person does not see. It is not as though they suffer from a deficiency like color blindness (although the early aestheticians postulated a sixth or seventh sense to account for the perception of beauty). So we cannot point to some item in the sensory array and say, as we can with red, that that is what we mean by beauty. Here, there might be an analogy with the morally impaired, who cannot grasp what is meant by calling something good or bad, right or wrong, but who see everything the rest of us see who regard these distinctions in some way fundamental to human life.

Beauty is a grading concept, under which – as with good, better, best – objects can be ranked from least to most beautiful. But when there are no differences among objects, there is no way to grade them differentially. If two things are in every perceptual respect exactly alike, then one cannot say that either of them is more beautiful than the other. So if one *can* say that, the objects must differ in some observable way. (This applies to the idea of goodness as well: two things or acts cannot be exactly alike, though one is good and the other not.) A group of grooming combs cannot, as said, be differentiated on grounds of beauty. This explains why it was important to the notion of readymades that the objects be mass-produced (a conception unavailable to Kant). Given a

buildings as much like one another as one grooming comb is like another. This would apply as well to urinals from the inventory of J. L. Mott Iron Works. It is possible that those urinals listed in the catalog as porcelain "flat back 'Bedfordshire' urinal, with lip"[15] were more appealing, aesthetically, than any of Mott's other urinals. But as between one flatback Bedfordshire urinal and another, no rational ground could exist for selecting one rather than any other. To the question of why he picked the one he did, Duchamp could merely say that the choice was inherently arbitrary. A remark on Andy Warhol's aesthetics might be in order here. Warhol saw American society as a world of readymades, between which no choice could make sense. "All Cokes are the same, and all cokes are good," he wrote on one occasion.[16] There is no way in which the Queen of England can get a better hot dog than the bum on the corner, he wrote on another. In such a world, one of Warhol's greatest pleasures would be ruled out, the pleasure, namely, of shopping. His most famous collection was of cookie jars [*fig. 58*]. But if all cookie jars are the same and all cookie jars are good, one would not require taste in choosing between them. One would "just choose" – as between cans of Campbell's tomato soup. "Campbells. Campbells. Campbells. Campbells," as Michel Foucault said in concluding an essay on René Magritte.[17]

These somewhat arid reflections help specify what must be the case when "beauty" is used as a grading concept. It must apply in such a way that the only difference between two things cannot

Beauty … in things … exists merely in the mind which contemplates them.

batch of metal grooming combs, one could not comply with an order to pick out the most or least beautiful. That perhaps explains why Duchamp finally decided that the Woolworth Building was not suitable as a readymade. It could serve that purpose only if there were an indefinitely large set of skyscrapers, the individual

be that one is beautiful and the other not. If x is beautiful and y is not, they have to differ in some other way. The aesthetically impaired can, let's suppose, see how two such objects differ. But he or she might then want to know if "beauty" simply refers to this difference, and, if not, on what basis can we claim the one to be

Fig. 58
Andy Warhol with his
cookie-jar collection
March 1974
New York

beautiful and the other not? The term "beautiful" would impress such a person as being otherwise meaningless. The best he or she might do to acquire a reputation for taste is to learn to distinguish what others call beautiful from that from which they withhold the term, by paying attention to the differences between them. They might always be right – but we would certainly not think of them as persons of taste and discernment if we knew how they arrived at their judgments. A person of taste should be able to make such choices without depending upon what others say. So upon what can taste depend?

As a man of his times, Kant had to have been in some degree a man of taste. But as a philosopher he clearly remained uneasy about such a notion. It seemed plain to him that questions of taste were not objective, in the specific sense that terms such as "beautiful" make reference to no objective features in the sensed world, and so "is beautiful" cannot express a piece of knowledge about the world. In this respect he would have held that there could be no science of the beautiful, of the kind Baumgarten presumably sought. The "determining ground" of aesthetic judgment could accordingly be "no[ne] other than subjective."[18]

It is important to stress that subjectivity does not mean relativity. Kant, in fact, thought that judgments of taste had to be universal to be valid. Persons inevitably differ in their subjective makeup. But this does not entail that everyone is always right, which is what makes relativism at once so difficult to respond to and to attack. In ancient philosophy the claim was made by one of the Sophists, Protagoras, that each man is the measure of truth – a thesis Socrates wrestled with throughout his life, since it was central to his project that it be possible to be wrong. How it was possible to make a false statement was the defining problem of his constant investigations into moral truth. But of course he recognized subjective differences and sought to explain how persons may differ subjectively – how some can be philosophers and some

cannot (in *The Republic*), how some have good, clear memories and others have indistinct recollections (in *Theatetus*). And persons have different thresholds of pain and pleasure, which are what Kant had in mind by subjective states. Pleasure (or pain) is not an objective feature of an object – it is a subjective feature induced by how those objects affect us. In itself an object could not be painfully bright. It can be that only if its brightness causes pain to someone's photophobic eyes.

Relativism enters the area of beauty only when it is discovered that the members of one culture receive aesthetic pleasure from objects to which those from another culture may be indifferent, or which give them pain. The possibility of such otherhood only began to enter European consciousness in Kant's time, when engravings appeared in conjunction with Captain Cook's expeditions in the South Seas [*fig. 59*]. The engravings would have been done in the spirit of science – of revealing how things were in truth, as in photographs for the *National Geographic* or videos on the Discovery Channel. Europeans felt they knew about aborigines in the New World through images showing the natives, for example, as cannibals, chewing away on unmistakably human haunches. These propagandistic pictures justified going forth to convert the savages, and to take away their gold to pay for it. Pictures have always had a considerable forensic value, which photographs shared until the age of digitalization. I remember a historian of science – Lorraine Dastin – lecturing on the history of

monsters. She described a bull with a sort of monk's cowl that caused wonderment in the sixteenth century. A scholar responded to that information by saying that had he not seen the picture – a wood engraving – he would never have believed such a beast existed.

At one point in the *Critique of Judgment*, Kant states: "We could adorn a figure with all kinds of spirals and light but regular lines, as the New Zealanders do with their tattooing, if only it were not the figure of a human being."[19] I surmise that Kant had to have seen an engraving of aboriginal tatooing, but what interests me is that he considers it adornment, and sets against it a different aesthetic – that the human body does not require adornment to be beautiful – thus implying that New Zealanders had a different conception of beauty. Anthropological knowledge was scarce in the eighteenth century, and it did not occur to Kant at least that the system of spiral lines may have had a meaning, that it was not accessory but perhaps enhancement and empowerment that a warrior acquired when he submitted to the exceedingly painful procedures of tattooing. The spirals connected him to the forces of the universe. It was not that the New Zealanders had a different conception of beauty, but that beauty did not arise as a concept in connection with tattoos, any more than it does, say, with circumcision, which hardly is done for aesthetic purposes, but rather, for medical reasons or as the sign of a covenant. This is generally true of architectural ornament, which almost always has its origins in

59

Fig. 59
William Hodges
**Head of a Maori
Man**
c. 1775
*pen and ink
on paper*

Fig. 60
Mark Rothko
Blue, Orange, Red
1961
oil on canvas

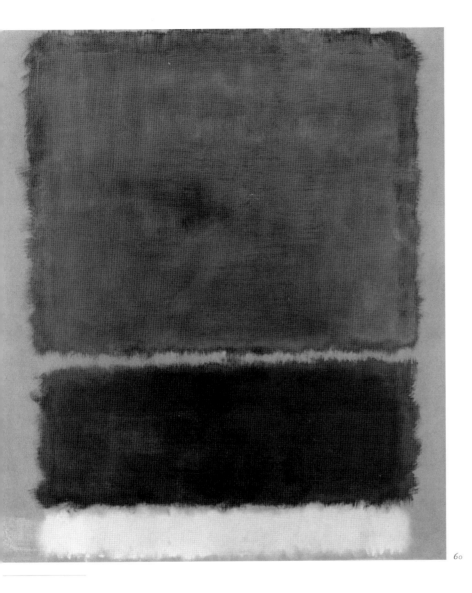

60

beliefs under which the tattoo has a cosmic meaning. And I think this is quite general. I believe it is in reading the spiral – or whatever – as an effort to beautify that one infers that beauty is relative, taking into consideration that extraordinary range of mutilations and scarifications we find in the museum of mankind. What made beauty itself so central in the eighteenth century was that art had no function except to be beautiful. The fine-arts museums assembled objects that may have had deep functions to perform in various forms of life, and gave them nothing to do – those forms of life having vanished – but please the eye.

Kant's analysis of "*x* is beautiful" is that "*x* pleases,"[21] which would explain why beauty could not be objective since pleasure is subjective. Santayana, who had the idea that beauty consists in projecting pleasure onto its causes, hence famously defined beauty as "pleasure objectified."[22] It is a subjective state that we read as an objective state only because we have projected the pleasure outward and onto the things we claim are beautiful. We can get a sense for this if we think of the way a gourmet projects the anticipated pleasure onto the dish he is about to eat, or the connoisseur of fine wines vests a glass of claret with the pleasure it will bring. But for just that reason, the objectification of pleasure cannot be an analysis of beauty, since the phenomenon would have many instances. But even with the favored case – beauty in the fine arts – Santayana's theory would be somehow too thin to account for beauty, though it might be a plausible premise for prettiness. More important, however, "Because it is beautiful" explains why something causes pleasure, so it would have to mean something different from that. It would only be in the eighteenth century that one would have thought of art as prompting pleasure. Does one feel pleasure in looking at Mark Rothko's paintings from his great period [*fig. 60*]? Well, maybe some do, but most of us feel something deeper than pleasure, which holds us in front of the paintings as if waiting for the disclosure of a possibly shattering truth. Pleasure can

some function beyond that of architecture. Indeed, it makes no contribution to the architecture of a building at all, which is why functionalists deplore ornament, finding it meaningless and distracting. It bears, rather, on the meaning of the building.

In any case it is important to distinguish somewhere between beauty and beautification. The paradigm of beautification is cosmetics, which derives from the Greek word *kosmos* and refers to order and arrangement. The dictionary tips its hand in defining it as "decorative or superficial rather than functional,"[20] but I would suppose the spiral tattoo looks to outsiders as a curious form of bodily decoration because they are too distant from the system of

be a component in the experience, which includes too much else for it to be a measure of the whole complex, the way it is inadequate to describe the whole of sex in which it plays an undeniable part.

Beyond this, pleasure does not discriminate between artistic beauty and natural beauty.[23] It is interesting to note that Kant did not treat that distinction as especially important – or he appealed to natural beauty to explain artistic beauty, as he could only have done when art was considered imitative, and the beauty of the work a function of the natural beauty of the subject, providing the imitation was sufficiently transparent, that is, did not draw attention to itself. So the pleasure elicited by the painting would be that by the subject of the painting, were we to be in front of it. The concept of taste, which defined the eighteenth century in part, fell out of the aesthetic equation in the nineteenth. In his *Lectures on Aesthetics*, perhaps the greatest work devoted to the philosophy of art, Friedrich Hegel wrote: "The depths of the thing [that is, art] remained a sealed book to taste, since these depths required not only sensing and abstract reflections but also the entirety of rea-

as an analogy. In moral judgment, he writes, "The final sentence depends upon some internal sense or feeling.... But in order to pave the way for such a sentiment, and give a proper discernment of its object, it is often necessary, we find, that much reasoning should precede."And this is paralleled not in the concept of beauty as such but in the beauty of art. He continues:

Some species of beauty, especially the natural kinds, on their first appearance, command our affection and approbation, and where they fail of this effect, it is impossible for any reasoning to redress their influence, or adapt them better to our taste and sentiment.... [But] in many orders of beauty, particularly those of the finer arts, it is requisite to employ much reasoning, in order to feel the proper sentiment; and a false relish may frequently be corrected by argument.... There are just grounds to conclude that moral beauty partakes much of this latter species.[25]

I love this passage, in part because so much of our century's own concept of beauty seems to correspond to what Hume restricts to natural beauty – that it smacks you in the eye, that if you have to ask questions, you don't understand, that beauty is like a blow

Beauty – which we must not speak of today – was a living presence or an ach

son and the solidity of spirit, while taste was directed only to the external surface on which feelings play.... So-called 'good taste' takes fright at all the deeper effects of art."[24]

Hegel delivered these lectures for the last time in 1828, when Romanticism was at the flood. But in fairness, the eighteenth-century Scottish philosopher David Hume drew the distinction in what I regard as a fundamental way when he used the sense of beauty to help adjudicate the question of whether moral judgments appeal to moral sentiments (or feelings) – which may be innate – or to reasons. That was a powerful distinction in Hume's time, and he sought to resolve it through considering judgments of beauty

to the head. What Hume has done has been to build the structures of art criticism into the assessment of artistic beauty. We arrive at the judgment of beauty only after critical analysis – which means that it is finally not subjective at all, since it depends on the kind of reasoning in which criticism at its best consists. "The first merit of a picture is to be a feast for the eyes," Eugène Delacroix wrote in his *Journal*. "That is not to say that reason is not needed in it."[26] The former attitude is embodied in a particularly spiteful work by Jasper Johns, *The Critic Sees*, 1961 [*fig. 61*], in which Johns has placed mouths behind a pair of glasses where eyes should be. Doubtless the critic should look. But seeing is inseparable from reasoning, and

response to a work of art is mediated by a discourse of reasons parallel entirely to what takes place in dealing with moral questions.

Hume cites "Truth is disputable, not taste"[27] as a reason someone might give who believes that whether or not something is to your taste cannot seriously be argued. This may be true, Hume admits, with natural beauty, though on genetic grounds it can be argued that naturally beautiful things are experienced as beautiful by most people. A similar outcome can be postulated for disagreements over art, Hume argues in a famous essay "Of the Standard of Taste," in which he proposes that there is an inevitable consensus — much as there is with truth, if truth is what everyone qualified to have an opinion agrees on. But the important point is that arriving at a correct aesthetic judgment is an outcome of reasoning, as much so as a factual belief. That implies that the parties to any dispute be open. Hume wrote "Beauty is no quality in things themselves: It exists merely in the mind which contemplates them," which has been popularly sloganized as "Beauty is in the eye of the beholder."[28] But for eighteenth-century philosophy, everything was in the mind of the beholder. The difference between judging something as beautiful and judging it to be red is that whereas you cannot talk a blind man into seeing red, you can finally talk someone into seeing that something is beautiful. When the National Gallery of Canada purchased Mark Rothko's *Number 16, 1957*, in 1993, the press and the parliament were in an uproar. Their reaction in part was owed to the fact that so much money was

spent on a non-Canadian artist — and insult of insults, on an American. But mainly it was an expression of bafflement: how could anything that looked like that be worth anything? A child could do it. Indeed, one of the mad-dog tabloids of Toronto held a contest to see which child did the best Rothko.[29] Compare this with the way the ranchers in California came to appreciate the beauty of Christo and Jeanne-Claude's *Running Fence* [*fig. 62*]. They had participated in a discourse, had internalized the explanation of the work, and were profoundly stirred, as if by an ephemeral Great Wall running down to the sea. In one of the Maysles Brothers's films, a rancher slept with his herds next to the fence. It was a powerfully moving scene.

This brings me once more to Hegel. In *Lectures on Aesthetics*, Hegel speaks of artistic beauty as higher than natural beauty. It is so, he says, because "The beauty of art is beauty born of the spirit and born again."[30] "Spirit" is not a term congenial to the American temperament, and indeed we have no word in English that quite corresponds to *Geist* in German. But Hegel intends that we should see art as a product of spirit and hence something for whose existence there are reasons we can grasp. Since only humans are spiritual beings, to understand a work of art is like understanding another person through understanding his or her internal states, and accounting for the person's outward behavior in terms of such an internal state. Hegel's thought, like Hume's, is that artistic beauty is in part cognitive. It holds a truth. It may not be entirely clear

Fig. 61
Jasper Johns
The Critic Sees
1961
sculptmetal over
plaster with glass

ence night and day. GEORGE SANTAYANA, 1928

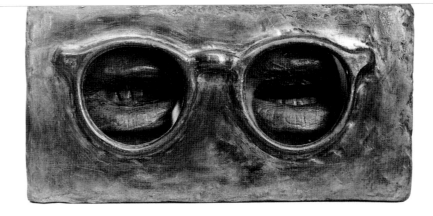

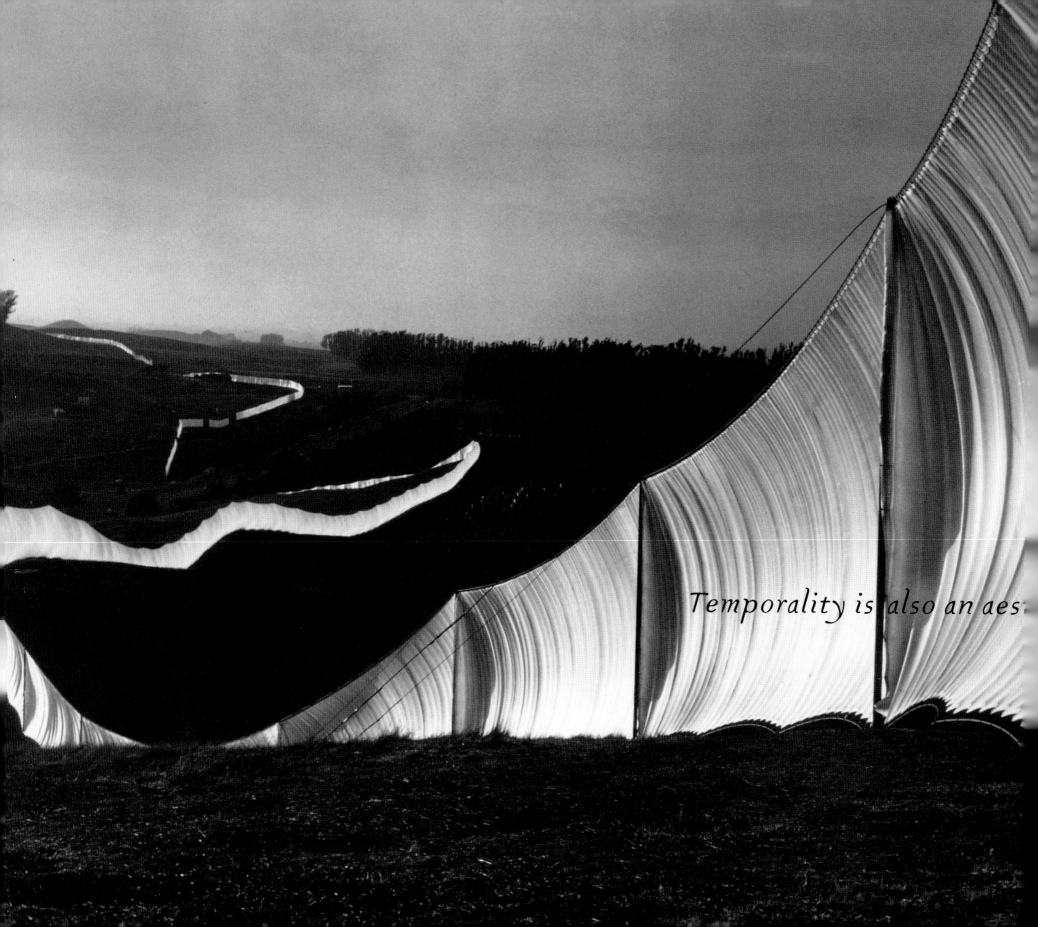

Temporality is also an aes

what the truth is – but beauty is the outward sign or embodiment of a truth to be discovered. Hegel goes so far as to say that in its "highest vocation," art, together with philosophy and religion, marks what he calls Absolute Spirit. In its highest form, art projects the highest truths of spirit in sensuous form. Like Duchamp, Hegel regards art as inferior to philosophy because beauty has a sensuous component. Whatever the case, beauty is at the intersection of sensuousness and truth. "Spiritual culture," he writes, "produces this opposition in man which makes him an amphibious animal, because he now has to live in two worlds which contradict one another."[31] The "vocation of art" is "to unveil the truth in the form of sensuous artistic configuration." And finally, "The beauty of art is one of the means which dissolve and reduce to unity the above mentioned opposition and contradictions."[32]

Genius that he was, Hegel would have had no way to think of art as we have learned to think of it since Dada and Duchamp: as not necessarily beautiful at all. Yet his thesis in a general way stands: what art, beautiful or not, presents us with is a truth of spirit – a proposition, if you wish – in a sensuous medium. The visual artist finds a way of presenting truth, whether that way is beautiful or not. Hegel recognized that beauty is but one of the means for overcoming the difference between sense and reason. Such means are found in the daily practice of art criticism, I think. There has to be some connection between the "sensuous artistic configuration" and the truth it expresses. Works of art, like we humans, have an amphibious nature, living at once in the two worlds of spirit and sense. Natural beauty does not have this oppositional structure, not unless we think of nature as the Hudson River school painters did, as the language through which God communicates his grandeur. We may in one sense perceive a beautiful work of art – such as a painting by Rothko – in the same way as we perceive anything beautiful – such as the brilliance of a sunset. What makes the former experience humanly meaningful is the way beauty acquires meaning against the background of reason. "Now art and works of art, by springing from and being created by the spirit, are themselves of a spiritual kind, even if their presentation assumes an appearance of sensuousness and pervades the sensuous with the spirit."[33]

In my own somewhat less-exalted view, it is required that artistic beauty be part of the meaning of the work, internally connected with its truth.[34] I speak of this as internal as against external beauty, which is indeed but skin-deep. This structure once occurred to me in considering what was profound in Robert Motherwell's greatest "Elegies to the Spanish Republic," 1948–91 [*fig. 63*]. As an object, I thought, the "Elegies" are beautiful in a way that may be indifferent to the distinction between natural and artistic beauty, much as that distinction would have appeared to Kant. But I wondered what the beauty of the forms had to do with the terrible reality of the Spanish Republic's defeat. And I thought then of the role beauty plays in the way we respond to death – associating the dead

Fig. 62
Christo and Jeanne-Claude
Running Fence,
Sonoma and Marin
Counties, California
1972–76

Fig. 63
Robert Motherwell
Elegy to the Spanish
Republic, 108
1965–67
oil on canvas

quality.

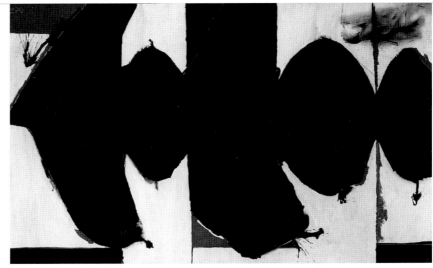

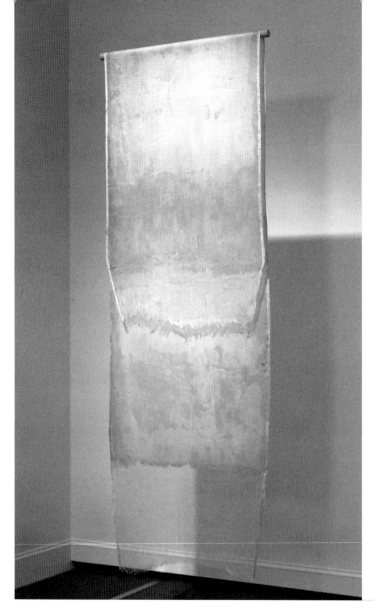

Fig. 64
Eva Hesse
Test Piece for "Contingent"
1969
latex over
cheesecloth

with flowers, reading poetry, listening to the deceased's favorite music. An elegy creates a portrait in words of the departed's best characteristic. The meaning of Motherwell's beauty is internally related in this way to what the painting is about. It makes the anti-beauty of Dada all at once look morally shallow. Beauty might have yielded a significant means of criticizing the values of the society they deplored, using one value to defeat another – giving beauty for ashes.

This internalist model will have to be adopted by those who seek to bring beauty back into art. But it impossible to predict how it will work. In a sense, much of contemporary art is in the Dada spirit, as artists have found ways of voicing their political concerns. And the pluralism that has overtaken the art world, which has entailed that nothing can be ruled out as art, must cause us to wonder how some works can be made beautiful. How, for example, could Robert Morris make beauty out of randomly strewn scraps of felt? Or, supposing she were interested in doing so, how would Eva Hesse have made beauty of a length of latex-soaked cheese-cloth [*fig. 64*]? (Though a beautiful woman, Hesse deplored the idea of beauty in art.[35]) Beauty would have been inconsistent with

The beautiful is that which apart f

the implications of these works, and making them beautiful would be like painting roses red, as they do in Alice in Wonderland. Such work as Morris's and Hesse's have their own aesthetic qualities, internally related to the meanings their works are intended to have. We know in a general way how beauty relates to the traditional forms – with painting, sculpture, and drawing, and most particularly with the crafts. But these occupy only a small sector of artistic production today. Happily, that is not our problem. It is a problem, however, for the artists bent on bringing their art together with beauty once again, whatever their reasons. A philosopher can only demand that the beauty be internal, and that the connection between it and the meaning of the work be accessible through reason.

1
George Santayana, 1928, *The Letters of George Santayana*, ed. Daniel Cory (New York: Scribners, 1055), 238–39.

2
My translation of *"Un soir, j'ai assis la Beauté sur mes genoux—Et je l'ai trouvée amère,—Et e l'ai injuriée"* and *"Jadis, si je me souviens bien, ma vie etait un festin, ou s'ouvrait tous les coeurs, ou tous les vins coulait"* (Yesterday, if I remember well, my life was a banquet, where every heart was open, and the wines all flowed). From Arthur Rimbaud, *Une Saison en Enfer* (1873), in *Oeuvres complètes*, ed. Antoine Adam (Paris: Bibliothèque de la Pléiade, 1972), 95.

3
J. L. Austin, "A Plea for Excuses," *Philosophical Papers*, ed. J. O. Urmson and G. J. Warnock (Oxford: Clarendon Press, 1961), 131.

4
Frank Sibley, "Aesthetic Concepts," *Philosophical Review* 68, no. 4 (1959): 421.

5
Marcel Duchamp, "Talk at the Museum of Modern Art, October 19, 1961." Reprinted in Michel Sanouillet, ed., *Salt Seller: The Writings of Marcel Duchamp* (Oxford and New York: Oxford University Press, 1973), 141.

6
Calvin Tomkins, *Duchamp: A Biography* (New York: Henry Holt, 1996), 160.

7
Walter Arensberg, "A lovely form has been revealed, freed from its functional purpose, therefore a man has clearly made an aesthetic contribution." Quoted in Beatrice Wood, *I Shock Myself: The Autobiography of Beatrice Wood* (Ojai, California: Dillingham Press, 1985), 29.

8
Tomkins, *Duchamp*, 186.

9
Stieglitz quoted in "Van Vechten to Gertrude Stein," *Letters of Carl Van Vechten*, ed. Bruce Kellner (New Haven, Connecticut: Yale University Press, 1987), 24. Cited in Steven Watson, *Strange Bedfellows* (New York: Abbeville Press, 1991), 318.

10
Duchamp quoted in ibid.

11
Plato, *Symposium*, 206 c–e; *Republic*, 479 e.

12
From Edna St. Vincent Millay, Sonnet 22, Part 4, in *The Harp-Weaver and Other Poems* (New York and London: Harper, 1923), 70.

13
Immanuel Kant, *Critique of Pure Reason*. Trans. Norman Kemp Smith (London: Macmillan, 1963), 66, note *a*.

14
Ibid., "Conclusion," *Critique of Practical Reason*, in *Critique of Practical Reason and Other Writings in Moral Philosophy*. Trans. Lewis White Beck (Chicago: University of Chicago Press, 1949), 253.

15
Kirk Varnedoe and Adam Gopnik, *High and Low: Modern Art and Popular Culture* (New York: Museum of Modern Art, 1991), 276.

16
Andy Warhol, *The Philosophy of Andy Warhol (From A to B and Back Again)*. New York: Harcourt Brace Jovanovich, 1975), 100–101.

17
Michel Foucault, *This Is Not a Pipe*. Trans. James Harkness (Berkeley and Los Angeles: University of California Press, 1983), 61.

18
Kant, *Critique of Judgment*. Trans. J. H. Bernard (New York: Hafner, 1951), section 1, 37.

19
Ibid., 16.

20
The American Heritage Dictionary of the English Language, 1973, s.v. "Cosmetics."

21
Kant, *Critique of Judgment*, section 1, 37.

22
Santayana, *The Sense of Beauty* (New York: Scribners, 1896), 52.

23
Kant, *Critique of Judgment*, section 45, 149. "Through [beautiful art] is designed, it must not seem to be designed, i.e., beautiful art must look like nature."

24
G. W. F. Hegel, *Aesthetics: Lectures on Fine Arts*. Trans. T. M. Knox (Oxford: Clarendon Press, 1975), vol. 1, 34.

25
David Hume, *An Enquiry Concerning the Principles of Morals*. Section 1 in *Moral and Political Philosophy*, ed. Henry D. Aiken (New York: Hafner, 1948), 178.

26
Eugène Delacroix, *The Journal of Eugène Delacroix*. Trans. Walter Pach (New York: Crown, 1948), 700.

27
Hume, *An Enquiry*, 178.

28
Ibid., "Of the Standard of Taste" (1757) in *The Philosophical Works*, 4 vols., ed. Thomas Hill Green and Thomas Hodge Grose (Aalen, Germany: Scientia Verlag, 1964), vol. 3, 268. Reprint of *Essays: Moral, Political, and Literary*, vol. 1 (London, 1882). "Beauty is in the eye of the beholder" is attributed to

29
Margaret Wolfe Hungerford in *Molly Brown* (1878) according to John Bartlett, *Familiar Quotations*, 14th ed. (Boston and Toronto: Little, Brown, 1968), 831.

29
I recently saw *Number 16* at the exhibition of Rothko's work at the Whitney Museum of American Art (September 10–November 29, 1998). It was, I felt, a very underfinished work. It was sold posthumously, and I wondered if Rothko would have let it go, had he still been alive. It makes it somewhat easier to sympathize with the Canadian press' response to the museum's acquisition of the work. But the violence of their attack was perhaps as reprehensible as the adamancy of the curatoriat in simply insisting what a great work it is. See my review "Mark Rothko" in *The Nation*, December 21, 1998, 31–34.

30
Hegel, *Aesthetics*, 2.

31
Ibid., 54.

32
Ibid., 56.

33
Ibid., 12.

34
See my "Beauty and Morality," in *Embodied Meanings* (New York: Farrar, Straus, and Giroux, 1994).

35
Cindy Nemser, "An Interview with Eva Hesse," *Artforum* 8, no. 9 (May 1970): 59–63.

cepts is represented as the object of a universal satisfaction. IMMANUEL KANT, 1790

In dimensions, height
precedes width and depth.

JANINE ANTONI

1 *Lick and Lather*, 1993–94
Seven chocolate and
seven soap busts
Each bust 24 x 16 x 13 in.
(61 x 40.6 x 33 cm)
Collection of Jeffrey Deitch,
New York
Illus. pp. 44, 45

JOHN BALDESSARI

2 *Pure Beauty*, 1967–68
Acrylic on canvas
45 3/8 x 45 3/8 in.
(115.3 x 115.3 cm)
Nancy Reddin Kienholz
Illus. p. 142

MATTHEW BARNEY

3 *CR4: Faerie Field*, 1994
© 1994 Matthew Barney
Photography:
Michael James O'Brien
4 C-prints in self-lubricating
plastic frames
Edition of 3
Each small image
17 1/2 x 12 3/4 x 1 1/2 in.
(44.5 x 32.4 x 3.8 cm)
Large image 27 1/2 x 33 1/4 x 1 1/2 in.
(69.9 x 84.5 x 3.8 cm)
Thea Westreich and Ethan Wagner
Illus. pp. 84–85

5 *CR1: Choreography of
Goodyear*, 1995
© 1995 Matthew Barney
Photography:
Michael James O'Brien
Diptych: 2 C-prints in
self-lubricating plastic frames
Edition of 6
Each image 27 3/4 x 33 1/2 x 1 in.
(70.5 x 85 x 2.5 cm)
Courtesy Barbara Gladstone
Gallery, New York
Illus. p. 81

6 *CR1: Goodyear Chorus*, 1995
© 1995 Matthew Barney
Photography:
Michael James O'Brien
C-print in self-lubricating
plastic frame
Edition of 6
43 3/4 x 53 3/4 x 1 in.
(111.1 x 136.5 x 2.5 cm)
Courtesy Barbara Gladstone
Gallery, New York
Illus. p. 79

7 *Cremaster 5:
Court of Chain*, 1997
© 1997 Matthew Barney
Photography:
Michael James O'Brien
Triptych: 2 C-prints and 1 black-
and-white in acrylic frames
Edition of 3

8 *Cremaster 5: her Giant*, 1997
© 1997 Matthew Barney
Photography:
Michael James O'Brien
C-print in acrylic frame
Edition of 6
52 3/4 x 42 5/8 x 1 in.
(134 x 108.3 x 2.5 cm)
Courtesy Barbara Gladstone
Gallery, New York
Illus. p. 83

LOUISE BOURGEOIS

9 *The She-Fox*, 1985
Marble
70 1/2 x 27 x 32 in.
(179 x 68.5 x 81.2 cm)
Camille Oliver-Hoffmann
Illus. p. 60

10 *Mamelles*, 1991
Rubber
Edition 3 of 6
19 x 120 x 19 in.
(48.2 x 304.8 x 48.2 cm)
Courtesy Cheim and Reid,
New York
Illus. p. 62

11 *Single III*, 1996
Fabric
17 x 25 1/2 x 83 in.
(43.2 x 64.8 x 210.8 cm)
Collezione Prada, Milan
Illus. p. 61

CATALOG OF THE *EXHIBITION*

4 *CR4: Loughton Manual*, 1994
© 1994 Matthew Barney
Photography:
Michael James O'Brien
C-print in self-lubricating
plastic frame
Edition of 6
25 x 21 x 1 1/2 in.
(63.5 x 53.3 x 3.8 cm)
Courtesy Barbara Gladstone
Gallery, New York
Illus. p. 80

Each C-print 35 1/8 x 29 1/4 x 1 in.
(89.2 x 74.3 x 2.5 cm)
Black-and-white print
41 3/4 x 34 1/4 x 1 in.
(106 x 87 x 2.5 cm)
Courtesy Barbara Gladstone
Gallery, New York
Illus. p. 82

VIJA CELMINS

12 *Untitled (Ocean)*, 1968
Graphite on acrylic ground
on paper
13 3/4 x 18 1/2 in. (34.9 x 47 cm)
Helen and Tony Berlant
Illus. p. 163

13 *Untitled (Big Sea #1)*, 1969
Graphite on acrylic ground
on paper
34 1/8 x 45 1/4 in.
(86.7 x 114.9 cm)
Private collection, New York
Illus. p. 161

14 *Untitled (Double Moon Surface)*,
1969
Graphite and resin (with
traces of ink) on paper
14 1/8 x 18 7/8 in. (35.8 x 47.9 cm)
Hirshhorn Museum and Sculpture
Garden, Smithsonian Institution,
Washington, D.C.;
Museum Purchase, 1998
Illus. p. 164

15 *Untitled (Ocean)*, 1970
Graphite on acrylic ground
on paper
12 3/4 x 17 1/2 in. (32.4 x 44.5 cm)
Collection of the Modern Art
Museum of Fort Worth;
The Benjamin J. Tillar Memorial
Trust, 1972
Illus. p. 162

16 *Galaxy (Cassiopeia)*, 1973
Graphite on acrylic ground
on paper
11 7/8 x 14 7/8 in. (30.4 x 37.6 cm)
The Baltimore Museum of Art;
Gertrude Rosenthal Bequest Fund,
1991
Illus. p. 160

17 *Night Sky #5*, 1992
Oil on canvas mounted
on wood panel
31 x 37 1/2 in. (78.7 x 95.3 cm)
Collection PaineWebber
Group, Inc.
Illus. p. 158

18 *Night Sky #11*, 1995
Oil on canvas mounted on
wood panel
30 7/8 x 37 1/8 in. (78.7 x 95.2 cm)
Collection Fondation Cartier
pour l'Art Contemporain, Paris
Illus. p. 157
[Washington, D.C., only]

19 *Night Sky #12*, 1995–96
Oil on canvas mounted on
wood panel
31 x 37 1/2 in. (78.9 x 95.3 cm)
The Carnegie Museum of Art,
Pittsburgh; The Henry L.
Hillman Fund, 1996
Illus. p. 159

WILLEM DE KOONING

20 *Woman, Sag Harbor*, 1964
Oil and charcoal on wood
80 x 36 in. (203.1 x 91.2 cm)
Hirshhorn Museum and Sculpture
Garden, Smithsonian Institution,
Washington, D.C.; Gift of
Joseph H. Hirshhorn, 1966
Illus. p. 54

MARLENE DUMAS

21 *The First People (I–IV)*, 1990
Oil on canvas
Four panels, each
70 1/4 x 35 1/8 in. (180 x 90 cm)
De Pont Foundation for
Contemporary Art, Tilburg,
The Netherlands
Illus. p. 59

LUCIAN FREUD

22 *Nude with Leg Up
(Leigh Bowery)*, 1992
Oil on canvas
72 x 90 in. (183 x 228.5 cm)
Hirshhorn Museum and Sculpture
Garden, Smithsonian Institution,
Washington, D.C.; Joseph H.
Hirshhorn Purchase Fund, 1993
Illus. p. 57

23 *Leigh under the Skylight*, 1994
Oil on canvas
117 x 47 1/2 in.
(297.2 x 120.7 cm)
Private collection
Illus. p. 58

24 *Benefits Supervisor Sleeping*,
1995
Oil on canvas
59 x 98 1/2 in. (150 x 250 cm)
The Collection of Guy +
Marion Naggar
Illus. p. 56

FELIX GONZALEZ-TORRES

25 *"Untitled" (Aparición)*, 1991
Offset print on paper
(endless copies)
8 in. (20.3 cm) at ideal height x
44 7/8 x 29 3/4 in. (114 x 75.6 cm)
FUCUTEL/Centro de Cultura
Casa Lamm A.C.
Illus. p. 179

26-A *"Untitled" (America #3)*, 1992
15-watt lightbulbs, porcelain light
sockets, extension cord
42 ft. (12.8 m) in length,
with 20 ft. (6 m) extra cord;
installation dimensions variable
Carlos and Rosa de la Cruz
Collection
Illus. p. 180
[Washington, D.C., only]

26-B *"Untitled" (For New York)*, 1992
15-watt lightbulbs, porcelain light
sockets, extension cord
42 ft. (12.8 m) in length,
with 20 ft. (6 m) extra cord;
installation dimensions variable
Goetz Collection, Munich
Illus. p. 181
[Munich only]

DOUGLAS GORDON

27 *Untitled (Text for some place
other than this)*, 1996
Wall text for corner; vinyl letter-
ing in 125 pt Bembo typeface
Installation dimensions variable
Stedelijk Van Abbemuseum,
Eindhoven, The Netherlands
Illus. p. 178

RODNEY GRAHAM

28 *Oak, Banford, Oxfordshire,
Fall 1990*, 1990
Unique color monochrome print
91 x 72 in. (231.1 x 182.8 cm)
Collection Emily Fisher Landau,
New York
Illus. p. 175

29 *Oak, Wroxton Heath II,
Oxfordshire, Fall 1990*, 1990
Unique color monochrome print
91 x 72 in. (231.1 x 182.8 cm)
Collection Emily Fisher Landau,
New York
Illus. p. 174

JIM HODGES

30 *This Way In*, 1999
Silk, plastic, wire, and pins
Installation dimensions variable
Collection of the artist and CRG,
New York
Not illus.

Representative works:

Our Day, 1993, silk, plastic,
wire, and pins
52 x 50 x 1 in. (127 x 132.1
x 2.54 cm). Private collection.
Illus. on cover

No Betweens, 1996, silk, cotton,
polyester, and thread, overall 360
x 324 in. (914.4 x 823 cm). San
Francisco Museum of Modern Art;
Purchased through a gift of
Kimberley S. L. Knight and John B.
Knight III
Illus. p. 176

Changing Things, 1997, silk,
plastic, and wire in 342 parts,
overall 84 x 144 in. (213.4 x
365.8 cm). Dallas Museum of Art;
Mary Margaret Munson Wilcox
Fund: Gift of Catherine Will Rose,
Howard Rachofsky, Christopher
Drew, and Alexandra May,
and Martin Posner and Robyn
Menter-Posner.
Illus. p. 177

ANISH KAPOOR

31 *My Body Your Body II*, 1993/99
Fiberglass and pigment
96 7/8 x 40 3/8 x 80 in.
(248 x 103 x 205 cm)
Courtesy Barbara Gladstone
Gallery, New York/Lisson Gallery,
London
Illus. p. 140, blue version

YVES KLEIN

32 *Untitled (Monogold)*, c. 1960
Gold leaf on primed board
78 1/2 x 60 1/4 (199.5 x 153 cm)
The Menil Collection, Houston
Illus. p. 141
[Washington, D.C. only]

33 *FC1 (Untitled Fire Color
Painting)*, 1961
Dry pigment in synthetic resin on
paper mounted on wood in frame
55 1/2 x 118 in. (141 x 299.5 cm)
Private collection
Illus. pp. 52–53

IMI KNOEBEL

34 *Grace Kelly*, 1990/98
Acrylic on wood
97 1/2 x 66 3/8 in. (250 x 170 cm)
Collection of the artist
Illus. p. 51

JANNIS KOUNELLIS

35 *Untitled,* 1980
Door blocked with stones and
fragments of plaster casts
81 x 37 in. (206 x 94 cm)
Collection Ulrich Knecht,
Stuttgart
Illus. p. 42

ROY LICHTENSTEIN

36 *Sinking Sun,* 1964
Oil and resin-based acrylic
on canvas
68 x 80 in. (172.7 x 203.2 cm)
Courtesy the Helman Collection,
New York
Illus. p. 153

AGNES MARTIN

37 *Grey Stone II,* 1961
Oil, gold leaf, and pencil
on canvas
74 3/4 x 74 3/4 in.
(189.9 x 189.9 cm)
Collection Emily Fisher Landau,
New York
Illus. p. 136

38 *Falling Blue,* 1963
Oil and pencil on canvas
71 7/8 x 72 in. (182.6 x 182.9 cm)
San Francisco Museum of
Modern Art; Gift of Mr. and
Mrs. Moses Lasky
Illus. p. 138

39 *Flower in the Wind,* 1963
Oil and pencil on canvas
75 x 75 in. (190.5 x 190.5 cm)
Daros Collection, Switzerland
Illus. p. 137

40 *Night Sea,* 1963
Oil and gold leaf on canvas
72 x 72 in. (182.9 x 182.9 cm)
Private collection, San Francisco
Illus. p. 139
[Washington, D.C., only]

MARIKO MORI

41 *Tea Ceremony III,* 1995
Laminate crystal print
Edition of 5
58 x 60 x 2 1/2 in.
(147.3 x 152.4 x 6.4 cm)
Collection of Eileen and Peter
Norton, Santa Monica, California
Illus. p. 78

YASUMASA MORIMURA

42 *Portrait (Futago),* 1988
Color photograph
82 7/8 x 118 in. (209.6 x 301 cm)
The Carnegie Museum of Art,
Pittsburgh; A. W. Mellon
Acquisition Endowment Fund,
1992
Illus. p. 49

GIULIO PAOLINI

43 *Mimesis,* 1975–76
Two plaster casts
Each cast 82 3/4 in. (210 cm) high
Christian Stein Collection, Turin
Illus. p. 41

PABLO PICASSO

44 *Reclining Woman Playing with
a Cat,* 1964
Oil on canvas
44 7/8 x 76 5/8 in.
(114 x 194.5 cm)
Fondation Beyeler, Riehen/Basel
Illus. p. 55
[Washington, D.C., only]

MICHELANGELO
PISTOLETTO

45 *Venus of the Rags,* 1967
Plaster cast and rags
70 3/8 x 78 x 46 7/8 in.
(180 x 200 x 120 cm)
Collection of the artist
Illus. p. 43

SIGMAR POLKE

46 *Bunnies,* 1966
Acrylic on linen
58 3/4 x 39 1/8 in.
(149.2 x 99.3 cm)
Hirshhorn Museum and Sculpture
Garden, Smithsonian Institution,
Washington, D.C.; Joseph H.
Hirshhorn Bequest and Purchase
Funds, 1992
Illus. p. 68

CHARLES RAY

47 *Fall '91,* 1992
Mixed media
96 x 26 x 36 in.
(243.8 x 66 x 91.4 cm)
The Eli Broad Family Foundation,
Santa Monica, California
Illus. p. 72

GERHARD RICHTER

48 *Seascape (with Clouds),* 1969
Oil on canvas
78 x 78 in. (200 x 200 cm)
Private collection, Berlin
Illus. p. 145

49 *Garmisch,* 1981
Oil on canvas
27 1/2 x 39 3/8 in. (70 x 100 cm)
Collection of Robert Lehrman,
Washington, D.C.
Illus. p. 146

50 *Barn,* 1984
Oil on canvas
37 1/2 x 39 1/2 in. (95 x 100 cm)
Private collection, courtesy
Massimo Martino Fine Arts and
Projects, Mendrisio, Switzerland
Illus. p. 151

51 *Structure (1),* 1989
Oil on canvas
88 1/2 x 78 3/4 in. (225 x 200 cm)
Camille Oliver-Hoffmann
Illus. p. 149

52 *Structure (2),* 1989
Oil on canvas
88 1/2 x 78 3/4 in. (225 x 200 cm)
From the collection of
Howard E. Rachofsky
Illus. p. 147

53 *Structure (3),* 1989
Oil on canvas
88 1/2 x 78 3/4 in. (225 x 200 cm)
Private collection, New York
Illus. p. 150

54 *Structure (4),* 1989
Oil on canvas
88 1/2 x 78 3/4 in. (225 x 200 cm)
Susan and Lewis Manilow
Illus. p. 144

55 *Waterfall,* 1997
Oil on canvas
64 7/8 x 43 3/8 (164.8 x 110.1 cm)
Hirshhorn Museum and Sculpture
Garden, Smithsonian Institution,
Washington, D.C.; Joseph H.
Hirshhorn Purchase Fund, 1998
Illus. p. 148

PIPILOTTI RIST

56 *Ever Is Over All,* 1997
Video installation, 2 projections
Installation dimensions variable
Donald L. Bryant Jr. Family Trust
Illus. pp. 64, 65

EDWARD RUSCHA

57 *Who Am I?,* 1979
Oil on canvas
22 x 80 in. (55.9 x 203.2 cm)
Mocci Hammer
Illus. p. 155

BEVERLY SEMMES

58 *Red Dress,* 1992
Velvet, wood, and metal hanger
Installation dimensions variable
Private collection
Illus. p. 73

CINDY SHERMAN

59 *Untitled Film Still #2,* 1977
Black-and-white photograph
Edition of 10
10 x 8 in. (25.4 x 20.3 cm)
Samuel and Ronnie Heyman
Illus. p. 74

60 *Untitled Film Still #6,* 1977
Black-and-white photograph
Edition of 10
10 x 8 in. (25.4 x 20.3 cm)
Samuel and Ronnie Heyman
Illus. p. 74

61 *Untitled Film Still #7,* 1978
Black-and-white photograph
Edition of 10
10 x 8 in. (25.4 x 20.3 cm)
The Eli Broad Family Foundation,
Santa Monica, California
Illus. p. 76

62 *Untitled Film Still #16,* 1978
Black-and-white photograph
Edition of 10
10 x 8 in. (25.4 x 20.3 cm)
The Eli Broad Family Foundation,
Santa Monica, California
Illus. p. 77

63 *Untitled Film Still #35,* 1979
Black-and-white photograph
Edition of 10
10 x 8 in. (25.4 x 20.3 cm)
The Eli Broad Family Foundation,
Santa Monica, California
Illus. p. 75

64 *Untitled Film Still #43*, 1979
Black-and-white photograph
Edition of 10
8 x 10 in. (20.3 x 25.4 cm)
The Eli Broad Family Foundation,
Santa Monica, California
Illus. p. 76

65 *Untitled Film Still #54*, 1980
Black-and-white photograph
Edition of 10
8 x 10 in. (20.3 x 25.4 cm)
The Eli Broad Family Foundation,
Santa Monica, California
Illus. p. 77

66 *Untitled #205*, 1989
Color photograph
Edition of 6
53 1/2 x 40 1/4 in.
(135.9 x 102.2 cm)
Jerry + Emily Spiegel
Illus. p. 48

67 *Untitled #209*, 1989
Color photograph
Edition of 6
57 x 41 in. (144.8 x 104.1 cm)
U.S. Senator Frank R. Lautenberg
Illus. p. 47

68 *Untitled #224*, 1990
Color photograph
Edition of 6
48 x 38 in. (121.9 x 96.5 cm)
Mr. and Mrs. Charles Diker
Illus. p. 48
[Washington, D.C., only]

LORNA SIMPSON

69 *Wigs*, 1994
69 waterless lithographs on felt
Overall 97 x 297 in.
(246.4 x 754.4 cm)
Des Moines Art Center Permanent
Collections, purchased with

funds from the Edmundson Art
Foundation, Inc., 1995; exhibition
copy courtesy Rhona Hoffman
Gallery, Chicago
Illus. pp. 70–71

KIKI SMITH

70 *Peacock*, 1994
Papier-mâché figure and 28 ink
drawings on Nepal paper
Installation dimensions variable;
figure 26 3/8 x 17 3/8 in.
(67.3 x 44.5 cm)
The Collection: Irish Museum
of Modern Art, Dublin
Illus. p. 63

HIROSHI SUGIMOTO

71 *Aegean Sea, Pilion I*, 1990
Black-and-white photograph
Edition of 25
20 x 24 in. (50.8 x 61 cm)
Courtesy Sonnabend Gallery,
New York
Illus. p. 170

72 *Boden Sea, Uttwil*, 1993
Black-and-white photograph
Edition of 25
20 x 24 in. (50.8 x 61 cm)
Courtesy Sonnabend Gallery,
New York
Illus. p. 169

73 *Ligurean Sea, Saviore*, 1993
Black-and-white photograph
Edition of 25
20 x 24 in. (50.8 x 61 cm)
Courtesy Sonnabend Gallery,
New York
Illus. p. 168

74 *N. Atlantic Ocean, Cape Breton
Island*, 1996
Black-and-white photograph
Edition of 25
20 x 24 in. (50.8 x 61 cm)
Courtesy Sonnabend Gallery,
New York
Illus. p. 165

75 *Bay of Sagami, Atami*, 1997
Black-and-white photograph
Edition of 25
20 x 24 in. (50.8 x 61 cm)
Courtesy Sonnabend Gallery,
New York
Illus. p. 166

76 *Bay of Sagami, Atami*, 1997
Black-and-white photograph
Edition of 25
20 x 24 in. (50.8 x 61 cm)
Courtesy Sonnabend Gallery,
New York
Illus. p. 167

77 *Bay of Sagami, Atami*, 1997
Black-and-white photograph
Edition of 25
20 x 24 in. (50.8 x 61 cm)
Courtesy Sonnabend Gallery,
New York
Illus. p. 171

78 *Bay of Sagami, Atami*, 1997
Black-and-white photograph
Edition of 25
20 x 24 in. (50.8 x 61 cm)
Courtesy Sonnabend Gallery,
New York
Illus. p. 172

79 *Bay of Sagami, Atami*, 1997
Black-and-white photograph
Edition of 25
20 x 24 in. (50.8 x 61 cm)
Courtesy Sonnabend

Gallery, New York
Illus. p. 173

ROSEMARIE TROCKEL

80 *Beauty*, 1995
12 posters; photomechanical
reproductions on paper
Overall 97 7/8 x 196 5/8 in.
(238 x 504 cm)
Museum in Progress, Vienna
Illus. p. 67

JAMES TURRELL

81 *Milk Run*, 1996
Light projection
Installation dimensions variable
Hirshhorn Museum and Sculpture
Garden, Smithsonian Institution,
Washington, D.C.; Joseph H.
Hirshhorn Bequest Fund, 1998
Illus. p. 156

ANDY WARHOL

82 *Do It Yourself (Flowers)*, 1962
Synthetic polymer and Prestype
on canvas
69 x 59 in. (175 x 150 cm)
Daros Collection, Switzerland
Illus. p. 154

83 *Do It Yourself (Landscape)*, 1962
Synthetic polymer and Prestype
on canvas
70 x 54 in. (178 x 137 cm)
Museum Ludwig, Cologne
Illus. p. 152

84 *Gold Marilyn*, 1962
Silkscreen ink on synthetic
polymer on canvas
Tondo, 17 3/4 in. (45.1 cm)
in diameter

Private collection
Illus. p. 50
[Washington, D.C., only]

85 *Marilyn Monroe's Lips*, 1962
Synthetic polymer, enamel, and
pencil on canvas
Two panels: left 82 3/4 x 80 3/4 in.
(210.7 x 204.9 cm);
right 82 3/4 x 82 3/8 in.
(210.7 x 209.7 cm)
Hirshhorn Museum and Sculpture
Garden, Smithsonian Institution,
Washington, D.C.; Gift of
Joseph H. Hirshhorn, 1972
Illus. p. 66

86 *Mona Lisa*, 1963
Silkscreen ink on synthetic
polymer on canvas
44 x 29 in. (111.8 x 73.7 cm)
The Metropolitan Museum of Art,
New York; Gift of Henry
Geldzahler, 1965
Illus. p. 46

87 *Triple Elvis*, 1963
Silkscreen ink on aluminum paint
on canvas
82 x 71 in. (208.3 x 180.3 cm)
Virginia Museum of Fine Arts,
Richmond; Gift of Sydney and
Frances Lewis
Illus. p. 69
[Washington, D.C., only]

88 *Oxidation Painting*, 1978
Urine on copper metallic paint in
acrylic medium on canvas
76 x 52 in. (193 x 132 cm)
The Baltimore Museum of Art;
Purchase with funds provided by
the Pearlstone Family Fund, and
partial gift of The Andy Warhol
Foundation for the Visual Arts,
Inc., 1994
Illus. p. 143

JANINE ANTONI

Bahamian, b. Freeport, 1964
lives in New York

Since the early 1990s, Janine Antoni has made performance-based sculptures and photographs that address preconceived notions about the body, gender, identity, and beauty. She has transformed everyday processes such as chewing, blinking, and dreaming into objects by using her own body to reveal traces of her physical presence and stimulate the viewer's senses.

Antoni graduated from Sarah Lawrence College in 1986 and the Rhode Island School of Design in 1989. Her first solo exhibition, the installation *Gnaw*, at Sandra Gering Gallery, New York, in 1992, consisted of two six-hundred pound cubes — one lard, one chocolate — which the artist sculpted by biting off and spitting out the pieces. The by-products of those actions were then transformed into boxes of chocolate candy and three-hun-

dred tubes of red lipstick; the metamorphosis curiously exposed the contents of the commercial products and commented on consumer consumption. In *Loving Care*, first performed at the Anthony d'Offay Gallery, London, also in 1992, Antoni used her own hair, dipped in Clairol hair dye, to mop the gallery floor. That performance, a humorous send-up to Yves Klein's "Anthropometries" [see fig. 20], reveals Antoni's frequent dialog with art history and its patriarchal heritage. *Lick and Lather*, 1993–94 [cat. no. 1, pp. 44, 45], made of chocolate and soap, followed soon after. While many of her works from the early to mid-1990s address gender issues and the conditions of producing art as a woman, Antoni's sculptures, video installations, and photographs from the late 1990s explore broader concerns such as physical endurance, the psychology of performance, coupling, and nurturing.

Antoni has been included in group shows such as the Whitney Biennial, New York, and the "Aperto" section at the Venice

BIOGRAPHIES OF *ARTISTS*

CHRIS GILBERT AND ANNE–LOUISE MARQUIS
UNLESS OTHERWISE NOTED

Biennale, 1993; "Self/Made Self/Conscious," School of the Museum of Fine Arts, Boston, and "Bad Girls," the New Museum of Contemporary Art, New York, both 1994; "Cocido y Crudo," the Museo Nacional Centro de Arte Reina Sofía, Madrid, 1995; and "PerForms," the Philadelphia Museum of Art, 1996. She has had solo shows at the Centre for Contemporary Arts, Glasgow, Scotland, which traveled to the Irish Museum of Modern Art, Dublin, 1995; the Wadsworth Atheneum, Hartford, Connecticut, and the Fundació "la Caixa," Barcelona, both 1996; the Capp Street Project, San Francisco, 1997; and the Whitney Museum of American Art, New York, 1998. Antoni received the Glen Dimplex Award from the Irish Museum of Modern Art, 1996; the Joan Mitchell Foundation Award and a MacArthur Foundation Fellowship, both 1998; and the Larry Aldrich Foundation Award, 1999. *A.L.M.*

Cottingham, Laura. "Janine Antoni." *Flash Art*, no. 171 (Summer 1993): 104–5.

Janine Antoni. Barcelona: Fundació "la Caixa," 1996. Exhibition catalog.

Janine Antoni: MATRIX 129. Hartford: Wadsworth Atheneum, 1996. Essay by Andrea Miller- Keller. Exhibition brochure.

Janine Antoni—Slip of the Tongue. Dublin: Irish Museum of Modern Art, 1995. Essay by Dan Cameron. Exhibition catalog.

JOHN BALDESSARI

American, b. National City, California, 1931 lives in Santa Monica, California

During his long career as an artist and educator, John Baldessari has earned a reputation for a unique approach to Conceptual Art that combines intellectual content and formal achievement. His work covers a wide range of styles and media and continues to evolve in ways that defy easy categorization.

Baldessari attended San Diego State College (now San Diego State University), completing a B.F.A. in 1953 and an M.A. in 1956. For nearly a decade he taught art in public schools while creating a body of painting and sculpture that brought him little recognition. In the summer of 1966, Baldessari began to take casual snapshots of his neighborhood in National City. Using a photo-emulsion process, he printed the images on canvas and hired a sign painter to execute captions for them. With these works as well as a number of text-only paintings of that period, he began to remove his own hand from his art, whether through mechanical processes or technical assistance. In 1970, confirming his commitment to that approach, Baldessari burned all of his unsold work from 1953 to 1966 and exhibited the ashes under the title *Cremation Project*.

That year, Baldessari began teaching at the California Institute of the Arts (CalArts), where he conceived and taught a class called "Post-Studio Art." He remained there until 1987, during which time his work continued to diversify. In addition to his photo-text pieces, he made films, videos, and art books. In these works he analyzed the basic elements of a specific genre or presented exhaustive variations of a single form or phrase. In the early 1980s, Baldessari turned to a more intuitive form of photomontage, grafting movie stills and television imagery onto multipanel works. He also began to use color-coded dots to obscure or highlight parts of his images.

A major retrospective of Baldessari's work was held in 1990 at the Museum of Contemporary Art, Los Angeles. The exhibition traveled to five other North American museums, including the Hirshhorn Museum and Sculpture Garden. A solo exhibition in 1996 at the Museum of Contemporary Art, San Diego, featured a selection of his early photo-text pieces together with work in his latest medium: images from a laser-jet printer. After teaching part-time for several years at the University of California, Los Angeles, Baldessari joined the faculty there in 1996. *C.G.*

John Baldessari. New York: New Museum of Contemporary Art, 1981. Essays by Marcia Tucker and Robert Pincus-Witten; interview by Nancy Drew. Exhibition catalog.

Davies, Hugh M., and Andrea Hales. *John Baldessari: National City*. San Diego: Museum of Contemporary Art, 1996. Exhibition catalog.

Baldessari, John. *This Not That*. Manchester, England: Cornerhouse, 1995. Exhibition catalog.

Parkett, no. 29 (1991). Essays by Susan A. Davis, Patrick Frey, Dave Hickey, James Lewis, Thomas Lawson, and Howard Singerman.

Van Bruggen, Coosje. *John Baldessari*. Los Angeles: Museum of Contemporary Art, 1990. Exhibition catalog.

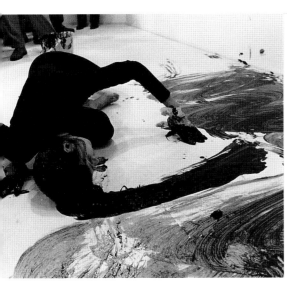

Performing **Loving** *Care, 1992*

Poster for "Fragments" exhibition, 1966, detail

MATTHEW BARNEY

American, b. San Francisco, California, 1967
lives in New York

Matthew Barney, whose mother was an abstract painter, grew up in Boise, Idaho, where he played high-school football and wrestled. His interest in physical endurance carried over into his early performance art, which has since evolved into a body of allegorical films. The artist writes, directs, and performs in the films, at the same time creating related sculptures and photographs.

From 1985 to 1989, Barney attended Yale University, first taking premedical courses, then switching to fine arts. In performance-based works of that time, such as *Scab Action*, 1988, and *Field Dressing* and *Drawing Restraint*, both 1989, he combined his athletic interests, brief experience as a fashion model, and knowledge of medicine. After completing his B.F.A., Barney moved to New York where, in 1991, he had his first solo exhibition at the Barbara Gladstone Gallery, followed later that year by a solo exhibition at the San Francisco Museum of Modern Art. Both shows featured ritualistic actions that united tests of endurance with frequent references to the legendary escape artist Harry Houdini and the pro-football Hall of Famer Jim Otto. Barney documented the performances by exhibiting videotapes, sculptures, photographs, and drawings. The attendant works, which he calls "docu-fragments," often incorporate non-traditional materials, such as petroleum jelly or tapioca, which allude to transmutable bodily substances.

In 1992, Barney participated in Documenta in Kassel, Germany. The following year his work was included in the Venice and Whitney biennials. He is currently completing "Cremaster," a five-part film series begun in 1994. Rich in cryptic allegory, the films are shot out of sequence and feature Barney and others in carefully controlled landscape or interior environments. Whether the location is the salt flats of Utah as in *Cremaster 2*, 1999, or a Baroque opera house in Hungary as in *Cremaster 5*, 1997 [see cat. nos. 7 and 8, pp. 82, 83], each site is central to the meaning of the film.

Barney's work has appeared in solo exhibitions at the San Francisco Museum of Modern Art, 1991 and 1996; the Tate Gallery, London, the Museum Boymans–van Beuningen, Rotterdam, and the Fondation Cartier pour l'Art Contemporain, Paris, all 1995; Portikus, Frankfurt am Main, 1997; and the Walker Art Center, Minneapolis, 1999. In 1996 the Solomon R. Guggenheim Museum, New York, awarded Barney the Hugo Boss Prize and is currently organizing a survey exhibition of the "Cremaster" films and sculpture scheduled for the year 2001. *C.G.*

Barney, Matthew. *Cremaster 1*. Vienna: Kunsthalle Wien, 1994. Project catalog.

———. *Cremaster 2*. Minneapolis: Walker Art Center, 1999. Essay by Richard Flood. Project catalog.

———. *Cremaster 4*. Paris: Fondation Cartier pour l'Art Contemporain, 1995. Project catalog.

———. *Cremaster 5*. Frankfurt: Portikus and Barbara Gladstone Gallery, 1997. Project catalog.

———. *Drawing Restraint 7*. Ostfildern, Germany: Cantz, 1996. Essay by Klaus Kertess. Project catalog.

Parkett, no. 45 (1995). Essays by Norman Bryson, Thryza Nichols Goodeve, Michel Onfray, and Keith Seward.

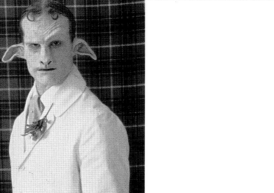

Cremaster 4: The Loughton Candidate, 1994

LOUISE BOURGEOIS

American, b. Paris, France, 1911
lives in New York

Louise Bourgeois marries the grotesque with the beautiful in work that is aggressive, erotic, and disturbing yet often defines the fragility of relationships. Her art is a personal response to the human condition based on her childhood in France and her impressions of relationships between the sexes.

Studying mathematics at the Sorbonne in Paris in 1932, Bourgeois determined that the sciences had no absolute certainty and turned to making art. She worked with Fernand Léger, became an acquaintance of Marcel Duchamp's, and spent time in the studios of many Surrealists. In 1938, Bourgeois married American art historian Robert Goldwater and permanently relocated to New York. In 1945 she had a solo show at the Bertha Schaefer Gallery and was included in the Whitney Museum of American Art Annual Exhibition.

Bourgeois first began making sculpture in 1946. "Personnages," her series representing family and friends in France with whom she had lost contact during World War II, were made of scavenged wood, which she painted. Bourgeois continued making wood constructions throughout the 1950s, occasionally introducing plaster. In the 1960s she also used bronze, marble, rubber, latex, and, in the 1980s, steel.

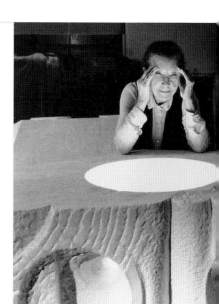

Bourgeois's pungent, metaphorical work contrasted with the cool, ironic tone of Pop, Minimal, and Conceptual Art. By the mid-1970s, feminist artists hailed her as a role model and allied her with women who expanded the lexicon of art through many means, especially the body.

Following a retrospective at the Museum of Modern Art, New York, in 1982, Bourgeois began to receive widespread critical attention. Her solo exhibition "The Locus of Memory" at the United States Pavilion, Venice Biennale, in 1993 traveled to the Brooklyn Museum of Art, New York, and the Corcoran Gallery of Art, Washington, D.C., 1994–95, and then to Prague, Paris, Hamburg, and Montreal. Other major shows include "Louise Bourgeois: Sculptures, Environments, Dessins 1938–1995," Musée d'Art Moderne de la Ville de Paris, 1995, which toured to Japan and Korea; a solo exhibition, Fondazione Prada, Milan, 1997; and a show organized in 1998 by Musée d'Art Contemporain, Bordeaux, which traveled to Lisbon, Malmö, and London. Bourgeois received a Gold Medal from the American Academy and Institute of Arts and Letters, New York, 1989; the U.S. National Medal of Arts, 1997; and the Wexner Prize, 1999. *A.L.M.*

Bourgeois, Louise. *Destruction of the Father, Reconstruction of the Father: Writings and Interviews 1923–1997.* London: Violette Editions, 1998.

Gorovoy, Jerry, and Pandora Tabatabai Asbaghi. *Louise Bourgeois: Blue Days and Pink Days.* Milan: Fondazione Prada, 1997. Exhibition catalog.

Parkett, no. 27 (March 1991). Essays by Manuel J. Borga-Villel, Josef Helfenstein, Christiane Meyer-Thoss, Mignon Nixon, and Harald Szeemann.

Sultan, Terrie, and Christian Leigh. *Louise Bourgeois: The Locus of Memory.* New York: Harry N. Abrams, 1994. Exhibition catalog.

Wye, Deborah. *Louise Bourgeois.* New York: Museum of Modern Art, 1982. Exhibition catalog.

VIJA CELMINS

American, b. Riga, Latvia, 1938 lives in New York

Over the last four decades, Vija Celmins has applied her keen powers of observation to subjects ranging from household appliances and documentary news photos to views of the natural world. In her meticulously detailed paintings and drawings of vast seas and limitless skies, she combines an attention to surface with the illusion of infinite space.

After leaving Latvia in 1944, Celmins and her family traveled through war-torn Europe, then settled in Indianapolis, Indiana. There she attended the Herron School of Art from 1955 to 1961 for a B.F.A. She continued her studies at the University of California, Los Angeles, where, in the milieu of a developing Southern California art scene, she completed her M.F.A. in 1965.

The artist's early works consist of close-up studies of isolated household objects painted on modest-size canvases. These seeming "portraits" of portable heaters, lamps, and hot plates, rendered on muted earth-tone grounds, derive in part from her early fascination with the work of Italian still-life painter Giorgio Morandi (1890–1964). In the mid-1960s, Celmins turned the same dispassionate eye to consumer objects and images of war culled from magazines. In 1968 she completed a second series, which featured images of military planes and an atomic cloud. She then abandoned painting to focus primarily on photo-derived drawings. Her work in that vein tended to emphasize topographic details of particular landscapes or the intricacies of celestial constellations. She began with "Oceans" in 1968 and "Moon Surfaces" in 1969, and initiated the "Galaxy" and "Desert" series in the early 1970s.

After devoting fifteen years to drawing, Celmins returned to painting in 1983, a few years after she moved from California to New York. At first she painted small black-and-white monochromes but gradually switched to a larger scale. The resulting "Night Sky" series combines the exacting surfaces of her drawings with the rich layering afforded by oil paint.

Two major retrospectives of Celmins's work were held in the 1990s: the first was organized by the Institute of Contemporary Art, University of Pennsylvania, Philadelphia, in 1992 and traveled to four other venues in the United States; the second was organized by the Institute of Contemporary Art, London, in 1996 and traveled to Spain, Switzerland, and Germany. Celmins received the Award in Art from the American Academy and Institute of Arts and Letters, New York, in 1986 and a MacArthur Foundation Fellowship in 1997. *C.G.*

Bartman, William, ed. *Vija Celmins.* New York: Art Press, 1992. Interview by Chuck Close.

Parkett, no. 44 (July 1995). Essays by Jim Lewis, Nancy Princinthal, Richard Schiff, and Jeanne Silverthorne.

Tannenbaum, Judith. *Vija Celmins.* Philadelphia: Institute of Contemporary Art, 1992. Essays by Douglas Blau, and Dave Hickey. Exhibition catalog.

Vija Celmins. London: Institute of Contemporary Arts, 1996. Essays by James Lingwood, Stuart Morgan, Richard Rhodes, and Neville Wakefield. Exhibition catalog.

Vija Celmins. Paris: Fondation Cartier pour l'Art Contemporain, 1995. Essays by Robert Storr and Jeanne Silverthorne. Exhibition catalog.

Bourgeois with Pass, 1988

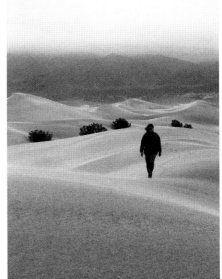

Sand Dunes – Death Valley, California, 1988

WILLEM DE KOONING

American, b. Rotterdam, The Netherlands, 1904–1997

Willem de Kooning, who helped define Abstract Expressionism in the 1940s and 1950s, is celebrated for his powerful command of abstraction and figuration. In a career spanning six decades he successfully translated European modern traditions into a distinctively American idiom.

De Kooning studied fine and commercial art at the Rotterdam Academy of Art from 1916 to 1924 while working at a decorating firm. In 1926 he immigrated to the United States and eventually settled in Manhattan. Supporting himself as a house painter and designer of department-store displays, he experimented with biomorphic imagery merged within Cubist space. In 1935 he participated briefly in a project for the Works Progress Administration.

In the early 1940s, de Kooning's first series of women were inspired in part by artist and writer Elaine Fried, whom he married in 1943. In 1946, de Kooning used cheap commercial paint to create black-and-white gestural abstractions, which were exhibited in his first solo show, at Egan Gallery, New York, in 1948. From 1950 to 1953 he developed the most controversial series of his "Woman" paintings. These grotesque images, which de Kooning considered to be humorous, established him as a major figure in the American art scene. By 1953 his notoriety was such that Robert Rauschenberg erased a drawing by de Kooning [see fig. 17] both to honor and challenge the older artist's influence.

In 1963, de Kooning moved from Manhattan to a new studio in Springs, Long Island. While he continued to produce paintings of women [cat. no. 20, p. 54], the beaches and light there inspired pastoral landscapes and luminous abstractions until the early 1980s, when de Kooning abandoned the intense expressionism of his mature work for austere linearity and elegiac imagery.

De Kooning was included in the Venice Biennale, 1950; the São Paulo Bienal, 1951; and the Carnegie International, Pittsburgh, 1952. He had major exhibitions at the Museum of Modern Art, New York, 1968, which traveled to museums in London and Amsterdam; the Solomon R. Guggenheim Museum, New York, 1978; the Whitney Museum of American Art, New York, 1983; the Hirshhorn Museum and Sculpture Garden, 1993, which traveled to four museums; the National Gallery of Art, Washington, D.C., 1994; and the San Francisco Museum of Art, 1995. He was awarded the Logan Prize from the Art Institute of Chicago, 1951; the Presidential Medal of Freedom, 1964; the Max Beckmann Prize, 1984; and the U.S. National Medal of Arts, 1986. He died in 1997 at age ninety-two. *A.L.M.*

Prather, Marla, David Sylvester, and Richard Shiff. *Willem de Kooning: Paintings.* Washington, D.C.: National Gallery of Art, 1994. Exhibition catalog.

Sichère, Marie-Anne, ed. *Willem de Kooning: Ecrits et propos* (Willem de Kooning: writings and interviews). Paris: École Nationale Supérieure des Beaux-arts, 1992.

Waldman, Diane. *Willem de Kooning.* New York: Harry N. Abrams in association with the National Museum of American Art, 1988.

Yard, Sally. *Willem de Kooning.* New York: Rizzoli, 1997.

Zilczer, Judith. *Willem de Kooning from the Hirshhorn Museum Collection.* New York: Rizzoli and Hirshhorn Museum and Sculpture Garden, 1993. Exhibition catalog.

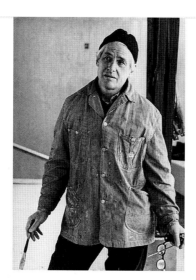

c. 1960s

MARLENE DUMAS

Dutch, b. Cape Town, South Africa, 1953 lives in Amsterdam

Marlene Dumas emerged as an artist in the early 1980s, when many artists worldwide were working to revitalize painting. As an important contemporary figure painter, she addresses difficult subjects, attempting to redefine the aesthetics of the human body.

Born in South Africa, where she lived until her early twenties, Dumas studied painting at the Michaelis School of Fine Arts at the University of Cape Town from 1972 to 1975. After receiving her B.F.A. in 1975, she immigrated to the Netherlands in search of a less-restrictive environment in which to live and paint. There she attended Ateliers '63 in Haarlem, a leading Dutch art school, and later the Psychological Institute at the University of Amsterdam.

Dumas's early work consisted of nonfigurative drawings and mixed-media collages, but in 1983 she shifted her focus to the human figure. Her first series of figure paintings were haunting bust-length images inspired by photographs of acquaintances and strangers. At the end of the decade she turned from frontal busts to images of reclining nudes. In a subsequent series of drawings, "Defining the Negative," 1988, she combined word

and image by showing full-length female nudes in studio poses together with inscriptions that referred to certain contemporary male artists.

After Dumas gave birth in 1987, the experience of raising her daughter inspired a series of large-scale images of newborn infants, *The First People (I–IV)*, 1990 [cat. no. 21, p. 59]. She subsequently began to work in series of small ink portraits on paper, which she arranged in grids. In 1995, Dumas created the "Magdalena" series, paintings depicting female figures of varied appearances, occupations, and backgrounds in the full-length poses normally reserved for models. More recently, Dumas has begun to use clothing as a central prop in her portrayal of human identity.

Dumas's work has been featured in numerous international group exhibitions, including the São Paulo Bienal, 1985; Documenta, Kassel, Germany, 1982 and 1992; the Carnegie International, Pittsburgh, 1995; and the Venice Biennale, 1995 and 1997. She has also been in many solo exhibitions, including those at the Centraal Museum Utrecht, 1984; the Kunsthalle Bern, 1989; and the Stedelijk Van Abbemuseum, Eindhoven, The Netherlands, 1992. Dumas received the David Roell Prize from the Prince Bernard Foundation in 1998. *C.G.*

Dumas, Marlene. *Sweet Nothings: Notes and Text*. Amsterdam: Galerie Paul Andriesse, 1998.

Marlene Dumas. London: Phaidon Press, 1999. Essays by Dominic van den Boogerd, Barbara Bloom, and Mariuccia Casadio.

Marlene Dumas: Models. Salzburg: Salzburger Kunstverein; Frankfurt: Portikus, 1995. Essays by Silvia Eibmayr and Ernst van Alphen. Exhibition catalog.

Miss Interpreted: Marlene Dumas. Eindhoven: Stedelijk Van Abbemuseum, 1992. Essays by Marlene Dumas, Selma Klein Essink, and Marcel Vos. Exhibition catalog.

Parkett, no. 38 (1993). Essays by Ulrich Loock, Ingrid Schaffner, Anna Tilroe, and Marina Warner.

LUCIAN FREUD

British, b. Berlin, Germany, 1922
lives in London

Lucian Freud works in the distinguished tradition of European realist painting yet has redefined that tradition in contemporary terms. Seeking an intimacy with the human form, observed from odd perspectives and in awkward positions, he has, since the 1940s, painted with a relentlessly probing eye, depicting figures without sentimentality.

Freud, grandson of psychoanalyst Sigmund Freud, began drawing at an early age. The family moved from Germany to London in 1933, and Freud began to study art formally in 1938 at the Central School of Art, London. From 1939 to 1941 he attended the East Anglian School of Drawing and Painting, Dedham. Naturalized in 1939, Freud served briefly in the British Merchant Navy, then began painting and published several drawings in *Horizon* magazine.

Freud's early portraits of the 1940s are characterized by hyperreal heads and busts depicted in full light, with firm draftsmanship and tight brushwork. Evoking the unsparing directness of works by fellow British artist Stanley Spencer (1891–1959), Freud's paintings were inspired by the detached grandeur in portraits by the nineteenth-century French master Jean-Auguste Dominique Ingres.

By the late 1950s, Freud modified his rigid, linear style into a more fluid, plastic modeling of form. Although he continued to paint portraits, his focus shifted in the mid-1960s to freely painted images of female nudes and, a decade later, to the male nude. Like earlier masters such as Rembrandt, Frans Hals, Gustave Courbet, and Edgar Degas, Freud is attracted to the coarse beauty of his models, usually people he knows. During the 1990s, Freud painted serial images of two large nudes – performance artist Leigh Bowery and his friend Sue Tilley – continuing his unsparing examination of the beauty of the odd and the grotesque.

Freud's first exhibition was in 1944 at the Lefevre Gallery, London. Together with Ben Nicholson and Francis Bacon, Freud represented the United Kingdom at the British Pavilion of the Venice Biennale in 1954. The Arts Council of Great Britain, London, had a major retrospective of Freud's work in 1974. In 1987 the British Council, London, organized an exhibition that traveled to the Hirshhorn Museum and Sculpture Garden and then to museums in Paris, London, and Berlin. In 1993 the Whitechapel Art Gallery, London, organized an exhibition that traveled to the Metropolitan Museum of Art, New York, and the Museo Nacional Centro de Arte Reina Sofía, Madrid. Freud won the Festival of Britain Arts Council Prize in 1951 and was awarded a Companion of Honour in 1983. *A.L.M.*

Bernard, Bruce, and Derek Birdsall, eds. *Lucian Freud*. New York: Random House, 1996.

Gowing, Lawrence. *Lucian Freud*. London: Thames and Hudson, 1982.

Hughes, Robert. *Lucian Freud, Paintings*. Washington, D.C.: Hirshhorn Museum and Sculpture Garden and British Council, 1987. Exhibition catalog.

Lampert, Catherine. *Lucian Freud: Recent Work*. London: Whitechapel Art Gallery, 1993. Exhibition catalog.

Lucian Freud. London: Arts Council of Great Britain and Hayward Gallery, 1974. Introduction by John Russell. Exhibition catalog.

Lucian Freud. New South Wales: Art Gallery of New South Wales, 1992. Exhibition catalog.

1996

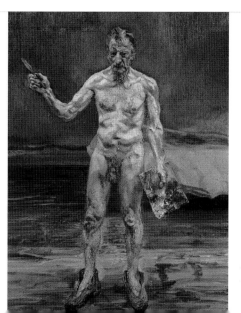

Painter Working, Reflection, 1993

FELIX GONZALEZ-TORRES

American, b. Guáimaro, Cuba, 1957–1996

Making sculptures out of everyday materials, Felix Gonzalez-Torres sought to provoke from his viewers reflection and reminiscence as well as to encourage the possibility of political change. His signature candy spills, paper stacks, billboards, and light strings of the late 1980s and early 1990s are aesthetic yet political, intimate yet publicly accessible.

After growing up in Cuba, Spain, and Puerto Rico, Gonzalez-Torres moved to New York in 1979 to attend the Pratt Institute, Brooklyn, where he completed a B.F.A. in 1981. Later he participated in the Independent Study Program at the Whitney Museum of American Art in 1982–83 and completed an M.F.A. at the International Center for Photography, New York University, in 1987. That year, Gonzalez-Torres joined the East Village artists' collective Group Material and contributed briefly to the group's installations dealing with gender inequalities, the United States' intervention in Central and Latin America, and the AIDS epidemic.

In his own work, Gonzales-Torres employed a constant set of forms that he altered in response to different audiences and changes in his personal life. Beginning in 1986 he made photo-based works, which included black-and-white images transformed into jigsaw puzzles, inserted into bottles, or applied to canvases. He also exhibited works consisting of simple text on photostats. His first stacks of printed or colored paper, begun in 1989, invited viewers to remove a sheet, thus participating in the destruction of a Minimalist form. The artist began to make candy spills in 1990, followed by double mirrors, light strings, and beaded curtains in 1991.

Gonzales-Torres's work garnered widespread recognition with a solo debut at New York's Rastovski Gallery in 1988 and a commission from the Public Art Fund for a billboard in Sheridan Square in 1989. In 1990 he began to exhibit at the Andrea Rosen Gallery, New York. Two years later he was featured in a Museum of Modern Art "Projects" show, followed in 1994 by a survey exhibition jointly organized by the Hirshhorn Museum and Sculpture Garden, the Museum of Contemporary Art, Los Angeles, and the Renaissance Society at the University of Chicago. The Solomon R. Guggenheim Museum organized a retrospective in 1995. Following his death from AIDS-related complications in 1996, the Sprengel Museum in Hanover, Germany, organized a retrospective and published a catalogue raisonné of his work. *C. G.*

Bartman, William S., ed. *Felix Gonzalez-Torres.* New York: Art Press, 1993. Texts by Susan Cahan, Tim Rollins, and Jan Avgikos.

Felix Gonzalez-Torres. Ostfildern, Germany: Cantz, 1998. 2 vols. Text/Catalogue raisonné. Essays by David Deitcher, Dietmar Elger, Rainer Fuchs, Andrea Rosen, and Roland Wäspe. Exhibition catalog.

Felix Gonzalez-Torres. Washington, D.C.: Hirshhorn Museum and Sculpture Garden, 1994. Essays by Amada Cruz, Russell Ferguson, Ann Goldstein, bell hooks, Joseph Kosuth, and Charles Merewether. Exhibiton catalog.

Parkett, no. 39 (1994). Essays by Nancy Spector, Susan Tallman, and Simon Watney.

Spector, Nancy. *Felix Gonzalez-Torres.* New York: Solomon R. Guggenheim Museum, 1995. Exhibition catalog.

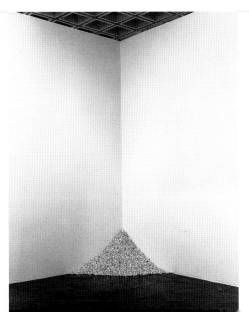

Untitled (Loverboys), 1991

DOUGLAS GORDON

British, b. Glasgow, Scotland, 1966 lives in Glasgow

Using a variety of media, including text, video, installation, and performance, Douglas Gordon presents the viewer with unresolved and morally ambiguous situations. Without definite conclusions, his works of the 1990s focus on moments of existential choice: between life and death, the sacred and the profane, good and evil, and beauty and ugliness.

Gordon grew up in Glasgow and from 1984 to 1988 attended the Glasgow School of Art, where his work revolved around performance. Later, at the Slade School of Art in London, his art became more text-based, often with site-specific references. After completing his M.A. in 1990, Gordon returned to Scotland, where he exhibited *List of Names* at the Third Eye Centre, Glasgow. For that piece, Gordon recorded the names of all the people he could remember and had them typeset and mounted on the gallery wall; the work has been expanded for subsequent installations.

In 1993, Gordon came to international prominence with the video installation *24 Hour Psycho,* first exhibited at Tramway, an alternative space in Glasgow. Slowing down the projection of Alfred Hitchcock's classic film *Psycho,* 1960, to last a full day, the work reflects Gordon's debt to Andy Warhol and his own implicitly transgressive attempt to reveal the film's hidden contents through slow motion. The

Self-Portrait as Kurt Cobain, as Andy Warhol, as Myra Hindley, as Marilyn Monroe, 1996, detail

extended projection time also raised issues of duration and control of the viewer's attention.

Since making *24 Hour Psycho*, the artist has made video a central component in his many-sided oeuvre. At his first major solo exhibition, held at London's Lisson Gallery in 1994, Gordon exhibited video works drawn from archival footage, including *10ms-1*, 1994, a film of a shell-shock victim attempting to stand, and *Trigger Finger*, also 1994, which records a murderer's neurotic hand gestures after killing his brother. Gordon has continued to work with video and film footage culled from television, cinema, and medical archives.

Gordon has had solo exhibitions at the Museum für Gegenwartskunst, Zurich, 1996; the Kunstverein Hannover and the Stedelijk Van Abbemuseum, Eindhoven, The Netherlands, both 1998; and the Centro Cultural de Belém, Lisbon, 1999. He has also participated in numerous international group shows, including Skulptur Projekte Münster, 1997, and the Venice Biennale, 1997 and 1999. Gordon was awarded the Tate Gallery's Turner Prize in 1996 and the Solomon R. Guggenheim Museum's Hugo Boss Prize in 1998. *C.G.*

Close Your Eyes: Open Your Mouth. Zurich: Museum für Gegenwartskunst, 1996. Essays by Francis McKee and Rein Wolfs. Exhibition catalog.

Douglas Gordon. Belém, Portugal: Centro Cultural de Belém, 1999. Essays by Christine van Assche, Raymond Bellour, Pavel Büchler, and Jeremy Miller. Exhibition catalog.

Kidnapping. Eindhoven: Stedelijk Van Abbemuseum, 1998. Essays by David Gordon, Douglas Gordon, Russell Ferguson, and Thomas Lawson; interview by Jan Debbaut. Exhibition catalog.

Parkett, no. 49 (1997). Essays by Tobia Bezzola, Russell Ferguson, and Richard Flood; a correspondence with Liam Gillick.

RODNEY GRAHAM

Canadian, b. Matsqui, British Columbia, 1949; lives in Vancouver

Since the early 1970s, Rodney Graham has worked in a broad spectrum of media, including architectural projects, book arts, film, music, photography, and video. He often adds to or extrapolates from existing works of art as part of an ongoing exploration of how we represent and categorize the natural world.

Growing up in the Vancouver suburb of Abbotsford, Graham studied art history at the University of British Columbia, Vancouver, from 1968 to 1972 and at Simon Fraser University, Burnaby, in 1978 and 1979. His early work involved a variety of optical devices. In 1973 he used a pinhole camera in *Rome Ruins*, and in 1979 he placed a room-size camera obscura in a field in Abbotsford; those who entered the darkened space discovered the image of an isolated tree projected upside down on the back wall. The Abbotsford project provided a point of reference for his subsequent photographs of trees taken with an ordinary view camera yet always displayed upside down. These series, created in different locations in Europe and North America, include "Oxfordshire Oaks," shot in England in 1990 [cat. nos. 28 and 29, pp. 175, 174].

The skewed vision of Graham's photographs carried over into his first work of textual intervention, *Lenz*, 1983. The piece consists of 1,434 words appropriated from a nineteenth-century novella in which a repeated phrase describing a forest journey allows the narrative to loop back on itself. Graham has since gone on to treat other books with equal whimsy, housing texts by Lewis Carroll, Sigmund Freud, and Dr. Seuss in Minimalist structures and creating supplements to works by Ian Fleming, Herman Melville, Edgar Allan Poe, and Richard Wagner.

Graham has recently been working in video and film. His video *Halcion Sleep*, 1994, depicts the artist on a chauffeured drive while under the influence of the prescription sleeping drug called Halcion. *Coruscating Cinnamon Granules*, a black-and-white film from 1996, records the scintillating light effects created as grains of the household spice fall onto a glowing hot plate.

Since 1973, Graham's work has been widely exhibited in Australia, Canada, Europe, Japan, and the United States. He has participated in Skulptur Projekte Münster, 1987; Documenta, Kassel, Germany, 1992; and the Venice Biennale, 1993 and 1997. An exhibition of the artist's time-based music installations, *Parsifal* and *School of Velocity*, both 1993, traveled to five different venues in Canada, Italy, and the United States from 1994 to 1996. *C.G.*

Archer, Michael. "Rodney Graham: Lisson Gallery," *Artforum* 36, no. 7 (March 1997): 102–3.

Island Thought: An Archipelagic Journal Published at Irregular Intervals. Venice: Canadian Pavilion, 1997. Essays by William Gibson, Rodney Graham, Robert Linsley, Shep Steiner, and Loretta Yarlow. Exhibition catalog.

Rodney Graham: The School of Velocity, Parsifal. Chicago: Renaissance Society at the University of Chicago, 1995. Exhibition brochure.

Rodney Graham: Works from 1976 to 1994. Toronto: Art Gallery of York University, 1994. Essays by Marie-Ange Brayer, Boris Groys, Matthew Teitelbaum, and Jeff Wall. Exhibtion catalog/catalogue raisonné.

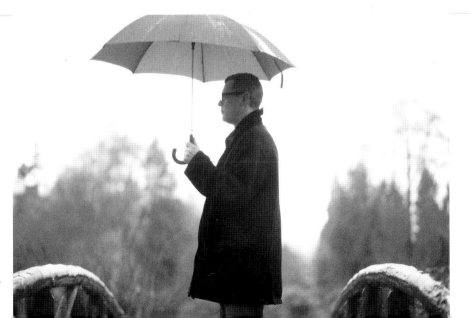

1999

JIM HODGES

*American b. Spokane, Washington, 1957
lives in New York*

Working with everyday materials, Jim Hodges has, since the late 1980s, made art that reflects on the passage of time and the layered effects of memory. Using decorative imagery and processes normally associated with craft, Hodges invites a reconsideration of cultural and aesthetic hierarchies.

Hodges received a B.F.A. from Fort Wright College, Spokane, in 1980 and an M.F.A. from the Pratt Institute, Brooklyn, in 1986. Having concentrated on painting at both institutions, he continued to paint after graduating, only later realizing that his real interest lay in drawing and sculpture. Among his earliest exhibited pieces were tar-paper "drawings" of roses that appeared in a group show at the Postmasters Gallery, New York, in 1990, and a spiral-shaped floor piece made from a photocopied magazine cover announcing a "New AIDS Drug," shown at the Apollohuis, Amsterdam, in 1992.

Hodges had his first solo exhibition in New York, "A Diary of Flowers," at the gallery CRG in 1994. In addition to the title piece, created from more than five hundred drawings of flowers on paper napkins, the exhibition included *Not Here*, a collection of reworked silk and plastic flowers pinned to the wall, and *Untitled (Broken)*, a spiderweb made of white brass chains. The three motifs of the exhibition—artificial flowers, spiderwebs, and drawings on paper napkins—continued to appear in his work over the next several years.

Hodges took a new direction with an exhibition at CRG in 1998. In the gallery were two wall pieces constructed from fragments: *As close as I can get*, a mosaic of Pantone color samples, and *Folding (into a greater world)*, an irregular grid of nearly square mirror shards. Also exhibited were two sculptures, *Landscape* and *When the light comes on*, that respectively layered and connected men's shirts of different sizes. Hodges expanded on the layer motif again with a piece consisting of a tree sliced into horizontal sections, *One with the Other*, 1999, shown that year in a solo exhibition of his work at the Museum of Contemporary Art, Chicago.

Hodges has participated in many international group shows, including the São Paulo Bienal in 1996, the Venice Biennale in 1997, and the San Francisco Museum of Modern Art's "Present Tense: Nine Artists of the Nineties," also in 1997. In 1998 the Kemper Museum of Contemporary Art in Kansas City, Missouri, organized a six-year survey of his work. *C.G.*

Decter, Joshua. "Jim Hodges." *Artforum* 35, no. 3 (November 1996): 104–5.

Deitcher, David. "Death in the Marketplace." *Frieze*, no. 29 (July/August 1996): 40–45.

Heartney, Eleanor. "Review: Jim Hodges." *Art in America* 86, no. 11 (November 1998): 135.

Hodges, Jim. *Every Way*. Chicago: Museum of Contemporary Art, 1999. Essay by Amada Cruz. Exhibition catalog.

Jim Hodges: Welcome. Kansas City, Missouri: Kemper Museum of Contemporary Art, 1998. Essay by Dana Self. Exhibition brochure.

Weinstein, Matthew. "Review." *Artforum* 32, no. 9 (May 1994): 102.

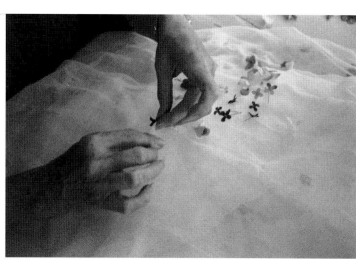

My Mom Sewing a Possible Cloud, 1993

ANISH KAPOOR

*British, b. Bombay, India, 1954
lives in London*

Anish Kapoor's elemental structures evoke sensuality and spirituality through dense texture, intense color, and enigmatic spaces. The artist draws inspiration from Hinduism, Judaisim, Buddhism, Christianity, and Islam. Since the 1970s he has been making objects that mediate between the human and the divine.

At age eighteen, Kapoor left Bombay for London to study at the Hornsey College of Art from 1973 to 1977, followed by postgraduate work at the Chelsea College of Art, London, from 1977 to 1978. During those years, Kapoor absorbed the ideas of Swiss psychoanalyst Carl Jung and German artist Joseph Beuys [see fig. 21], reinforcing Kapoor's belief in art as a ritualized process. In 1973–74, Kapoor created a chalk drawing on the floor in which cubes and spheres identified male and female parts of the body.

Kapoor taught sculpture at Wolverhampton Polytechnic, Staffordshire, from 1979 to 1982 and was an artist-in-residence at the Walker Art Gallery, Liverpool, in 1982. While visiting India in 1979, he perceived a metaphysical power in the pure pigments left outside Hindu temples for rituals. After returning to London, Kapoor began the sculpture series "1000-Names," a title meant to convey a sense of infinity. He covered pyramidal

and rounded forms with pigment, intentionally leaving powdery halos around them.

By the late 1980s, Kapoor was working with stone and metal, carefully selecting materials for weight, volume, and reflective qualities and making sculptures with convex and concave surfaces, small voids, or geometric cut-throughs. In 1992, Kapoor designed two concrete architectural projects: the cylindrical *Building for a Void*, for Expo 1992 in Seville, and the cubical *Descent into Limbo*, for Documenta in Kassel, Germany.

In 1985 the Kunsthalle Basel organized a solo exhibition of his work. Two years later the San Francisco Museum of Modern Art included Kapoor in "A Quiet Revolution: British Sculpture Since 1965," which toured to four North American museums, including the Hirshhorn Museum and Sculpture Garden. Kapoor won the Premio Duemila representing Great Britain in the Venice Biennale in 1990 and the Turner Prize in 1991. The Fondazione Prada, Milan, presented a retrospective of his work in 1995. In 1998, Kapoor designed the enormous red-domed gallery *At the Edge of the World* for the Centro Galego de Arte Contemporanea, Santiago de Compostela, Spain, and exhibited at the Hayward Gallery, London. *A.L.M.*

Ammann, Jean-Christophe, and Alexander von Graevenstein. *Anish Kapoor*. Basel: Kunsthalle Basel, 1985. Exhibition catalog.

Bhabha, Homi K., and Pier Luigi Tazzi. *Anish Kapoor*. London: Hayward Gallery and University of California Press, 1998. Exhibition catalog.

Celant, Germano. *Anish Kapoor*. Milan: Charta, 1998. Exhibition catalog.

Livingstone, Marco. *Anish Kapoor: Feeling into Form*. Lyon-Villeurbanne, France: Edition Le Nouveau Musée, 1983.

McEvilley, Thomas, and Marjorie Allthorpe-Guyton. *Anish Kapoor: British Pavilion, XLIV Venice Biennale*. London: British Council, 1990. Exhibition catalog.

YVES KLEIN

French, b. Nice, 1928–1962

In his short career, Yves Klein merged painting and performance in a passionate effort to wed art to life. His monochromatic canvases, sculptures, musical and artistic actions, and conceptual performances of the 1950s and early 1960s challenged traditional materials, methods, and notions in art.

A self-taught artist, Klein studied Judo and Rosicrucianism (an occult religion devoted to esoteric wisdom) in his teens and twenties. His early works were small, single-hued paintings, which he considered metaphysical fields devoid of subjective emotion. He also began his predominant use of the color blue, claiming it was beyond physical dimension, possessing only abstract associations. By 1955, after establishing a Judo school in Paris in 1954, Klein committed himself solely to art. In 1956 the Galerie Colette Allendy presented his first major exhibition of large-scale monochromatic paintings, which was followed a year later by an exhibition at the Galleria Apollinaire, Milan. The same year, 1,001 blue balloons were released in his "aerostatic sculpture" exhibition at Galerie Colette Allendy. In 1958, Klein staged "The Void," in which the exterior of Galerie Iris Clert, Paris, was painted blue and the interior white, creating an ethereal space.

During the same period Klein experimented with "living brushes" — nude, pigment-covered female models who, under his direction, left imprints on large sheets of paper. In 1960 the "living brushes" evolved into "Anthropometries," in which orchestral music accompanied the models' movements. Klein also staged his infamous "Leap into the Void," in which he simulated a flying dive out of a window with the aid of photomontage. Also in 1960 he founded the New Realists group with Arman, Martial Raysse, Pierre Restany, Jean Tinguely, and others seeking to renew art's relation to daily life. At that time, Klein explored the immaterial in his "fire" paintings [such as cat. no. 33, pp. 52–53] and "pigment" and "rain" paintings of 1960–61. In January 1962, Klein married German artist Rotraut Uecker; in June he died of heart failure at age thirty-four.

In 1974, Klein's work was featured in a retrospective exhibition at the Tate Gallery, London. In 1982, Rice University, Houston, organized a retrospective that traveled to the Museum of Contemporary Art, Chicago, the Solomon R. Guggenheim Museum, New York, and the Musée National d'Art Moderne, Centre Georges Pompidou, Paris. Klein's fire paintings, which were first shown at Museum Haus Lange, Krefeld, Germany, in 1961, were the subject of an exhibition in 1992 at the Museum of Contemporary Art, Los Angeles. *A.L.M.*

Buchloh, Benjamin H. D., and Nan Rosenthal. "Into the Blue." *Artforum* 33 (Summer 1995): 92–97, 130, 136.

Caumont, Jacques, and Jennifer Gough-Cooper, eds. *Yves Klein, 1928–1962: Selected Writings*. Trans. by Barbara Wright. London: Tate Gallery, 1974.

Restany, Pierre. *Yves Klein: A Retrospective*. Houston: Institute for the Arts, Rice University, 1982. Exhibition catalog.

Stich, Sidra. *Yves Klein*. Cologne: Museum Ludwig, 1994. Exhibition catalog.

Yves Klein: The Anthropometries. New York: Danese and Galerie Gmurzynska, 1997. Interview with Rotraut Klein-Moquay by Greta Tüllmann and Hannah Weitemeir. Exhibition catalog.

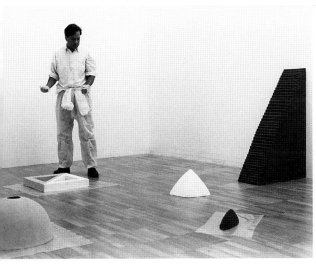

In Galerie Jeu de Paume, Paris, 1996

Leap into the Void, 1960

IMI KNOEBEL

German, b. Dessau, 1940
lives in Düsseldorf, Germany

In his intimately conceived three-dimensional paintings and installations, Imi Knoebel has since the late 1960s merged the painterly means of color and surface with the sculptural qualities of geometric form, volume, and space to create complex, layered compositions.

From 1964 to 1971, Knoebel studied at the Kunstakademie Düsseldorf under Joseph Beuys [see fig. 21]. Knoebel began to make nonobjective art, influenced by the then-neglected tradition of Russian Suprematism. His installation *Raum 19*, 1968, was inspired by the studio space he shared with fellow students Blinky Palermo and Jörg Immendorf. With its stacked and modular components, the work had the disordered appearance of a stocked warehouse, but closer inspection revealed a form and order to its geometric elements, which followed Classical logic and proportion.

Throughout his career, Knoebel has abstracted images from his own experience. The catalog for his exhibition in 1985 at the Rijksmuseum Kröller-Müller, Otterlo, The Netherlands, includes a photograph of the triangular attic window through which Knoebel, at age five, watched the fire bombing of Dresden in 1945. The image is juxtaposed with a schematic drawing of Knoebel's relief painting, *Otterlo II*, 1985, which consists of four triangles of various scale, placed atop four equal-size rectangles. Here, the triangular shape of the window, which is removed from its context and repeated in various sizes, carries an emotional potency as a symbol of trauma.

By 1989, Knoebel began to employ similar means to explore the expressive possibilities of color. The series "Grace Kelly," 1990–93, is composed of thirty-three paintings of the same size on panels, each of which has a unique chromatic combination. By associating the series with a celebrated icon of female beauty, Knoebel lends an emotional complexity to the subtle variations of paint.

In addition to his inclusion in every Documenta exhibition from 1972 to 1987, Knoebel has been the subject of numerous solo exhibitions, including those at the Dia Center for the Arts, New York, 1988; Bonnefanten Museum, Maastricht, The Netherlands, 1989 and 1992; and the Hessisches Landesmuseum, Darmstadt, Germany, 1992. In 1996 he was the subject of a retrospective, "Imi Knoebel, Works 1968–1996," jointly organized by the Haus der Kunst, Munich, and the Stedelijk Van Abbemuseum, Eindhoven, The Netherlands. *HUBERTUS GASSNER WITH SARAH FINLAY*

Imi Knoebel. Maastricht, The Netherlands: Bonnefanten Museum, 1989. Exhibition catalog.

Imi Knoebel. New York: Dia Art Foundation, 1987. Exhibition catalog.

Imi Knoebel: Works 1968–1996. Munich: Haus der Kunst; Amsterdam: Stedelijk Museum; Valencia: IVAM Centre Julio González; Düsseldorf: Kunsthalle Düsseldorf; Grenoble: Musée de Grenoble, 1996. Essays by Rudi Fuchs, Hubertus Gassner, Johannes Stuttgen, and Max Wechsler. Exhibition catalog.

Kuspit, Donald. "Imi Knoebel's Triangle." *Artforum International* 25, no. 5 (January 1987: 72–79).

Parkett, no. 32 (1992). Essays by Rudolf Bumiller, Rainer Crone, Lisa Liebman, and David Moos.

JANNIS KOUNELLIS

Italian, b. Piraeus, Greece, 1936
lives in Rome

Associated with the Italian Arte Povera movement early in his career, Jannis Kounellis uses industrial and everyday materials in his paintings, sculptures, performances, and large-scale installations. His work initially evolved out of reflection on the fragmentary state of the post–World War II world and its contrast to the more unified cultures in Classical and Medieval times.

Kounellis's interest in art and music began in childhood. At age twenty he left the political turmoil in his native Greece for Rome, where he attended the Accademia di Belle Arti and pursued a career as an artist. After his first solo exhibition at the Galleria La Tartaruga, Rome, in 1960, he became known as a painter. His early work consisted of stenciled letter and number paintings, which increasingly incorporated collage elements. Despite his success, the artist ceased painting in 1965, believing that the medium no longer constituted a viable response to the modern world.

After two years Kounellis reemerged as a sculptor associated with Arte Povera, a group of artists who asserted the poetic qualities of common materials. His work of the 1960s presented juxtapositions between structure and sensibility, and between inorganic shapes and formless, organic materials, such as steel and flow-

1993

ers. These type of contrasts were evident in his exhibition at the L'Attico Gallery in Rome in 1969 for which he brought twelve horses into the gallery, and in his sculptures made of wool compressed between sheets of steel and loose coal in metal containers. In the mid-1970s the artist began stacking broken pieces of plaster sculptures in doorways [cat. no. 35, p. 42], placing them on tables and shelves, and displaying them individually, painted, bound, or burnished with fire.

Since 1980, Kounellis has been combining and reworking his former motifs in an increasingly complex syntax. This anthologizing approach to his work has coincided with his many retrospectives over the past two decades, including those at the Museum of Contemporary Art, Chicago, 1986; on board the *Ionian Cargo* in Piraeus, 1994; and at the Museo Nacional Centro de Arte Reina Sofía, Madrid, 1996. His work has appeared frequently in such international group exhibitions as the Venice Biennale and Documenta in Kassel, Germany. Kounellis has been the recipient of numerous awards, including the V Premio "Pino Pascali," Bari, Italy, 1979, and the Kunstpreis der Norddeutsche Landesbank, Hanover, 1989. *C.G.*

Jannis Kounellis. Chicago: Museum of Contemporary Art, 1986. Essay by Thomas McEvilley. Exhibition catalog.

Kounellis. Athens: J. F. Costopoulos Foundation, 1997. Essays by Katerina Koskina and Thomas McEvilley. Exhibition catalog.

Kounellis. Madrid: Museo Nacional Centro de Arte Reina Sofía, 1996. Essays by José Jiménez, Angel González, Jannis Kounellis, and Gloria Moure; interview by Mario Diacono. Exhibition catalog.

Moure, Gloria. *Kounellis.* New York: Rizzoli, 1990. Essays by Bruno Corà, Jean-Louis Froment, Rudi Fuchs, Mary Jane Jacob, and Jannis Kounellis.

1989

ROY LICHTENSTEIN

American, b. New York, 1923–1997

Basing his work on modern art and popular culture, Roy Lichtenstein combined the methods of commercial printing with images of deadpan irony to create witty paintings and sculptures that helped define Pop Art.

Born in Manhattan, Lichtenstein attended Ohio State University, Columbus, with three intervening years in the military, and received a B.F.A. in 1946. He then entered Ohio State's graduate program and became an instructor, earning an M.F.A. in 1949. From 1950 to 1957, Lichtenstein and his family lived in Columbus and Cleveland, where he held various commercial art and design jobs. During that period, he created childlike images of American historical scenes and frontier imagery.

While he was Assistant Professor of Art at State University College of New York at Oswego (1957–59) and Douglass College, Rutgers University, New Brunswick, New Jersey (1960–62), Lichtenstein began to combine the gestures of Abstract Expressionism with appropriated cartoon images, as seen in the Benday dots and dialog balloon of *Look Mickey*, 1961. In quick succession, Lichtenstein painted images drawn from comic books and advertising.

In 1964, Lichtenstein made his first sculptures, inspired by New York's enameled metal subways signs, and began painting invented landscapes. In 1965 he created his first "Brushstroke" painting, parodying the gestural mode of Abstract Expressionism. He began making series inspired by architectural ornamentation, artworks, and everyday scenes. Lichtenstein also designed large-scale sculpture and mural projects in the 1970s.

Lichtenstein had early solo shows at the John Heller Gallery, New York, from 1952 to 1954. His first solo museum exhibition was at the Cleveland Museum of Art in 1966; the following year, the Stedelijk Museum, Amsterdam, The Netherlands, organized his first European solo show, which traveled to three other museums. Elected in 1979 to the American Academy and Institute of Arts and Letters, New York, Lichtenstein was an artist-in-residence at the American Academy in Rome in 1989. In 1993 he received an honorary doctorate from Royal College of Art, London, and the Solomon R. Guggenheim Museum, New York, organized a traveling retrospective of his work. Lichtenstein was awarded the U.S. National Medal of Arts in 1995. He died in 1997 at age seventy-three. The Fondation Beyeler, Basel, held a memorial retrospective of his work in 1998. *A.L.M.*

Alloway, Lawrence. *Roy Lichtenstein.* New York: Abbeville, 1983.

Coplans, John, ed. *Roy Lichtenstein.* New York: Praeger, 1972.

Cowart, Jack, and Frank Braun. *Roy Lichtenstein.* Basel: Fondation Beyeler, 1998. Exhibition catalog.

Morphet, Richard. *Roy Lichtenstein.* London: Tate Gallery, 1968. Exhibition catalog.

Roy Lichtenstein. Pully/Lausanne: FAE Musée d'Art Contemporain; Liverpool: Tate Gallery, 1992. Essay and interview by Charles Riley. Exhibition catalog.

Waldman, Diane. *Roy Lichtenstein.* New York: Solomon R. Guggenheim Museum, 1993. Exhibition catalog.

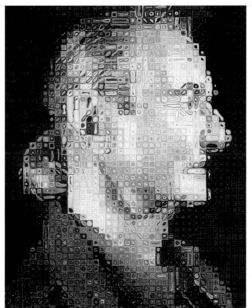

Roy II, 1994, by Chuck Close

AGNES MARTIN

American, b. Maklin, Canada, 1912
lives in Taos, New Mexico

Agnes Martin uses the self-imposed confines of her art to create images that are noble and formal yet possess a handmade quality. From her early figurative works of the 1930s to the quiet grids of her mature canvases since the 1960s, she continues to be interested in painting in a vocabulary of extreme subtlety.

Raised in Saskatchewan and British Columbia, Martin in 1931 emigrated from the United States to Bellingham, Washington. Although she aspired to a career as an artist, she studied to become an elementary school teacher. After attending school in Bellingham, she received a B.S. in fine art and art education from Teachers College, Columbia University, New York, in 1938. She taught in public schools in Washington, Delaware, and New Mexico from 1937 to 1950 and taught painting during the late 1940s and early 1950s. She earned an M.F.A. at Columbia in 1952.

By the mid-1950s, Martin had become dissatisfied with her narrative paintings, portraits, and landscapes of the previous twenty years and turned from figurative to geometric and abstract art. Inspired by her new direction, she destroyed the output of her first two decades and moved to New York in 1957 to pursue a career as a painter. The next year she had her first solo show at the Betty Parsons Gallery. By the early 1960s, Martin developed her signature style of simple, hand-painted grids in muted colors, painted on equally sized canvases (6x6 ft.) in subtle variations. The rigorous demands and spiritual aspects of her work reveal an interest in Eastern art and philosophy.

In 1967, Martin stopped painting to concentrate on writing. Receiving a National Endowment for the Arts grant, she toured the country for eighteen months, eventually settling in rural New Mexico. Martin resumed painting full-time in the 1970s, continuing to distill space, light, texture, and feeling through grids and quiet colors. In the 1990s, Martin moved from Galisteo to Taos, New Mexico, where she continues to paint.

The Whitney Museum of American Art, New York, organized a major retrospective of her work, which toured from 1992 to 1994. A member of the American Academy and Institute of Arts and Letters, New York, since 1989, Martin also received the Alexej von Jawlensky Prize from the Museum Wiesbaden, Germany, in 1990; the Oskar Kokoschka Prize, Austria, in 1992; and the U.S. National Medal of Arts in 1998. *A.L.M.*

Bloem, Marja, ed. *Agnes Martin: Paintings and Drawings*. Amsterdam: Stedelijk Museum, 1991. Exhibition catalog.

Cotter, Holland. "Agnes Martin: All the Way to Heaven." *Art in America* 81 (April 1993): 88–97, 149.

Haskell, Barbara. *Agnes Martin*. New York: Whitney Museum of American Art with Harry N. Abrams, 1992. Exhibition catalog.

Martin, Agnes. *Writings*. Winterthur: Kunstmuseum and Cantz, 1992.

Simon, Joan. "Perfection Is in the Mind: An Interview with Agnes Martin." *Art in America* 84 (May 1996): 82–89, 124.

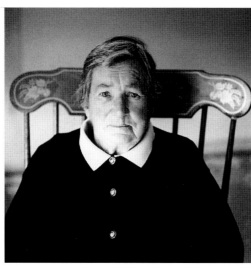

1992

MARIKO MORI

Japanese, b. Tokyo, 1967
lives in New York and Tokyo

Creating fantasy visions and futuristic personae, Mariko Mori navigates the boundaries between fashion, technology, and fine art. Her work of the 1990s has taken a variety of forms, including multi-paneled photographic tableaux, digitally manipulated photographs, three-dimensional videos, and multimedia installations.

Mori attended a traditional Japanese high school for girls, and later Tokyo's Bunka Fashion College from 1986 to 1988. After modeling part-time in Japan, she relocated to London in 1988 to attend the Byam Shaw School of Art and then the Chelsea College of Art. In 1992 she moved to New York, where she participated in the Independent Study Program at the Whitney Museum of American Art. Mori's early works of the 1990s drew on her experiences as a model and addressed the loss of personal identity common to the swiftly changing worlds of fashion and vanguard art. By 1993 her work had evolved into full-fledged installations, which she exhibited at the Project Room, New York, and the Art and Public Gallery, Geneva.

In the mid-1990s, Mori addressed the stereotypes of the Japanese office lady, school girl, and prostitute, as well as science-fiction warriors and space travelers, in large photographic tableaux such as *Play with Me*, *Subway*, *Love Hotel*, and *Warrior*, all 1994. As digital technology

became more readily available, she was able to effect a more thorough transformation of her costumed science-fiction figures in such pieces as the shimmering, large-scale hologram *Birth of a Star*, 1995 [see fig. 47], the three-dimensional video installation *Nirvana*, 1996–98, and the multimedia structure *Dream Temple*, 1999. The latter work addresses both past and future, encompassing ancient Buddhist beliefs and attitudes toward the coming millennium.

Mori's work was included in the Venice and Lyon biennials of 1997 and has been featured in solo exhibitions at Deitch Projects, New York, 1996, and at the Koyangi Gallery, Tokyo, and the Dallas Museum of Art, both 1997. In 1998–99 a survey exhibition was jointly organized by and shown at the Los Angeles County Museum of Art; the Serpentine Gallery, London; the Andy Warhol Museum, Pittsburgh; and the Museum of Contemporary Art, Chicago, then traveled to the Brooklyn Museum of Art, New York. A solo show at the Fondazione Prada, Milan, in 1999 demonstrated Mori's desire to be at the forefront of new media in contemporary art. *C.G.*

Cohen, Michael. "Moriko Mori: Plastic Dreams and the Reality Bubble." *Flash Art* 30 (May/June 1997): 94–97.

Concentrations 30: Mariko Mori, Play with Me. Dallas: Dallas Museum of Art. 1997. Essay by Suzanne Weaver. Exhibition brochure.

Mariko Mori. Chicago: Museum of Contemporary Art; London: Serpentine Gallery, 1998. Essays by Lisa Corrin, Carol S. Eliel, Margery King, and Dominic Molon. Exhibition catalog.

Paparoni, Demetrio. "Mariko Mori." *Tema Celeste* 65 (December 1997): 44.

Parkett, no. 54 (1998/99). Essays by Norman Bryson, Thryza Nichols Goodeve, and Shin'ichi Nakazawa.

Vincent, Steven. "Mariko Mori." *Art and Auction* 19 (March 1997): 68–70.

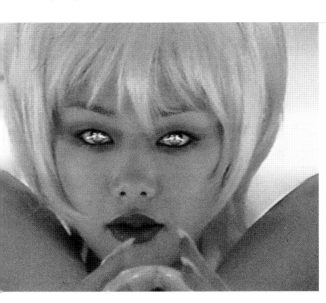

YASUMASA MORIMURA

Japanese, b. Osaka, 1951
lives in Osaka

Yasumasa Morimura's photographs of the 1980s and 1990s take art history and the media as their primary subjects. By inserting his own likeness into iconic cultural images, the artist creates a fluid identity that challenges the boundaries between male and female, East and West, original and copy.

Morimura entered Kyoto City University of Arts in 1971, completing his B.A. in 1975 and a two-year research course in visual design in 1978. He then created his own abstract prints and photographs while working as an art instructor. In 1985, Morimura conceived his first series of photographs in what would become a signature style of transforming his own image. For these, he developed elaborate sets with costumes and props in campy simulations of European masterpieces. His art historical references included paintings by Vincent van Gogh, Jean-Auguste-Dominique Ingres, and Édouard Manet [see cat. no. 42, p. 49].

In the late 1980s, Morimura began to exploit the reproducibility of photographs to make series of sequential images, each creatively altered from the original, as in *Portraits (Shonen 1, 2, 3)*, 1988, which progressively undresses the subject of Manet's *Fifer*, 1866. Continuing that trend, Morimura by 1989 found that he could easily duplicate his own likeness with the aid of computer scanning and digital manipulation, allowing him to incorporate multiple likenesses into a single work, as in *Portrait Nine Faces*, 1990, a version of Rembrandt's *Anatomy Lesson of Dr. Nicolaes Tulp*, 1632.

Subsequent series by Morimura include "Psychoborg," 1994, which examines media figures Michael Jackson and Madonna, and "Self-Portrait as an Actress," 1994–96, which features the artist in the personae of international cinema stars. The latter series was exhibited at the Contemporary Arts Museum, Houston, in 1997. More recently, he has delved into other types of media, including monthly serials, fashion, film, video, and television.

Morimura's work has appeared in a variety of exhibitions, including the "Aperto" section of the Venice Biennale in 1988 and the tenth Sydney Biennial in 1996. That year he was a finalist for the Hugo Boss Prize awarded by the Solomon R. Guggenheim Museum, New York. In 1998 a major survey of the "Daughter of Art History" series was jointly organized by and shown at the Museum of Contemporary Art, Tokyo; the National Museum of Modern Art, Kyoto; and the Marugame Genichiro Inokuma Museum of Contemporary Art. *C.G.*

Annear, Judy. "Peepshow: Inside Yasumasa Morimura's Looking Glass." *Art-Asia Pacific*, no. 13 (1997): 43–47.

Bryson, Norman. "Three Morimura Readings." *Art and Text*, no. 52 (1995): 74–79.

Morimura Yasumasa: Self-Portrait as Art History. Tokyo: Musuem of Contemporary Art, 1998. Essays by Yoko Hayashi, Akio Obigane, and Junichi Shioda. Exhibition catalog.

The Sickness unto Beauty, Self-Portait as Actress. [Yokohama]: Yokohama Museum of Art, 1996. Essays by Taro Amano, Kaori Chino, and Yasuo Kobayashi. Exhibition catalog.

Yasumasa Morimura: Actor Actress. Houston: Contemporary Arts Museum, 1997. Essay by Dana Friis-Hansen. Exhibition brochure.

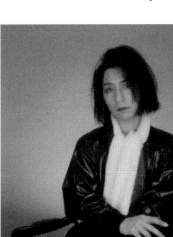

1999

GIULIO PAOLINI

Italian, b. Genoa, 1940
lives in Turin

Guilio Paolini conducts an ongoing dialog with the history of art in his complex multimedia installations. Associated with Art Povera in the 1960s and 1970s, the artist has often focused on the means of constructing pictorial and sculptural illusions in art. His work is reductive and conceptual yet always maintains a strong aesthetic dimension.

Early in his career Paolini began examining the conditions and techniques of artistic production. *Geometrical Drawing,* 1960, consists of crossed ink lines on a white surface, in abbreviated reference to the traditional painter's act of squaring off a canvas. Other works from that period endeavored to represent such elementary components of painting as color, support structure, and preliminary draftsmanship. Later in the decade Paolini began to allude to specific works from art history, appropriating details and complete images from Lorenzo Lotto, Raphael, and Nicolas Poussin, among others.

As his work became richer in visual content, Paolini employed casts of Classical sculpture in his creations. An example of that practice, the "Mimesis" series of 1975–76 [cat. no. 43, p. 41], consists of paired casts of well-known sculptures from antiquity. The artist positioned the works to face each other, inciting the viewer to reflect on not only the space between the statues but also the distance between the viewers and the historic past.

In the 1980s and 1990s, Paolini's installations became increasingly complex and expansive yet continued to investigate the conditions of artistic practice. *House of Lucretius,* 1981–84, places a number of casts of an angel's head by seventeenth-century Italian sculptor Allessandro Algardi on pedestals. The work evokes and disrupts the traditional aura of the singular work of art. Similar in intent yet less systematic, *The Guest,* 1993, crowds together chairs, frames, and canvases in a confined space.

Paolini has been the subject of many retrospectives, the first at the Art History Institute of the University of Parma in 1976 and more recently at the Neuen Galerie am Landesmuseum Joanneum, Graz, Austria, in 1998. He has been included in all major exhibitions of the Arte Povera artists and has participated frequently in Documenta, Kassel, Germany, and the Venice Biennale. His work was introduced to American audiences with a solo exhibition at the Museum of Modern Art in 1974 and as part of the group exhibition "The Knot: Arte Povera at P.S. 1" at P.S. 1, The Institute for Art and Urban Resources, Long Island City, New York, in 1985. *C.G.*

Celant, Germano. *The Knot: Arte Povera at P.S. 1*. Long Island City, N. Y.: P.S. 1, The Institute for Art and Urban Resources; Turin: Umberto Allemandi, 1985. Exhibition catalog.

Giulio Paolini. Nagoya: Institute of Contemporary Art, 1987.

Giulio Paolini: La Voce del Pittore, Scritti e Interviste 1965–1995 (The voice of the painter: writings and interviews 1965–1995). Lugano: ADV Publishing House, 1995.

Giulio Paolini: Von Heute bis Gestern, Da Oggi a Ieri (Giulio Paolini: from today to yesterday). Graz, Austria: Neue Galerie im Landesmuseum Joanneum, 1998. Exhibition catalog.

Poli, Francesco. *Giulio Paolini.* Turin: Lindau, 1990.

PABLO PICASSO

Spanish, b. Málaga, 1881–1973

Pablo Picasso dominated the art of the twentieth century through a combination of prolific creativity, technical brilliance, and forceful personality. A master of the Classical tradition as well as a succession of vanguard styles, his innovations in painting and sculpture and dynamic expressiveness propelled many of the radical changes in art since 1900.

Picasso studied with his painter father and at the academies in La Coruña, Barcelona, and Madrid in the late 1880s and 1890s. In 1899, at age eighteen, Picasso became part of the Barcelona avant-garde circle Els Quatre Gats, commencing his lifelong involvement with critics, poets, artists, dancers, and theater producers. From 1900 to 1906, primarily in Paris, Picasso created the paintings of his so-called Blue Period – images that explored themes of poverty, depression, prostitution, and the circus – and the Rose Period – works inspired by Greek art and Paul Cézanne's landscapes and bathers. By 1906, Picasso began the experimentation that produced *Les Demoiselles d'Avignon,* 1907 [see fig. 3], and in 1908 he initiated a friendship with Georges Braque that resulted in Analytic, and later Synthetic, Cubism.

By 1919, Picasso emphasized sculptural weight, monumentality, and draftsmanship in his Neoclassical figurative style. He became associated with Surrealism in

1995

the 1920s for his dreamlike mingling of emotion-laden images with mythic creatures. Also in that decade, Picasso began dividing his time between Paris and southern France. In 1937 he painted *Guernica* as a statement of his abhorrence of war.

Picasso's inventiveness continued unabated into his final decades. In the 1940s he created sculptures with found objects, experimented with ceramics, and painted images and portraits that explored themes of war and violence. In the 1950s he fused Cubism with subjects taken from historical paintings. These works became "conversations" with artists such as Diego Velázquez, Édouard Manet, and his contemporary Henri Matisse. He died at age ninety-two in 1973.

Picasso first exhibited at Els Quatre Gats, Barcelona, in 1900 and Ambroise Vollard Gallery, Paris, in 1901. He was widely exhibited during his lifetime and major shows continue to be organized. Some major exhibitions have been organized by the Museum of Modern Art, New York, 1980; the Tate Gallery, London, 1988; the National Gallery of Art, Washington, D.C., 1997; and the Fine Arts Museums of San Francisco in collaboration with the Solomon R. Guggenheim Museum, New York. *A.L.M.*

Ashton, Dore, comp. *Picasso on Art: A Selection of Views.* New York: Viking Press, 1972.

Leiris, Michel, et al. *Late Picasso: Paintings, Sculpture, Drawings, Prints, 1953–1972.* London: Tate Gallery, 1988. Exhibition catalog.

Nash, Steven A., ed., and Robert Rosenblum. *Picasso and the War Years: 1937–1945.* London: Thames and Hudson and the Fine Arts Museums of San Francisco, 1998. Essays by Brigitte Baer, Michelle Cone, Michael FitzGerald, Lydia Csato Gasman, and Gertje Utley. Exhibition catalog.

Richardson, John. *A Life of Picasso.* 2 vols. New York: Random House, 1991 and 1996. With the collaboration of Marilyn McCully.

Rubin, William, ed. *Pablo Picasso: A Retrospective.* New York: Museum of Modern Art, 1980. Exhibition catalog.

MICHELANGELO PISTOLETTO

Italian, b. Biella, 1933 lives in Turin

Since his first exhibition in the late 1950s, Michelangelo Pistoletto has created a body of work governed by a humanistic approach rather than a single artistic method. Beginning with a focus on self-portraiture, Pistoletto established a signature style of painting on reflective surfaces. He later elaborated on the interactive elements of those works, branching out into architecture, performance, sculpture, and theater.

Pistoletto was born in the hill country of Italy, the son of two artists. His father restored frescoes, and by age fourteen Pistoletto was assisting in the family workshop, learning the traditional techniques of painting. In the late 1950s, Pistoletto developed his first mature works, self-portraits painted on mirrors, which eventually led him to superimpose other figures on reflective surfaces. The "Mirror Works," begun in 1961, each present a life-size figure realistically rendered on a surface of polished stainless steel, thereby representing a constant element that contrasts with the changing reflective surface.

In the early 1960s, Pistoletto expanded the mirror motif to develop several new themes. His "Plexiglass" series of 1964 consists of photographs of ordinary objects applied to panes of the transparent medium. Later, Pistoletto, together with other Italian artists of the Arte Povera movement, began to work with nontraditional materials. In the late 1960s he introduced rags into his work, creating *Venus of the Rags*, 1967 [cat. no. 45, p. 43], and *Small Wall of Rags* and *Orchestra of Rags*, both 1968. During that period he also opened his studio to intellectuals, filmmakers, and poets and experimented with a form of collective street theater called *Zoo*, which staged events in cities throughout Europe that resembled the 1950s "Happenings" in the United States.

Pistoletto's later forays into theater included productions of Samuel Beckett's *Neither*, 1977, as well as his own *Opera Ah*, 1979, and *Anno Uno* (Year One), 1981. He experimented with architectural installation in an exhibition at the Galleria Christian Stein, Turin, called "The Rooms," 1975–76, and in the "Hard Poetics" series of 1985. "White Year" of 1989, consisted of a yearlong series of events and exhibitions that culminated in a show of white marble slabs at the Museo di Capodimonte, Naples. Pistoletto has written numerous manifestos, statements, and theater scripts. His work was included in Documenta, Kassel, Germany, in 1982, 1992, and 1997, and he has been featured in solo exhibitions at the Museum Moderner Kunst Stiftung Ludwig, Vienna, Austria, in 1995 and the Städtische Galerie im Lenbachhaus, Munich, in 1996. *C.G.*

Celant, Germano, and Alanna Heiss. *Pistoletto: Division and Multiplication of the Mirror.* Milan: Gruppo Editoriale Fabbri, 1988. Exhibition catalog.

Corà, Bruno. *Pistoletto.* Milan: Charta, 1995. Contributions by Chiara d'Aflitto, Michelangelo Pistoletto, and Elizabeth Schweeger. Exhibition catalog.

Michelangelo Pistoletto: Zeit-Räume (Michelangelo Pistoletto: Time-space). Vienna: Museum Moderner Kunst Stiftung Ludwig, 1995. Essays by Monika Faber, Lorand Hegyi, and Denys Zacharopoulos. Exhibition catalog.

Pistoletto, Michelangelo. *A Minus Artist.* Florence: Hopefulmonster, 1989.

PISTOLETTO

Painting a portrait of Jacqueline Roque, 1957

With granddaughter, Ginerva, 1998

SIGMAR POLKE

German, b. Oleśnica, Poland, 1941
lives in Cologne

In his paintings, drawings, photographs, and early assemblages, Sigmar Polke marries aesthetics and alchemy, politics and parody, to critique the present and recent past. Forging a path between abstraction and narrative, using innovative materials and images, he creates work permeated with irony.

Born in the Silesia region of eastern Germany (today part of Poland), Polke fled with his family to the German state of Thuringia in 1945, then immigrated to Düsseldorf, West Germany, in 1953. After studying glass painting in 1959 and 1960, Polke studied painting at the Kunstakademie Düsseldorf from 1961 to 1967. In 1963 he and fellow students Gerhard Richter and Konrad Fischer Lueg originated Capitalist Realism, the acerbic and satirical style that mocked the banal pleasures of Western consumer culture and challenged the bright optimism of American Pop Art. Depicting four suggestively attired Playboy hostesses, Polke's *Bunnies* [cat. no. 46, p. 68] quotes Pop artist Roy Lichtenstein's use of Benday dots and makes reference to a peculiarly American icon.

By the late 1960s, Polke began using appropriated images – drawn with studied carelessness or stenciled from high and low visual sources – on printed fabrics. In 1970, Polke moved to Krefeld to take a position as guest instructor at the Akademie der Bildenden Künste, Hamburg, becoming a professor in 1977.

In 1978, Polke moved to Cologne. By 1980 he was creating series of works, such as "Watch Tower," which addressed the burden of recent German history. Since the late 1980s, Polke has culled images from eighteenth-century prints and nineteenth-century illustrations, the outlines of which he embeds in polyester resins to create opaque "transparencies."

Polke's first solo exhibition was at Galerie h, Hanover, in 1966. The Städtisches Kunstmuseum Bonn presented his first major museum exhibition in 1974. Polke's United States debut was at the Holly Solomon Gallery, New York, 1984. The San Francisco Museum of Modern Art organized a major exhibition that toured the United States, 1990–91. In 1997 the Kunst und Ausstellungshalle der Bundesrepublik Deutschland, Bonn, organized a retrospective of his work, which traveled to the Nationalgalerie im Hamburger Bahnhof in Berlin. The Museum of Modern Art, New York, presented an exhibition of Polke's works on paper in 1999. Polke has won the Painting Prize at the São Paulo Bienal, 1975; the Golden Lion Prize at the Venice Biennale, 1986; the Erasmus Prize, Amsterdam, 1994; and the Carnegie International Prize, Pittsburgh, 1995. *A.L.M.*

Rainbird, Sean, Judith Nesbitt, and Thomas McEvilley. *Sigmar Polke: Join the Dots*. Liverpool: Tate Gallery, 1995. Exhibition catalog.

Scholz, Dieter, et al. *Die Drei Lügen der Malerei* (Three lies of painting). Berlin: Staatliche Museen zu Berlin, 1997. Exhibition catalog.

Sigmar Polke. San Francisco: Museum of Modern Art, 1990. Essays by John Baldessari, John Caldwell, Michael Oppitz, Peter Schjeldahl, and Reiner Speck. Exhibition catalog.

Sigmar Polke: Illumination. Minneapolis: Walker Art Center, 1995. Exhibition catalog.

Sloterdijk, Peter, et al. *Sigmar Polke*. Amsterdam: Stedelijk Museum, 1992. Exhibition catalog.

1995

CHARLES RAY

American, b. 1953, Chicago
lives in Los Angeles

Throughout his career, Charles Ray has subverted the traditional language and expectations of sculpture. His early performances of the 1970s and subsequent figurative and abstract works challenge the viewer on psychological and perceptual levels.

The son of a commercial artist who also ran an art school, Ray took summer classes at the School of the Art Institute of Chicago and then enrolled at the University of Iowa, Iowa City, in 1971. There he created abstract metal sculptures that explored formal relationships between balance and tension. Soon after, he began to conduct performances using wooden planks and rope to support his body in extreme positions. After receiving his B.F.A. in 1975, Ray attended several graduate schools before completing his M.F.A. in 1978 at the Mason Gross School of the Arts, Rutgers University.

Ray moved to Los Angeles in 1981 to accept a teaching position at the University of California, where he continues to teach. For the next four years he created work that presented his body in relation to hard, geometrical forms. Later, exhausted by the demands of his performances and seeking ways to activate his sculpture without the presence of his own body, Ray returned to object

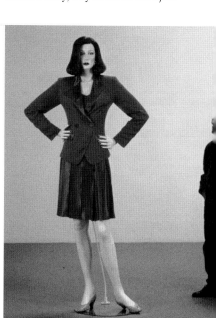

making in the mid-1980s. Works such as *Ink Box*, 1986, a black cube that appears solid but is actually an open container filled to the top with printer's ink, reveal his interest in making work that has the immediacy of performance.

Between 1990 and 1993, Ray returned to more figurative works and created a number of mannequin sculptures that address issues of scale and idealization. He has also made large-scale sculptures like *Firetruck*, 1993, and the fiberglass cast of a crushed car, *Unpainted Sculpture*, 1997, which play with viewers' perceptions and expectations.

Ray was the subject of a survey exhibition organized in 1994 by the Rooseum Center for Contemporary Art in Malmö, Sweden, which traveled to the Institute of Contemporary Arts, London, the Kunsthalle Zürich, and the Kunsthalle Bern. A later retrospective, which opened in 1998 at the Whitney Museum of American Art, New York, traveled to the Museum of Contemporary Art, Los Angeles, and to the Museum of Contemporary Art, Chicago. Ray was included in the Whitney Biennial in 1993, 1995, and 1997 and won the Larry Aldrich Foundation Award in 1997. *C.G.*

Charles Ray. Malmö, Sweden: Rooseum Center for Contemporary Art, 1994. Essay by Bruce W. Ferguson. Exhibition catalog.

Charles Ray. Newport Beach, Calif.: Newport Harbor Art Museum, 1990. Interviews by Lucinda Barnes and Dennis Cooper. Exhibition catalog.

Parkett, no. 37 (1993). Essays by Klaus Kertess, Christopher Knight, Peter Schjeldahl, and Robert Storr.

Schimmel, Paul. *Charles Ray*. Los Angeles: Museum of Contemporary Art, 1998. Essay by Lisa Phillips. Exhibition catalog.

Storr, Robert. "Anxious Spaces: Interview with Charles Ray." *Art in America* 86, no. 11 (November 1998): 101–5.

GERHARD RICHTER

German, b. Dresden, 1932
lives in Cologne

In his long career as a painter, Gerhard Richter has worked in an astonishing variety of styles ranging from photo-based figurative work to color charts and painterly abstractions. He has moved with ease among subjects, including portraits, landscapes, and modern history, defying the formalist dictate that an artist must achieve a signature style.

After working as a painter of stage sets and billboards from 1952 to 1956, Richter attended the Kunstakademie Dresden, where he learned traditional methods of oil painting and produced canvases in a social realist style. In 1961 he immigrated to West Germany and from 1961 to 1963 attended the Kunstakademie Düsseldorf. There he was exposed to the Pop Art and Fluxus movements and began making paintings based on snapshots and news images. His paintings of that period depict a gamut of subjects, including family groups, airplanes, automobiles, and bathers. Richter exhibited that work at the Galerie Heiner Friedrich, Munich; the Galerie Alfred Schmela, Düsseldorf; and the Galerie René Block, Berlin, all in 1964.

Although he did not abandon the realist style, Richter's repertoire expanded in 1966 when he began the "Color Chart" paintings, serially arranged compositions resembling charts of paint samples. In the late 1960s, Richter initiated a series of romantic landscapes derived from his own photographs as well as the thematically grouped "Cityscapes," "Cloud Formations," "Alpine Scenes," and "Seascapes." A sampling of those series and a photo-based work, *48 Portraits*, 1971, depicting noted European humanists, appeared at the German Pavilion of the Venice Biennale in 1972.

Richter's first "Abstract Paintings," which he began in 1976, combine boldly brushed surfaces with a brilliant palette. An ongoing project, they have become the largest body of work in his oeuvre.

Exhibitions of Richter's work include a retrospective jointly organized in 1988 by the Museum of Contemporary Art, Chicago, and the Art Gallery of Ontario, Toronto, which traveled to the Hirshhorn Museum and Sculpture Garden and the San Francisco Musuem of Modern Art; a major exhibition at the Tate Gallery, London, in 1991; and a retrospective, organized by the Kunst und Ausstellungshalle der Bundesrepublik Deutschland, Bonn, which traveled throughout Europe in 1993–94. A survey of Richter's landscape paintings, spanning some thirty-five years, also appeared at the Sprengel Museum in Hanover in 1998. Among the artist's many awards and honors are the Wolf Prize, 1995, and the Wexner Prize, 1997. *C.G.*

Gerhard Richter. Bonn: Kunst und Ausstellungshalle der Bundesrepublik Deutschland, 1993. 3 vols. Text by Benjamin H. D. Buchloh. Catalogue raisonné/exhibition catalog.

Gerhardt Richter: Landscapes. Ostfildern, Germany: Cantz, 1998. Essays by Oskar Bätschmann and Dieter Elgar. Exhibition catalog.

Jahn, Fred, ed. *Gerhard Richter: Atlas*. Munich: Städtische Galerie im Lenbachhaus; Cologne: Museum Ludwig, 1989. Essay by Armin Zweite. Exhibition catalog.

Obrist, Hans-Ulrich, ed. *The Daily Practice of Painting: Writings 1962–1993*. Trans. David Britt. Cambridge: M.I.T. Press; London: Anthony d'Offay Gallery, 1995.

Gerhard Richter, Madrid, 1994, by Thomas Ruff

Swiss, b. Grabs, 1962
lives in Zurich

Pipilotti Rist blends entertainment culture and fine art in her videos and installations dating from the mid-1980s. Her work often focuses on the feminine aspects of culture, creating environments that affect the viewer on an aesthetic rather than an ideological level.

Rist grew up in the Swiss farming town of Grabs near St. Gallen. She was educated at the Hochschule für Angewandte Kunst, Vienna, 1982–86, in graphic design and photography, and later studied audiovisual design at the Schule für Gestaltung, Basel, 1986–88.

Rist initially pursued a career in pop music and performance. In the early 1980s she created music videos for rock groups, then from 1988 to 1994 played bass, drums, flute, and sang in the all-women band "Les Reines Prochaines" (The Next Queens). In 1985, after working briefly in small-format film, Rist began to explore videotape's capacity to easily combine sound and image, creating the audiovisual art for which she is known today. Her first pieces in this genre were most often single-channel video recordings, in which she assumed the various roles of performer, screenwriter, and cameraperson. For example, *I'm Not the Girl Who Misses Much*, 1986, features the artist in an MTV-style performance, dancing frenetically while singing a modified version of a John Lennon song. In the early 1990s, the focus of Rist's work shifted from single-channel videos to installations that use innovative display formats to collapse the space between the viewer and the screen.

Rist was included in the São Paulo Bienal in 1992 and the Venice Biennale, 1993, 1997, and 1999; she won a Premio award in 1997 at the Venice Biennale for *Ever Is Over All*, 1997 [cat. no. 56, pp. 64, 65]. The artist has had numerous solo exhibitions in Europe, Israel, and the United States. In 1998 the Nationalgalerie im Hamburger Bahnhof in Berlin organized a retrospective of her work, "Remake of the Weekend," which traveled to the Kunsthalle Wien, Austria; Le Magazin, Centre National d'Art Contemporain de Grenoble, France; and the Kunsthalle Zürich, Switzerland. That year she was a finalist for the second Hugo Boss Prize from by the Solomon R. Guggenheim Museum, New York. In 1999 the Musée d'Art Moderne de la Ville de Paris had a two-person exhibition of her work with that of Martine Aballéa. *C. G.*

I'm Not the Girl Who Misses Much. Stuttgart: Oktagon in association with Kunstmuseum St. Gallen, the Neuen Galerie am Landesmuseum Joanneum, Graz, and the Kunstverein in Hamburg, 1994. Exhibition catalog.

Parkett, no. 48 (1996). Essays by Laurie Anderson, Marius Babias, Paolo Colombo, Nancy Spector, and Philip Ursprung.

Remake of the Weekend. Berlin: Nationalgalerie im Hamburger Bahnhof, 1998. Essays by Bernhard Bürgi, Alessandra Galasso, Gerald Matt, Britta Schmitz, and Immo Wagner-Douglas. Exhibition catalog.

Ziegler, Ulf Erdman. "Rist Factor." *Art in America* 86, no. 6 (June 1998): 80–83.

American, b. Omaha, Nebraska, 1937
lives in Los Angeles

Edward Ruscha's subjects are usually drawn from the images and phrases of popular culture, which he treats with a unique mixture of irony and reverence. Although best known for his paintings and works on paper, since the 1960s he has also created numerous artist's books and two short films.

Ruscha attended high school in Oklahoma City and then moved to Los Angeles, where he studied at the Chouinard Art Institute (now CalArts) from 1956 to 1960. Immediately after graduating, he spent a year working as a graphic designer at an advertising firm. Later he was a printer's apprentice and a book designer, and from 1965 to 1969 he was on the staff of *Artforum* magazine.

In the early 1960s, Ruscha made schematic paintings of Standard gas stations and the 20th Century Fox logo and text paintings that sometimes included images from comic books or of floating food products. He also made small-format books. By the middle of the decade the text paintings had become sparer, with a single word formed by a pool of liquid or a three-dimensional ribbon. He developed a practice in the late 1960s and early 1970s of staining paper and fabric with organic materials, such as strawberries, chutney, and squid ink.

PIPILOTTI RIST

EDWARD RUSCHA

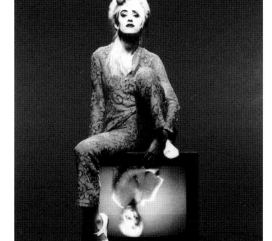

1994

Ruscha began to incorporate cinematic references into his work in the late 1970s, beginning with a series of panoramic landscapes. In the mid-1980s he placed text over ominous film noir shadows and began a series of "Silhouette" paintings in which dark, grainy forms depict houses, ships, or animals. Recently, he has painted words over alpine imagery and experimented with city plans and shaped canvases.

Ruscha had his first one-person show at the Ferus Gallery, Los Angeles, in 1963. His first retrospective was organized by the San Francisco Museum of Modern Art in 1982. A second retrospective, jointly organized by the Musée National d'Art Moderne, Centre Georges Pompidou, Paris, and the Museum Boymans–van Beuningen, Rotterdam, traveled to the Fundació "la Caixa," Barcelona; the Serpentine Gallery, London; and the Museum of Contemporary Art, Los Angeles, from 1989 to 1991. Ruscha has been included in such group shows as the Whitney Biennial, 1987, and "Prospect 98" at the Frankfurter Kunstverein and the Schirn Kunsthalle, Frankfurt. In 1999 the Walker Art Center, Minneapolis, organized a retrospective of his prints, books, and graphic works. In the year 2000, Ruscha will have a retrospective at the Hirshhorn Museum and Sculpture Garden, organized jointly with the Museum of Modern Art, Oxford. *C.G.*

Ed Ruscha: New Paintings and a Retrospective of Works on Paper. London: Anthony d'Offay Gallery, 1998. Essays by Dave Hickey and Neville Wakefield. Exhibition catalog.

Edward Ruscha: Editions, 1959–1999. Minneapolis: Walker Art Center, 1999. Essays by Siri Engberg and Clive Phillpot. Catalogue raisonné.

Edward Ruscha: Paintings/Schilderijen. Rotterdam: Museum Boymans–van Beuningen, [1989]. Essays by Dan Cameron and Pontus Hulten; interview by Bernard Blistène. Exhibition catalog.

The Works of Edward Ruscha. New York: Hudson Hills Press and San Francisco Museum of Modern Art, 1982. Essays by Dave Hickey and Peter Plagens. Exhibition catalog.

American, b. Washington, D.C.
lives in New York

Beverly Semmes's work includes fabric sculpture, still photography, film, and video installation. She is best known for her wall-mounted dresses of the 1990s, which allude to an absent female body while addressing issues of scale, landscape, and architectural space.

Semmes was a student at the School of the Museum of Fine Arts, Boston, where she completed her B.F.A. in 1982. She then studied at the Skowhegan Institute in Maine and the New York Studio School before attending Yale University, 1985–87, for her M.F.A. Upon graduating, Semmes exhibited large sculptures that explored the boundary between nature and art. A crucial turning point in her work came in 1988, when she staged a private outdoor performance in the gardens of a New York hospital. The short film that records the performance depicts a figure strolling in a manicured landscape wearing an oversize hat and pink feather dress. These performance "props" anticipated her later work, in which clothes are treated both as substitutes for and extensions of the human form.

Semmes constructed her first garment sculptures of the early 1990s on a wearable scale, although many were absurdly elongated. Later, she eliminated any obvious connection to the human form, sometimes sewing up necklines or connecting sleeves together. Her work could be austere and sexless, as in *House Dress*, 1992, a broad-shouldered dress made out of rayon, or overtly sumptuous, as in *Red Dress*, also 1992 [cat. no. 58, p. 73], which was first exhibited at the Sculpture Center, New York, in 1992.

In the past five years, Semmes has gone beyond the garment motif, exhibiting large-scale handmade ceramics in 1994 and experimenting with kinetic sculpture in such works as *Big Silver*, 1996. In 1997 she filled a room at the Wexner Center for the Arts in Columbus, Ohio, with ninety-nine velvet pillows and perched an enormous stuffed cat on top. More recently, Semmes has employed large-scale still photography and video to record performances that juxtapose mysterious cloaked figures with the natural landscape.

In addition to being included in many international group shows dealing with clothing and the body, Semmes has had solo exhibitions in galleries and museums in the United States and Europe, including those at the Hirshhorn Museum and Sculpture Garden; the Norton Museum of Art, West Palm Beach, Florida; the Smith College Museum of Art, Northampton, Massachusetts; and the Virginia Museum of Fine Arts, Richmond, all in 1996. That year, a five-year survey of her work was held at the Irish Museum of Modern Art, Dublin. *C.G.*

Beverly Semmes. Northampton, Mass.: Smith College Museum of Art, 1996. Essays by Margo A. Crutchfield, Russell Ferguson, Lisa Hurley, and Linda Muehlig. Exhibition catalog.

Beverly Semmes. Farnham, Mass.: James Hockey Gallery, 1994. Essay by Patricia Phillips. Exhibition catalog.

Feldman, Melissa. *Beverly Semmes.* Philadelphia: Institute of Contemporary Art, 1993. Exhibition brochure.

Heartney, Eleanor. "Beverly Semmes: Art to the Nines/Beverly Semmes: l'habit et son alibi." *Art Press* 188 (February 1994): E10–12, 27–29.

Photograph inscribed to Joseph and Olga Hirshhorn, 1968

1998

CINDY SHERMAN

*American, b. Glen Ridge, New Jersey, 1954
lives in New York*

Since the late 1970s, Cindy Sherman has used photography to document scenes of her own creation, which refer to imagery from both the fine arts and popular culture. Her earliest work was inspired by cinema, but she later turned to a wide range of historical media and styles, bringing dolls and prosthetic devices into her repertoire.

After growing up in suburban Long Island, Sherman studied painting and photography at the State University College at Buffalo, New York. She completed her B.F.A. in 1976, then spent a year after graduation managing Hallwalls, an alternative space in Buffalo. In 1977 she moved to New York and began photographing herself in a variety of imagined scenarios. The photographs, 8x10 black-and-white prints, soon developed into the series "Film Stills," 1977–80 [cat. nos. 59–65, pp. 74–77], which mimics the stereotypical gestures and situations of women in cinema.

In 1980, Sherman developed a new body of work, "Rear Projections," 1980–81, color photographs shot in a studio. That year *Artforum* magazine invited her to create a portfolio, which became the "Centerfolds," or "Horizontals," series, color images depicting vulnerable, reclining women. In the middle of the decade Sherman began to work with a broad array of historical and literary references. In

"Fairy Tales," 1985, and "Disasters," 1986–89, she depicted herself as fantasy creatures, monsters, and mutants. In the "History Portraits," 1988–90, she loosely reworked Old Master paintings. Sherman's most controversial body of work to date, the "Sex Pictures," 1992, dispenses with images of the artist's body in favor of surreal compositions made out of doll parts and prosthetic devices. At the suggestion of film producer Christine Vachon, Sherman directed her first motion picture, *Office Killer*, in 1997.

Sherman's work has been included in numerous solo and group exhibitions in America, Europe, and Japan; the Whitney Biennial, 1985, 1991, 1993, and 1995; and the Carnegie International, 1985 and 1995. Retrospectives of her work include those at the Whitney Museum of American Art, New York, 1987; the Museum Boymans–van Beuningen, Rotterdam, 1996; and an exhibition jointly organized by the Museum of Contemporary Art, Los Angeles, and the Museum of Contemporary Art, Chicago, 1997, which traveled to five other museums. Sherman won a Larry Aldrich Foundation Award in 1994 and a MacArthur Foundation Fellowship in 1995. *C.G.*

Cindy Sherman. New York: Whitney Museum of American Art, 1987. Essays by Lisa Phillips and Peter Schjeldahl. Exhibition catalog.

Cindy Sherman: Retrospective. Chicago: Museum of Contemporary Art, 1997. Essays by Amada Cruz, Amelia Jones, and Elizabeth A. T. Smith. Exhibition catalog.

Danto, Arthur C. *Cindy Sherman: History Portraits.* New York: Rizzoli, 1991.

———. *Cindy Sherman: Untitled Film Stills.* New York: Rizzoli, 1990.

Kraus, Rosalind, and Norman Bryson. *Cindy Sherman 1975–1993.* New York: Rizzoli, 1993.

Parkett, no. 30 (1991). Essays by Norman Bryson, Wilfried Dickhoff, Ursula Pia Jauch, Elfriede Jelinek, and Abigail Solomon-Godeau.

1990

LORNA SIMPSON

*American, b. Brooklyn, New York, 1960
lives in Brooklyn*

Since 1985, Lorna Simpson's photo-text pieces, installations, and recent film projections have addressed issues of identity, gender, race, and memory. Her works force the viewer to consider unsettling readings and question the way we interpret images in art and life.

Simpson completed her B.F.A. at the School of Visual Arts, New York, in 1982 and her M.F.A. at the University of California, San Diego, in 1985. Because her earliest work – photographs of street life in Africa, Europe, and the United States in the late 1970s – were misread as straightforward documents, she turned to making carefully controlled studio shots. These often depicted a woman's body, with the face obscured or turned away, together with brief texts.

In 1990, Simpson started to develop a vocabulary of symbolic objects that served as surrogates for the human body, including shoes, shoe boxes, African masks, and coiled or braided hair. A residency at the Fabric Workshop and Museum in Philadelphia in 1994 inspired her to experiment with printing on felt. That experience led to several large-scale works including *Standing in the Water*, 1994, installed that year at the Whitney Museum of American Art at Phillip Morris, New York, and *Wigs*, also 1994

[cat. no. 69, pp. 70–71], which was first exhibited at the Rhona Hoffman Gallery, Chicago, in 1995. Simpson then commenced a series of large-scale images of building interiors and exteriors that she also silkscreened onto felt and accompanied with written narratives. As a participant in the Wexner Center for the Art's Residency Award Program, she began to work in the medium of film. There, in 1997, she exhibited her first cinematic work, *Interior/Exterior, Full/Empty,* a seven-channel installation. A second film, *Call Waiting,* was followed in 1998 by *Recollections,* both single-channel installations.

Simpson's work has appeared in the "Aperto" section of the Venice Biennale in 1990, the Whitney Biennial in 1991 and 1993, and "Prospect 93" at the Frankfurter Kunsverein in 1993. A survey of her work, "Lorna Simpson: For the Sake of the Viewer," was organized at the Museum of Contemporary Art, Chicago, in 1992 and traveled to Honolulu, Cincinnati, Seattle, and New York. In 1994, Simpson became the youngest artist to win the College Art Association's Artists Award for a Distinguished Body of Work. She was a finalist for the Hugo Boss Award from the Solomon R. Guggenheim Museum, New York, in 1998. *C.G.*

Enwezor, Okwui. "Social Grace: The Work of Lorna Simpson." *Third Text* 35 (Summer 1996): 43–58.

Heartney, Eleanor. "Figuring Absence." *Art in America* 83, no. 12 (December 1995): 86–87.

Lorna Simpson. Vienna: Wiener Secession, 1995. Essay by bell hooks. Exhibition catalog.

Lorna Simpson: For the Sake of the Viewer. Chicago: Museum of Contemporary Art, 1992. Essays by Sadiya V. Hartman and Beryl J. Wright. Exhibition catalog.

Simpson, Lorna, and Sarah J. Rogers. *Lorna Simpson: Interior/ Exterior, Full/Empty.* Columbus: Wexner Center for the Arts, Ohio State University, 1997. Exhibition catalog.

KIKI SMITH

American, b. Nuremberg, Germany, 1954 lives in New York

In her sculptures, prints, drawings, and installations of the 1980s, Kiki Smith often focused on unidealized images of the human body, depicting anatomical fragments and internal organs as well as full figures. During the past decade she has turned more often to the animal world and the natural environment for the subjects of her exquisitely crafted work.

Smith grew up in a family of artists and assisted her artist-architect father Tony Smith. After high school she spent a year studying industrial baking and later became certified as an emergency medical technician. When Smith moved to New York in 1978, she worked as part of Collaborative Projects (Co-Lab), an artists' collective that included John Ahearn, Jane Dickson, Jenny Holzer, and Robin Winters, among others.

From 1980 to 1985, Smith drifted away from the activism of her colleagues at Co-Lab. She began to represent the human body in such works as *Hand in Jar,* a latex hand floating in a mason jar, and *Hand Choking Throat,* an X-ray of the strangulation process, both 1983. Her interest in the mechanics of the body led to works such as *Womb,* 1985, a uterus made of bronze, and *Heart,* 1986, a plaster model of the heart coated with silver leaf. In the late 1980s she turned from examining the body's protected interior to dealing with its exposed surface, which Smith sees as a region of political rather than personal or biological meaning. Works in that vein included life-size figures made of paper and, later, wax.

In 1995, with the cast-bronze *Jersey Crows,* Smith increasingly drew on subjects from the animal world and the natural environment. In these works she used multiples of glass eggs and stars, neon rainbows, silver-leafed snowflakes, and etchings on paper.

Smith had her first solo exhibition at the Fawbush Gallery, New York, in 1988, followed by a "Projects" exhibition two years later at the Museum of Modern Art, New York. At the Whitney Biennial in 1991 and 1993 and the Venice Biennale in 1993 she exhibited her wax and paper figures, which also figured significantly in her first survey show, at the Whitechapel Art Gallery, London, in 1995. More recent solo shows include those at the Museum of Modern Art, New York, 1997–98; in Pittsburgh at the Mattress Factory and the Carnegie Museum of Natural History, both 1998; and "Directions – Kiki Smith: Night" at the Hirshhorn Museum and Sculpture Garden, also in 1998. *C.G.*

Gould, Claudia, and Linda Shearer. *Kiki Smith.* Williamstown, Mass.: Williams College Museum of Art; Columbus: Wexner Center for the Arts, Ohio State University, 1992. Text by Marguerite Yourcenar. Exhibition catalog.

Kiki Smith. Montreal: Montreal Museum of Fine Arts, 1996. Exhibition catalog.

Kiki Smith: Prints and Multiples 1985–1993. Boston: Barbara Krakow Gallery, 1994. Text by Nancy Stapen. Exhibition catalog.

Posner, Helaine. *Kiki Smith.* Boston: Little, Brown, 1998.

Tillman, Lynne, and Kiki Smith. *Madame Realism.* New York: Print Center, 1984.

th daughter, Zora Simpson sebere, 1999

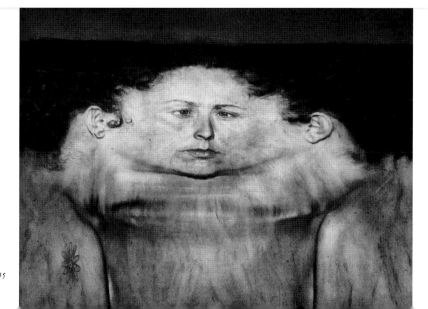

My Blue Lake, 1995

HIROSHI SUGIMOTO

Japanese, b. Tokyo, 1948
lives in New York and outside Tokyo

Since the 1970s, the subjects of Hiroshi Sugimoto's photographic series have included museum dioramas, movie theaters, seascapes, and wax museums. His minimal black-and-white images are studies in stillness and serenity as well as emptiness.

Sugimoto completed his B.A. at Saint Paul's University, Tokyo, in 1970. After traveling through the Soviet Union and Europe, he settled in Los Angeles and attended the Art Center College of Design, Pasadena, receiving a B.F.A. in 1972. Since 1974, Sugimoto has been based in New York, but he visits Japan annually and travels internationally to take photographs.

The artist's first series of photographs, begun in 1974 and completed in the 1980s, document the wildlife dioramas at the American Museum of Natural History, New York. Using a wide-angle lens to flatten out the curve of the painted background, Sugimoto cropped the images to leave no evidence of the museum environment, thus enhancing the simulation of the display. A second series, begun in 1976, portrayed American movie theaters of the late 1920s and 1930s. In the darkened theaters, he exposed the film for the duration of a feature-length movie, leaving only a washed out area of pure light on the screen. Works from these two series,

together with a lesser-known series, "Here There and Everywhere," 1976, featuring text from a Buddhist sutra, were included in his first solo exhibition, at the Minami Gallery, Tokyo, in 1977.

In 1978, Sugimoto began his "Seascape" series consisting of carefully planned images of sea and sky in which the horizon line bisects each picture. While continually adding to these series, Sugimoto also developed other photographic projects. In 1994 he documented the hyperreal vignettes at the Movieland Wax Museum in Los Angeles and Madame Tussaud's Chamber of Horrors in London. After a six-year negotiation with government authorities, he obtained permission, in 1995, to photograph and film the 1,001 statues of the bodhisattva Kannon in a Buddhist temple in Kyoto. The resulting series of still photographs, "Hall of the Thirty-Three Bays," comprises forty-eight nearly identical images of the impassive figurines.

Sugimoto has been the subject of solo exhibitions at the Museum of Contemporary Art, Los Angeles, 1994; the Kunsthalle Basel, 1995; the Metropolitan Museum of Art, New York, 1995–96; and the Fundació "la Caixa," Madrid, 1998. He has participated in such international group exhibitions as "Prospect 96" at the Schirn Kunsthalle, Frankfurt, in 1996 and the tenth Sydney Biennial in 1996. *C.G.*

Hiroshi Sugimoto. Norwich: Salisbury Centre for Visual Arts, 1997. Essays by Norman Bryson, Kohtaro Iizawa, William Jeffett, and Nicole Coolidge Roosmaniere. Exhibition catalog.

Kellein, Thomas. *Hiroshi Sugimoto: Time Exposed.* London: Thames and Hudson, 1995. Exhibition catalog.

Parkett, no. 46 (1996). Essays by Norman Bryson, Roger Denson, and Ralph Rugoff.

Sugimoto. Houston: Contemporary Arts Museum; Tokyo: Hara Museum of Contemporary Art, 1996. Exhibition catalog.

Sugimoto. Madrid: Fundació "la Caixa," 1998. Essays by Kerry Brougher, Peter Hay Halpert, Helena Tatay Huici, Jacinto Lageira, and John Yau. Exhibition catalog.

ROSEMARIE TROCKEL

German, b. Schwerte, 1952
lives in Cologne

Challenging issues of sexuality, culture, and means of artistic production, Rosemarie Trockel in her drawings, videos, sculptures, and so-called knitted paintings of the 1980s offered a critique of common perceptions of women's creativity. Since the 1990s her highly eclectic videos, multimedia installations, and collaborative public projects have employed a variety of themes and techniques to subtly engage the psychology of the viewer.

After brief studies in anthropology, sociology, theology, and mathematics, Trockel studied painting at the Werkkunstschule in Cologne from 1974 to 1978. By the mid-1980s she began to make art that challenged the connotations of knitting as a feminine craft. Trockel designed large-scale images on computer and reproduced them with a knitting machine, making patterns that incorporated such commercial and cultural symbols as the Playboy Bunny and the hammer and sickle. Later, she made "functional" knitted pieces, including a ski mask with no mouth (a terrorist's cap) and a pair of elongated "endless" stockings.

In the late 1980s, Trockel increasingly turned to making videos. In such works as *Ants,* 1989, she continued to manipulate conventional techniques by embracing amateurish, low-tech effects, producing tapes that look like old home movies. Another video, *Out of the Kitchen into the*

Self-Portrait,
1999, detail

Fire, 1993, presents in slow-motion a woman giving birth to an egg, which then breaks open to reveal a black fluid. More recent videos range from complex narratives, as in *For Example, Balthasaar, 6 years old*, 1996, which follows two children on their journey down a country road, juxtaposing the brutality of nature with its ritualization in society; to successions of still images, as in *Yvonne*, 1997, in which one of Trockel's friends or family members wearing a piece of her knitwear appears in each frame.

Since 1996, Trockel has also been collaborating with German artist Carsten Höller to create installations that use live animals. At Documenta in Kassel, Germany, in 1997 they presented *A House for Pigs and People* consisting of a carefully tended pigpen, designed to make viewers part of the spectacle.

In 1991 the Institute of Contemporary Art, Boston, and the University Art Museum, Berkeley, California, co-organized a solo exhibition of her work, which traveled to Chicago, Toronto, and Madrid. In 1998, Trockel was the subject of a retrospective organized by the Hamburger Kunsthalle, Hamburg, which traveled to the Whitechapel Art Gallery, London; the Staatsgalerie Stuttgart; and the M.A.C. Galeries Contemporaines des Musées de Marseille, France. She represented Germany at the Venice Biennale in 1999.
STEPHANIE ROSENTHAL WITH SARAH FINLAY

Burke, Gregory, ed. *Rosemarie Trockel*. Wellington, New Zealand: City Gallery, 1993. Essays by Gregory Burke, Robyn Gardner, and Jutta Koether, Exhibition catalog.

Parkett, no. 33 (1992). Essays by Véronique Bacchetta, Anne M. Wagner, and Barrett Watten.

Rosemarie Trockel: Werkgruppen 1986–1998 (Rosemarie Trockel: Works 1986–1998). Hamburg: Hamburger Kunsthalle, 1998. Essays by Simone de Beauvoir, Gudrun Inboden, Uwe M. Schneede, et al. Exhibition catalog.

Stich, Sidra, ed. *Rosemarie Trockel*. Munich: Prestel, 1991. Essays by Sidra Stich and Elisabeth Sussman. Exhibition catalog.

1993

JAMES TURRELL

American, b. Los Angeles, California, 1943 lives in Flagstaff, Arizona

James Turrell uses light and human perception as the materials of his art. Since the 1960s he has applied principles of physics, psychology, and aesthetics to create intimate and environmental installations that enable the viewer to experience the sublime in contemporary terms.

Turrell earned a B.A. in psychology, Pomona College, California, in 1965. He pursued his M.A. in art at Claremont Graduate School from 1968 to 1973, during which time he was also a lecturer and visiting artist at various California colleges. From 1966 to 1969 he used projectors to make "Projection Pieces," light installations shown on walls or in corners that appeared to dematerialize architecture. The "Single Wall Projections" from 1967 and "Shallow Space Constructions" from 1968 similarly create space that seems tangible but is difficult to locate.

In 1968, in a collaborative art and technology project at the Los Angeles County Museum of Art, Turrell learned to manipulate light without projectors by employing xenon and ambient light. From 1969 to 1974, Turrell exploited perceptual difficulty in "Mendota Stoppages," studio experiments that combined daylight, moonlight, street light (from traffic signals and cars), shadows, and refracted light.

Since 1969, Turrell has made "Wedgework" installations in which colored lights diagonally slice across darkened space, as in *Milk Run*, 1996 [cat. no. 81, p. 66]. In 1976 he initiated "Space Division Constructions," or "Apertures" – horizontal spaces that open to the sky. These series test the viewer's perception of illuminated space as light conditions vary.

In 1974, Turrell moved from Santa Monica, California, to Flagstaff, Arizona, and began his magnum opus, *Roden Crater* [see fig. 52]. Working with geologists and astronomers, Turrell is reshaping a dormant volcano into a natural observatory. Other projects include the mobile rooms "Perceptual Cells," 1990–92, and the constructions "Autonomous Structures," from the early 1990s.

Turrell's first solo exhibition was at the Pasadena Art Museum, 1967; his next important show was at the Stedelijk Van Abbemuseum, Eindhoven, The Netherlands, 1976. The Whitney Museum of American Art, New York, presented his work in 1980, after which numerous exhibitions were held in Europe, Japan, and the United States. Turrell received a MacArthur Foundation Fellowship, 1984; the Andy Warhol Foundation for the Visual Arts Award, 1990; the Chevalier des Arts et des Lettres, France, 1991; and the Wolf Prize, 1997. *A.L.M.*

Adcock, Craig. *James Turrell: The Art of Light and Space*. Berkeley: University of California Press, 1990.

Andrews, Richard. *James Turrell: Sensing Space*. Seattle: University of Washington, 1992. Exhibition catalog.

Hasegawa, Yuko, et al. *James Turrell: Where Does the Light in Our Dreams Come From?*. James Turrell Exhibition Committee: Setagaya, Japan: Setagaya Art Museum; Saitama, Japan: Museum of Modern Art; Nagoya City Art Museum, 1997. Exhibition catalog.

Herbert, Lynn M., et al. *James Turrell: Spirit and Light*. Houston: Contemporary Arts Museum, 1998. Exhibition catalog.

In his vintage truck, 1998

ANDY **WARHOL**

American, b. Pittsburgh, Pennsylvania,
1928–1987

Born in the United States to Czech immi-
grant parents, Andy Warhol was a key fig-
ure in the American Pop Art movement
and a major influence on contemporary
art. Working with many assistants and
collaborators, he was active in a range of
visual media, including painting, sculp-
ture, serigraphy, and filmmaking.

Warhol received his formal art training at
the Carnegie Institute of Art in Pittsburgh,
studying there from 1945 to 1949. After
graduating with a B.A. in fine arts, he moved
to New York to begin a career as a com-
mercial illustrator. His stylish drawings
appeared on the pages of *Glamour*, *Vogue*,
and *Harper's Bazaar*. He also illustrated a
book by Truman Capote, designed theater
backdrops, and created limited-edition art
books using an ink-blot monotype process.

In the early 1960s, Warhol gave up maga-
zine illustration and turned to fine art.
Transgressing the standards of high art, he
made paintings derived from subjects from
the media, such as cartoon characters, Coca-
Cola bottles, and Campbell Soup cans, and
created sculptures resembling Brillo boxes,
which he displayed stacked on gallery
floors. His first solo shows were held at the
Ferus Gallery, Los Angeles, and the Stable
Gallery, New York, in 1962. Three years
later he had a solo museum exhibition at

the Institute of Contemporary Art,
University of Pennsylvania, Philadelphia.

In 1963, Warhol began to work in inde-
pendent cinema, creating such films as
Sleep, 1963, and *Empire*, 1964. He joined
forces with Paul Morrisey in the middle
of the decade for a period of more intense
film production, but the filmmaking
came to a temporary halt in 1968 when an
actress shot and seriously wounded
Warhol in his studio. Following his recov-
ery, Warhol painted numerous portraits
of artists, art collectors, politicians, and
friends. In 1969 he began to publish
Inter/View (later *Interview*), a monthly
magazine modeled on the tabloids and
dedicated to fashion, art, entertainment,
and film.

Warhol's later work often included
reworkings of his earlier imagery. In 1982
and 1983 he collaborated with painter
Jean-Michel Basquiat, exhibiting with the
younger artist in New York and Zurich.
Warhol died unexpectedly in 1987 follow-
ing a routine gallbladder operation.
Since 1995 the Andy Warhol Museum in
Pittsburgh has housed a large personal
collection of Warhol's art and extensive
archives on the artist. c.g.

*The Andy Warhol
Museum*. Pittsburgh:
Andy Warhol Museum,
1994. Essays by Callie
Angell, Avis Berman,
Arthur C. Danto, Mark
Francis, Richard
Hellinger, Bennard B.
Perlman, and Helen
Searing.

*Andy Warhol: A
Retrospective*. New
York: Museum of Modern
Art, 1989. Essays by
Benjamin H. D. Buchloh,
Marco Livingstone,
Kynaston McShine, and
Robert Rosenblum.
Exhibition catalog.

Smith, Patrick. *Warhol:
Conversations about the
Artist*. Ann Arbor, Mich.:
UMI Research Press, 1988.

Warhol, Andy. *The
Philosophy of Andy
Warhol: From A to B and
Back Again*. New York:
Harcourt Brace, 1988.

LIST OF FIGU

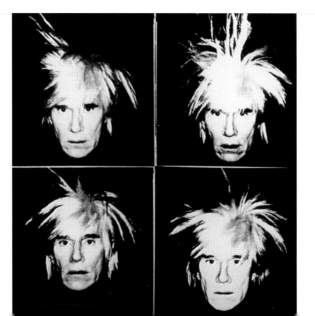

Self-Portrait, 1986

LLUSTRATIONS

fig. 29
Leonardo da Vinci (Italian, 1452–1519), *Study of Human Proportion in the Manner of Vitruvius,* c. 1490, pen, ink, wash, and chalk on paper, 13 1/2 x 9 5/8 in. (34.3 x 24.5 cm). Gallerie dell' Accademia, Venice, Italy.

fig. 30
Max Factor with the "Beauty Calibrator," 1932, a measuring device to reveal the "perfect" face. Hollywood Entertainment Museum, Los Angeles.

fig. 31
Andy Warhol (American, 1928–1987), *Before and After,* 1960, synthetic polymer and silkscreen ink on canvas, 54 x 70 in. (137.2 x 177.8 cm). The Andy Warhol Foundation for the Visual Arts, Inc., New York.

fig. 32
Vitaly Komar (American, b. Moscow, 1943) and Alexander Melamid (American, b. Moscow, 1945), *The People's Choice: America's Most Wanted Painting,* 1994, acrylic and oil on canvas, 26 x 36 in. (66 x 91.4 cm). Collection of the artists.

fig. 33
Vitaly Komar (American, b. Moscow, 1943) and Alexander Melamid (American, b. Moscow, 1945), *The People's Choice: Germany's Most Wanted Painting,* 1997, oil on canvas, 14 7/8 x 14 7/8 in. (37.75 x 37.75 cm). Collection of the artists.

fig. 34
Pop star Madonna performs "Vogue" at the MTV Video Music Awards, 1990.

fig. 35
Orlan (French, b. 1947), *Madone blanche en assomption* (The Assumption of the White Madonna), 1984, Cibachrome, 42 7/8 x 64 3/8 in. (110 x 165 cm). Collection of the artist.

fig. 36
Photograph by Fergus Greer (British) of performance artist Leigh Bowery (Australian, 1961– 1994) in *Future Juliette,* 1991.

fig. 37
Marlene Dumas (Dutch, b. South Africa, 1953), *Naomi,* 1995, oil on canvas, 50 7/8 x 42 7/8 in. (130 x 110 cm). Collection De Heus, The Netherlands.

fig. 38
Barbara Kruger (American, b. 1945), *Untitled (Your Body Is a Battleground),* 1989, photographic silkscreen on vinyl, 112 x 112 in. (284.5 x 284.5 cm). The Eli Broad Family Foundation, Santa Monica, California.

fig. 39
Carolee Schneemann (American, b. 1939), *Interior Scroll,* 1975, performance. Detail, photograph of performance and scroll text, 48 x 72 in. (121.9 x 182.9 cm). Collection of Eileen and Peter Norton, Santa Monica, California.

fig. 40
Guerrilla Girls, *Do Women Have to Be Naked to Get Into the Met. Museum?,* 1989, poster, 28 x 11 in. (71.1 x 28 cm). Collection of The Guerilla Girls, New York.

fig. 41
Lady Yang, Tang dynasty (A.D. 618–906), glazed ceramic, excavated in 1986 in Hansenzhai in Xian, Shaanxi Province, China. Bureau of Cultural Relics and Gardening of Xian, Shaanxi, China.

fig. 42
Joseph Blackburn (active in U.S., 1752–74), *Jonathan Warner,* 1761, oil on canvas, 50 x 40 in. (127 x 101.6 cm). Museum of Fine Arts, Boston; general funds.

Fig. 43
Pop star Marilyn Manson performs at the MTV Video Music Awards, 1998.

Fig. 44
Actress Bo Derek in the movie *10,* 1979, directed by Blake Edwards for Warner Brothers.

fig. 45
Cindy Sherman (American, b. 1954), *Untitled #122,* 1983, unique color photograph, 74 1/2 x 45 3/4 in. (189.2 x 116.2 cm). Private collection, London.

fig. 46
Charles Ray (American, b. 1953), *Self-Portrait,* 1990, mixed media, 75 x 26 x 20 in. (190.5 x 66 x 50.8 cm). Orange County Museum of Art, Newport Beach, California.

fig. 47
Mariko Mori (Japanese, b. 1967), *Birth of a Star,* 1995, 3D Duratrans print, acrylic, and fluorescent lights, 70 3/8 x 46 7/8 in. (180 x 120 cm). Museum of Contemporary Art, Chicago.

fig. 48
Caspar David Friedrich (German, 1774–1840), *Monk by the Sea,* 1808/10, oil on canvas, 42 7/8 x 66 7/8 in. (110 x 171.5 cm). Schloss Charlottenburg, Berlin.

fig. 49
In Tantric philosophy, the *yantra* is a vehicle for concentrating the mind and creating a fundamental map of harmony.

fig. 50
Anish Kapoor (British, b. India, 1954), *At the Hub of Things,* 1987, fiberglass and blue pigment, 64 1/8 x 55 1/2 x 59 in. (163.2 x 141 x 149.9 cm). Hirshhorn Museum and Sculpture Garden, Smithsonian Institution, Washington, D.C.; Gift of the Marion L. Ring Estate, by Exchange, 1989.

fig. 51
Bruce Nauman (American, b. 1941), *The True Artist Helps the World by Revealing Mystic Truths (Window or Wall Sign),* 1967, neon tubing with clear glass tubing suspension frame, 59 x 55 x 2 in. (149.9 x 139.7 x 5.1 cm), edition of 3, plus artist's proof. Collection of the artist.

fig. 52
Roden Crater by James Turrell (American, b. 1943), 1982.

fig. 53
Rodney Graham (Canadian, b. 1949), *Millennial Project for an Urban Plaza (with Cappucino Bar),* 1992, architectural model with the collaboration of Robert Kleyn, plexiglass, brass, and painted iron base. Fonds Régional d'Art Contemporain du Centre, Orléans, France.

fig. 54
Kensington Palace lawn covered with flowers after Princess Diana's death, September 1997, London.

fig. 55
Jim Hodges (American b. 1957) with The Fabric Workshop, *Every Touch,* 1995, detail, silk flowers and thread, 192 x 192 in. (487.7 x 487.7 cm). Philadelphia Museum of Art; Purchased with funds contributed by Mr. and Mrs. W. B. Dixon Stroud, 1995.

fig. 56
Yves Klein, *FC1 (Untitled Fire Color Painting),* 1961 (cat. no. 33), detail.

fig. 57
Marcel Duchamp (American, b. France, 1887–1968), *Bicycle Wheel,* 1951 (3d version, after lost original of 1913), assemblage: metal wheel, 25 1/2 in. (63.8 cm) in diameter, mounted on painted wood stool 23 3/4 in. (60.2 cm) high; overall 50 1/2 x 25 1/2 x 16 5/8 in. (128.3 x 63.8 x 42 cm). The Museum of Modern Art, New York; The Sidney and Harriet Janis Collection.

fig. 58
Andy Warhol (American, 1928–1987) with his cookie-jar collection, March 1974, New York.

fig. 59
William Hodges (British, 1744–1797), *Head of a Maori Man,* c. 1775, pen and ink on paper, 4 x 3 7/8 in. (10.2 x 9.5 cm). National Library of Australia, Canberra.

fig. 60
Mark Rothko (American, b. Russia, 1903–1970), *Blue, Orange, Red,* 1961, oil on canvas, 90 1/4 x 81 1/4 in. (229.2 x 205.9 cm). Hirshhorn Museum and Sculpture Garden, Smithsonian Institution, Washington, D.C.; Gift of the Joseph H. Hirshhorn Foundation, 1966.

fig. 61
Jasper Johns (American, b. 1930), *The Critic Sees,* 1961, sculptmetal over plaster with glass, 3 1/4 x 6 1/4 x 2 1/8 in. (8.3 x 15.9 x 5.3 cm). Private collection.

fig. 62
Christo (American, b. Bulgaria, 1935) and Jeanne-Claude (American, b. France, 1935), *Running Fence, Sonoma and Marin Counties, California, 1972–76.* Height 216 in. (548.6 cm), length 24 1/2 miles (40 km).

fig. 63
Robert Motherwell (American, 1915–1991), *Elegy to the Spanish Republic, 108*, 1965–67, oil on canvas, 81 3/8 x 136 7/8 in. (208.2 x 351.1 cm). The Museum of Modern Art, New York; Charles Mergentime Fund.

fig. 64
Eva Hesse (American, b. Germany, 1936–1970), *Test Piece for "Contingent,"* 1969, latex over cheesecloth, 144 x 44 in. (365.7 x 111.8 cm). National Gallery of Art, Washington, D.C.; Gift of the Collections Committee, 1996.

page 204, Matthew Barney
Cremaster 4: The Loughton Candidate, 1994, color photograph in cast plastic frame, 19 1/2 x 17 5/6 x 1 1/2 in. (49.5 x 45.3 x 3.8 cm), edition of 30. Photography: Michael James O'Brien.

page 207, Lucian Freud
Painter Working, Reflection, 1993, oil on canvas, 40 x 32 1/4 in. (101.3 x 81.7 cm). Private collection.

page 208, Felix Gonzalez-Torres
Untitled (Loverboys), 1991, candies individually wrapped in silver cellophane (endless supply), installation dimensions variable; ideal weight, 355 lbs. Goetz Collection, Munich.

page 211, Yves Klein
Leap into the Void, 1960, photomontage. Photography: Harry Shunk. Private collection.

page 213, Roy Lichtenstein
Chuck Close (American, b. 1940), *Roy II,* 1994, oil on canvas, 102 x 84 in. (259.1 x 213.4 cm). Hirshhorn Museum and Sculpture Garden; Smithsonian Collections Acquisition Program and Joseph H. Hirshhorn Purchase Fund, 1995.

page 215, Mariko Mori
Mirage, 1997, glass with photo interlayer, 24 x 30 in. (61 x 76.2 cm).

page 219, Gerhard Richter
Thomas Ruff (German, b. 1958), *Gerhard Richter, Madrid,* 1994, C-print, 52 x 73 1/4 in. (132 x 186 cm), edition of 10.

page 223, Kiki Smith
My Blue Lake, 1995, photogravure and monoprint, trial proof, 42 1/2 x 53 3/4 in. (108 x 136.5 cm), edition of 41.

page 226, Andy Warhol
Self-Portrait, 1986, synthetic polymer and silkscreen ink on linen, 80 x 80 1/2 in. (203 x 203.4 cm). Hirshhorn Museum and Sculpture Garden; Partial Gift of the Andy Warhol Foundation for the Visual Arts and Partial Purchase, Smithsonian Collections, 1995.

The publishers wish to thank the museums, galleries, artists, and private collectors who supplied photographs of works of art in their possession to be reproduced as illustrations. Every attempt has been made to ascertain complete information on photography.

FIGURE ILLUSTRATIONS

Fig. 1: courtesy Andrea Rosen Gallery, New York (photo by Peter Muscato); *fig. 2*: courtesy Vanessa Beecroft (photo by Annika Larsson); *figs. 3, 4, 7, 12, 23, 57, and 63*: © 1999 The Museum of Modern Art, New York; *fig. 5*: courtesy Seattle Art Museum, Washington (photo by Paul Macapia); *fig. 8*: © The Art Institute of Chicago. All rights reserved; *fig. 9*: Allen Memorial Art Museum, Oberlin College, Ohio, © Ingeborg and Dr. Wolfgang Henze-Ketterer, Wichtrach/Bern; *fig. 10*: Städtische Galerie im Lenbachhaus, Munich.; *fig. 11*: Tate Gallery, London, 1999; *fig. 13*: © Successin Picasso, Paris, photo © Moderna Museet; *fig. 14*: courtesy First Run Features, New York; *fig. 15*: reproduced from Stephanie Barron, *"Degenerate Art": The Fate of the Avant-Garde in Nazi Germany* (Los Angeles: Los Angeles County Museum of Art, 1991), 24; *figs. 16, 50, and 60*: Hirshhorn Museum and Sculpture Garden (photos by Lee Stalsworth); *fig. 17*: courtesy San Francisco Museum of Modern Art; *fig. 18*: © Piero Manzoni/Licensed by VAGA, New York, courtesy Hirschl and Adler, New York; *fig. 19*: courtesy Center for Creative Photography, The University of Arizona, Tucson. © 1991 Hans Namuth Estate; *fig. 20*: © Yves Klein/ADAGP, Paris, courtesy Yves Klein Archives, Paris, photo © Harry Shunk, New York; *fig. 21*: courtesy René Block, Berlin (photo by W. Zellien); *fig. 22*: courtesy Claes Oldenburg/Coosje van Bruggen, New York (photo by Charles Rappaport); *fig. 24*: courtesy McKee Gallery, New York; *fig. 25*: © The Art Institute of Chicago. All rights reserved (photo by Douglas M. Parker Studio); *fig. 26*: courtesy Galleria Christian Stein, Milan; *fig. 27*: The Metropolitan Museum of Art, New York. All rights reserved; *figs. 28 and 29*: Alinari/Art Resource, New York; *fig. 30*: courtesy Proctor and Gamble Archives, Cincinnati; *fig. 31*: The Andy Warhol Foundation, Inc./Art Resource, New York. © The Andy Warhol Foundation, Inc./Artists Rights Society (ARS), New York; *figs. 32 and 33*: courtesy Alexander Melamid (photo by James Dee); *fig. 34*: © 1999 ImageDirect, New York (photo by Frank Micelotta); *fig. 35*: courtesy Orlan (photo by école de photo ACE 3 P); *fig. 36*: courtesy Violette Editions, London; *fig. 37*: courtesy Galerie Paul Andriesse, Amsterdam; *fig. 38*: courtesy Mary Boone Gallery, New York (photo by Allan Zindman and Lucy Fremont, New York); *fig. 39*: courtesy Carolee Schneemann; *fig. 40*: courtesy The Guerilla Girls, New York; *fig. 41*: © 1995 WONDERS, Memphis, Tennessee (photo by Murray Riss), courtesy WONDERS: The Memphis International Cultural Series; *fig. 42*: © 1999 Museum of Fine Arts, Boston. All rights reserved; *fig. 43*: AP/Wide

PHOTOGRAPHIC *CREDITS*

World (photo by Kevork Djansezian); *fig. 44*: The Gamma Liaison Agency, New York (photo by Hulton Getty); *fig. 45*: courtesy Cindy Sherman and Metro Pictures, New York; *fig. 46*: courtesy Regen Projects, Los Angeles; *fig. 47*: courtesy Deitch Projects, New York; *fig. 48*: Staatliche Museen zu Berlin, Preussischer Kulturbesitz (photo by Karin März, 1998); *fig. 49*: reproduced from José and Miriam Argüelles, *Mandala* (Berkeley, Calif.: Shambala, 1972), 102; *fig. 51*: courtesy Sperone Westwater, New York, © 1999 Bruce Nauman/Artists Rights Society (ARS), New York; *fig. 52*: courtesy James Turrell; *fig. 53*: courtesy Yves Gevaert, Brussels; *fig. 54*: AP/Wide World (photo by Bebeto Matthews); *fig. 55*: courtesy CRG, New York (photo by Allan Zindman and Lucy Fremont, New York); *fig. 56*: courtesy Yves Klein Archives, Paris, © Yves Klein/ADAGP, Paris; *fig. 58*: © J. P. Laffont/Sygma, Paris; *fig. 59*: courtesy National Library of Australia, Canberra; *fig. 61*: private collection (photo by Rudolph Burckhardt); *fig. 62*: courtesy Christo and Jeanne-Claude, © Christo 1976 (photo by Jeanne-Claude); *fig. 64*: © 1999 Board of Trustees, National Gallery of Art, Washington, D.C.

COLOR PLATES

Cat. no. 1: installation view, p. 44, *nos. 9 and 10*, pp. 60, 62, *no. 14*, p. 164, *no. 20*, p. 54, *no. 22*, p. 57, *no. 46*, p. 68, *no. 49* (© Gerhard Richter), p. 146, *no. 55*, p. 148, *no. 69*, pp. 70–71, and *no. 85*, p. 66: Hirshhorn Museum and Sculpture Garden (photos by Lee Stalsworth); *cat. no. 1, details*, p. 45: courtesy Janine Antoni (photo by John Bessler); *cat. no. 2*, p. 142: courtesy John Baldessari Studio, Santa Monica, California; *cat. no. 3*, pp. 84–85, and *no. 4*, p. 80 (reproduction photos by Joshua White), *no. 5*, p. 81 (reproduction photo by Allan Zindman and Lucy Fremont), *no. 6*, p. 79, *nos. 7 and 8*, pp. 82, 83 (reproduction photos by Lari Lamay), and *no. 81*, p. 156 (photo by Ernst Moritz): courtesy Barbara Gladstone Gallery, New York; *cat. no. 11*, p. 61: courtesy Louise Bourgeois Studio, New York (photo by Peter Bellamy); *cat. no. 12*, p. 163: photo by Brian Forrest, Santa Monica, California; *cat. no. 13*, p. 161, and *no. 17*, p. 158 (photo by Scott Bowron): courtesy McKee Gallery, New York; *cat. no. 15*, p. 162: courtesy Modern Art Museum of Fort Worth; *cat. no. 16*, p. 160, and no. 88, p. 143: The Baltimore Museum of Art; *cat. no. 18*, p. 157: courtesy Fondation Cartier pour l'Art Contemporain, Paris; *cat. no. 19*, p. 159, and *no. 42*, p. 49: The Carnegie Museum of Art, Pittsburgh; *cat. no. 21*, p. 59: courtesy De Pont Foundation for Contemporary Art, Tilburg, The Netherlands (photo by Peter Cox); *cat. no. 23*, p. 58 (photo by Scott Bowron), and *no. 24*, p. 56: courtesy Acquavella Contemporary Art, Inc., New York; *cat. no. 25*, p. 179, and *no. 26-A*, p. 180 (photo by David Heald): courtesy Andrea Rosen Gallery, New York; *cat. no. 26-B*, p. 181: courtesy Goetz Collection, Munich (photo © 1995 by Philipp Schönborn, Munich); *cat. no. 27*, p. 178: Stedelijk Van Abbemuseum, Eindhoven, The Netherlands; *cat. nos. 28 and 29*, pp. 175, 174, and *no. 37*, p. 136: courtesy Fisher Landau Center, Long Island, New York; Jim Hodges, *No Betweens*, 1996, p. 176, and *Changing Things*, 1997, p. 177: courtesy CRG, New York (photos by Allan Zindman and Lucy Fremont); *cat. no. 31*, p. 140: courtesy Lisson Gallery, London (photo by John Riddy); *cat. no. 32*, p. 141: The Menil Collection, Houston (photo by Hickey-Robertson); *cat. no. 33*, pp. 52–53: © Yves Klein/ADAGP, Paris, courtesy Yves Klein Archives, Paris; *cat. no. 34*, p. 51: courtesy Imi Knoebel; *cat. no. 35*, p. 42: courtesy Ulrich Knecht, Stuttgart; *cat. no. 36*, p. 153: courtesy Joseph Helman Gallery, New York; *cat. no. 38*, p. 138: San Francisco Museum of Modern Art (photo by Ben Blackwell); *cat. no. 39*, p. 137, and *no. 82*, p. 154: courtesy Daros Collection, Switzerland; *cat. no. 40*, p. 139: courtesy private collection, San Francisco; *cat. no. 41*, p. 78: courtesy Deitch Projects, New York; *cat. no. 43*, p. 41: courtesy Galleria Christian Stein, Milan; *cat. no. 44*, p. 55: Fondation Beyeler, Riehen/Basel; *cat. no. 45*, p. 43: courtesy Michelangelo Pistoletto (photo by P. Pellion); *cat. no. 47*, p. 72: courtesy The Eli Broad Family Foundation, Santa Monica, California; *cat. no. 48*, p. 145: © Gerhard Richter, courtesy Anthony d'Offay Gallery, London (photo by J. Littkemann, Berlin); *cat. no. 50*, p. 151: © Gerhard Richter, courtesy Massimo Martino Fine Arts and Projects, Mendrisio, Switzerland; *cat. no. 51*, p. 149, *no. 52*, p. 147, *no. 53*, p. 150, and *no. 54*, p. 144: © Gerhard Richter, courtesy Gerhard Richter (photo by Friedrich Rosenstiel, Cologne); *cat. no. 56*, installation view, p. 64: © Niklaus Stauss, Zurich, fotograf BR/SAB; *cat. no. 56*, video stills, p. 65: courtesy Galerie Hauser und Wirth AG, Zurich; *cat. no. 57*, p. 155: © Bildteameti Halmstad AB, Halmstad, Sweden (photo by Jesper Anderson); *cat. no. 58*, p. 73: courtesy Beverly Semmes; *cat. nos. 59–65*, pp. 74–77, and *nos. 66–68*, pp. 47, 48: courtesy Cindy Sherman and Metro Pictures, New York; *cat. no. 70*, p. 63: courtesy Pace Wildenstein, New York (photo by Ellen Page Wilson); *cat. nos. 71–79*, pp. 165–73: courtesy Sonnabend Gallery, New York; *cat. no. 80*, p. 67: courtesy Art Publishing, Cologne; *cat. no. 83*, p. 152: © Rheinisches Bildarchiv, Museen der Stadt, Cologne; *cat. no. 84*, p. 50: private collection; *cat. no. 86*, p. 46: © 1988 by The Metropolitan Museum of Art, New York; *cat. no. 87*, p. 69: © Virginia Museum of Fine Arts, Richmond (photo by Katherine Wetzel).

BIOGRAPHIES OF ARTISTS

Antoni, p. 203: courtesy Luhring Augustine, New York (photo by Prudence Cuming Associates, London); *Baldessari*, p. 203: courtesy John Baldessari; *Barney*, p. 204: courtesy Barbara Gladstone Gallery, New York (reproduction photo by Lari Lamay); *Bourgeois*, pp. 204–5: courtesy Louise Bourgeois (photo by Claudio Edinger); *Celmins*, p. 205: courtesy Vija Celmins (photo by Susan Titelman); *de Kooning*, p. 206: photo by Hans Namuth, courtesy Hans Namuth Papers, Archives of American Art, Smithsonian Institution, Washington, D.C.; *Dumas*, pp. 206–7: courtesy Galerie Paul Andriesse, Amsterdam (photo by Paul Andriesse); *Freud*, p. 207: courtesy Acquavella Contemporary Art, Inc., New York; *Gonzalez-Torres*, p. 208: courtesy Andrea Rosen Gallery, New York (photo by Peter Muscato); *Gordon*, p. 208: courtesy Lisson Gallery, London; *Graham*, p. 209: photo by Timothy Klein; *Hodges*, p. 210: photo by Jim Hodges, courtesy Jim Hodges; *Kapoor*, p. 211: courtesy Lisson Gallery, London (photo by Gautier Deblonde, London); *Klein*, p. 211: © Yves Klein/ADAGP, Paris, courtesy Yves Klein Archives, Paris, photo © Harry Shunk, New York; *Knoebel*, p. 212: photo © Anton Corbijn, courtesy Anton Courbijn; *Kounellis*, p. 213: © Claudio Abate; *Lichtenstein*, p. 213: Hirshhorn Museum and Sculpture Garden (photo by Lee Stalsworth); *Martin*, p. 214: photo by Timothy Greenfield-Sanders, New York; *Mori*, p. 215: courtesy Deitch Projects, New York; *Morimura*, p. 215: photo by Yasumasa Morimura, courtesy Yoshiko Isshiki Gallery, Tokyo; *Paolini*, p. 216: courtesy Christian Stein, Milan (photo by Matteo Piazza, Milan); *Picasso*, p. 217:

HIRSHHORN *STAFF*

Library of Congress Cataloging-in-Publication Data: Benezra, Neal David, 1953–

Regarding beauty : a view of the late twentieth century / Neal Benezra, Olga M. Viso ;

with an essay by Arthur C. Danto. p. cm.

Catalog of an exhibition held at the Hirshhorn Museum and Sculpture Garden, Smithsonian Institution,

Washington, D.C., Oct. 7, 1999–Jan. 17, 2000

and the Haus der Kunst, Munich, Germany, Feb. 11–Apr. 30, 2000.

Includes bibliographical references.

ISBN 3-89322-782-2 (English : alk. Paper). – ISBN 3-89322-779-2 (German : alk. Paper)

1. Art, Modern – 20th century – Exhibitions. 2. Aesthetics, Modern – 20th century – Exhibitions.

I. Viso, Olga. M., 1966– . II. Danto, Arthur Coleman, 1924– .

III. Hirshhorn Museum and Sculpture Garden. IV. Haus der Kunst München. V. Title.

N6487.W3H5724 1999 99–14570 CIP

The paper used in this publication meets the minimum requirement for the

American National Standard for Permanence of Paper for Printed Library Materials, Z39.48-1984.

ISBN: 3-89322-782-2

Editor: Jane McAllister, Hirshhorn Museum *Design and production*: studio blue, Chicago Printed and bound in Germany

Typeset in Fournier and Gararond Color separations by C+S Repro, Filderstadt, Germany

Printed on BVS matt paper, 170g/sqm

Produced by Hatje Cantz Publishers Senefelderstrasse 12 73760 Ostfildern, Germany tel 49.711.4405.0 fax 49.711.4405-220

U.S. Distribution : D.A.P./Distributed Art Publishers 155 Avenue of the Americas, second floor

New York, New York 10013 tel 212.627.1999 fax 212.627.9484

Beauty is a power we should reinvest with our own purpose